The Collages of Kurt Schwitters

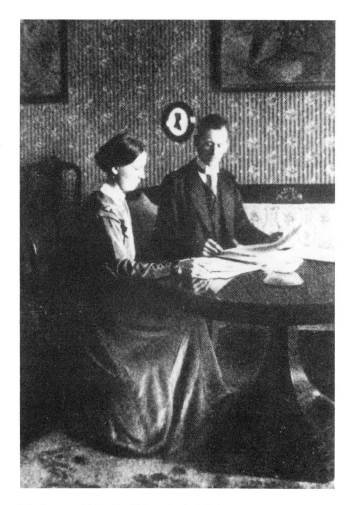

Schwitters and his wife, Helma, in their living room, ca. 1920.

The Collages of Kurt Schwitters

Tradition and Innovation

Dorothea Dietrich
Princeton University

CAMBRIDGE
UNIVERSITY PRESS

Published by the Press Syndicate of the University of Cambridge
The Pitt Building, Trumpington Street, Cambridge CB2 1RP
40 West 20th Street, New York, NY 10011-4211, USA
10 Stamford Road, Oakleigh, Melbourne 3166, Australia

First published 1993

Printed in the United States of America

Library of Congress Cataloging-in-Publication Data
Dietrich, Dorothea.
The collages of Kurt Schwitters : tradition and innovation / Dorothea Dietrich.
 p. cm.
Includes bibliographical references.
ISBN 0-521-41936-0
1. Schwitters, Kurt, 1887–1948. 2. Artists – Germany – Biography.
I. Title.
N6888.S42D54 1993
709'.2 – dc20 92–44956
 CIP

A catalog record for this book is available from the British Library

ISBN 0-521-41936-0 hardback

"Die Unsterblichkeit ist nicht jedermanns Sache." – Kurt Schwitters, 1921

CONTENTS

ILLUSTRATIONS

Color plates appear on unnumbered pages between pages xvi and 1.

ACKNOWLEDGMENTS

In the course of my research and writing I incurred numerous intellectual and scholarly debts. I benefited above all from John Elderfield's comprehensive study of Kurt Schwitters, as well as from his commentary and advice. I am similarly indebted to Hanne Bergius, Dietmar Elger, Ernst Nündel, Werner Schmalenbach, Joan Weinstein, and O. K. Werckmeister, as well as to Schwitters's friends, Robert Michel and Edith Tschichold. I am particularly grateful to Ernst Schwitters, who graciously accommodated my many questions and made available material at his home in Lysaker, Norway.

At Princeton, I profited from conversations with Alan Colquhoun and Carl Schorske. Arno J. Mayer helped me recognize the importance of tradition within modernist culture. Michael Jennings, with whom I explored the nature of Weimar culture in several undergraduate and graduate seminars, deserves special thanks for many stimulating discussions. My thanks go equally to my students at Yale University and Princeton University for their challenging questions and comments.

I gratefully acknowledge the assistance of the staffs of many libraries: the Beinecke Rare Book Library at Yale University; in Paris, the Bibliothèque Littéraire Jacques Doucet and the Bibliothèque Nationale; in Hannover, the Schwitters Archiv, in particular Frau Maria Haldenwanger; in Berlin, the Hannah Höch Archiv in the Berlinische Galerie, especially Herr Wolfgang Erler; the Sturm Archiv in the Staatsbibliothek Preußischer Kulturbesitz, and the Bauhaus Archiv. The staffs of many galleries and museums helped me locate Schwitters's works and kindly provided photographs: Marlborough Fine Arts, Ltd., London; Annely Juda Fine Arts, London; Galerie Gmurzynska, Cologne; and Galleries Carus and Helen Serger/La Boetie, New York. Vivian Barnett at the Solomon R. Guggenheim Museum, New York, and Beatrice Kernan at the Museum of Modern Art, New York, generously gave of their time and expertise. Without Shari Kenfield and David Connelly at Princeton University, the task of gathering photographs would have been even

more daunting. I would like to extend my thanks to the owners of the works of art who kindly granted me permission to reproduce them in this book.

My research was made possible with grants from the American Council of Learned Societies and the Spears Fund of the Department of Art and Archaeology and the Committee on Research in the Humanities and Social Sciences at Princeton University, whose support I gratefully acknowledge. This book finds its origin in my dissertation on Schwitters written at Yale University with the support of a Samuel H. Kress Travel Grant and a Richardson dissertation fellowship.

I presented some of the material in this book in lectures at Berkeley, Harvard, and Yale universities, Mount Holyoke College, the German Studies Association, and the College Art Association of America, and I am grateful for the criticisms and comments I received. Sections of the *Merzbau* chapter and those on Schwitters's representation of women were previously published as separate articles in *Assemblage* and *The Yale University Art Gallery Bulletin*.

I owe a special debt to Daniel Robbins and Beth Irwin Lewis for their incisive comments on my manuscript. My editor at Cambridge University Press, Beatrice Rehl, deserves my warmest thanks. Most of all, however, I am indebted to Robert L. Herbert, whose approach to modern art has been an inspiration to me since my first class as an undergraduate at Yale. For his support, and for bearing with me throughout this lengthy project, my thanks go to John Peter Boorsch.

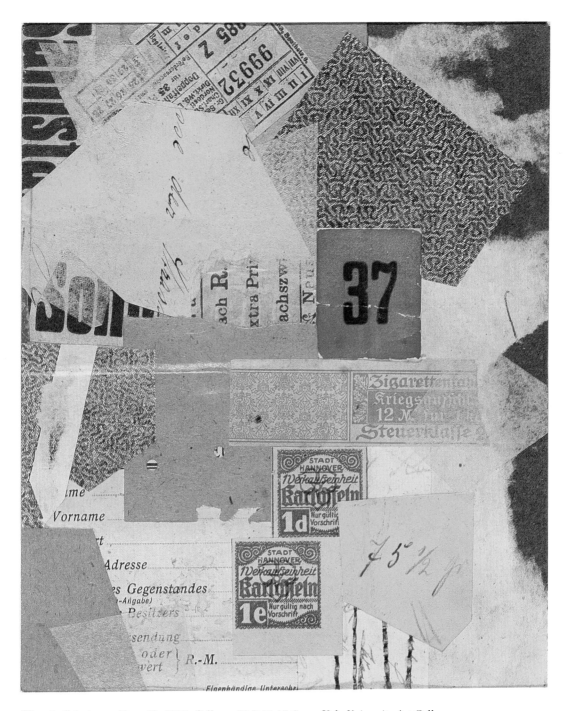

Plate 1. Schwitters, *Merz. 19*, 1920. Collage, 20.2 × 17.2 cm. Yale University Art Gallery. Gift of the Société Anonyme.

Plate 2. Schwitters, *Hochgebirgsfriedhof* [Mountain Graveyard], 1919. Oil on board mounted on cork, 91.6 × 72.4 cm. Solomon R. Guggenheim Museum, New York, Gift, Mr. and Mrs. Frederick M. Stern, 1962. Photo: David Heald, © The Solomon R. Guggenheim Foundation, New York, FN 62.1617.

Plate 3. Schwitters, *Aq. 23, Koketterie* [Coquettishness], 1919. Watercolor, 11.9 × 17.2 cm.
Galerie Gmurzynska, Cologne.

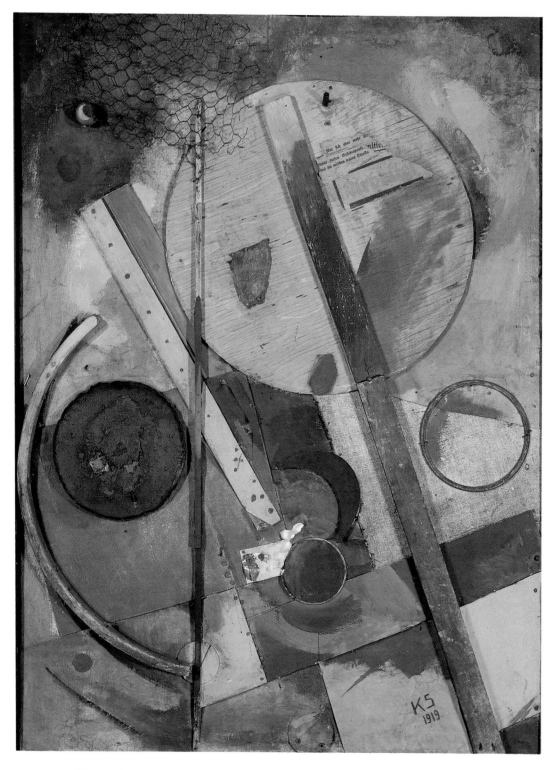

Plate 4. Schwitters, *Das Arbeiterbild* [The Worker Picture], 1919. Assemblage, 125 × 91 cm. National Art Museums of Sweden.

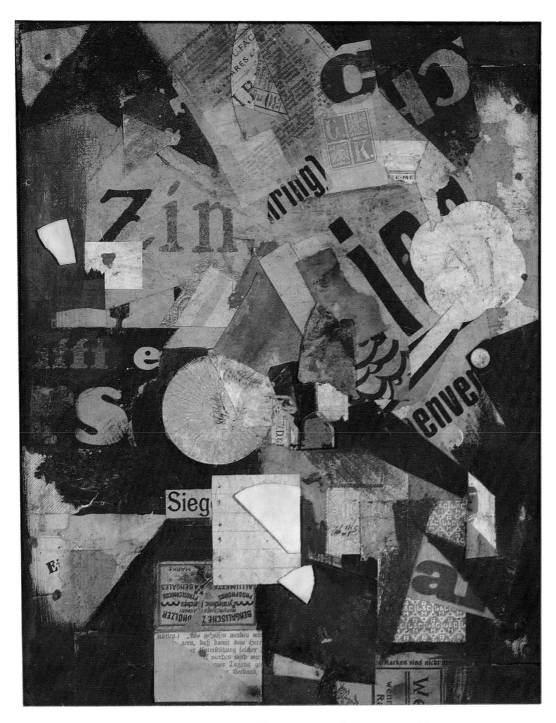

Plate 5. Schwitters, *Das Siegbild* [Victory Picture], ca. 1920–5. Collage, 38 × 32 cm. Wilhelm-Hack-Museum, Ludwigshafen.

Plate 6. Schwitters, *Mz. 169, Formen im Raum* [Forms in Space], 1920. Collage, 18 × 14.3 cm. Kunstsammlung Nordrhein-Westfalen, Düsseldorf.

Plate 7. Schwitters, *Mz. 158, Das Kotsbild* [The Vomit Picture], 1920. Collage. 27 × 19.5 cm. Photo © Sprengel Museum, Hannover.

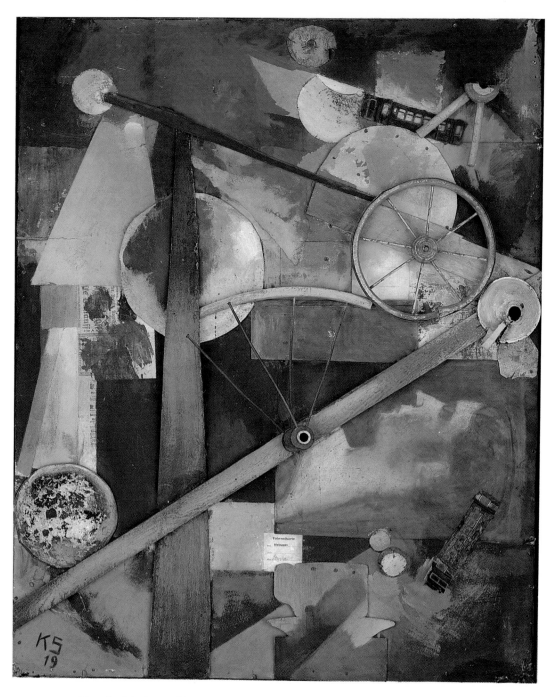

Plate 8. Schwitters, *Konstruktion für edle Frauen* [Construction for Noble Ladies], 1919. Assemblage, 103 × 83.3 cm. Los Angeles County Museum of Art. M.62.22. Purchased with Funds Provided by Mr. and Mrs. Norton Simon, The Junior Arts Council, Mr. and Mrs. Frederick M. Weisman, Mr. and Mrs. Taft Schreiber, Hans De Schulthess, Mr. and Mrs. Edwin Janss, Mr. and Mrs. Gifford Phillips. © 1992 Museum Associates, Los Angeles County Museum of Art. All rights reserved.

INTRODUCTION

The discussion of modern art is predicated on the notion of progress. Freed by photography from the traditional task of depicting the external world, artists began to investigate the specific properties of their craft: Art became increasingly concerned with itself. In the realm of painting, the inquiry focused on the material components of representation: the actual two-dimensional support of the canvas and the carriers of expression, pigment and line, eventually leading, according to the critic Clement Greenberg, to the suppression of all sculptural illusion in favor of the affirmation of the picture plane:

The essence of modernism lies, as I see it, in the use of the characteristic methods of a discipline to criticize the discipline itself, not in order to subvert it, but in order to entrench it more firmly in its area of competence.[1]

Modernism, in this view, was understood as stylistic change based primarily on technical innovation; progress and aesthetic pleasure were identified with the advancement of painterly or sculptural techniques that increased the degree of purity with which a medium was employed. Artistic achievement was seen from the perspective of the new, spearheaded by the avant-garde, a group of artists and writers whose inquiries and formal solutions disdained the old and who produced work deemed progressive. Hence all art was divided along strictly hierarchical lines between the old and the new, the traditional and avant-garde. Yet like all such categorizations the rigid division between the traditional and the new offers an impoverished view of events; more damaging, by excising multiplicity and variety from the historical picture in favor of linearity, a distorted view of the progressive (or traditional) emerges.

In addition, the terminology employed in the debate about the old and the new further distorts the issue. A case in point is the term "avant-garde." Although it is a key concept in the discussion, there is no agreement on what really constitutes the avant-garde. Definitions range from the all-encompassing, in which the label

is attached to everything that occurs outside the mainstream and that serves the advancement of ideas (as seen in Renato Poggioli's broad historical study, *The Theory of the Avant-Garde*), to the notion of the avant-garde as linked to specific utopian, anarchist goals in the nineteenth century. Included is the rigid explanation offered by Peter Bürger in his *Theorie der Avantgarde*, which describes the avant-garde as the self-conscious and directed critique of the institutions of art, i.e., the investigation of the nature of artistic production in relation to the institutional framework in which art is located and which, in turn, defines artistic practice.

Bürger's definition is eminently applicable to Dada, the iconoclastic artistic movement that arose during World War I within a group of international emigrés gathered in Zurich. These artists and writers sought to develop new artistic forms that could critique the hierarchical political and cultural traditions of Western materialist societies they believed had contributed to the outbreak of the war. Dada found a more radical reincarnation toward the end of the war and the years immediately following it in Berlin, where artists vehemently decried the authority of the past and called for the embracing of the new. Yet even though Bürger's theory helps us grasp the significance of Berlin Dada, it does not facilitate the placement of any art less radical than Dada – and even variants of Dada – within the category of the avant-garde if the artistic activity has not purposefully served to critique the institution of art itself.

However, the concept of the rigid division between the old and the new and the notion of historical progress in terms of a linear development are certainly subject to dispute. It has been most seriously challenged by Arno J. Mayer, whose *Persistence of the Old Regime* amply demonstrates the remarkable resilience of traditional societal forms, particularly evident in the continued stratification of society by class and cultural habits, and their resistance to change even in the wake of revolutions. Mayer's argument is supported by Charles S. Maier's delineation, in *Recasting Bourgeois Europe*, of the processes of political stabilization in Europe in the decade after World War I. In the case of Weimar Germany, historians like Fritz Stern, in his *The Politics of Cultural Despair*, and more recently Jeffrey Herf, in his *Reactionary Modernism*, have described the selective embrace of modernism by conservative thinkers and politicians, who saw the potential for conservative social change through the exploitation of modern technologies.

The more nuanced views presented by these historians on the relationship between tradition and innovation, and the intimation of a middle ground in which the avant-garde intersects with the traditional, suggest a fertile field of inquiry. In addition, new and frequently interdisciplinary methodologies have in recent years profoundly challenged a dominant, hierarchical view of history. Drawing on economic, psychoanalytic, sociological, and literary theories, these critical approaches pose alternate readings of history to arrive at multilayered interpretations of historical data; in the realm of art history, these postmodern theories are beginning

to unmask modernism (and thus the dichotomy between the old and the new) as a myth created by the dominant culture.

In this book, I focus on the work of the Hannover artist Kurt Schwitters (1887–1948) in order to demonstrate the survival of tradition within avant-garde innovation and the multifaceted character of innovation itself. A close investigation of the progressive artist at a particular moment may uncover in the process the limitations of critical thought organized along the strict dichotomy of the old and the new. Schwitters's work is particularly suited to this task: At the end of World War I he effected a break with artistic traditions, particularly easel painting, through his adoption of a decidedly modern artistic process: collage. With its emphasis on ready-made forms that are largely the products of urban culture (fragments of newsprint, photographic imagery, urban debris), collage has long been understood as the quintessential modernist medium. It displaces traditional creativity and artistic expression, which were thought to be located in the subject matter and individual artists' marks – the notion of a personal style – by substituting prefabricated forms and thus links artistic production with modern industrial production. In the case of Schwitters, the adoption of the collage process extended to all his varied artistic pursuits, the making of images as well as the writing of texts, graphic design, architecture, and even musical composition.

Schwitters's work spans the life of the Weimar Republic, but finds its origins in the prewar era and lives on in the Fascist period, when the artist was in exile, through World War II. From the moment of his transformation into a collage artist, Schwitters identified with the modern: The machine makes its appearance both in images and symbols, and the historical caesura brought about by the machine age is echoed in the fissures and discontinuities of the collaged images and texts themselves.

In Schwitters, we find the coexistence of the contradictory projects of the avant-garde and those of the more traditional artists, especially the postwar Expressionists, fused into an all-encompassing new work of art: the *Merzbau*, an assemblage always expanding toward architecture. However, this fusion of the modern with the traditional hardly makes Schwitters a reactionary modernist: In the political realm, the link between technology and the crafts, between society and community, was forged for nationalistic goals; Schwitters, on the other hand, always identified himself as a member of the transnational community: the international avant-garde of Russian Constructivist, de Stijl, and German, French, and Hungarian Dada artists; and later, the international Abstraction/Création group. Schwitters's work was never part of conservative discourse within Germany: He was derided by the conservative critics of the German art establishment in Fascist Germany, declared a degenerate artist, and forced to leave the country in 1937 to escape Nazi persecution.

Investigating the form and content of Schwitters's work in a broader context, against the background of historical continuity and change, permits a new look at

art in Weimar Germany and at the diversity of attitudes present within the progressive artistic community. Schwitters's work raises questions about the validity of the established dichotomy between the progressive and the conservative, between avant-garde and tradition. His works blur boundaries, and progressive and conservative attitudes may be present simultaneously within a single work.

In this study, I address several broader aspects of Schwitters's work, in particular his grounding in Expressionist theory, the formulation of a new language based on collage, his representation of postwar politics, the depiction of women, and, finally, the *Merzbau* and related sculptures. In each instance, I investigate the interplay of Schwitters's innovative and conservative tendencies. My treatment does not attempt to be comprehensive, especially as there are already several substantial studies of Schwitters's life and artistic development. Rather, I highlight specific moments in the artist's career to illuminate the complex interweaving of progressive and conservative thought and expression in Schwitters and the culture at large in a period of political and social change. Several important texts offer an overview of Schwitters's life and art: Werner Schmalenbach's introductions to the artist began with the organization of several exhibitions in the late 1950s and early 1960s and led, in 1965, to the publication of his comprehensive monograph, *Kurt Schwitters*. This was followed in 1971 by Friedhelm Lach's study of the artist as a writer, *Der Merz Künstler Kurt Schwitters*, a work that eventually led him to edit and publish Schwitters's entire literary oeuvre in a five-volume set during 1973–81. Bernd Scheffer's *Anfänge experimenteller Literatur* places Schwitters's literary texts in the context of early twentieth-century experimental writing and offers detailed readings of selected pieces of prose and poetry.

Although Lach had considered Schwitters in a broader cultural context in *Der Merz Künstler*, it was Ernst Nündel, the editor of Schwitters's letters, who first proposed that Schwitters was fascinated with the possibilities of play and ambiguity inherent in the collage process. In his biography of the artist, Nündel was also the first modern critic whose extensive reading of one of Schwitters's collages, the late *Ein fertiggemachter Poet* (1947), explored the relation between private experience and modernist artistic concerns.[2]

John Elderfield's *Kurt Schwitters* offers a superb, richly annotated study of the artist's work. Building on Schmalenbach's monograph, he has delineated Schwitters's work in its connectedness to other artists and cultural organizations. Yet, much like Schmalenbach, Elderfield has treated Schwitters as a great modernist artist and has largely shied away from the analysis of content. Elderfield's work constitutes the background to the present study and is often called on to provide specific detail.

My detailed examination of individual collages is echoed in the writings by Annegreth Nill. In several articles, Nill has presented probing analyses of select collages and has traced in detail the origin of the collage fragments.[3] As opposed to my own work, Nill's study is more concerned with the detection of sources than

with broader conclusions about the nature of Schwitters's art and Weimar modernism. Her recent dissertation, "Decoding Merz," became available only in the final stages of my manuscript revisions, unfortunately too late to be considered for this study.

My own investigation of Schwitters's *Merzbau* has been enriched by Elderfield's presentation as well as Dietmar Elgar's concise historical survey. My discussion of Schwitters's attitude toward innovation and tradition has grown out of my dissertation "The Fragment Reformed: The Early Collages of Kurt Schwitters," which was concerned with Schwitters's creation of Anna Blume, a fictitious character indicative of the modern and the past, and with the close analysis of specific collages. This research led me to investigate the larger issue of tradition and innovation in Schwitters's work in the context of the Weimar Republic, particularly as evident in the *Merzbau*, and to consider the limitations imposed on art history when categories are too narrowly applied.

POLITICAL AND CULTURAL CHAOS AND THE FORMATION OF MERZ

In May 1919 the satirical magazine *Der Simplicissimus* published a cartoon by Karl Arnold entitled *Das Ende vom Lied* [The Song's End; or, The End of the Matter][1] (Fig. 1), which depicted a huge junk pile formed of the typical debris of a middle-class European household: broken chairs and bottles, household objects, the elaborately carved handles of a baby carriage, a lamp, a grand piano, even a stuffed bird. The allusion would have been clear to contemporary German readers: The demise of the Second Empire, the lost war, the failed postwar revolutions from both left and right, and the months of civil unrest revealed that the structure of Wilhelminian society had collapsed, leaving behind mere shards of itself. To underscore this point – and as a jab at the Social Democratic government of the newly founded Weimar Republic – the caricaturist added the inscription "Alles gehört allen" (everything belongs to everybody). The cartoon thus rendered the belief widespread among German conservatives that materialism and socialism together were to blame for the nation's sorry state of affairs and the demise of the old order. Born out of the "formless chaos" created by materialism (as one conservative critic put it), the Weimar Republic was experienced as a rupture and, for many, a frightening void. In contrast to Arnold, the Hannover artist Kurt Schwitters (1887–1948) described the chaos created by the demise of the Wilhelminian empire as liberating. Reflecting in 1930 on the war's impact on his art, he wrote:

In the war, things were in terrible turmoil. What I had learned at the academy was of no use to me and the useful new ideas were still unready. . . . Then suddenly the glorious revolution was upon us. I don't think highly of revolutions; mankind has to be ripe for such things. It is as though the wind shakes down the unripe apples, such a shame. . . . I felt myself freed and had to shout my jubilation out to the world. Out of parsimony I took whatever I found to do this, because we were now an impoverished country. One can even shout with refuse, and this is what I did, nailing and gluing it together. I called it "Merz;" it was a prayer about the victorious end of the war, victorious as once again peace had won

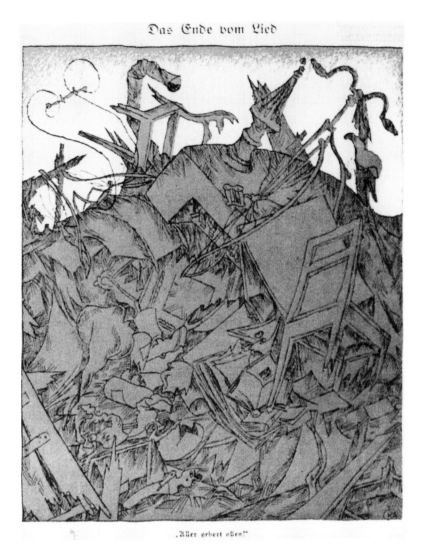

Figure 1. Karl Arnold, *Das Ende vom Lied* [The Song's End; or, The End of the Matter], 1919. *Der Simplicissimus* 24 (7), May 13, 1919. © 1992 ARS, New York/Bild-Kunst, Bonn.

in the end; everything had broken down in any case and new things had to be made out of the fragments: and this is Merz. It was like an image of the revolution within me, not as it was, but as it should have been.[2]

For Schwitters, the political crisis was a positive event: It brought into focus his own artistic energies and led to a tremendous surge in his creativity. Schwitters, like other artists in the early twentieth century, adopted collage in response to the experience of rupture and displacement. Indeed, little continuity can be seen in his naturalistic paintings done before 1918 and the abstract collages and assem-

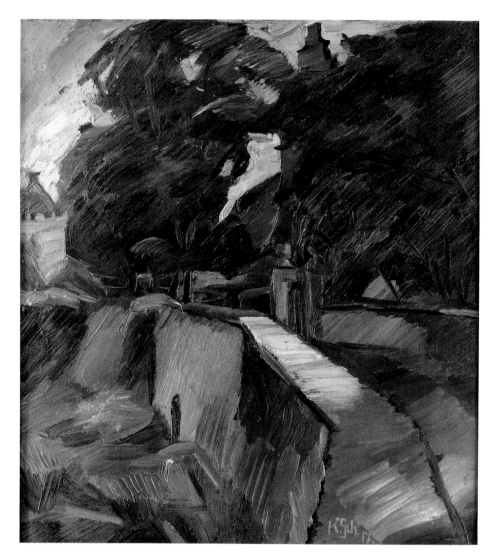

Figure 2. Schwitters, *Landschaft aus Opherdicke* [Landscape from Opherdicke], 1917. Oil on board, 55.6 × 50.2 cm. Photo: Marlborough Fine Art, London.

blages to which he devoted himself after the war. These later works, fashioned from the discards of the modern printing press and the debris of contemporary German society, symbolized to him the fragmentations and discontinuities of modern life. *Landschaft aus Opherdicke* (1917; Fig. 2), for example, is executed in heavy impasto with rich tonal gradations, but the bold gestures of the artist's hand are bound to the representation of a specific place. *Merz. 19* (1920; Plate 1), by contrast, is composed of address labels, food stamps, coat checks, and other found bits of

paper arranged in overlapping forms. Placed against a blue background and white papers with frayed edges, these horizontally and vertically oriented geometric shapes evoke the architectural forms of an urban landscape; yet we are constantly reminded in this work of the absence of such representation by the edges and overlaps of each collage element, and by the shattering of the image. It is a work in which the formal discontinuities of the collage medium serve as analogues to the dislocations typical of postwar German urban environments. By creating an expression of the new from the discarded fragments of the past, Schwitters clearly demonstrated the transformative energies set free by his liberation from tradition.

Collage is a process of construction with found papers and other materials that may be already colored or imprinted with texts or images. The work of art is no longer the result of traditional artistic craftsmanship – the carefully honed skill, usually acquired at the academy, of applying paint to canvas to achieve a realistically looking image or expression. Rather, collage is the result of a process of assemblage that in itself highlights the break with tradition and redefines the artist as a manipulator of prefabricated forms.

Schwitters did not, of course, invent the medium, but reformulated it to suit his particular needs. Roughly speaking, the history of collage in the years around World War I invokes two distinct yet parallel and often overlapping goals: formal innovation and political progressivism. Although collage had been popular in the Victorian era as a method for making album pages and for producing composite photographic imagery, it was not until 1912 that it was "reinvented" by Picasso and Braque as a self-consciously artistic medium.[3] Within a few years, artists of the nascent Dada movement seized upon collage as the ideal means for expressing the experience of rupture and loss of tradition generated by the war.

In Germany, the advent of collage is linked unequivocally to the experience of political crisis: the war and the subsequent struggles for supremacy of both the left and the right. Unlike in France, there were only a few isolated collage experiments before 1914 – one thinks, for example, of a few postcard-size gouaches by Kandinsky that include collage elements. However, German collage developed fully only during and after the war in the hands of the Berlin Dadaists and artists like Schwitters and Max Ernst, who lived in other cities but had been in contact with the Zurich Dadaists, an international group of artists and writers who had sought refuge in neutral Switzerland during the war. The artists in this group were united in their belief that traditional, hierarchical Western culture and capitalist political systems had brought about the disastrous political conflict, and they banded together to develop new, oppositional languages to undermine those traditions. It is in the context of Zurich and especially Berlin Dada, and not in prewar France, that collage – the language of fragmentation – truly developed its capacity for social critique.

The Zurich Dada artists drew on cabaret performances and the spectacle to

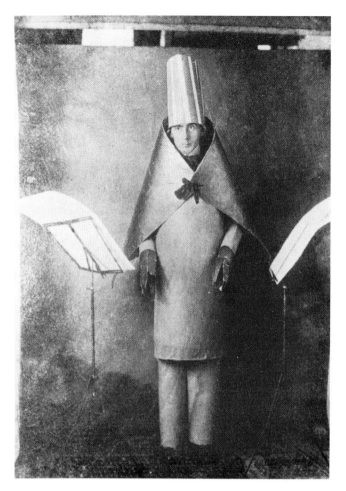

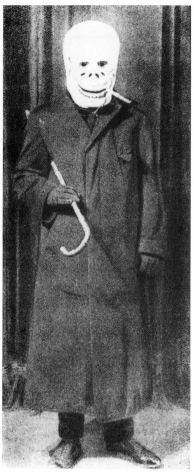

Figure 3. Hugo Ball reciting poetry at the Cabaret Voltaire, Zurich, 1917.

Figure 4. George Grosz dressed up as death, ca. 1920.

critique bourgeois culture. In the Cabaret Voltaire, founded in Zurich in 1915, the Dadaists assaulted the logic and communicative power of language, transforming it into abstract sound poems, or drew on masquerade to suggest alternative realities. Hugo Ball, for example, recited his abstract poems in a costume that almost immobilized him; the suit was fashioned for him by Tristan Tzara out of cardboard and foil (Fig. 3). Ball's concept of art in performance was later radicalized by George Grosz within the context of Berlin Dada when he promenaded through the city dressed up as death (Fig. 4). Also in Zurich, Hans (Jean) Arp investigated nonmimetic representation in collage in conjunction with automatism and chance, as, for example, in his *Squares Arranged According to the Laws of Chance* (1917; Fig. 5).

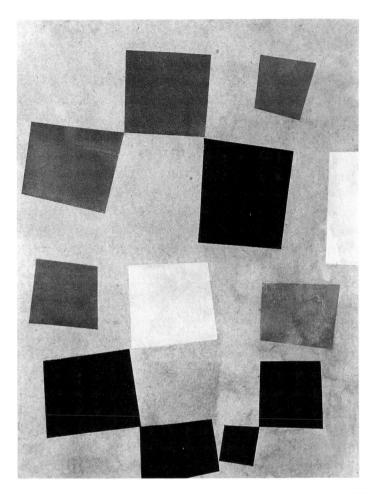

Figure 5. Hans (Jean) Arp, *Squares Arranged According to the Laws of Chance*, 1917. Cut-and-pasted papers, ink, and bronze paint, 33.3 × 26 cm. The Museum of Modern Art, New York. Gift of Philip Johnson. © 1992 ARS, New York/Bild-Kunst, Bonn.

The shift away from the artist's hand and individualized mark on the canvas led some Berlin Dadaists, such as George Grosz and John Heartfield, to refer to each other not as artists but as "engineers." They proclaimed themselves the shapers of a new art and, by implication, a new society. Aligning themselves with postrevolutionary Soviet art and politics, they declared at the First International Dada Fair in Berlin in 1920: "Art is Dead! Long Live Tatlin's New Machine Art!"[4] In the hands of these Dadaists, collage was not merely a stylistic medium but a political tool as well. It offered the means to celebrate and intensify the shattering of tradition brought about by the war and by the founding of the Weimar Republic. Many artists responded to the political call to order in the postwar years by abandoning the

stance of the prewar avant-garde in favor of a return to traditional subjects and techniques; however, the Dadaists felt that the process of change had not yet gone far enough.[5] Although collage maintained continuity with the innovative art of the recent past, the Berlin Dadaists exploited it toward ends less singularly formal and more deeply embedded in the social and political fabric of the day.

The metaphors of rupture and fragmentation, the images of death and lack of control conjured up by these artists powerfully evoke the loss of a totalizing tradition. They compellingly articulate a quintessentially modern experience: a sense of crisis, the reshuffling of the self in a moment when belief systems and societal forms have become defunct, made more urgent still by the war and the prolonged political conflict that would follow. However, their language of fragmentation is not without nuances: Where Arnold saw only destruction, Schwitters discerned the building stones of a new art. For him, the junk heap of the past harbored the possibility of a new future that acknowledged fragmentation as a given, but conceived of creativity as an act of redemption. Schwitters prefigures Walter Benjamin's well-known poignant characterization of history as presented in his *Theses on the Philosophy of History*, 1940; however, like Benjamin, Schwitters would not come to pessimistic conclusions about the possibilities of redemption until the following decade, when the increasingly repressive rule of Nazism is evident in Schwitters's approach to fragmentation in his *Merzbau*. Discussing Paul Klee's watercolor *Angelus Novus*, 1920, Benjamin stated:

A Klee painting named *Angelus Novus* shows an angel looking as though he is about to move away from something he is fixedly contemplating. His eyes are staring, his mouth is open, his wings are spread. This is how one pictures the angel of history. His face is turned toward the past. Where we perceive a chain of events, he sees one single catastrophe which keeps piling wreckage upon wreckage and hurls it in front of his feet. The angel would like to stay, awaken the dead, and make whole what has been smashed. But a storm is blowing from Paradise; it has got caught in his wings with such violence that the angel can no longer close them. This storm irresistibly propels him into the future to which his back is turned, while the pile of debris before him grows skyward. This storm is what we call progress.[6]

At a moment of crisis one rarely finds a commonly shared view about the nature of the new. Arnold and the German collage artists created their images in a period of political and social chaos, in which many contradictory goals were voiced. Neither the conservative nor the progressive camps could agree about what constituted tradition and what the new, and no one voice took clear dominance. This lack of cohesion was already apparent at the Weimar Republic's inception; the new republic was announced not once, but twice. Philipp Scheidemann, a Social Democrat, proclaimed, "The German people have been victorious . . . The Hohenzollern have abdicated! Long live the German Republic! Representative Ebert has been declared Reichskanzler . . . I therefore ask you to take care that no violation of security might arise. . . . Peace, order, and security, that is what we need now."[7]

Scheidemann acted spontaneously and without authority; he merely wanted to forestall the proclamation of a soviet republic by the Spartacus League. Yet within hours, just a few blocks away from the Reichstag, the Spartacus leader Karl Liebknecht announced his vision of a new German state in front of the Hohenzollern palace:

The day of the revolution has come. We have forced a peace. Peace has been declared in this instant. The old is no longer. The reign of the Hohenzollern, who resided in this palace for centuries, has passed. At this hour we declare the free socialist German Republic. . . . The morning of freedom has broken. We must yoke all our powers in order to build the government of the workers and soldiers and to create a new state order of the proletariat, an order of peace, of happiness, and of freedom for our German brothers and for our brothers throughout the world. We extend our hand to them and call them to the completion of the world revolution.[8]

Scheidemann spoke of the collapse of the old order and the victory of the German people; Liebknecht portrayed the same events in the language of revolution. Although this brief period of turmoil has often been described as the German revolution, it was in fact not a true revolution but merely a series of mostly localized revolts, spreading at times to large areas of Germany. For short moments the rebellions took on the character of a revolution; yet the shift from the old government to the new was orchestrated not by the people, but by the military. When it became clear that Germany would lose the war and rebellion and pressure mounted, the military advised Wilhelm II to abdicate. The military, facing the demeaning task of negotiating a peace treaty as the now vanquished aggressor, thought it wise to saddle another political group with that burden. It therefore urged the members of the Reichstag, of which the Social Democratic Party (SPD) was the largest group, to proclaim a republic. This move forced the new government to shoulder the burden of defeat brought about by the imperial government and the military and to accept the vindictive terms of the peace treaty.[9]

Elections to the National Assembly in January 1919 brought the Social Democratic Party of Ebert and Scheidemann into power, but in a telling reflection of the absence of a clearly defined political agenda, also a host of small splinter parties. The main tasks for the Majority Socialists (the ruling coalition) were the writing of a constitution, the negotiation of more favorable terms for the peace treaty, and the creation of order in the country. The tasks were clearly circumscribed, but the conditions for solving these problems were anything but favorable. A battle for political control was being waged in the streets: During the first four months of 1919, and again later in the year, the jostling for power among the different political factions and within the parties themselves resulted in increasingly brutally suppressed riots and strikes, erupting at times into virtual civil war (Fig. 6).

The political maneuvers that the provisional government had undertaken to gain control were characteristic of the entire Weimar era. On occasion after occasion,

the ruling party of the Social Democrats forged alliances with members of the former power elite at the expense of leftist revolutionary impulses. Thus, although the founding of the Weimar Republic constituted a significant break with the imperial past, it also maintained and fostered considerable continuity. This is visible in many different arenas: the process of demilitarization, the organization of the police force and civil service administration, and the development and implementation of the new legal code; it is equally apparent in the cultural sphere.

In the immediate need for control and the establishment of order, the Majority Socialists looked for assistance to the Freikorps (Free Corps), quasi-military conservative groups of dissatisfied veterans formed during the first months of the Weimar Republic, and also appealed to the civil service. Already on November 10, the day after the proclamation of the republic, General Groener of the Army Supreme Command offered the President, Friedrich Ebert, his assistance in maintaining order and the organization of the retreat of the German army. There was a proviso, however: Ebert would do his best to fight the Bolshevik danger and would work for the early convention of a constituent assembly. When Ebert gave his assurance and declared his willingness to keep General Hindenburg in his position as the Supreme Commander, he cemented an alliance between the old and new orders.

Within the government institutions the situation did not look much different. The Majority Socialists did not count among their followers the personnel necessary to fill the ranks of the old civil service. This service, much like the former military, willingly took work in the new government, but again like the military, they could not be relied on as builders of democracy. The special privileges the civil service enjoyed under the former government of Wilhelm II were extended under the new constitution, which took effect on August 11, 1919. This move had the effect of creating continuity between the military and administrative institutions of the old and new governments.

Although the new constitution was hailed as one of the most progressive in the Western world, the government instituted the actual reforms only hesitantly.[10] As with the constitution, the government retained a large body of Imperial law, such as the criminal code of 1871, which outlawed abortion and restricted access to birth control, and the civil code of 1900, which restricted women's rights in marriage and divorce.[11]

Overall, reforms were conservative rather than socialist in nature. Few could be described as clearly liberal. Reforms were further threatened by a nationalist backlash in response to the harsh conditions of the Peace Treaty of Versailles, signed June 28, 1919, which stipulated extraordinarily high reparation payments and the loss of important territory. To appease the powerful right, the Majority Socialists alienated the left and brought themselves ever closer to the surviving forces of the Wilhelminian empire, which had placed the Ebert government into power in the first place during the last days of the Great War.

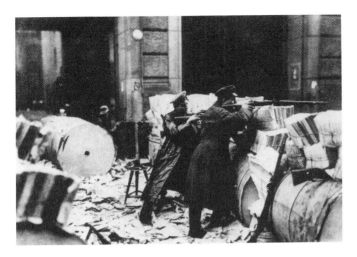

Figure 6. Street fighting in the Newspaper District, Berlin, 1918.

Political destabilization was exacerbated by the tremendous economic problems brought about by the war and, subsequently, the terms of the Versailles Peace Treaty. When Germany defaulted on its debt in 1923, France occupied the Ruhr region – Germany's most important industrial area – in order to force payment. Helpless, the government resorted to printing money, which triggered runaway inflation: By November 1923, the mark was valued at 4.3 trillion to the dollar. The situation, felt most acutely by the lower and middle classes, actually benefited big industry and estate owners, thus reinforcing the empowerment of the traditional elites. At the same time, inflation turned the moral universe upside down, powerfully contributing to the sense of displacement and chaos first brought about by the war and the creation of the Weimar Republic.

Although it is customary to consider the Weimar Republic as spanning three periods of development, it is more accurate to view the entire Weimar era in terms of a chronic, deep-rooted conflict. From this vantage, the few years (1924–9) of relative stability before Hitler's rise to power brought only a lull in the general experience of political, social, and economic dislocation. The chaos that – in spite of the apparent continuities between the former and present government – characterized life in the first months of the Weimar Republic was never truly contained. Diarist Harry Graf Kessler's observations about life in the early days of the republic may well stand as a characterization for the entire period:

There is shouting all the time. Berlin has become a witches' cauldron wherein opposing forces and ideas are being brewed together. Today history is in the making and the issue is not only whether Germany shall continue to exist in the shape of the Reich or the

democratic republic, but whether East or West, war or peace, an exhilarating vision of Utopia or the humdrum everyday world shall have the upper hand. Not since the great days of the French Revolution has humanity depended so much on the outcome of street-fighting in a single city.[12]

As revealed in Kessler's diary, life in the early months of the Weimar Republic was a struggle for survival, a clashing of opposing parties and conflicting interests. But beneath the chaos, Kessler detects a powerful impetus: the search for structure within chaos, expressed in the will either to form a new political and societal order or to restore the old.

Schwitters evoked the daily political turmoil of the early months of the Weimar Republic and the inversion of traditional values in a call for a new stage on which chaos reigned, bodies dissolved, and violent clashes were acted out:

Materials for the stage set are solid, liquid and gaseous bodies, such as white wall, man, wire-entanglement, waterjet, blue distance, cone of light. Use is made of surfaces, which can compress or can dissolve into meshes; surfaces which can fold like curtains, expand or shrink. Objects will be allowed to move and revolve, and lines will be allowed to expand into surfaces. Parts will be inserted into the stage set, and parts will be taken out. . . . [13]

And then Schwitters conjures up the new actors of his theater:

Take wheels and axles, throw them up and let them sing (mighty erections of aquatic giants). Axles dance midwheel roll globes barrel. Cogs nose out teeth, find a sewing-machine that yawns. Turn up or bowed down, the sewing-machine beheads itself, feet upwards. Take a dentist's drill, a meat-mincing machine, a track-scraper for tramcars, buses and automobiles, bicycles, tandems, and their tires, also ersatz wartime tires and deform them. Take lights and deform them as brutally as possible. Make locomotives crash into one another, curtains and portieres make threads of spiderwebs dance with window-frames and break whining glass. Bring steam-boilers to an explosion to make railway mist. Take petticoats and other similar articles, shoes and false hair, also ice-skates . . . [14]

Schwitters's proposal for a new stage bespeaks a new relation between man and machine, one generated by the experience of war. Schwitters had not been at the front – he suffered from epilepsy and had served for only three months (March–June 1917) with his regiment in his hometown Hannover[15] – but his spectacle of powerful, brutalizing machines acting out of control appears to be engendered by reports from the battlefields of World War I. His prose captures the experience of many soldiers who had served at the front, namely, their feeling that powerful machines had taken the place of humans. To a certain extent, Schwitters's account parallels Ernst Jünger's poeticized warfare in his vastly popular war novels, such as 1920 *In Stahlgewittern* [Storm of Steel], but Schwitters neutralizes the war experience into an abstracted vision of machines. In this theatrical mise-en-scène, Schwitters forged a clear link between the modern and the machine characteristic

of the period after World War I, in which the machine and its products would increasingly stand for the modern itself. Although Schwitters's new stage appears to be full of chaotic life, it is a dehumanized life in which people, when they appear at all, are treated like objects and as easily manipulated:

People can be used, even.
 People can be tied to backdrops.
 People can be used actively, even in their everyday position, they can speak on two legs, even in rational sentences.
 Now begin to wed the materials to each other. For example, marry the oilcloth over with the Building Society, bring the map cleaner into a relationship with the marriage between Anna Blume and A-natural, concert pitch. Give the globe to the surface to consume and cause a cracked angle to be destroyed by the beam of a 22-thousand-candlepower arc lamp. . . . [16]

Schwitters was recreating the chaos Graf Kessler described in his diary. Like Graf Kessler, he set out to discover its underlying structure and give it a new order. His answer to the disjointed times was the formulation of Merz, the term he coined in 1919 to describe his new collage and assemblage art and soon began to apply like a brand name to all of his artistic activity.

Merzbilder [Merz-pictures] are abstract works of art. The word *Merz* denotes essentially the combination of all conceivable materials for artistic purposes, and technically the principle of equal evaluation of the individual materials. *Merzmalerei* [Merz-painting] makes use not only of paint and canvas, brush and palette, but of all materials perceptible to the eye and of all required implements. Moreover, it is unimportant whether or not the material was already formed for some purpose or other. . . . The artist creates through the choice, distribution and metamorphosis of his materials. [17]

Recognizing the changed conditions of artistic production, Schwitters alludes to an altered sense of time, in which speed is a new imperative: "*Merzmalerei* aims at direct expression by shortening the interval between the intuition and realization of the work of art." The shortening of that process is achieved by the use of ready-made materials and forms rather than by the creation of a painted image, in which matter has to be coaxed into a resemblance of form. Merz is a theory of collage in which collage is defined in the most encompassing sense, including all preformed materials, organic and inorganic.

Schwitters designates art as a process of organization fueled by creativity through which the artist effects a new order. His is an inherently democratic process, "the combination of *all* conceivable materials" and of "equal evaluation." Schwitters's response to the political and social chaos – to modernity – is comprehensive. He transformed his method of artistic production, developed new subject matter grounded in modern culture and the spectacle, and created an organizational apparatus, Merz, to lend it structure. He based his art and new artistic persona on other available models, freely taking from Expressionism and the nascent Dada

movement to define his own style. Even though he saw the limitations of Expressionism and some of the shortcomings of Dada, he was by no means always able to transcend them; his art amply testifies to the struggle any artist faces in the formulation of a new language, particularly in a period when long-established values no longer assist in a successful organization of life.

Schwitters referred to this dilemma at the beginning of his description of his artistic liberation at the end of the war: "What I had learned at the academy was of no use to me and the useful ideas were still unready." Not only were his own ideas still evolving, they were evolving at a moment when the cultural and political spheres were also undergoing substantial transformations. Today we tend to see clear choices and assign to artistic production such labels as "progressive" and "conservative"; however, these categorizations are made with the hindsight of history – to the artist at the time the choices are not always so clear-cut. Although Schwitters turned to collage as the most modern artistic method, he echoes the Romantic and Expressionist belief in a larger project in which disparate parts are joined in a harmonious, more complete whole:

My aim is the total work of art [Gesamtkunstwerk], which combines all branches of art into an artistic unit. . . . First I combined individual categories of art. I have pasted together poems from words and sentences so as to produce a rhythmic design. I have on the other hand pasted up pictures and drawings so that sentences could be read in them. I have driven nails into pictures so as to produce a plastic relief apart from the pictorial quality of the paintings. I did so as to efface the boundaries between the arts.[18]

At the same time, Schwitters's language of brutal fragmentation and violence, his explosion of traditional form, and his evident inspiration in the popular arts, particularly advertising ("I have pasted up pictures and drawings so that sentences could be read in them"), evoke the Berlin Dadaist's approach to art making. Schwitters's work, as we shall see, straddles the boundaries between Expressionism and Dadaism; his actions and statements bear powerful witness to the artist's need for a new language that would capture the turbulent spirit of the times, the experience of violence in daily life, and the upheavals in the social and political environment. In Schwitters, one sees a new assertive spirit in response to the changed postwar economic situation, for his creation of Merz is tied to his search for a market. He had coined the term *Merz* on the occasion of his first major exhibition at Herwarth Walden's important Der Sturm gallery in Berlin in 1919 – after he had been rejected by the Berlin Dadaists, whom he had hoped to join. In response to this rejection, he created a one-man postwar artistic movement that lasted until the artist's death in 1948, longer than all the other movements that had originated in the postwar era. He frankly admitted that the word Merz derived from commerce: "You may believe it or not, but the word Merz is actually nothing else but the second syllable of Commerce":[19] He had found the word on a piece of paper in one of his collages. Schwitters, however, characteristically imbued its mercantile past with the spirit of utopian idealism:

I compared Dadaism at its most exalted form with Merz and came to this conclusion: whereas Dadaism merely poses antitheses, Merz reconciles antitheses by assigning relative values to every element in the work of art. Pure Merz is pure art, pure Dadaism is nonart; in both cases deliberately so.[20]

In forging a collage style that stressed accommodation and artistic values over "antithesis," Schwitters defined an artistic position distinct from that of the Berlin Dadaists, who were adamantly opposed to reconciliation. To the Berlin artists, reconciliation was akin to political accommodation; they believed that stressing the artistic and aesthetic contributed to the survival of traditional values. Whereas some Berlin Dadaists explored the possibilities of collage and photomontage to illuminate the class struggle, Schwitters investigated collage for the deliberate evaluation of different positions. Even as he was acknowledging rupture and fragmentation as a given, he attempted to overcome it through the joining of unrelated parts. In so doing, he not only found continuity among the fragments of his contemporary existence, but between the past and the present as well. Schwitters's work bears testimony to the survival of tradition within avant-garde innovation.

2

ART AFTER THE WAR:
EXPRESSIONISM AND DADA

The political search for a new order was mirrored in the cultural sphere. Artists, writers, architects, and critics banded together to chart new courses and define meaningful artistic practice in light of the changed political situation. Freed from the censorship of the war years and the highly institutionalized cultural life of the Wilheminian period, they sensed the potential for a new beginning and sought an active role in the shaping of the new republic, in particular the reorganization of the imperial art organizations: the academies, museums, art societies, and grant-giving organs. The founders of the dozens of groups that sprang up in the early months of the Weimar Republic were plainly stimulated by the model of the revolutionary workers' and soldiers' councils that had been formed all over Germany late in 1918. The prewar Secession movement, led by artist groups formed in opposition to the established art institutions, also inspired the founders, who knew something about the role artists were playing in postrevolutionary Russia.

Among these many groups, the Novembergruppe (November Group), the Arbeitsrat für Kunst (Working Council for Art), the Rat geistiger Arbeiter (Council of Intellectual Workers), the Aktionsausschuß revolutionärer Künstler (Action Committee of Revolutionary Artists), and the Sezession, Gruppe 1919, are probably the best known. By evoking the goals of the November revolts, they all define themselves as revolutionary in intent. Programs and statements reveal a common desire for a link with the revolutionary class but also demonstrate a striking lack of understanding of political process. Moreover, there was little that could serve as a viable model for the shaping of the new cultural landscape. These groups' political engagement was grounded in the German intellectual tradition, in which the political and the cultural spheres were considered separate and the intellectual and creative artist enjoyed an elevated status; the problem was further compounded by the fact that most of the artists and writers who demanded a revolutionary role after the war had been trained, and for the most part fully integrated, in the imperial art insti-

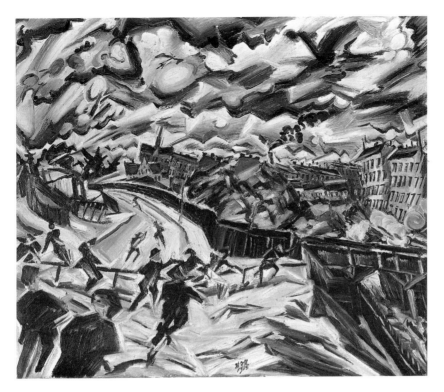

Figure 7. Ludwig Meidner, *Apokalyptische Landschaft* [Apocalyptic Landscape] (1912–13). Oil on canvas, 93.7 × 79 cm. Los Angeles County Museum of Arts, gift of Clifford Odets.

tutions before the war. They were Expressionists, used to summon pictures of doom and despair rather than formulate the prescription of revolutionary change.

Expressionism was Germany's most advanced style in the prewar period. Expressionists were motivated by a search for a new reality, a new kind of humanity, a transcendental ideal. Inspired by Nietzsche, Expressionist writers and poets condemned modern Western culture; they characterized modernity, symbolized by the city, as dehumanizing, a modern monster that had uprooted the individual and forced him to the edge of an emotional abyss. In the visual arts, Franz Marc's images of impending doom and deliverance give form to the Expressionist mistrust of modernity. In his *Tierschicksale* [Animal Fate] (1913), animals, as purer and more vulnerable surrogates, are subjected to brutal, destructive forces. His pastoral landscapes are battered by violent storms, as in *Armes Tyrol* [Unhappy Tyrol] (1913–14). Ludwig Meidner conjured up images of cataclysms, exemplified by his *Brennende Stadt* [Burning City] (1913) or *Apokalyptische Landschaft* [Apocalyptic Landscape] (1912–13; Fig. 7), in which the earth bursts apart, the heavens are lit by the fire of explosions, and buildings are toppling on small, scrambling figures in contemporary garb. Wassily Kandinsky described his vision of the apocalypse with

increasingly more abstract images of charged fields of vibrant colors and activated lines.

Other Expressionist artists demonstrated their fundamentally conflicted relationship to modernity in the celebration of nature and elevation of man in his natural, precivilized state, as the Brücke artists did in their communal summer stays at the Moritzburg lakes, where they practiced nudity and advocated free sexuality or, as in the case of Emil Nolde and Max Pechstein, in their fascination with the exotic. Following Paul Gauguin, these artists turned their back on Western culture and sought salvation in travels to the supposedly unspoiled landscapes and societies of the South Pacific.

Kurt Pinthus's well-known anthology of Expressionist poetry, *Menschheitsdämmerung* [Twilight of Humanity] (1920), offers an apt summary of literary expressionist themes. Although published after the war, all the poems included in his anthology were written before 1915. He organized them into four sections, entitled "Collapse and Scream," "Awakening of the Heart," "Rallying Cry and Indignation," and "Love of Mankind." As in the visual arts, a sense of deliverance and disfranchisement prevails, countered only by a call for empathy in the form of human fellowship as a measure against debilitating isolation and fear. The Expressionist drama delineated the bankruptcy of the old world and its social, political, and artistic conventions, suggesting revolt as the appropriate response. A recurrent theme before and especially after the war is the father–son conflict, as in Walter Hasenclever's *Der Sohn* [The Son] (1914) and Georg Kaiser's two-part *Gas* (1918–20). In these plays the son revolts against the restrictive world of the father, but the rebellion usually ends in failure. This type of Expressionist drama enjoyed a brief period of tremendous popular success (about 1919–23), but as a prescription for political action it failed. Its themes are still active in some of the highly popular films of the later 1920s, culminating on a grand scale in Fritz Lang's *Metropolis* (1927). The Expressionist play, as one critic summarized it, succeeded at best in reproducing chaos on the stage; it failed in showing a way out.[1]

These artists' distance from political reality and practice – the very traditional, thoroughly hierarchical manner in which they thought about political power – is clearly evident in Expressionist theory. Most Expressionist theorists rejected not only "art for art's sake," but also "politics for politics' sake."[2] "True" art and "true" politics were defined as overlapping subcategories of a philosophical ideal, "the ethical." The early Expressionist political activist Kurt Hiller, for example, later chairman of the Berlin Rat geistiger Arbeiter in 1918 and the founder of the Deutsche Friedensgesellschaft in 1920, formulated a politics of *Geist* (the word comprises the meanings of "intellect," "spirit," and even "soul"). He argued that *Geist* stood in opposition to Nature and that only certain select people were endowed with *Geist*. The function of the person endowed with *Geist* was to think for and guide the people, the masses at the bottom of the social pyramid: "In him, people become conscious of their needs; through him they think."[3] He stated: "The most powerful method

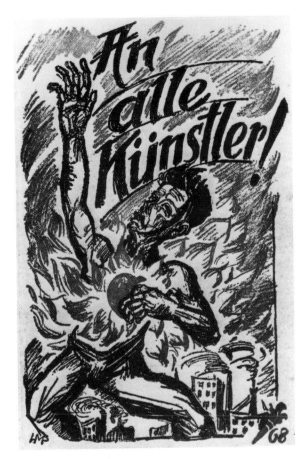

Figure 8. Max Pechstein, *An Alle Künstler* [To All Artists], 1919. Lithograph, book cover, 20 × 14 cm. © Pechstein/Hamburg-Tökendorf.

[of influencing the masses and achieving utopia] is from the top down"[4] a belief later reflected in the program of the Rat geistiger Arbeiter.

This attitude characterizes Expressionism and Expressionists' political engagement after the war. Max Pechstein's lithograph *An Alle Künstler* [To All Artists] (1919; Fig. 8), reproduced as the cover illustration for the pamphlet of the same name published by the Novembergruppe in that year, calls on artists to become politically engaged[5]; yet his image is thoroughly indebted to and perpetuates prewar Expressionist thinking about the role of the artist and the relationship of art and politics. It depicts a man towering above a modern industrial cityscape dotted with smokestacks; he is holding aloft a flaming heart radiating out from him into the space beyond. This man is clearly the artist, but with his bare chest and worker's clothing, he is also the modern industrial worker. On the most obvious level, Pechstein

invites his artist-viewer to forge a link with the proletariat, but on a less immediately apparent level, he also maintains, as did the prewar theoreticians of Expressionism, a conceptual separation between the artist and the working class. Pechstein endows the artist with the flaming heart – a quintessentially romantic metaphor of the potential fusion of interiority and exteriority – and places him high above the city. There he hovers, phoenixlike, reminiscent of Cesar Klein's drawing reproduced in the same pamphlet, *Der neue Vogel Phönix* [The New Bird Phoenix] (1919). Pechstein thus singles out the artist as the owner of special powers, of empathy. He, like Hiller's members of the Rat geistiger Arbeiter, is a savior but not a true participant in political life. Pechstein suggests that creative commitment can bring about social change, but his image of empathy does not offer guidance on how to articulate such an agenda.

Pechstein's idealistic call for political activism, his visionary linkage of worker and artist and his problematic separation of their spheres of action is mirrored in the newly founded artist organization of the early Weimar Republic. The Rat geistiger Arbeiter was already founded the day the new republic was proclaimed, November 9, 1918. The council advocated a series of broad social reforms geared toward putting an end to what they saw as the basic flaw of modern society, the intimate connection between war and capitalism. As the organization's name indicates, the council essentially adopted Kurt Hiller's activist philosophy and carried his notion of a Rat geistiger Arbeiter into the contemporary politicocultural arena. It is precisely in the envisioned governmental system that Hiller's typical separation and unequal ranking of intellectual and political life becomes most readily apparent. The Rat geistiger Arbeiter advocated a lower chamber, the Reichstag, based on free elections and proportional representation; but controlling the Reichstag would be the Rat der Geistigen (Council of the Intellectuals). Its function, according to Hiller, would be to "remove the danger of an encroachment of one-sided, economic viewpoints on politics and to offset the damage caused by the torpor of party bureaucracy."[6] Hiller's concept of the Rat der Geistigen was based on a curiously organicist view of political and social group formation: "It will be created neither by nomination nor by election, but by the intrinsic right, which derives from the duty of *Geist* to help. It will renew itself according to its own law."[7]

The Arbeitsrat für Kunst was founded on the model of the Rat geistiger Arbeiter toward the end of November 1918. Its leaders were the architects Bruno Taut and Walter Gropius, as well as the critic Adolf Behne. Although the Arbeitsrat für Kunst was more engaged in actual politics, it similarly espoused organicist and utopian ideals, tied in particular to the role of architecture in a new society. Taut believed that architecture could reconcile differences and unite all other arts to achieve social and political change. He, too, spoke of a higher life force that would rise from the old, materialist society to unite education, religion, and art:

A pure and noble conception must reign over everything. . . . The new rebuilding must be led clearly and resolutely. A great design must guide all the forces involved – a ministry

of *geistig* affairs, new in its resolve and in its intellectual make-up, which will influence education, teaching, the church and art in the new Germany.[8]

Taut and the Arbeitsrat für Kunst, concerned with influencing the actual physical and material forms that the new society would take, sought a direct governmental role: "Rebuilding is the watchword of the moment: the rebuilding of the material world under the supreme control of the spiritual. The material world is *Geist* which has become substance."[9] A related spirit prevailed in the Novembergruppe. Run mostly by artists rather than architects, it also included poets, composers, and writers. Invoking the goals of the French revolution, it too championed an alignment with the working class. Like the other groups the Novembergruppe called for spiritual transformation, although it did not offer a true political program:

We stand in the fertile ground of the revolution. Our slogan is: LIBERTY, EQUALITY, FRATERNITY! We have come together because we share the same human and artistic beliefs. We regard it as our noblest duty to dedicate our efforts to the moral task of building Germany young and free.[10]

The Novembergruppe did try to engage in negotiations with the government about the fate of the art institutions in particular; their political successes, however, were meager. Disillusioned, the Novembergruppe ceased its political activities within a year and became an exhibition society. In this capacity, though, it remained active through 1932 and outlasted all the other revolutionary artists' groups.[11]

The political ideologies of these different artists' groups were for the most part utopian; their active political life was short. The formation of the different groups attests not only to the revolutionary turmoil of the early months of the Weimar Republic, but also to the vague hopes (rather than concrete goals) for a new society harbored by so many German citizens. The organizations' quick demise reveals the lack of political acumen of a large sector of the German intellectual and artistic left, whose rhetoric indicates an ingrained and profound hesitation about the forging of an enabling alliance with the revolutionary class.

It is imperative to remember, however, that the programs of these various organizations in the course of their brief life span were anything but fixed. Organizational politics were evolving in response to the political situation which itself was in turmoil. Furthermore, positions taken by the various artists within each group could also vary significantly, reflecting in no small measure the fundamentally different understandings of what constituted revolution and revolutionary activity. Here the rhetoric of Expressionism adds to the confusion. Because the Expressionists understood themselves as revolutionaries, in the postwar period the political and artistic domains were considered by some to be congruent. In addition, in the critical and theoretical debates surrounding the movement in the 1920s and later in the 1930s, Expressionism was seen as the very embodiment of modernism. It is this perception that informed the heated theoretical debates – known as the Expressionism Debate – about meaningful responses to Fascism. In this debate, Expres-

sionism was seen as exemplary of modernism and pitted against realism, first in Georg Lukács's 1934 essay "Größe und Verfall des Expressionismus," then in 1937–8 in a sustained, fervent exchange, most notably among Lukács, Bertolt Brecht, and Ernst Bloch, in the Moscow emigré journal *Das Wort*.[12] The discussion equally informs the evolving cultural politics of the Nazi regime, particularly visible in the 1937 Degenerate Art Exhibition, in which Expressionism was singled out as "cultural bolshevism" and considered synonymous with the modern.

As far as different attitudes within the radical art organizations are concerned, the example of Max Pechstein and Ludwig Meidner is especially instructive. In her incisive study of postwar Expressionism, Joan Weinstein has clearly delineated their differences and changing attitudes in response to the political events of a few months. Both were members of the Novembergruppe, but Pechstein identified with the new Social Democratic government and saw it as the fulfillment of the revolution, whereas Meidner implicity criticized its revolutionary claims by calling for an alliance with the proletariat.[13] For Pechstein, the revolution had taken place in November 1919. In his written contribution to the pamphlet *An Alle Künstler*, entitled "What We Want," he stated: "The revolution brought us the freedom to give voice to and to realize wishes of years. . . . May the social republic give us trust; we have freedom, and soon flowers will bloom from its dry soil to its honor."[14] Meidner, in contrast, exclaimed:

We painters and poets are united with the poor in a holy solidarity! Have not many of us known misery and the shame of hunger and material dependence? Do we stand much better or more secure in society than the proletarian?! Are we not like beggars dependent upon the whims of an art collecting bourgeoisie![15]

He called on his fellow artists to become involved in organized party politics: "We must join the workers' party, the determined, unambiguous party."[16] But in February 1919, he no longer identified with the party of the proletariat, the KPD (German Communist Party, formerly the Spartacists); by then it had become apparent that there was an unbridgeable gap between the workers and the intelligentsia and artistic communities. Reissuing his essay "Brother, Light the Torch: In Remembrance of Carl [sic] Liebknecht and Rosa Luxemburg" in the journal *Neue Erde*, Meidner now deleted the sentence: "Become communists like me!"[17]

The problematic conflation of Expressionist rhetoric and contemporary politics is perhaps best studied in a series of political posters executed by Expressionist artists beginning in December 1918 for the Publicity Office, an organization that had been created late in October 1918 as a division of the Military Department of the Foreign Office and that was now under control of the Council of People's Representatives. The office, run by the Expressionist writer Paul Zech, a member of the SPD, was charged with handling the publicity of the election campaign of the SPD.[18] Repeating the wording of a public announcement by the Novembergruppe, the provisional government had called on "all radical artists, Expressionists and Cubists" to help

design the posters and flyers.[19] It comes as no surprise, then, that many of the artists who responded belonged to the Novembergruppe, among them Pechstein, Klein, and Richter-Berlin. Their support of the SPD, an increasingly bourgeois party, rather than the KPD, the revolutionary party, is a strong indication of the vastly divergent perceptions of radicalism and revolution.

Even if the artists had not closely followed politics from the time of the November events, the slogans they illustrated for the political campaign would have disclosed that their political activism was not in support of revolutionary politics. In the name of "preserving the revolution," and to quench leftist uprisings, the posters, by advocating law, order, and productivity, implicitly and explicitly addressed the Spartacist. Some called merely for unity, as seen in Cesar Klein's lithograph "Workers, Citizens, Farmers, Soldiers from all Areas of Germany. Unite for the National Assembly." Others drew skillfully on parental emotions to maintain orderly behavior: "Don't strangle the newly won freedom with disorderly conduct and fratricide, otherwise your children will starve" (illustrated by Max Pechstein). More ominously, the call to duty is seen in a lithograph by Heinz Fuchs: "Workers. Hunger, Death approaches. Strike Destroys, Work Nourishes. Do Your Duty and Work." Other posters, equally executed in an Expressionist style but designed for conservative or reactionary organizations, were more outspoken still. In one poster death, silhouetted against a sky tinted by fires and filled with black birds, marches with his scythe over a crowd. The implication is ominous: "That's how Spartacus leads you! Brothers, save our revolution!" (Fig. 9). In a similar vein, a poster designed by Rudi Feld for the Vereinigung zur Bekämpfung des Bolschevismus depicts death cloaked in black, clutching a bloody knife in his teeth. Against a hilly landscape dotted with grave markers and a gallows, the figure simply announced: "The Danger of Bolshevism."

By the end of 1918 and early 1919 it was apparent that the provisional Social Democratic government was not behind the reforms. The intelligentsia's mistrust was registered unequivocally on January 20, 1919, just after the elections for the National Assembly brought the provisional government into power, by the art critic Adolf Behne, who observed with apprehension:

We survey the achievements of our revolution with a feeling of sadness and shame. What has happened in the ten weeks of the revolutionary period? Censorship and the state of siege have been lifted – a foregone conclusion. But otherwise the spirit of the old regime has returned to our people after a few short days of initial enthusiasm. Ideally, they want to set the old machine in motion again, only slightly repainted.[20]

In a telling move in February 1919, the Social Democratic–dominated Ministry of Culture advised a reform commission at the art academy (which had previously decided that "as little as possible should be reformed") to make concessions only in order to "take the wind out of the sails of the young people who represent themselves as repressed."[21] Behne evaluated the poster campaign in his book *Das politische Plakat* (1919) as "the first official step to influence the masses with the

help of the new art." Using Expressionist language for the empowerment of an increasingly bourgeois political party, the artists who worked for the poster campaign transformed the Expressionist utopian dream of a new society into the decidedly less radical goals of the Weimar Republic and legitimized the Social Democrats as their standard bearer. In the process, the language of the prewar German avant-garde, Expressionism – as well as the printmaking techniques associated with this artistic movement – was transformed into the language of bourgeois culture.

But again, the issue is not as straightforward as it appears to be. Expressionist style and rhetoric were employed by artists on all parts of the political spectrum; indeed, a poster designed by an anonymous artist during the rule of the Council Republic in Bremen (Fig. 10) exploited an Expressionist style and the rhetoric of the New Man; however, unlike the posters of the SPD campaign, this work called for people to organize into consumer cooperatives to further the cause of socialist economics.[22] If one looks at the use of the woodcut, the medium most keenly associated with Expressionism, it becomes readily apparent that it was used willy-nilly by artists who identified with the entire political spectrum – left, center, right – often in a remarkably similar style. Perhaps more surprisingly, the Expressionist rhetoric of martyrdom, death, and transfiguration is present in both SPD and Spartacist/KPD circles.

In 1919 Constantin von Mitschke-Collande, a Dresden Secession artist, created a portfolio of six woodcuts as illustrations to Walter Georg Hartmann's allegorical book, *Der begeisterte Weg* [The Inspired Way] (Fig. 11). Hartmann tells of a young soldier who experiences the beginnings of the revolution, the funeral of Liebknecht, and the outbreak of street violence, during which he is killed. His spirit does not die: It wanders through revolutionary Germany, observing. Von Mitschke-Collande focuses on the religious salvation promised in Hartmann's text. He combines images of the Crucifixion and the Revelation of St. John with Expressionist religious imagery and a message about revolution.[23] Hartmann conflated political and artistic rhet-orics, and von Mitschke-Collande followed his lead in the illustrations. He shows mass demonstrations, but he also draws on the favorite Expressionist image of man in a state of transfiguration. His woodcuts, especially the first and last print of the series, recall Cesar Klein's drawing *Der neue Vogel Phönix* [The New Bird Phoenix].

Käthe Kollwitz similarly used the woodcut. In her mind, the medium was closely associated with political activism, and so she set out to learn how to make woodcuts after the war. Her powerful prints address social and political issues. One of the best-known is her *Gedenkblatt für Karl Liebknecht* [Commemorative Print for Karl Liebknecht] (1919–20). Liebknecht and Rosa Luxemburg, the Spartacusbund lead-ers, had been murdered in Berlin in January 1919 by Freikorps members working under orders from the SPD – as some suspected publicly already in the discussions following his death.[24] Kollwitz had not supported Spartacist politics but was com-mitted to the working class. Asked by Liebknecht's family to sketch him on his

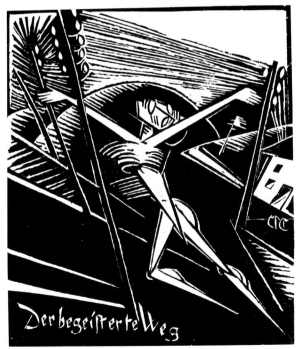

Figure 9 (*above left*). Anonymous, *So führt Euch Spartakus!* [That's How Spartacus Leads You!], ca. 1919. Poster, lithograph; image 91.4 × 86.5 cm. The Robert Gore Rifkind Collection, Beverly Hills.

Figure 10 (*above right*). Anonymous, *Konsumenten. Vereinigt Euch!* [Consumers Unite!], 1919. Poster, lithograph, 79.7 × 57.8 cm. The Robert Gore Rifkind Collection, Beverly Hills.

Figure 11 (*left*). Constantin von Mitschke-Collande, *Der begeisterte Weg* [The Inspired Way], 1919. Portfolio of 6 woodcuts; images 34.3 × 29.8 cm. Los Angeles County Museum of Art, Robert Gore Rifkind Center for German Expressionist Studies.

deathbed she ultimately created a print in which she explored the possibilities of the medium to the fullest to lend her image a stark, exaggerated expressiveness, focusing on the rough-hewn quality to render the workers' grief over the slain politician.

The woodcut medium was used for similar activist causes by a Rhenish group of leftist artists, the Gruppe progressiver Künstler, Köln (Group of Progressive Artists, Cologne) which counted Peter Abelen, Angelika Hoerle, Anton Räderscheidt, and Franz Seiwert among its members. These artists tried to develop a collective approach to art making and set as their goal the representation of proletarian culture.[25] They too employed the woodcut for a collaborative project, the publication of a commemorative portfolio, entitled *Lebendige* [The Living] (1919) (Fig. 12), depicting slain leaders of the Socialist revolution: Rosa Luxemburg and Karl Liebknecht; Kurt Eisner, the leader of the Independent Socialists (who, as Bavaria's prime minister, had attempted to create a parliamentary Bolshevik state in Bavaria), murdered by a nobleman, Graf Arco, on February 21, 1919; Gustav Landauer and Eugen Leviné-Niessen, members of the Bavarian Soviet Republic that had been proclaimed in April after Eisner's assassination, both murdered on May 2, 1919 in the two-day fight against government troops (assisted by Free Corps members) sent to recapture Munich for the Social Democrats;[26] and the French Socialist leader Jean Leon Jaurès, murdered in 1914. These artists identified with the Spartacists; they resorted to the woodcut medium because it imbued their portraits with a stark pathos resulting from simplified form and large areas of black. The antiacademic connotations of the prewar Expressionist use of the woodcut made it the suitable medium for the depiction of political leaders who had worked to abolish a hierarchical organization of society. Like von Mitschke-Collande and Kollwitz, they conveyed the Expressionist notion of the New Man by means of traditional religious symbolism, alluding to resurrection and transfiguration (in the case of the Gruppe Progressiver Künstler, their outlook is underscored by the title itself of their work). Significantly, the fusion of religious, Expressionist, and revolutionary rhetoric is evident in Liebknecht's writing: In his last statement, published in the Communist Party's newspaper *Die Rote Fahne* on the day he was murdered, Liebknecht expressed a combination of martyrdom and political commitment that finds resonance in the rhetoric of the Novembergruppe: "Yes!... Ebert–Scheidemann–Noske have won. . . . the Golgatha Way of the German working class has not ended."[27]

Clearly, Expressionism could not offer a model for a politically engaged, critical art. Based on the belief that the internal and external are intertwined – a concept that found its formal expression in the concept of empathy, which states that the subject exists in the object – Expressionism could not foster a critical, disengaged view of the self and its relation to society. Here was the dilemma of the postwar Expressionist artist: Called on to participate in the shaping of a new society, he could, as an artist, interpret the events only in light of the empathic self. Despite the rhetoric of the New Man, the Expressionist artist did not have the tools to

Figure 12. Gruppe progressiver Künstler, Köln (Group of Progressive Artists, Cologne: Peter Abelen, Angelika Hoerle, Franz Seiwert, and Anton Räderscheidt), *Lebendige* [The Living], 1919. Portfolio in Honor of the Murdered Revolutionaries, seven woodcuts, 29.5 × 23 cm. Private collection.

analyze situations from the perspective of a common political good. What becomes apparent most of all from looking at these prints is a general sense of confusion about how to develop meaningful pictorial responses to the political events taking place and a vagueness about what it meant to be a politically engaged artist. Prewar Expressionism offered certain models that were indeed explored by the postwar Expressionists, but one thing is clear: After the war Expressionist artists failed to direct their political engagement toward genuine revolutionary action and thus, sometimes unwittingly, served a counterrevolutionary function.

Looking back in 1925 to the postwar period, the former Dadaist George Grosz offered a biting critique of artistic activism, implicating the Expressionists as political opportunists:

In November 1918, when political fortunes seemed to change, suddenly even the most detached simpletons discovered their feelings for the working class. For a few months red and pink allegories and pamphlets were produced in quantity and held their own in the art market. But soon peace and order returned to the country and lo and behold, our artists, with the least amount of commotion possible, returned to the higher regions.[28]

Raoul Hausmann, another member of the Berlin Dada group, similarly directed criticism at Expressionism. Already in 1918 he had pronounced in his *Pamphlet gegen die Weimarische Lebensauffassung* [Pamphlet against the Weimar Way of Life]:

Dadaism is the sole artistic movement of the present day that has fought for the renewal of expressive means and against the classical educational ideals of the order-loving bourgeois

and his last progeny, Expressionism. During the war, Club Dada stood for the internationality of the world; it is an international, anti-bourgeois movement.[29]

Berlin Dada is usually described as the political, antiart phase of Dada; in support of that claim, one or another of the many slogans posted at the First International Dada Fair in 1920 in Berlin is cited as evidence: "Dada sides with the revolutionary proletariat," or "Dada is a German Bolshevik affair." Indeed, Berlin Dada was political, and several of its members were closely identified with the radical political left. In 1920, in a statement unlike Expressionist announcements on artistic activism, Grosz declared political engagement as an imperative:

Art today is absolutely a secondary affair. Anyone able to see beyond their studio will admit this. Just the same, art is something which demands a clear-cut decision of the artists. You can't be indifferent about your position in this trade, about your attitude toward the problem of the masses, a problem which is no problem if you can see straight. Are you on the side of the exploiters or on the side of the masses who are giving these exploiters a good tanning?[30]

Together with Grosz, John Heartfield, whose photomontages became the most powerful visual tool of leftist politics, particularly in the later 1920s and in the 1930s, had joined the German Communist Party in the very first days of its existence; they had received their membership cards from Rosa Luxemburg herself. In January 1919 Franz Jung, one of the publishers within the Berlin Dada circle, cofounded the Kommunistische Arbeiterpartei Deutschland (KAPD; German Communist Workers' Party), a party to the left of the German Communist Party (KPD). But it is also important to put Berlin Dada's postwar political activity into perspective, to recognize the diversity of attitudes within the group and the peculiar breadth of its scope.

Berlin Dada was launched in January 1918, when a group of artists, writers, and publishers spearheaded by Richard Huelsenbeck organized their first Dada evening in Neumann's Graphisches Kabinett. Huelsenbeck had returned a few months earlier from Zurich and brought news of the Dada activities at the Cabaret Voltaire there. In Berlin, the anarchic attitudes and tactics of Zurich Dada – cabaret performances, simultaneity and automatism in image and text, the exploration of new materials and celebration of the mechanical, abstraction and non-Western art – were employed to serve the liberation of the individual and the society at large. There was a difference, however. Zurich Dada had flourished in a neutral country barely touched by World War I; Berlin Dada, in contrast, developed in the center of political chaos. Berlin artists quickly transformed the Zurich Dadaists' vision of general freedom into a program of far-left politics anchored in bolshevism.

The participants knew each other well; some had already collaborated during the war on several antiwar and antigovernment publications. Counted in the group were Wieland Herzfelde (John Heartfield's brother), the founder of the Malik Verlag publishing house, and Franz Jung, the publisher of several short-lived satirical

magazines. Besides these men, and Grosz and Heartfield, who made up the left-wing, politically engaged section of the group, Berlin Dada also included such figures as Johannes Baader, known for one of the more spectacular actions of the group: On July 16, 1919, when the National Assembly was to debate the article on freedom of speech for the new constitution, Baader distributed from the balcony of the assembly hall his flyer *The Green Corpse*, which declared him the president of the world. Raoul Hausmann, Baader's friend and collaborator, wrote attacks on the new government and its self-satisfied citizens, singling out Expressionist artists in particular. To express his critique, he experimented with abstract poetry, collages and photomontages, and magazine publications. Hannah Höch, the only woman in the group and marginalized by her male colleagues as well as her lover Hausmann, was less polemical, but she produced some of Dada's most striking and important photomontages.[31] Höch, Hausmann, and Baader represented within Berlin Dada a more anarchistic and individualistic outlook; they remained more closely tied to Zurich Dada than did the other participants.

Berlin Dada's political agenda was comprehensive – it sought nothing less than a total revamping of society based on a newly liberated and fully emancipated individual – its means, however, were artistic. The Dadaists proclaimed, "Art is dead!" but like the British, who stubbornly declare at the death of their ruler, "The King is dead. Long live the King!", they too affirmed art triumphant, rallying with "Long live Tatlin's New Machine Art!" (Fig. 13). The Berlin Dadaists never gave up the making of art; they fought, however, any art that furthered the survival of artistic and cultural traditions. They also opposed political systems that fostered the status quo. They thus specifically opposed the Ebert–Scheidemann regime, for they felt that the Social Democratic Party had betrayed its own cause. It was social and democratic only by name; its politics were hostile to the liberation and emancipation of all members of society. With such a broad agenda, Berlin Dada was anything but uniform. Its members explored different venues, ranging from a specific critique of the political system to the interruption of political life to the advocacy of play as a source of transformative energy.

The Dadaists' political critique is most readily visible in Grosz's drawings. He developed a pictorial language uniquely suited to his political goal: a hard-edged realistic drawing style that relied almost entirely on outline drawing. His art, derived from caricatures and Cubist–Futurist abstraction, emphasized overlapping, two-dimensional forms and maintained the readability of his images. He frequently added captions to his drawings to raise questions about pressing political issues. Grosz's drawings and prints could easily be reproduced without loss of quality and published in newspapers and magazines.

Compare, for example, Grosz's *Feierabend* [Evening Leisure] (Fig. 14), a photolithograph done from an ink drawing in 1919, with the several commemorative prints of Liebknecht and Luxemburg made by the Expressionists. Grosz depicts a Free Corps member leaning against a tree and looking at a man's corpse on the

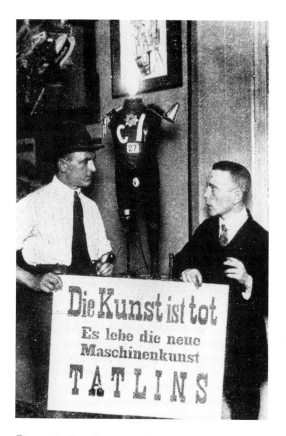

Figure 13. First International Dada Fair, Raoul Hausmann and John Heartfield, *Die Kunst ist tot. Es lebe die neue Maschinenkunst Tatlins.* [Art is Dead. Long Live Tatlin's New Machine Art!], 1920.

river's embankment; another corpse is partly submerged in the water. Grosz framed his composition with the readily recognizable silhouette of the Bavarian city of Munich, thus locating the event in a specific place. He made the print for publication in Berlin in the radical leftist magazine *Die Pleite* as a response to the political murders in Munich, but the condemnation extends to the Free Corps activities in Berlin.[32] Neither this work nor his *Die Gesundbeter* [The Faith Healers] (1918) offer much possibility for empathic identification with the subject, a response promoted by the Expressionist woodcuts of the Spartacist leaders. In this drawing, Grosz depicts high-ranking military officials taking a bemused look at a soldier receiving a physical examination for induction. The recruit, who has just been declared fit for service by the examining physician, is a skeleton. The drawing made a statement against the desperate recruitment policy in the later part of the war, when ever-older men, often in poor health, were drafted to fill the rapidly thinning ranks. When Grosz published his work in *Die Pleite* in 1919, he added a caption com-

Figure 14. George Grosz, *Feierabend* [Evening Leisure], 1919. Photolithograph from an ink drawing, 39.3 × 30 cm. Plate 3 from portfolio *Gott mit uns* [God Is with Us].

menting on a strike by physicians in several German cities: "Dedicated to the doctors of Stuttgart, Greifswald, Erfurt and Leipzig. Four and a half years they assured death his booty; now, when they should be saving lives, they have gone on strike. They have not changed. They have remained the same. They are fit for the 'German revolution.'"[33] The ironic interplay of text and image negates the possibility of aesthetic consumption and thus promotes critical thought rather than vague pathos. The addition of text is crucial: The disparity between image and text has an educational function aimed at furthering political awareness, for text and image become congruent only when the political reference is understood. Grosz skilfully blurs the boundaries between art and political cartoon.

Grosz shared a pictorial strategy with the Expressionists. He, too, resorted to a kind of shorthand – a stockpile of images – on which he could draw to quickly characterize a situation. His aging prostitutes, fat-necked capitalists, and corrupt clerics and generals were developed as easily identifiable representatives of social groups; they also served as antidotes to the Expressionists' idealized imagery: the New Man, the phoenix, the cathedral, a starry sky. Because Grosz wished to hold

up a critical mirror to society, he derived his characters not from the realm of art but from a close study of the sociopolitical environment.

Much like his Expressionist colleagues, Grosz distributed some of his prints in portfolios. His art created controversy and attested to the political power of his images – but the limits of Grosz's political engagement are also revealed. His portfolio *Gott mit uns* [God Is with Us] (1920) was a savage critique of military brutality. Exhibited at the International Dada Fair at the Galerie Burchard, it was deemed so offensive by the military establishment that a legal suit was filed against the artist. The writer Kurt Tucholsky described Grosz's portfolio as the most outstanding work in the exhibition, which he thought otherwise fairly tame: "If drawings could kill: the Prussian military would surely be dead. (Drawings, by the way, can kill.) His portfolio *Gott mit uns* should not be absent from any proper bourgeois family table – the faces of his majors and sergeants are infernal specters of reality. He alone is Sturm und Drang, agitation, parody, and – as rarely seen – revolution"[34] In the trial, Tucholsky reports, Grosz's defense lawyer argued that the portfolio was simply a joke. "His defense speech saved Grosz, but at the same time devastated him and his friends [Heartfield, as the publisher, also stood trial, as well as three others]," because as Tucholsky said, "That is your defense? That is how you meant it?"[35] (Here Tucholsky is questioning Grosz's political integrity.) Grosz was fined 300 marks, and Heartfield 600 marks.[36]

Grosz thought of his art as contributing to the proletarian revolution and grounded his figures in reality so that they could be easily identified. Yet his anticapitalist and antibourgeois messages were not universally accepted by the political left. The critical reception of Otto Dix's work offers an instructive parallel. Dix's work, which was modeled closely on Grosz's and used similarly verist figures to identify social class, was included in the First General German Art Exhibition in the Soviet Union, shown in Moscow and Leningrad in 1924–5. The Soviet critic Fedorov-Davydov, well-steeped in the language of class struggle but clearly mindful of the newly developing cultural theories in his country, could not discern any criticism of societal corruption in Dix's art. Instead, he saw these works as symptomatic of a sadistic, erotic nihilism:

Is this truly the art of the revolutionary proletariat? . . . How torn the social psyche must be . . . when artists . . . proletarian in their class consciousness come across as plain nihilists . . . Who . . . presents a positive ideal? What can an Otto Dix offer against the decay of the bourgeois and mass prostitution? . . . Horrors, nightmares, fever dreams on all sides. It may be that contemporary German reality is like this, but must the revolutionary agitation of art be so?[37]

In that critic's mind, the revolutionary artist's task was not only the advancement of the proletariat's cause, but also the production of morally uplifting images. One cannot help but think that he would have been happier with the postwar Expressionist eulogies of the slain Spartacus leaders.

It was in the realm of collage that Berlin Dada made its most important contribution. Seeing popular culture as the most significant new cultural form and as an arena outside the realm of tradition, Richard Huelsenbeck had proposed "the newspapers, the street, and advertising"[38] as new sources of artistic inspiration. To break the hold of tradition, the brutality of modern existence – to the Berlin Dadaists most evident in the metropolis and on the battlefield – had to be revealed as unequivocally and directly as possible. Adapting the language of popular culture to art, the Berlin Dadaists drew on the techniques of advertising and the newspaper headline to broadcast the breakdown of traditional culture. They assaulted their audience with numerous collages and collage-derived ephemera that impudently mingled images and texts. "Dada," Raoul Hausmann stated, "forms the world according to its own needs; it uses all forms and customs available to destroy the moral self-righteousness of the bourgeois with his own means."[39] Hausmann, in his *Synthetic Cino of Painting* (1918), declared in a manner analogous to Huelsenbeck's that the materiality of collage was a new venue to self-knowledge:

In Dada you will recognize your own true condition: wonderful constellations in real materials, wire, glass, cardboard, textiles are the organic equivalents of your own complete brittleness, your own shoddiness. . . . Through the superior force of our materials [we achieve] the final art of flexible and progressive self-representation as incorporated atmosphere without the traditional safeguards offered by the bystanders surrounding us.[40]

Collage became the means of representing reality directly and concretely without having to resort to mimesis. Hausmann announced in visual form his preference for new materials over traditional representation in a small collage, one of several he made as a cover design for his pamphlet *Material der Malerei, Plastik, Architektur* [Material of Painting, Sculpture, Architecture] (1918; Fig. 15). Reminiscent of Arp's abstract Zurich collages of 1915–16, geometric pieces of colored papers overlap and abut each other in a shallow space. Here, they function not merely as ciphers of abstraction, they also carry the text of the pamphlet's title, intimately linking collage and text. The text is no longer linear: Letters jump out of line and even tilt over backward, upper and lower case, bold and normal typefaces are deliberately mixed, calling to mind Marinetti's *Parole in libertà* as well as his own abstract poems of disconnected vowels or words blasted apart and scattered over the printed page in dynamic arrangements. Yet, even as he was defying typographic convention and seemingly exploding linearity, Hausmann in this collage organizes his letters along horizontal and vertical axes, insinuating a reference to construction within the visible destruction of conventional form. This small collage articulates a premise of Berlin Dada: The undoing of traditional form is the precondition of new construction. In Dada, painting, sculpture, and architecture all partake in fragmentation, but are reconstituted in a new syntax: the medium of collage developed to attack the "decaying culture of Europe."[41]

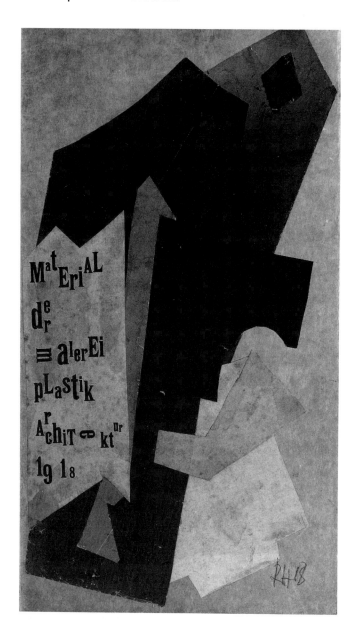

Figure 15. Raoul Hausmann, cover design for *Material der Malerei, Plastik, Architektur* [Material of Painting, Sculpture, Architecture], 1918. Collage, 32 × 18 cm. Mme. Marthe Prévot, Limoges. © 1992 ARS, New York/Bild-Kunst Bonn.

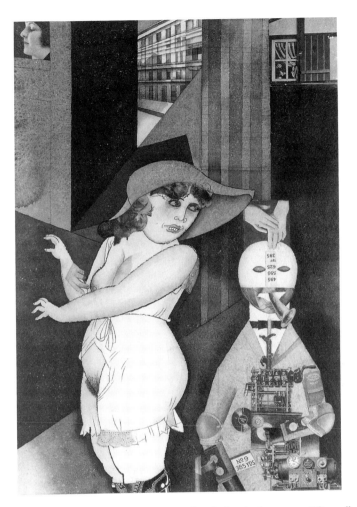

Figure 16. Grosz, *"Daum" Marries her Pedantic Automaton "George" in May 1920, John Heartfield Is Very Glad of It (Met.-mech. Constr. nach Prof. R. Hausmann)*, 1920. Watercolor and collage, 42 × 30.2 cm. Galerie Nierendorf, Berlin.

Thus, George Grosz employed collage when he set out to debunk marriage as a dehumanizing and repressive bourgeois institution. In his *"Daum" Marries her Pedantic Automaton "George" in May 1920, John Heartfield is Very Glad of It (Met.-mech. Constr. nach Prof. R. Hausmann)* (1920; Fig. 16), Grosz places the couple in a precisely rendered urban landscape, in which interior and exterior spaces are fused. In the background one sees an apartment building, to the upper left a woman in profile placed into a windowlike space, and to the upper right the window of a more rural home with wooden shutters, decoratively draped curtains, and flowers. The entire lower half of the composition is taken up with the image of the couple. She is shown as a prostitute in skimpy garb that exposes her pubic region; her nipples are tweaked by a detached male hand. While she stretches out her arms

toward the left side of the picture into the empty space, her head is turned backward, looking down at a diminutive male figure in suit and tie. In contrast to the female figure, which Grosz drew in watercolor, the male is constructed from collage elements. He is a machine-creature, his face an empty mask, his heart the counting mechanism of an adding machine, and other body parts various machine components set in motion by the figure's left robotlike arm. In the picture the female is sexually manipulated, but the male is also acted on: Two female hands hover above his head and hold on to a strip of numbers superimposed on his forehead.

The contrast of drawn and constructed elements, which finds an extension in the opposition of male and female, gives each figure a different reality. Endowing the woman with the attributes of a prostitute and the man of a mechanical puppet, Grosz implies that marriage robs men and women of their true identity and reduces individuality to stereotypes of maleness and femaleness. In the catalog to the First International Dada Fair, Wieland Herzfelde interpreted Grosz's work as a critique of marriage.

Grosz marries! For him, marriage is not a private, but above all a sociological event. A concession to society which resembles a mechanism and invariably turns the man into a cogwheel of its great machinery, so that marriage actually means a moving away from the bride in favor of society. At the same time a moving away from eroticism and sexuality. That is different with the female. For her, marriage turns everything on its head. The symbol for a young girl is a naked figure who covers her private parts with her hand or any bit of material. But with marriage, the denial of sexuality is abandoned, nay, even accentuated. . . . At the same time, Grosz shows how marriage isolates people, so that the world outside exists only through the window; and the image of the female that used to be at the center of the male's imagination, is now repressed to the last recesses of his brain.[42]

The revolutionary element in this collage lies in the carrying over of the mechanisms of caricature and satire into the realm of "high art." The use of the traditional medium of watercolor along with collage creates fissures and makes the work discontinuous; different realities clash pictorially and are accentuated in the work's subject matter. The ready-made images with which Grosz composes his architectural environment serve as analogues to the norms of behavior and thought passed from one generation to the next. Grosz plays off the various components of his composition to break open accepted notions about art and society. But there is another dimension to this collage as well: Although Grosz attacked marriage as a bourgeois institution, the work also documents his own marriage in May 1920 to Eva Peters, thus bearing testimony to his own anxieties and ambiguities.

Undoubtedly, the most important new collage material became the photograph. Culled from newspapers and magazines, joined with innovative typography and organized with the techniques learned from advertising, the photomontage became Berlin Dada's most aggressivly modern hybrid.[43] It exploited the seeming realism and truth value of photography only to debunk it in carefully manipulated montages. Thus revealing the contradiction between reality and appearance, the photomontage

trained at the same time the viewer's eye on a new mass culture in which photographic reproduction figured prominently. In the hands of the Berlin Dadaists, John Heartfield in particular, photomontage became a powerful political tool. Said Grosz and Herzfelde:

The artist of today . . . can only choose between technology and class struggle propaganda. In either case he has to give up "pure art." Either as architect, engineer, or commercial artist he joins the ranks of the army that develops the industrial forces and exploits the world . . . or he joins the army of the oppressed, becoming — in chronicling and criticizing the face of our time — a spokesman and defender of the revolutionary idea.[44]

The writer and editor of *Die Pleite*, Carl Einstein, defined art in a related manner as "conscious, effective activity."[45] For Grosz and Heartfield, subject matter was determined by political considerations; for Hannah Höch, the direct political satire or critique is rarer and done more underhandedly. Yet in all the different instances, the material and process of collage and particularly photomontage were used in a highly self-conscious manner to provide an antidote to Expressionist "interiority" and "sprirituality" and, more important, to point out with new materials and technological processes the prospect of a revolutionary transformation of society.

Hannah Höch's photomontage *Staatshäupter* [Heads of State] (1920; Fig. 17) ridiculed the idea of political office by displaying the president Friedrich Ebert and Minister of Defense Gustav Noske as beer-bellied male bathing beauties. The photographs of the politicians, recently published in the press, are set in an embroidery pattern of flower garlands, butterflies, and a woman with an extravagant hat coquettishly bending her head under an umbrella. Höch placed their images on the decorative pattern in such a way that Ebert appears to frolick in the flowers and Noske to be in intimate union with the woman. Höch, however, does not stop here. Her witty dismantling of the politician's authority as heads of state carries over into the manipulation of the collage material. Höch gave the embroidery pattern a flamboyant edge; placed at the bottom of the composition, below the politicians' bathing trunks, it suggests their sexual organs. Hausmann's (1919) assessment of Ebert (and Philipp Scheidemann) — "Wilhelm II was the incarnation of the peace-loving German. Ebert and Scheidemann are the German revolutionary's true face. A sleepy ass framed by a beard."[46] — is transformed by Höch's work into a more memorable and humorous commentary. At the same time, Höch also subtly celebrates her own powers as a visual artist. The embroidery pattern is most likely one of the many she designed herself as an employee of the Ullstein publishing house, the publisher of a popular woman's magazine. Making her own work the ground against which the photographs are placed, she extends her control over the holders of political power. In this collage the politicians take on an uncanny resemblance to Höch's mechanical dolls. Höch constructed many dolls, and they form an important part of her work; she exhibited them and had herself photographed holding

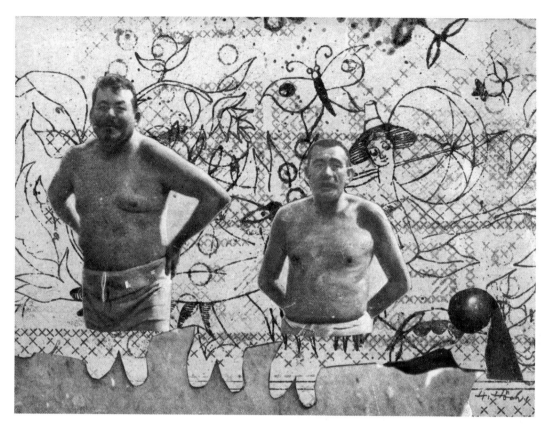

Figure 17. Hannah Höch, *Staatshäupter* [Heads of State], 1920. Photo collage, 16.2 × 23.3 cm. Berlinische Galerie, Berlin. © 1992 ARS, New York/Bild-Kunst, Bonn.

or posing her figurines, thus creating situations in which she would be perceived as exerting control.

The photomontage in Berlin Dada also functions as a referent to the supremacy of modern reproduction over outmoded forms of representation. In fact, many photographic images within Berlin Dada collages are of the technological world, underscoring the existence of a world dominated by machines. Wheels, ball bearings, and machine parts are scattered throughout the works of Hausmann, Höch, Grosz, and Heartfield. Frequently, the technological was alluded to with images of the United States – photographs of New York skyscrapers and publicity photographs for Hollywood films. The Berlin Dadaists, like so many Europeans, celebrated the United States as the land of the future, a free society in which man was no longer shackled to European cultural and political traditions. They idealized, in particular, the American West with its cowboy culture (notions gleaned from the new films as well the German popular writer Karl May) as a thoroughly antibourgeois environment

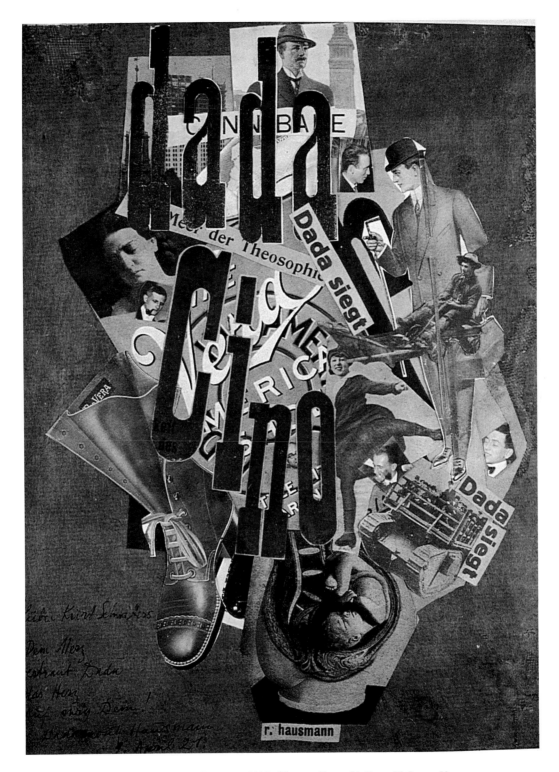

Figure 18. Raoul Hausmann, *dada-Cino*, ca. 1920. Photo collage, 31.7 × 22.5 cm. Mr. Philippe-Guy Woog, Vésenaz. © 1992 ARS, New York/Bild-Kunst, Bonn.

of boundless freedom. Already in 1916, in the middle of the war (as a period in Germany of vehement anti-American sentiment), Grosz is reported to have performed an impromptu ragtime dance in his American patent-leather shoes, exclaiming: "America!! The future!!"[47]

Raoul Hausmann, in his *dada-Cino* (ca. 1920;[48] Fig. 18) presents a dense and rich conglomeration of collaged images on a blue ground, a visual victory celebration for Dada and the world of modernity. Fragments of text and unrelated photographic images grow out of the medical textbook illustration of an embryo in utero placed at the bottom of the composition; read vertically, they culminate in the word "Dada" at the upper margin; read horizontally, the embryo becomes the base on which the other materials are affixed. Both readings connote a progression from an embryonic state to either Dada or to collage, Dada's "cinema." To the embryo's left is the prominent image of a laced boot; it seems to be marching out of the picture frame. It clearly has been culled from an advertisement, for its brandname "Vera" is revealed; to the right, Hausmann placed a photograph of a tank with a visitor's platform filled with people, surrounded by the words "Dada siegt" (Dada is victorious), which are repeated once more just above the center.

An advertisement for the Vera shoe company provides a verbal evocation of America as the harbinger of a new authenticity. Here one reads twice in large letters: "Vera-merica." The text is arranged in a circle and provides the visual hub around which the other images revolve. Surrounded by photographs of a female ice skater – who seems to represent the adult stage of the embryo supporting her right foot from below – the heads of elegant men, and a male fashion model in proper travel attire, the central text is capped by two photos of American skyscrapers. America, then, stood as a metaphor for the new, for a world in which freedom of movement is one of many positive characteristics. Hausmann has superimposed on the entire collage in large black print the words "Dada cino." Placed on the blue ground, the collage becomes the representation of a Dada globe moving and expanding in space as it develops from the embryo. Hausmann also offers a sarcastic nod toward the cosmic metaphors so favored by the Expressionists. Using the same metaphor, but substituting the bits of text and photographic reproductions culled from illustrated magazines, he indeed declares Dada victorious.

In this collage, the combination of image and text creates visual excitement. Even more, it proposes a new visual culture, the Dada cinema of rearranged fragments, in which the photographic representation of movement is coupled with the pictorial energy provided by the free-floating, yet controlled arrangement of the materials. As in his *Synthetic Cino of Painting*, Hausmann celebrates simultaneity as the source and hope for a newly liberated self; his image of the embryo at the bottom of the composition symbolizes the potential for growth and unfolding:

Mankind is simultaneous, a monstrosity of proper and alien parts, now, before, after, and simultaneously. . . . Mankind's discovery of its enormous potential for experience is ger-

minating; uncovering our sexual-psychic self, we no longer need the ethical pirouettes of art. . . . L'Art Dada offers an incredible refreshment, an impulse to truly experience all possible relationships.[49]

Hausmann, like his Dada colleagues, focused on the possibility of play in Schiller's sense, as an activity comprising both a material and an intuitive aspect – to liberate the individual from the norms superimposed by society and to delineate possible paths toward societal and individual transformation. Play as subject matter, but above all, actual play with form and material are the characteristic traits of Berlin Dada. It is the key component of Hannah Höch's famous large-scale collage, *Schnitt mit dem Küchenmesser Dada durch die letzte Weimarer Bierbauch-Kulturepoche Deutschlands* [Cut with the Kitchen-Knife Dada through the last Weimar Beer-Belly Cultural Epoch of Germany] (1919).[50] It is a composition organized into Dada and anti-Dada parts and interspersed with numerous images of ball bearings and of wheels and of people at play. Here the world of Dada is identified as the modern. It is again associated with the cityscapes of America, which are visible in a street scene in the lower left and in a group of high-rise buildings in the upper right and in modern machinery, as well as with leftist politicians and progressive thinkers, whose images are interspersed throughout the Dada part of the composition. Included are Marx, Lenin, and Radek as well as Baader and Albert Einstein, all identified as "great dadas," and several contemporary performers and artists. In contrast the world of anti-Dada, comprising the upper right hand of the composition, is the bourgeois world of top brass, old and new, including Hindenburg and contemporary political leaders. The entire composition revolves, however, around the pirouetting body of a contemporary female dancer. Headless herself, she tosses the much larger head of the artist Käthe Kollwitz – Höch's stand-in – into the air.

Höch defines the different arts as being at the core of Dada and capable of setting the world – and thus transformative processes – into motion. Indeed, the making and remaking of images is a pervasive theme within the collage: Throughout, she has playfully disassembled and reconfigured the human body, giving male bodies female heads and vice versa, endowing small bodies with huge faces or even two heads. It is a symbolic refashioning of reality, in which Dada is the moving force and declared victorious. Höch reveals Dada as a realm of total freedom in which the unbounded rethinking of reality is possible. Hausmann found descriptive words to explain a similar idea:

We see only means here in our play of consciousness-raising; driven by our instincts, we are playing at consciously entering the world. . . . We don't want the values that flatter the bourgeois – we want non-value and nonsense. We are against Potsdam-Weimar, it is not for us. We want to create everything ourselves – our own new world.[51]

The political element in Dada collage was less often evident in the actual illustration of political issues than in the dismantling of reality, made palpable in the collage

materials or the clash of actual materials with the traditional means of artistic representation. Dada was prescriptive: It not only spoke of the dire need to destroy the old order, but in emphasizing mass cultural materials and the nonhierarchical organization of space, it advocated the creation of a global (communist) society. The critic Carl Einstein defined the most urgent task of the revolution the "destruction of the object for the salvation of humanity," for only "dematerialization freed man from his objectified existence in ownership."[52] The Dadaists destroyed what Walter Benjamin termed the "aura" of the work of art, its secure link to time and place and its authority as derived from the artist's personal touch. The strategies for destruction and construction were the result of careful deliberations and drew on the techniques developed in the media. In turn, they influenced the media: The subsequent development of typography, graphic design, advertisement, and film cannot be thought of without Dada's formative influence.

This brief survey of Expressionist and Dadaist artistic production in the postwar era reveals the remarkable variety of ideological positions present within these two particular movements. The many different political attitudes manifest, for example, in the woodcut medium – the medium most fundamentally associated with Expressionism – or even in collage – the quintessentially Dadaist medium – put into question the notion that artistic movements are monolithic and constitute distinct moments in the history of art. Instead, these observations suggest that artistic developments rarely unfold in a linear fashion but rather happen in many small spurts, in which a progressive stance may coexist with more traditional modes of representation.

MERZ AND EXPRESSIONISM

Adopting collage in 1918–19, Schwitters acknowledged the loss of a totalizing tradition. He affirmed fragmentation as a given, and, by turning his back on easel painting, he also declared the value of newness. Yet his break with tradition was neither as abrupt nor as unequivocal as the artist's 1930 statement would have us believe. In spite of his jubilation about the end of the war and his liberation from the constrictions of past norms, Schwitters's vision remained firmly embedded in a German artistic tradition.

His unwillingness to relinquish the past is most notably evident in his activities as a collector – the maker of collages – who salvages the fragments of the past, but also in his continued engagement with naturalistic painting. He executed representational paintings alongside his abstract collages, and he explained his seemingly opposed styles in terms of a continual search for totality. It can be traced in his fascination with the organic, his fusion of two different modes of representation within one work, and finally, his enduring commitment even after the adoption of collage as an antitraditional medium, to Expressionist theory and practice. Indeed, Schwitters's theory of collage is grounded in German Expressionist theory.

Schwitters's engagement with modern art came relatively late in his artistic development. Until about 1917, he expressed no awareness of Expressionism, Germany's most advanced art before the war. He had studied art during 1909–14 at the Academy of the Arts in Dresden, the birthplace of Die Brücke in 1905 and home to several Brücke artists when Schwitters began his studies. There is no indication, however, that he had any contact with these artists or saw the important Brücke exhibition at the Galerie Arnold in 1910,[1] but he did report on May 2, 1909, two weeks after his arrival in Dresden, his visit to the international photography exhibition that had opened the previous day. Characteristically, Schwitters singled out the painterly qualities of some of the photographs:

Initially I was surprised how painterly photography can be treated. I became envious and afraid of the competition. But now I have realized that photography has a shortcoming: it lacks the personal, the conception.[2]

A decade later, Schwitters himself described his early art as "Impressionism," the term used in Germany during that period to describe the tonal painting of Naturalism: "I concerned myself with the extensive exploration of the effects of light in a sketch-like manner of painting (Impressionism)"[3] Nonetheless, during the war Schwitters seems to have become highly conscious of Expressionist art and theory. His opening up to new influences was accompanied by a shift in the themes and execution of his art, reflected in his turning away from landscape and portrait painting to more allegorical subjects. His metamorphosis into a collage artist marked the culmination of a brief period of experimentation during 1916–18, in which he explored different contemporary artistic styles and surprisingly quickly absorbed Expressionist theory.

The immediate visual sources for Schwitters's new collage style are undoubtedly to be found in the works of Picasso and Braque and the Italian Futurists transmitted to him by the Zurich and Berlin Dadaists and such art magazines as *Der Sturm*; it was apparently Hans Arp (who had himself transformed the French collage model into more organic forms) who introduced Schwitters to the new collage method in 1918. Schwitters, however, considered the collage process with the mental tools of an artist attracted to Expressionist theory, which amply supported an artistic process that advocated the manipulation of fragments or isolated objects. Schwitters reinterpreted Expressionist theory to accommodate his newly gained information on collage.

Schwitters's assimilation of modernism via Expressionism was at least in part a result of the suppression of information on French, Italian, or Russian avant-garde art during the war, although several of his drawings indicate that he had access to Italian Futurist and French Cubist art, some of which had been reproduced in prewar publications or was available in collections. Nevertheless, Schwitters's initial interest and subsequent adaptation of a German model was supported by a national debate during the war that increasingly celebrated Expressionism over foreign styles; more important, it was fueled by the changing cultural environment of his home town, Hannover, where he spent the war years and launched his artistic career. In the process, Schwitters developed a collage style that is best understood as a product of regionalism – the somewhat belated exposure to experimental modes and the slightly amateurish zeal with which he embraced them. It was above all Wilhelm Worringer and Wassily Kandinsky who provided Schwitters with the theoretical underpinnings for a collage style that conceptually grew out of Expressionism as opposed to French Cubism.

For a brief moment after the war, Hannover took on certain characteristics of the modern metropolis. Here, the turmoil and rupture of the era mostly associated with the city were experienced firsthand at the end of the war, when revolts initiated

by the soldiers and sailors swept within hours from Bremen to Hannover. Although the actual revolts did not last very long, the rift between the parties and social classes certainly did; they had smoldered for a long time, but had been contained during the war through censorship and the focus on the war effort. One must measure the cultural transformation of Hannover during this time against the backdrop of political and social change. As may be expected, the most visible changes were institutional, most notably the creation of alternative exhibition societies and meeting spaces – but they were also apparent in everyday life, as for example in the dance craze that swept the city after the war, as well as a general craving for entertainment much lamented in the conservative press.

Schwitters's friend and collaborator on several projects, Kate Steinitz, moved to Hannover from the nation's capital, Berlin, in 1918 and reported her impressions as an uprooted metropolitan:

[Hannover was] drab and gray with rain and fog. The streets were as wet as crying, and I was afraid they would float away in their own tears. Because they were good Hannoverian streets, however, they did not. They stood still at the streetcar stops, where the colorless, gray Hannoverians waited patiently under their umbrellas for the sad streetcars to come along.[4]

To Schwitters, an aspiring artist who had lived most of his life in Hannover, the city must have looked different. He must have sensed the awakening of a modernist spirit, a breath of fresh air, as the cultural and political climate took on a different tenor during and after the war. He became an active participant in the new institutions and sought out the emerging literary and cultural figures of his hometown.

In the visual arts, the most important events contributing to cultural change were the founding in 1916 of an art society, the Kestner-Gesellschaft, and the opening to the public of the important Garvens collection of modern and primitive art.[5] In June 1917 the Hannover Sezession was founded, offering a new forum for local artists – Schwitters joined it in February 1918 and began to exhibit with the Sezession in 1919. The Kestner-Gesellschaft and slightly later the Galerie Garvens were the two organizations most responsible for the new spirit in Hannover culture. Both offered a wide array of events, including ambitious exhibition programs of modern art, extensive lecture series with well-known visiting critics and art historians, and poetry readings and performances. These cultural events found an extension in the activities of two local publishers, Paul Steegemann and Christof Spengemann who developed strong voices in the German literary world and enlivened Hannover's literary establishment with their publications.

Both Spengemann and Steegemann founded cultural journals and new imprints within their publishing houses. Spengemann's monthly cultural journal, *Der Zweemann: Monatsblätter für Dichtung und Kunst*, was modeled on Walden's *Der Sturm* magazine and like it illustrated with original woodcuts and lithographs; its seven numbers appeared from 1919–20. His Zweeman Verlag printed in book form various modernist texts by an international group of writers. Steegemann similarly founded

a cultural journal, *Der Marstall: Zeit- und Streitschrift des Verlages Paul Steegemann* whose life was, however, even briefer: Only one double-number was published in 1920. Steegemann's book imprint, *Die Silbergäule*, in contrast, was economically much more successful. It became well known as an experimental series of books. Steegemann published 153 book numbers (several as double numbers) under this imprint, including texts by the anarchocommunists Heinrich Vogeler and Ludwig Bäumer. Schwitters himself designed a Dadaist cover for one of the books, Melchior Vischer's *Sekunde durch Hirn. Ein unheimlich schnell rotierender Roman*, 1920.

The art exhibitions and public lectures in Hannover during the last two years of the War gave prominence to Expressionism. In 1916–17 a number of naturalist painters were shown, among them Wilhelm Trübner, but the focus soon shifted to Expressionist artists. These included the painters Paula Modersohn-Becker, Lovis Corinth, Emil Nolde, August Macke, Cesar Klein, and an exhibition of recent Munich painting; the series of exhibitions was continued in 1918–19, with shows of Adolf Hölfels, Erich Heckel, and Christian Rohlfs, and followed in 1919–20 by an exhibition of French painting, "From Courbet to Picasso" (September 1919), which included also James Ensor, Paul Klee, and Lyonel Feininger. Much like the curators, many of the visiting lecturers were strong proponents of German Expressionism; in 1916–17, the introductory lecture by the director of the Kestner-Gesellschaft, Paul Erich Küppers, was followed by a talk by the art historian (and later museum director of the Mannheim Kunsthalle) Gustav Hartlaub, who predicted in his writings and lectures the subjugation of materialism and a new affirmation of the religious spirit, hoping that Expressionism would become a new religious art. In 1917–18, the critics Dr. Cohn-Wiener and Theodor Däubler, the reciter, Rudolf Blümner, as well as the art historian Wilhelm Worringer all presented lectures.[6] Many of the visiting lectures were closely associated with Herwarth Walden, the Berlin publisher of the Expressionist magazine *Der Sturm* and owner of the gallery of the same name. To Schwitters, these visitors must have been powerful indicators of the public success of Expressionism, as well as of Walden's stature in the German art world; they instilled a desire in him to become part of Walden's successful circle. When Schwitters decided to try his luck in the German art market, he approached Walden first and not Hans Goltz, an equally well-known dealer in Munich. Schwitters's exposure to Expressionism was extensive and thorough; it coincided with his own search for direction and decisively shaped his artistic development.

It has been argued that Expressionism is based on the simultaneous yet ambiguous presence in a single work of art of two or more contradictory meanings. Donald Gordon has attributed the Expressionist concern with polarity to Friedrich Nietzsche's profound influence on artists associated with that movement, among them the Viennese Expressionist Oskar Kokoschka, the artists of Die Brücke, particularly Ernst L. Kirchner, but also the artists of the Blaue Reiter, above all

Franz Marc and Wassily Kandinsky.[7] These artists, Gordon argues, as well as many Expressionist writers, adopted Nietzsche's concept of creation through destruction that he had formulated in his *The Will to Power*. It finds expression in Kandinsky's work from about 1909 to 1914, in his images of the Deluge and Last Judgment, but also in Marc's paintings of 1913–14, *Animal Fate* and *Fighting Forms*. Nietzsche's concepts are similarly reflected in Kandinsky's theoretical writings. In his widely read text from 1910 (published in 1912), *Über das Geistige in der Kunst* [Concerning the Spiritual in Art], Kandinsky argues that the "harmony" of the age was one of "antitheses and contradictions." "Harmony today rests chiefly on the principle of contrast," he wrote; even musical "discord," "ugly sounds," and "unbeautiful dance movements" could be considered beautiful, provided that [they] arise from internal necessity."[8] The concern with antithesis and contradiction became for Kandinsky, as for many of his contemporaries, a structuring principle of his art. It led him to introduce hidden imagery of contradiction – remnants of representational painting – into his increasingly abstract compositions, so that the dynamics of the works are based on the subtle dialogue between the two different modes.[9]

Kandinsky's writings reflect the influence not only of Nietzsche, but above all of Wilhelm Worringer. In Worringer's art theories, prominently set forth in his epochal *Abstraktion und Einfühlung* [Abstraction and Empathy] (1908), Kandinsky found support for his own dualistic mode of thinking and pictorial representation, a theoretical link to Romanticism in his use of terminology, as well as the encouragement to consider his formulation of an abstract style an appropriate response to the modern times. Worringer did not declare that he specifically devised his theory of abstraction to explain contemporary currents in the visual arts. Rather, he took the modern tendency toward abstraction as a starting point to consider the cyclical nature of the two major approaches to representation, which he defined as naturalism and abstraction. Yet, while he did not specifically point to the modern as context, he nevertheless repeatedly stressed as the overriding causes for abstraction the very psychic manifestations commonly associated with modernity in the critical and popular literature of the time, namely, displacement, anxiety, disharmony and the attendant need for tranquility and refuge.

In this context, it is not without significance that Worringer in his foreword to the 1948 reissue of his book singled out Georg Simmel – the great German theoretician of modern culture and the contemporary psyche in the modern metropolis – as that person who inspired him in his formulation of his theory of abstraction at no other place, no less, than the Trocadéro Museum in Paris, the very place where deracinated cultural objects (the spoils of imperialism) were displayed like specimens in glass vitrines. Worringer describes it in these words: "It was the ensuing hours spent in the halls of the Trocadéro with Simmel, in a contact consisting solely in the atmosphere created by his presence, that produced in a sudden, explosive act of birth the world of ideas which then found its way into my thesis."[10]

Not coincidentally, the Trocadéro was the place where, just about at the time of Worringer's visit, Picasso found his inspiration for his turn toward primitivism and abstraction.

Worringer's theory of abstraction finds its theoretical ground in German Romantic philosophy, particularly Friedrich Schelling's *Naturphilosophie*. Schelling's writings provide one of the sources for Worringer's – and Kandinsky's – thinking in oppositional pairs, in particular the notion of abstraction and empathy, except in a radically different formulation. Schelling understood nature to be composed of two contradictory forces, the real and the ideal.[11] Both are, in Schelling's view, expressions of one absolute. Nature is an unconsciously creative spirit, and the various processes in nature should be regarded as expressions of an unconscious spiritual or intellectual force. Knowledge, too, Schelling argued, is the result of the constant interaction of two contrasting forces, described as positive (matter-giving) and negative (form-giving). Similarly, nature consists of the same contrasting forces, characterized by Schelling in this context as endless expansion and constant contraction. Because of its expansionary properties, matter itself is compared with light; contraction, with heaviness and weight. The constant interaction of the two forces, comparable to seeing and feeling, or to expansion and contraction, should, Schelling argued, eventually lead to a new consciousness. At that moment the spirit – always active below the level of consciousness – will awaken, and it will be understood that the ideal is located within the self as the only real.

Important for our consideration is Schelling's belief in the constant interaction of two contrasting forces and his conclusion that the real can be found only through self-contemplation. The theoreticians Theodor Lipps and Alois Riegl applied Schelling's concept to art theory and developed a theory of empathy, based on the concept that the subject exists in the object, so that both are eternally intertwined, evolve together, and thus remain forever in flux. Art, in this view, exists only in the relationship between the viewer (or maker) and the object, as the final form of the object cannot be fixed for it is constantly evolving in the process of seeing and understanding: "The form of the object is always being-formed by me, by my inner activity."[12]

Worringer, who considered the theory of empathy "inapplicable to a wide spectrum of art history,"[13] introduced the concept of abstraction as a counterpole, effectively separating Schelling's opposing, yet intertwined forces into two distinct categories. The distinction permitted a broader view of art history in terms of cyclical development.

Just as the urge to empathy as a pre-assumption of aesthetic experience finds its gratification in the beauty of the organic, so the urge to abstraction finds its beauty in the life-denying inorganic, in the crystalline or, in general terms, in all abstract law and necessity.[14]

Although Worringer defined empathy and abstraction as opposing forces appearing under different historical circumstances, he also saw them as coexisting in every human being at all times. Depending on the psychic state of the individual

in a particular historical moment, either the one or the other would dominate: "the urge to empathy . . . is latently present within every human, and held in check only by the 'dread of space', by the urge to abstraction."[15]

Kandinsky adopted Worringer's dual concepts and his belief in their latent presence in all of humanity in order to explore the possibilities of a universal language – abstraction – tied, however, to empathy. Kandinsky believed that the careful and simultaneous stimulation of empathy and abstraction could result in a new wholeness and that art could thus serve a spiritually elevating function. He drew on the image of the pyramid to symbolize graphically the intertwining of both elements in an upward movement, which he considered a movement toward enlightenment – Schelling's notion of a new consciousness and the awakening of the spirit.

The first sign of Schwitters's engagement with prewar Expressionism is his new concern with opposites, visible in the formulation of a classification system that constitutes a rather literal emulation of both Worringer's and Kandinsky's theories; it becomes apparent also in the subject matter of his newly categorized art. He began, in 1917–18, to differentiate in his work between *Expressionen* and *Abstraktionen*. In some instances, he included the classification in the title, as in *G Expression 2 (Die Sonne im Hochgebirge)* [Sun in the High Mountains]; in others, the subject matter provides the clue for the work's classification.[16] The *Expressionen* are concerned in one form or another with the theme of empathy; the *Abstraktionen*, in contrast, with the representation of inanimate objects. Drawing on both Kandinsky, who linked pictorial expression with empathy, and Worringer, who associated naturalism with empathy, Schwitters tends toward a naturalist style in his *Expressionen*, but stresses the abstract components of his compositions in his *Abstraktionen*.

The *Expressionen*, as well as related works that do not bear these classifications, include several portraits of Schwitters's wife Helma, whom he had married in 1915, and some landscape and figurative paintings and drawings. In *Vision* (1916–17; Fig. 19), for example, Schwitters is concerned with the expression of an internal reality as experienced through an inwardly directed gaze. Helma's face is illuminated from above; Schwitters shows her experiencing reality not through empirical but through extrarational processes. Suggesting that the internal reality is as important as the external, he describes Helma's relationship to reality as empathetic. Similarly, *G Expression 3 (Die Liebe)* [Love] (1917; Fig. 20) stresses empathy. Undoubtedly inspired by Franz Marc's depiction of animals in harmony with nature, Schwitters with broad painterly marks naturalistically portrays love as the harmonious coexistence of man and woman, mankind and nature. He idealizes this doubly positive relationship in the representation of the couple resting against a rock and leaning against each other in relaxation. Their embrace forms the apex of the composition; the curves of their bodies are repeated in the deftly rendered

undulating lines of the hilly landscape as if there were a reciprocal relationship between nature and the harmony of the couple's embrace.

In *G Expression 2 (Die Sonne im Hochgebirge)* [Sun in the High Mountains] (1917; Fig. 21), Schwitters substituted a sign for the human figure – a single large cross atop a mountain – but otherwise he is equally concerned with an empathetic relationship between man and nature. Schwitters returns to this theme again in 1919 with his painting *Hochgebirgsfriedhof* [Cemetery in the High Mountains] (Plate 2). In this image of Golgatha a large single cross bisects the sun or moon and towers above two smaller crosses below. All three crosses are placed high in the mountains – Schwitters looks back to such Romantic paintings as Caspar David Friedrich's *Kreuz im Gebirge* [Cross in the Mountains] (ca. 1806; Fig. 22) and shows himself heir to the Romantic belief, so powerfully expressed in Friedrich's works, that truth and spirituality may be found in union with nature.

The *Expressionen* include, as we have seen, depictions of emotions as well as allegorical renderings of love and spirituality. In subject matter, style, and use of color these works reflect the influence of Expressionist artists such as Franz Marc and Wassily Kandinsky; but above all of the naturalist German painters, Hans Thoma and Wilhelm Trübner with their broad, painterly styles (these artists' public successes Schwitters charted with numerous newspaper clippings in his *Schwarzes Notizbuch*). The *Abstraktionen*, in contrast, look to Futurist and Cubist sources and show Schwitters's increasing awareness of a broader spectrum of avant-garde art. The group of *Abstraktionen* consists for the most of paintings, but also includes, like the *Expressionen*, a number of drawings.

Z. 57, Abstraktion [Abstraction] (1918; Fig. 23), one of the small drawings, emulates with its clear contours, pointed forms, and regularized crosshatching the dynamic force-lines of Futurist art, as for example, Umberto Boccioni's studies of movement. *Abstraktion 19, Die Entschleierung* [Unveiling] (1918; Fig. 24) similarly evokes Futurist precursors. It is a simple yet dynamic composition, consisting of a large illuminated circle placed in the upper right and intersecting diagonal and curved lines. The overall composition is related to *Die Sonne im Hochgebirge*, but its more dynamic form, as well as its title implying action rather than stasis, is closer to such Futurist works as Giacomo Balla's paintings of 1913–14 depicting planetary movements. Yet *Entschleierung*, much like the related drawing *Z. 199, Eisgebirge* [Ice Mountains] (1918; Fig. 25), also incorporates the polarities that we associate with Expressionism. The dynamics of the painting and the drawing derive from the interplay of contrasting expressions: The intersecting diagonals in the painting, the sharply pointed triangular forms in the drawing, are placed in opposition to the rounded form of the sun or moon, setting up a countermovement. Similarly, Schwitters employs in both works a rhythmic shift from light to dark, further enhancing the contrast.

More important to his development and a stronger indication of Schwitters's direct reading of Worringer are his depictions of objects in which we see him

Figure 19. Schwitters, *Vision*, 1916–17. Oil on board, 41.9 × 34.9 cm. Photo: Marlborough Fine Art, London.

Figure 20. Schwitters, *G Expression 3 (Die Liebe)* [Love], 1917. Lost.

55

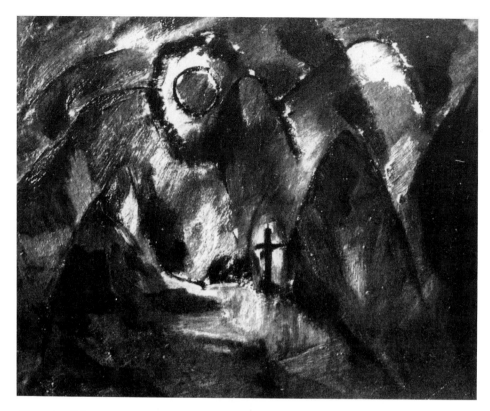

Figure 21. Schwitters, *G Expression 2 (Die Sonne im Hochgebirge)* [Sun in the High Mountains], 1917. Whereabouts unknown.

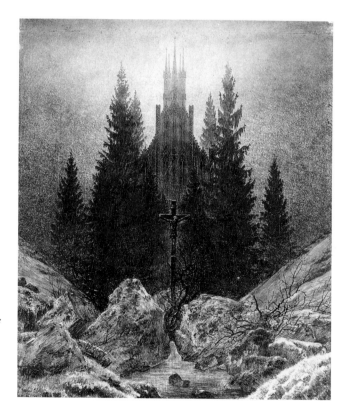

Figure 22. Caspar David Friedrich, *Kreuz im Gebirge* [Cross in the Mountains], ca. 1806. Oil on canvas, 44.5 × 37.4 cm. Kunstmuseum Düsseldorf im Ehrenhof.

Figure 23. Schwitters, *Z. 57, Abstraktion* [Abstraction], 1918. Black chalk on paper, 14.3 × 19.3 cm. Private collection, Switzerland.

Figure 24 (*right*). Schwitters, *Abstraktion 19, Die Entschleierung* [Unveiling], 1918. Oil on board, 69.5 × 49.8 cm. Marlborough Fine Art, London.

Figure 25 (*below*). Schwitters, *Z. 199, Eisgebirge* [Ice Mountains], 1918. Black chalk, 19.7 × 12.1 cm. Marlborough Fine Art, London.

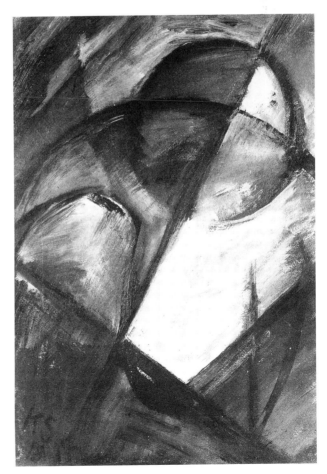

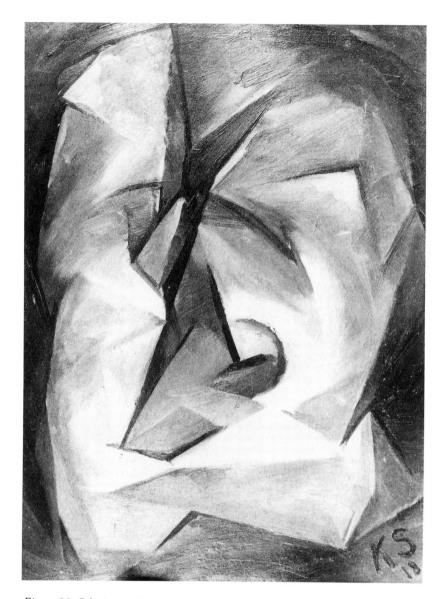

Figure 26. Schwitters, *Abstraktion 9, Der Bindeschlips* [The Bow Tie], 1918. Oil on board, 73.5 × 56.8 cm. Marlborough Fine Art, London.

wrestling with Worringer's observation that "the urge to abstraction finds its beauty in the life denying, inorganic forms, the crystalline or, in general terms, in all abstract law and necessity."[17] *Abstraktion 9, Der Bindeschlips* [The Bow Tie] (Fig. 26) and *Abstraktion 16, Schlafender Kristall* [Sleeping Crystal] (Fig. 27), both painted in 1918, are, as depictions of static objects, closer to Cubist than to Futurist sources. They are painted, Elderfield states, in a newly "severe and geometrized manner that shows for the first time the absorbed influence of Cubism in Schwitters' art."[18] Indeed, both are composed of interlocking polygons painted in predominantly

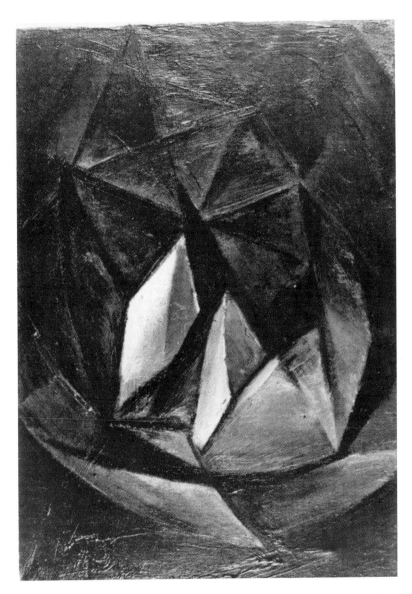

Figure 27. Schwitters, *Abstraktion 16, Schlafender Kristall* [Sleeping Crystal], 1918. Oil on canvas, 72.5 × 53.1 cm. Private collection.

dark hues. Schwitters approaches abstraction in these paintings in his emphasis on tonal areas and sharply accentuated edges. Yet even as he adopts the nonspecific Cubist lighting that seems to dissolve three-dimensional forms into planes, he never disavows the distinction between object and space. The concentration of light within the form suggests that light has emanated from the crystal or the bow tie itself and thus draws attention back to the object rather than to the plane or the space surrounding the object. Furthermore, Schwitters's focus on the crystal as subject matter resonates with Expressionist utopian concerns as expressed by the writer

Paul Scheerbart and equally by a group of architects around Bruno Taut, who articulated toward the end of World War I and the months that followed a utopian vision of a crystalline architecture that was to symbolize and foster a new spirituality.

In his essay "Merz" of 1920, in which Schwitters describes his artistic development, he characterizes his *Expressionen* and his *Abstraktionen* in a manner that is itself indicative of his attempt to join opposites. Declaring that pictorial expression was hampered by naturalism, he identified himself a follower of Worringer and his association of naturalism with empathy. Although Schwitters defined his *Abstraktionen* in opposition to his naturalist *Expressionen*, he nevertheless strove for expression in both.

The expression of a painting is so important that one should strive for it with determination. All intent to render a natural form interferes with the determination to work out an expression. Therefore, I renounced the representation of the natural world in favor of working with pictorial problems. These are my Abstractions. I still evaluated the different elements of a painting against each other in the manner I used at the academy, but not to represent nature but to attain expression.[19]

Schwitters characterizes his *Abstraktionen*, like his *Expressionen*, as expressionist; he describes his development as a move away from the human figure and from nature toward pure expression. Sensing that the depiction of nature would interfere with the expressiveness of the painting because it would draw attention to the setting rather than to pictorial properties, Schwitters chose the more neutral, inanimate object to be the carrier of *Ausdruck* [expression]. Yet, his objects, like the bow tie, would not stand by themselves; rather, they would be integrated into the pictorial composition to foster an intimate relationship between space and form and metaphorically between themselves and the world at large to which they as objects belong. Here, Schwitters differs from Worringer who believed that "in the contemplation of abstract regularity man would be, as it were, delivered from this tension [between the morphological laws of organic and inorganic nature]."[20] Following Kandinsky, Schwitters acknowledged abstraction and naturalism/empathy as distinct categories but attempted to join them. Rather than dissolving the object's identity in the composition of the painting, Schwitters retains references to the object's three-dimensionality. As clearly identifiable forms whose grounding in three-dimensional reality is still evident, the objects, more than the other pictorial elements, become the actual carrier of expression and are the main repositories of form in Schwitters's paintings.

Kandinsky explained that "Form . . . is [therefore] the expression of inner content. . . . The harmony of form can only be based upon the purposeful touching of the human soul."[21] While Kandinsky considered form an increasingly unnecessary component of painting in the development of an abstract language, as he discussed in his essay "Über die Formfrage" [On the Question of Form] (published in the *Blaue Reiter Almanach* in 1912), Schwitters, in contrast, equates "form" with "object" as the repository of pictorial form. Since form, or in Schwitters's more

direct usage, objects, must be capable according to Kandinsky of "touching the human soul," they cannot be depicted in a neutral way. This may explain the curious properties with which Schwitters endows his objects: The bow tie takes on facial characteristics with its twisted planes and the emphasis on the vertical axis, and the crystal is not an inanimate object, but rather has been given the ability to sleep (as the title implies) and, furthermore, seems to radiate light.

Elderfield's finding – that in the *Abstraktionen* Schwitters has "achieved a fullness of abstraction wherein individually weighted lines are subject in themselves"[22] – seems in view of these observations insufficient. The objects in the *Abstraktionen* contain the first indication of the power of expression with which Schwitters will endow the individual collage fragments as actual objects in the following year. We see in particular in the *Bindeschlips* with its mundane subject matter the beginnings of the object-fetishism of Schwitters's Merz-art and the source for his collage theory in Expressionist artistic theory.

Although Schwitters's definition of form slightly differs from Kandinsky's, Schwitters must have thought that he followed Kandinsky's theoretical considerations in his treatment of the individual collage components of his Merz-art. In his theoretical writings on Merz, Schwitters declared repeatedly that his collage materials lost their *Eigengift*, their particular characteristics of origin, when taken out of their original context and brought into the new context of the collage. As in his paintings of objects, however, Schwitters is never quite able and willing to erase the traces of their origin from his materials or not to endow them with characteristics that elicit responses of empathy, as any careful analysis of individual collages will reveal. His deliberate contrasting of the naturalistic and the abstract brings to mind Georg Simmel's argument set forth in his essay "Metropolis and Mental Life" that art arises at the intersection of nature and culture. Schwitters, much more than Kandinsky, locates his artistic expression precisely at this intersection, because it is there, in their surprising (and aesthetically pleasing) pictorial interdependence, that both the natural and the abstract may find redemption.

Having adopted collage, Schwitters abandoned the classification of his art into polar opposites. His abstract collages, which emphasize material objects as the carriers of content, appear as the logical extension of Schwitters's *Abstraktionen*. Yet polarities continued to exist in Schwitters's work even after he had broken with his own artistic past. Schwitters's ongoing conception of oppositional pairings in art is visible in his lasting involvement with naturalistic oil painting and in the form and content of the individual collages. Schwitters never gave up naturalistic oil painting. Throughout his career he painted landscapes and portraits, less frequently genre scenes, in a broad, naturalistic manner, and produced approximately the same number of naturalistic paintings as abstract collages.[23] The making of traditional oil paintings was clearly more than a pastime. Schwitters considered these paintings important enough to exhibit them alongside his abstract collages, as for example in his comprehensive traveling exhibition, the *Große Merzausstellung* of 1927. In

the catalog for the exhibition, Schwitters explained that "Art never imitates nature, but grows according to the same laws as nature,"[24] and went on to remark:

I have included numbers 17 and 31 in this exhibition to demonstrate that, next to the abstract compositions, I have also continued to study nature every year for a little while. It may be a private amusement, but I do not want to lose the connection with my earlier stages of development. I think it absolutely necessary that at the end, one's whole life with all its intentions is there in its fullness and that nothing be lost, even if it was wrong or idle. . . . We cannot make an ideal being out of ourselves. . . . I don't have to hide anything, not even the sentimentality of imitating nature still clinging to me so pleasantly today, without any artistic intention, only for purposes of orientation.[25]

The importance of this statement does not lie in Schwitters's ironic undercutting of a possible critique of his naturalistic painting, but in his emphasis on wholeness. Nothing, he says, must get lost; otherwise he will not be complete as an artist and human being. If Schwitters's adoption of abstraction threatened his naturalistic painting, then he felt that a conscious effort had to be made to keep his ability to paint naturalistically alive and well, so that both could coexist. To Schwitters, these concurrent expressions were not only desirable but necessary, for art and nature exist in an interdependent relationship. Because they grow "according to the same laws," granting them equal status provides a sense of totality at the very moment when a totalizing tradition seems to have been lost.

It can similarly be argued that Schwitters allows the two separate spheres of *Abstraktionen* and *Expressionen* to survive in his collage work proper, gathered up in one totalizing environment. The *Expressionen*, we remember, were meant to transmit an empathic relationship with nature. In the collages, Schwitters reformulates "nature" and presents it as "the organic." It exists in all the abstract works as a counterpoint to the more rigidly abstract, inorganic forms. In *Merzz. 19* (Plate 1), for example, the irregular, softly torn edge of a white paper is played off against more rectilinear forms; in other collages it is evident in the inclusion of organic materials, such as the feather in *Mz. 280, Rote Feder (für Lisker)* [Red Feather (for Lisker)] (1921; Fig. 28).

Sometimes the organic is alluded to in a more subtle manner, as in the simple contrast between shiny papers (suggestive of newness and anonymous machine productions of a technological era), and papers that have a more irregular, encrusted surface (suggestive of the passage of time and the handmade). The contrast articulates the contemporary understanding of crafts as indicative of a preindustrial time, when existence was experienced as organic. In a work like *Merz 380, Schlotheim* (1922; Fig. 29), for example, Schwitters creates a characteristically witty opposition of the machine and the handmade, drawing on both the suggestiveness of words and the possibilities of the artist's touch. The title itself alludes to smokestacks and thus evokes a modern industrial environment (*Schlot* = smokestack; *heim* = home [the latter is frequently also a suffix in a place name, indicating

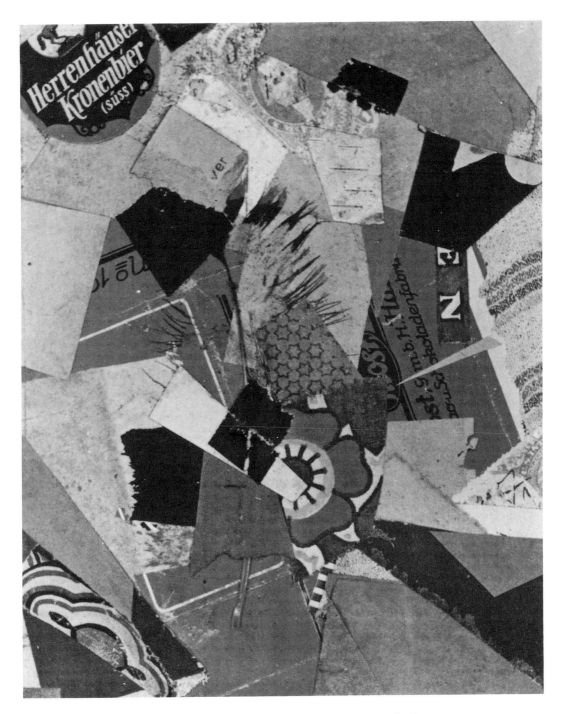

Figure 28. Schwitters, *Mz. 280, Rote Feder (für Lisker)* [Red Feather (for Lisker)], 1921. Collage, 17.2 × 14.2 cm. Private collection.

village or town]), which is denoted in the collage with rectilinear paper fragments. But these papers also suggest the artist's hand. Some are tinted, others covered with pencil or charcoal marks, and the final result is a blurring of categories and Schwitters's typical game of inversion: The handmade, in fact, signifies in this collage its opposite, namely industrial soot – the machine product.

In his catalog essay for the *Große Merzausstellung*, Schwitters tried to direct the reception of his work in terms of organic wholeness, in which the new, disruptive style was safely subsumed under the mantle of the old. One has the impression that this desire to deny the controversial nature of his work – collage was not yet a universally accepted artistic medium – existed in Schwitters right from the moment he first made collages. One of Schwitters's earliest supporters, his friend Christof Spengemann, probably adopted Schwitters's own view. In his 1919 *Cicerone* article, Spengemann characterized his friend's artistic development as an organic growth process beginning with the early landscapes and genre paintings and leading to his *Merzbilder*.[26] In fact, the reproductions accompanying the article suggest that there is no marked difference between the naturalistic paintings and the *Merzbilder* (an impression amplified, of course, by the fact that the reproductions were printed in black-and-white). Spengemann explains that Schwitters is a highly trained, able artist in the traditional sense and then states: "He likes that [his academic training]: even today he makes studies in front of nature. He derives inspiration from her – and is nevertheless creative. For him, it is the totality of experience. . . . Innumerable cells contribute to the understanding of the inner connections of things and lead to a cosmic vision."[27]

Schwitters was keen to show his artistic development as cohesive – to explain away the fundamental differences between naturalistic painting and the making of abstract collages. His self-conscious differentiation between the one and the other nevertheless points to a keen awareness of a break between the traditional and modern means of artistic production. In his vocabulary, naturalist painting is intimately associated with the organic world (the depiction of landscapes), whereas the collages are associated with the urban environment and the world of the machine. Thus, in making naturalistic painting and abstract collages simultaneously, Schwitters acknowledged – and continues to acknowledge – tradition and modernity as two distinct spheres; by bringing these two spheres together in one collage, he announces his aim to create a new totality. Schwitters's perception of the organic and inorganic as polar opposites, his insistence on a context in which both are forged into a totalizing union – both within each collage and within his work as a whole – are the surest indicators of the survival of Expressionism in Schwitters's postwar work. He maintained his ties to Expressionism even after his adoption of a medium – collage – that is usually thought of as having been conceived in opposition to it. Whereas Berlin Dada collage artists declared their keen aversion to Expressionism, Schwitters accommodated Expressionism and thus allowed for the survival of tradition in his art.

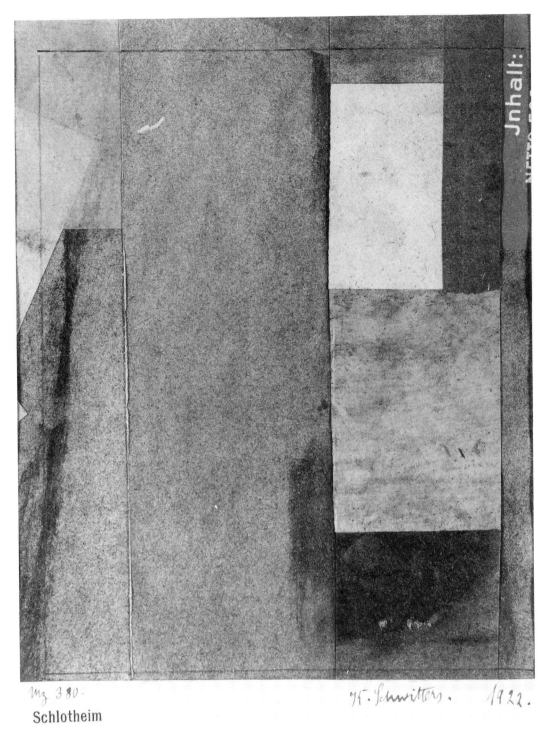

Figure 29. Schwitters, *Merz 380, Schlotheim,* 1922. Charcoal and collage, 22.2 × 19.2 cm. Yale University Art Gallery, New Haven. Gift of the Société Anonyme.

Schwitters's continued practice of naturalistic painting and his insistence on the organic as a crucial component of his work has proved a disturbing reminder that modern artists rarely fit neatly into predetermined categories. To most critics, Schwitters's naturalistic work has been an embarrassment, much like the realistic flower paintings Piet Mondrian continued to produce even after he had formulated his abstract style of intersecting horizontals and verticals. Following Schwitters's own directive, critics today describe his naturalistic paintings as a counterpoint to his abstract works, and not as a significant conceptual component. Elderfield characterized these paintings as the "necessary way of replenishing his imagination, even in the period of his most obviously urban collages and assemblages."[28] The "real" Schwitters, we are assured, is the maker of abstract collages.

In Schwitters's presentation of his own life history he links the destruction of nature to a fundamental experience of personal loss. His expression of loss in terms of Worringer's definitions of empathy and abstraction supports the premise that he grounded his collage theory in Expressionism. Worringer quoted Riegl when he stated that "the precondition for empathy is a happy pantheistic relationship of confidence between man and the phenomena of the external world."[29] He added:

This complete confidence in the external world, this unproblematic sense of being at home in the world, will lead, in a religious respect, to a naive anthropomorphic pantheism or polytheism, and in respect of art to a happy, world-revering naturalism. Neither in the former nor in the latter will any need for redemption be disclosed.[30]

Empathy, according to Worringer, is associated with a sense of ease about one's place in the world. Because reality is not seen as threatening, this confidence in the external world manifests itself stylistically in naturalism, thematically in the depiction of the phenomena of the external world. Schwitters's development is a self-conscious move away from naturalism; he retreats from a formalization of expression to the allegorization of feelings and expressions. Two small drawings of 1918, *Z. 42*, *Der Einsame* (see Fig. 73) and *Die Versuchung des heiligen Antonius*, show man in a state of disharmony with himself and his environment; not much later these are superseded by Schwitters's use of actual objects torn from their original contexts.

Worringer explained that in periods of unrest the urge to abstraction takes over: "The urge to abstraction is the outcome of a great inner unrest inspired in man by the phenomena of the outside world."[31] Worringer reasons that abstraction offers man a solution to his need to objectify, to wrest objects from the destructive progression of history so as to stabilize and eternalize them. The urge to abstraction is, according to Worringer, a search for absolute values or, as he stated it, a search for a "closed material individuality." It can be achieved in two ways: "By the exclusion of representation of space and by the exclusion of all subjective adulteration. The second possibility is to deliver the object from its relativity and to eternalise it by approximation to abstract crystalline form."[32]

Worringer's description of man's tendency to isolate objects in periods of emotional upheaval so as to wrest them from the destructive grip of time would be described by a psychologist as a form of object fixation. The underlying assumptions are the same for both: Isolating an object or an event makes that object or event accessible to inspection and contemplation, so that the associated trauma is eventually neutralized or channeled in other, more constructive directions.

When Schwitters wrote his "Merz" essay, an account of his artistic development, for *Der Ararat* in 1920, he began with his childhood: "I was born on June 20, 1887 in Hannover. When I was a child I had a small garden with roses and strawberries."[33] Schwitters's idyllic childhood garden is, however, associated with a traumatic loss. In an apparent allegory of chaos and loss he recounts this deprivation as the source of artistic creativity; in another essay, written on the occasion of the publication of his prints in the *Sturmbilderbuch* in 1921, he describes the intensity of his reaction:

[18]98, the village Isernhagen got to know me. My first stay in the country. I had a small garden there. Roses, strawberries, an artificial hill, an excavated pond. In the fall of 1901, some boys from the village destroyed my garden in front of my eyes. Out of excitement I got *Veitstanz* [epileptic seizures]. I was ill for two years, totally unable to work.[34]

His account thus parallels his 1930 statement, quoted at the beginning of Chapter 1, about his artistic birth in the moment of revolutionary upheaval at the end of World War I. Significantly, Schwitters links the loss of his garden with his original birth as an artist – he does not locate it in the November revolution, as he writes in his later memoir. He continues his report:

Because of my illness my interests changed. I discovered my love for art. At the beginning I made couplets in the manner of variety-artists. On an evening in the fall when the moon was full I noticed the clear, cold moon. Since then I wrote lyric-sentimental poetry. Then, music seemed to be *the* art. I learned to read music and played an instrument all afternoon. In 1906 I saw in Isernhagen for the first time a moonlit landscape and began to paint. 100 watercolors of moonlit landscapes done in front of nature. In candlelight. I decided to become an artist.[35]

Schwitters distances himself through irony from the painful memories of the traumatic event and the time of illness that followed it. As he looks back at his childhood, the garden seems to have represented personal fulfillment, providing him with a sense of oneness between himself and nature. Making the garden the place of destruction but, at the same time, the place of his artistic birth, Schwitters acknowledges the laws of nature. In so doing, he superimposes an organicist view, derived from Romanticism, on the event and his life, in which destruction and rebirth are seen as intimately linked as the cycles of nature. In fact, he makes a direct reference to the laws of nature in the same article: "In 1910 on a lonely hike in the mountains of the *Böhmische Schweiz*, in winter, I discovered the eternal laws

67

of nature. I recognized that art could only be in the uncompromising grasp of these eternal laws. Since then I painted *Abstraktionen*."[36]

Significantly, his first *Abstraktion* was entitled *Der verwunschene Garten* [The Enchanted Garden]. The painting is lost, and as no reproductions survive, we do not know what it looked like, but its title suggests a return to the childhood garden. It implies the evocation of a lost paradise, perhaps, one imagines, in the style of Franz Marc, whose work Schwitters had been studying and whose influence is visible in *Die Liebe* in the harmonious interconnectedness of mankind and nature.[37]

In his choice of the *Bömische Schweiz* as the location of his recognition of the deeper laws of nature, Schwitters ironically alludes once more to German Romanticism, for this geographic area had provided many subjects for artists of the Dresden Romantic School. In comparing his own wanderings to those of the German Romantics and their search for spiritual wholeness in nature, Schwitters establishes a firm link between himself and these artistic precursors.[38] In his work, the garden, or nature as the larger garden (as well as the organic in general), becomes a metaphor for wholeness, for the totalizing tradition lost with the outbreak of the war.

Schwitters locates the absolute in nature. Following Worringer's premise, set forth throughout his book, that the urge to abstraction represents a search for absolute values, Schwitters implies that the absolute is not attainable – the garden has been destroyed – but then defines the desire to reconstruct nature in its ideal state as the source of his artistic creativity. In this approach, the object is given a special role. As a fragment, it is part of a former whole; it points at once to nature as the locus of the absolute and to chaos, nature's destruction. In Schwitters's work, the object – or collage fragment – becomes the mediator between nature and culture. Here one is reminded of Worringer's and Simmel's visit to the Trocadéro, where the cultural artifacts on display similarly were understood as mediators between nature (the primitive society) and culture (the modern metropolis).

"If you looked carefully," Schwitters wrote, "you would see 7 women's heads on the picture." He was referring to his large assemblage of 1919, *Konstruktion für edle Frauen* [Construction for Noble Ladies] (Plate 8). Hinting that he was playing hide and seek with the viewer, he continued to describe the making of this work in a letter, written in awkward English, to a friend:

When I had almost finished, I knew there was lacking something. I went into the Eilenriede, the town forest of Hanover and found there half of the engine of a children's train. I knew at once, that belonged on the picture, and put it at the right spot. But where was the other half engine? I got quite uncomfortable, because I could not finish the picture without having the other half. I went to the opposite direction of the Eilenriede into the Masch, not a forest, but meadows. The first thing I saw was the second part, the opposite side of the same children's engine. Of course I don't know what was the reason that I at all needed the ruins of the children's toy, but there is a reason, and this reason made the composition of spiritual values correspondent to the composition in colours and the composition in lines and black and white. You must feel that, then you feel also that the picture is ready and is a *construction for distinguished ladies*, eminent ladies.[39]

The curious part of this account is not the unlikely coincidence of finding the two parts of the toy train, but rather Schwitters's inner need to bring the separated parts together and, through that act, to create an organic new whole. Although composed of deracinated objects, Schwitters's *Merzbild* is capable of growth and fusion.

The fusion between the organic and inorganic takes place through play, underscoring once more the importance Schwitters ascribes to play as a creative activity capable of generating constructive transformation. In his account of the creative process responsible for *Konstruktion für edle Frauen*, he gives palpable presence to the train engine, but in the image he hides another object as the product of his own craft: the portrait painting of his wife Helma. Hiding and finding create acts of inversion and play with notions of dominance and authority. The naturalistic painting is hidden under the pistonlike planks superimposed on the composition, and the inorganic is declared dominant. At the same time, the locomotive is endowed with organic properties, raising questions about the authority of technology over nature. The distinctions between the organic and the inorganic are blurred much like the distinctions between abstraction and expression. Describing the making of his image in terms of inner necessity ("Of course I don't know what was the reason that I at all needed the ruins of the children's toy . . . "), Schwitters voices Kandinsky's belief in art as the expression of the inner, feeling self. Schwitters, however, defines art in a more encompassing manner than does Kandinsky; he includes inanimate objects as transmitters of empathy. In another acknowledgment of Romanticism, Schwitters treats his objects like ruins that point simultaneously to construction (the building before its deterioration) and decay, but he arrests ruin's decay – the two halves of the locomotives are rejoined – by submitting it to new growth: Nature and culture are joined organically in one image. Art, in Schwitters's terminology, becomes a substitute totality, compensating and correcting for the loss of tradition.

THE INVENTION OF A NEW LANGUAGE

The period of late 1918–20, the nascent phase of Merz, is pivotal to Schwitters's development. In Schwitters's work of these years, small abstract collages coexist with larger mixed-media works, the half-painted, half-collaged *Merzbilder* (Merz-paintings) as well as assemblages,[1] and small designs made with rubber stamps, the so-called *Stempelzeichnungen* (rubber-stamp drawings), exist alongside works produced with the more traditional process of woodcut and watercolor drawing. During this time, Schwitters also began to compose prose texts, short plays, and sketches, wrote poetry, and tried his hand at art criticism. All his endeavors are marked by an attempt to employ the principle of collage as defined by Merz – the bringing together of different realities. These varied works are the first manifestations of Schwitters's formal break with the artistic traditions that defined the form and subject matter of his earlier work. They bear testimony to the artist's inventiveness and his capacity for growth in his self-conscious refashioning as an avant-garde artist. If one considers the significant increase in Schwitters's productivity, these works are indicators of the energies set free by his self-proclaimed liberation from the artistic norms of the Wilhelminian period. Indeed, the many projects Schwitters completed in this short time laid the foundation for much of his later work. In the more strictly abstract works that were to follow, content is carefully hidden, whereas here, in the early period of Merz, Schwitters is still willing to reveal his subject matter. As an encapsulation of his later works, these images and texts answer with greater clarity what specific form his break with tradition took.

What Schwitters was willing to discard and what he considered important enough to carry over into his new language are vitally important questions, for he has been a controversial figure from the moment he became a collage artist and remains so still today. To some, as to his Berlin Dada colleague Richard Huelsenbeck, Schwitters was a latter-day Romantic, to others the epitome of modernity, a modernist who was so outrageously modern that he could be described only as suffering from mental disease.[2] To quote Friedhelm Lach, the editor of Schwitters's literary work:

Today, to some, Schwitters counts as a revolutionary artist who, with a new conception of art, transformed the artistic landscape and continues to transform it. They argue that he discovered in art a new freedom, which offered new formal and aesthetic possibilities, and which enlarged the realm of individual freedom. Others see him as an eccentric outsider who, because of a lack of political engagement, has led art to a dead end from where it has no chance of further development.[3]

Lach himself discusses Schwitters in terms of the avant-garde. Lach introduces the volume of Schwitters's prose writings as follows:

From 1918–1922, at the beginning of his career, his writing was so experimental that the Dadaists counted him as one of their own. He applied the principle of Merz to the writing of prose. He found his material in everyday speech, and when he used it to write Merz-poetry, he parodied traditional modes of writing. Merz was in the service of liberation.[4]

In this brief period, Schwitters's literary work is closely interwoven with his visual work. Both exist in a symbiotic relationship in which techniques and subject matter are developed in one genre and carried over into the other. His new literary language consisted of textual collages of found and invented parts; his new visual language, of ready-made forms, which he substituted for conventional drawing or painting. Sharing the collage process, the literary and visual works delineate a common approach to the modern, but in playing off the new against the established, they eloquently tell of a struggle, the difficulty of establishing boundaries for the old and the new and of defining their exact relationship. Schwitters's short story, "Die Zwiebel" [The Onion], his poem, "An Anna Blume" [To Anna Blume (or Eve Blossom)], and a group of watercolor drawings, which he simply classified as *Aquarelle* (watercolors), or *Aq.* for short, may stand as examples of his artistic production in 1919. In image and text, Schwitters is concerned with the representation of chaos, dislocation, simultaneity, modes of perception, desire, and issues of control. We witness new thematic and formal solutions – in fact, they seem like a celebration of new freedom – but, significantly, we also discover a remarkable continuity of concern related to past traditions and traditional notions of artistic authority. Once laid bare, these references to the past can be detected as persistently present even within the more abstract works. They force us not only to reconsider Schwitters's status within German modernism, but also the nature of German modernism itself.

It was against the background of civic unrest that Schwitters restaged the battle for political power in his 1919 narrative "Die Zwiebel, Merzgedicht 8."[5] The text describes the slaughtering of the narrator, Alves Bäsenstiel (Bäsenstiel is the phonetic spelling of *Besenstiel* = broomstick), and his subsequent reassemblage. The act is performed by a butcher, assisted by two maidens, Anna and her near-palindromic relative Emma, and witnessed by a king, his daughter, and a crowd of spectators. As the stage is set and the dismemberment of the narrator's body commences, his blood is offered to the king, who also lusts after the narrator's

eyes. These are served to him on a platter, and the king feasts on them as if eating a couple of oysters; but the eyes poison the king. Mushrooms begin to sprout from his belly, he faints, and the frightened princess orders the narrator's reassemblage in the hope of rescuing her father. During the reassemblage it becomes apparent that Alves Bäsenstiel has special powers: He is endowed with magnetic currents that permit him to realign his poorly assembled inner parts. Reconstituted, the victim becomes at the end of the narrative the new holder of power. Cheered on by the crowd, he refuses to aid the powerless king; the king dies and Alves Bäsenstiel delights in watching him burn and finally explode.

As a narrative about a reversal of power, with its special evocation of renewal originating out of destruction, Schwitters's text can be considered, as John Elderfield rightly suggests, an ironic metaphor for the Expressionist notion of the New Man, who emerges spiritually reborn out of the chaos of the past only after having suffered self-sacrifice.[6] It is clear, however, that the story is also firmly grounded in the political events of the period, echoing popular sentiments about the actual reversal of political power in Germany (which Schwitters raised again in his narrative *Ursachen und Beginn der großen glorreichen Revolution in Revon* [Causes and Outbreak of the Great and Glorious Revolution in Revon], 1922.)[7]

"Die Zwiebel" is written in the form of a fairy tale, but a fairy tale made topical in its use of language and specific formal manifestations. Fairy tales begin with the timeless statement "Once upon a time . . . "; *Die Zwiebel*, in contrast, opens: "Es war ein begebenswürdiger Tag, an dem ich geschlachtet werden sollte." (It was a very memorable day on which I was to be butchered.)[8] The tense is ambiguous in the first phrase, but instantly specified in the following one as the present. Indeed, the action unrolls before our eyes, and the victim-narrator himself actively participates in the organization of the events, frequently drawing attention to the hour. He pronounces in the second paragraph:

Es ist doch ein eigentümliches Gefühl, wenn man in zehn Minuten geschlachtet werden soll. . . . Ich war bislang in meinem ganzen Leben noch nicht geschlachtet worden.
(It is a bit of a strange feeling when one is to be butchered in ten minutes. . . . So far, I had never been butchered in my entire life.)[9]

The narrative gives the impression of an eyewitness account, rather than of an event that has been abstracted into a moralizing, timeless tale in the course of its many recountings.

The sentence structure and use of language echo the activation and transformation of form in the text as a whole. Text insertions, little asides or longer sentences culled from unrelated texts, spoken language, and advertisements constantly interrupt the narrative as in the following sequence:

Zehn Minuten können sehr lang erscheinen. (Glaube, Liebe, Hoffnung.) (Enten gänsen auf der Wiese.) Es war alles bis aufs kleinste vorbereitet.

(Ten minutes can seem very long. [Faith, love, hope.] [Ducks geese on the meadow.][10] Everything was prepared down to the smallest detail.)[11]

Or, in a more politically oriented sequence: "Es fehlte auch ziemlich viel Blut, weil der König es getrunken hatte. (Für die Ideale des Sozialismus.)" (Quite a bit of blood was missing, too, since the king had drunk it. [For the ideals of Socialism.])[12] The text insertions become more numerous as the narrative unfolds, making it increasingly hard to differentiate between the dominant text and the parenthetical remarks. The insertions create a subtext that fragments the dominant text, but also stubbornly fragments itself in its piling of unrelated observations one upon the other.

Schwitters's rhetorical strategies aim at chaos by scrambling linguistic codes. The result is a verbal collage, a nonlinear, antihierarchical text, that brings together different literary genres as well as elevated and popular speech, and in the process strips each of its authority. The breakdown of logic, the denial of the linear unfolding of events, the competing goals and languages that characterize this short story evoke the larger breakdown of political and cultural authority in the early months of the Weimar Republic: *Die Zwiebel* is firmly embedded in the modern. Schwitters underscores the shift from traditional high culture to modern popular culture by choosing a fairy tale rather than a novella as his literary form and by substituting popular speech for refined speech expressive of the old order.

The sense of chaos is replayed in the narrative itself: The narrator's dismemberment is a violent, bloody affair described in gruesome detail. It is staged for the king's delectation, but leads to his painful death. The princess, introduced as someone who is in command, calm, and enticing (her description is interrupted with allusions to intensified emotions and sexual desire), is at the end of the story a supplicant, vainly urging the reassembled victim to help her father. However, the reversal of power stands: The doctor who is called to the scene faints, the king explodes, the crowd is jubilant. "Die Zwiebel" is a tale about chaotic reversals: a story about a king's violent demise – undoubtedly inspired by the political events in Germany – and an ordinary man's ascent to power.

Alves Bäsenstiel, the narrator and main character, is the embodiment of chaos and fragmentation. Endowed with multiple personalities, he is witness, victim, holder of special inner powers, and the new ruler all in one. The disemboweling fragments his body: The butcher shatters his skull; knives slit his innards and sever his eyes. During his reassemblage, Alves observes laconically that his innards are "ein wenig durcheinander geraten" ("a bit messed up"). Even the final step of the reassemblage can only be achieved through maiming:

Der Schlächter berührte die Wunde in meiner Seite mit dem Messer, stach tief hinein und zog das Messer heraus, und – die Wunde war zu. (Hier abtrennen und an obige Adresse senden.)

(The butcher touched the wound in my side with a knife, plunged in deep and pulled it out and – the wound closed. [Tear off here and send to the above address.])[13]

Although reconfigured, Alves's body remains incomplete and maimed: "Ich hatte meine Teile nun wieder zusammen, es waren bloß einige Lücken, da kleine Fetzchen an den Messern haften geblieben waren." (My parts were back together but there were a few gaps, because little bits had stuck to the knives.);[14] yet it is capable of taking on the political reins.

A fairy tale about political change, *Die Zwiebel* makes allusions to the events in Germany, but is ambiguous in its political stance. The story is peppered with many remarks about the political left. Elderfield mentions the "Arbeiterlied," which Alves requests to be sung before his execution,[15] and there are many other, more veiled references as well.[16] Obviously, the king and his family represent the top of the old hierarchy, but Alves Bäsenstiel's role is less clear. He, the workers, and the crowd share the same social status as victims or subordinates, and the parenthetical remarks link them to socialism and communism. Alves thus seems to represent the disenfranchised masses – the victims – and their ascent to power after the toppling of the king; in this parable of contemporary politics, Alves would represent the Social Democrats (Majority Socialists) who came to power after the toppling of Wilhelm II.

Reading *Die Zwiebel* as a political tale about Germany is valid only to a point. The parallel to the historical events exists, but more specifically, the story resonates with Schwitters's autobiographical description about finding liberation and artistic empowerment in the moment of political change. He draws an image of the artist as capable of directing events, of providing a spectacle for the masses, and of holding the key to change. In this light, Alves's special knowledge of the inner person, of spirituality and the transcendental, may be read less as a parody of Expressionism (as Elderfield has suggested) than as an enunciation of the special status of the artist – a concept common to Expressionist theory. In referring to the transcendental in conjunction with his autobiographical celebration of newfound literary and pictorial skills, Schwitters does not break with tradition; rather, he embeds himself in the tradition of Kantian thought, in which the self is understood as the transcendental subject. Linking the eyes to destruction and reconstruction, Schwitters paints a powerful image of Alves, the modern artist. He is identified as the cleansweep who brushes aside debris and in so doing creates a new and functioning order. The reassembled Alves, although missing a few bits and pieces, is in full possession of his power – a fact emphasized in the metaphor for erection contained in his name – and is even more powerful than before.

Alves, whose name is an anagram of "salve," is not one with the people, he is separate from them. As the anagram suggests with its evocation of "Salve regina" (Salute the Queen or Hail ye, Mary), at the end of the story he is saluted as the new ruler and savior. Alves's special powers and insights contrast with the purely

reactive behavior of the crowd. Not only does he order the king to attend his disembowelment, he also supervises the event himself, recognizes that certain implements for his execution are missing, orders them to be brought in, and knows when he has to be tough-minded, as in his treatment of the princess: "Ich wußte, daß ich hier nicht gutmütig sein durfte, an der Gutmütigkeit erkennt man den Dummen." (I knew that I could not be soft-hearted here. Soft-heartedness identifies the fool.)[17] He has also a particular knowledge of the inner man, as indicated by his command over his "inner magnetic currents." Nothing, however, embodies Alves's superiority more than his eyes. The story pivots around his eyes.[18] The sentence "Der König gierte meine Augen" (The king lusted after my eyes)[19] is at the center of the narrative; the consumption of the eyes initiates the reversal of power. Alves Bäsenstiel, as the owner of powerful and knowledgeable – literally, insightful – eyes, is singled out as unique from the beginning of the story. The dismemberment only serves to bring out his special qualities. Alves clearly is no more a representative of the people than he is a representative of the king. The power of seeing is greater than monarchical power: It is the power of God, and Schwitters describes it here as the power of the artist.

In "Die Zwiebel," Schwitters fictionalized his own empowerment as a newly emerged collage artist and presented it as a spectacle. It was, however, not a short story, but one of his poems that created a sensation in postwar Germany and propelled Schwitters almost overnight to fame. Rarely has a poem provoked such vehement responses, both negative and positive, as did Schwitters's "An Anna Blume," published in Herwarth Walden's *Der Sturm* in 1919, the same year as the publication of "Die Zwiebel."[20] The poem captured the public's imagination like a popular song. Parodied in newspapers and magazines, "An Anna Blume" represented to many the madness of the period, the misguidedness of modern poets, and, to a few, the promise of a new poetic language.[21] Indeed, both poet and poem were announced as the harbingers of the new and the embodiment of the modern times. In July 1919, a month before the publication of the poem, the readers of *Der Sturm* were teased with a tantalizing question posed by Schwitters's friend and publisher, Christof Spengemann: "Wer ist überhaupt Anna Blume? Verbogenes Hirn! Er malte das Bildnis seiner Zeit und wußte es nicht...." (Who really is Anna Blume? Twisted brain! He painted the image of his times and did not know it....)[22]

Perpetuating Schwitters's own Romantic characterization of the artist, Spengemann portrayed him as an unconsciously creative spirit. He regarded his subject matter, however, as the very essence of modernity. Like "Die Zwiebel," "An Anna Blume," with its non sequiturs, textual fragmentation, and play with meaning, exemplifies Schwitters's new poetic language. It too is based on a well-established model, not a fairy tale but a love poem, and declares itself part of that literary genre in the first line. Love poetry often expresses two concerns – the adulation of the beloved and the experience of thwarted desire – and Schwitters's poem voices

both. In this poem, the conflicting emotions of new love – elation, separation, and a general sense of disorientation – are mirrored and given concrete form in the multiple perspectives and fragmentations of the text. Schwitters's own translation into English, which features some important variations from the German text, is also reprinted below:

AN ANNA BLUME

O, du Geliebte meiner 27 Sinne, ich liebe Dir! –
Du deiner dich dir, ich dir, du mir. – Wir?
Das gehört (beiläufig) nicht hierher.
Wer bist du, ungezähltes Frauenzimmer? Du bist – bist du? –
Die Leute sagen, du wärest – laß sie sagen, sie wissen nicht wie der Kirchturm steht.
Du trägst den Hut auf deinen Füßen und wanderst auf die Hände, auf den Händen
 wanderst du.
Hallo deine roten Kleider, in weiße Falten zersägt. Rot liebe ich Anna Blume, rot
 liebe ich dir! –
Du deiner dich dir, ich dir, du mir. – Wir?
Das gehört (beiläufig) in die kalte Glut.
Rote Blume, rote Anna Blume, wie sagen die Leute?
Preisfrage: 1. Anna Blume hat ein Vogel.
 2. Anna Blume ist rot.
 3. Welche Farbe hat der Vogel?
Blau ist die Farbe deines gelben Haares.
Rot ist das Girren deines grünen Vogels.
Du schlichtes Mädchen im Alltagskleid, du liebes grünes Tier, ich liebe dir! –
Du deiner dich dir, ich dir, du mir. – Wir?
Das gehört (beiläufig) in die Glutenkiste.
Anna Blume! Anna, a-n-n-a ich träufle deinen Namen. Dein Name tropft wie weiches
 Rindertalg.
Weißt du es Anna, weißt du es schon?
Man kann dich auch von hinten lesen, und du, du Herrlichste von allen,
du bist von hinten wie von vorne: "a-n-n-a".
Rindertalg träufelt streicheln über meinen Rücken.
Anna Blume, du tropfes Tier, ich liebe dir!

TO EVE BLOSSOM

O thou, beloved of my twenty-seven senses,
I love thine!
Thou thee thee thine, I thine, thou mine, we?
That (by the way) is beside the point!
Who art thou, uncounted woman,
Thou art, art thou?
People say, thou werst,
Let them say, they don't know what they are talking about.
Thou wearest thine hat on thy feet, and wanderest on thy hands,
On thine hands thou wanderest
Hallo, thy red dress, sawn into white folds,
Red I love eve Blossom, red I love thine,
Thou thee thee thine, I thine, thou mine, we?
That (by the way) belongs to the cold glow!

Eve Blossom, red eve Blossom what do people say?
PRIZE QUESTION: 1. eve Blossom is red,
 2. eve Blossom has wheels,
 3. what color are the wheels?
Blue is the color of your yellow hair,
Red is the whirl of your green wheels,
Thou simple maiden in everyday dress,
Thou small green animal,
I love thine!
Thou thee thee thine, I thine, thou mine, we?
That (by the way) belongs to the glowing brazier!
eve Blossom,
eve,
E-V-E,
E easy, V victory, E easy,
I trickle your name.
Your name drops like soft tallow.
Do you know it, eve,
Do you already know it?
One can also read you from the back
And you, you most glorious of all,
You are from the back as from the front,
E-V-E.
Easy victory.
Tallow trickles to strike over my back!
eve Blossom,
Thou drippy animal,
I
Love
Thine!
I love you!!!![23]

"An Anna Blume," an ode to Anna Blume, begins with a commonplace evocation of the beloved, "O, du Geliebte" (O, my beloved), which firmly anchors the poem in the genre of love poetry. The next three words, however, radically undermine that tradition, for Schwitters continues with "meiner 27 Sinne" (of my 27 senses).[24] By overaugmenting normal sensory capacity, Schwitters shifts perspectives and transfers the poem, as Bernd Scheffer has convincingly pointed out, from the category of love poetry to that of nonsense.[25] Nonsense, then, sets the stage for the poetic action and creates a new frame of reference. Above all, the shift of perspectives, implying multivalence, permits different approaches to poetry. The playing off of sense against nonsense brings to mind Schwitters's statement in 1920:

Elements of poetry are letters, syllables, words, sentences. Poetry arises from the interaction of these elements. Meaning is important only if it is employed as one such factor. I play off sense against nonsense. I prefer nonsense, but that is a purely personal matter.[26]

The play with perspectives characterizes the entire poem: Schwitters calls upon the tradition of a particular form and then immediately debunks it through parody

and word play, much as he does by making text insertions to undermine the authority of the dominant text in "Die Zwiebel." Thus, the poetic narrator's "27 senses" not only thematically create the effect of multivalence, they underscore this effect with manipulations of the sentence structure. The poem's syntax becomes as multivalent as the actions described in the text.

The poetic narrator's multiple senses are echoed in Anna Blume, his object of desire. She is introduced in line 4 with the eternal quandary about the true nature of the beloved: "Wer bist du, ungezähltes Frauenzimmer?" (Who are thou, uncounted woman?) Anna Blume is indeterminate and cannot adequately be described within the conventions of ordinary speech or traditional poetic language: Schwitters sets out to extend the language of poetry to capture the multifarious characters of both the poetic narrator and Anna Blume. What follows is a rapid-fire succession of images, disruptions of the text, and verbal plays that convey the impression of multiple, constantly shifting perspectives as well as the ambiguities they generate.

"An Anna Blume" is not a simultanistic poem, but it suggests simultaneity in its linguistic strategies and its helter-skelter use of images. The Berlin Dadaist Richard Huelsenbeck stated that "simultanistic poetry teaches the meaning of hurling all things together pell-mell."[27] In "An Anna Blume," Schwitters evokes the sensation of "things hurled together" with his staccato rhythm, the constant disruptions in the flow of the text, the apparent arbitrariness of observations, mixed meanings and different forms of speech, and, above all, the suggestion of physical movement through the linking of words.

For the most part, Schwitters uses one- or two-syllable words; at times bunched together, they accelerate the speed with which they are read or spoken. There are only two four-syllable and one five-syllable words in this poem, and significantly these are used to single out the narrator and his beloved: the adjectives "siebenundzwanzig" (twenty-seven) in line 1 (which Schwitters translated into its more visually punchy numerical form), and "ungezähltes" of "ungezähltes Frauenzimmer" (uncounted woman) in line 4. The others are predominantly one- or two-syllable words, with a few three-syllable ones strewn in between. Schwitters's technique gives the poem an emphatic, even exclamatory, sound, which is further enhanced by the visual metaphors. Line 4, for example, alternates between easily understood questions: "wer bist du?" and "bist du?" (in exact translation, rather than Schwitters's own poetic one: who are you? are you?).[28] The answers are also as readily grasped: "du bist" (you are). Line 7 consists entirely of exclamations or exclamatory statements: "Hallo deine roten Kleider, in weiße Falten zersägt" (Hallo, thy red dress, sawn into white folds) – here the visual contrast of red and white, together with the suggestion of a mechanical action, enhances the poem's exclamatory power – and "Rot liebe ich Anna Blume, rot liebe ich dir!" (Red I love [Anna Blume], red I love thine). The sentences diminish in length, and the words used become less complex, making comprehension instantaneous.

There are also abrupt shifts in the flow of language: dashes that separate one observation from the next; parenthetical remarks, such as "beiläufig" (by the way) in line 3, where the parentheses become the visual representation of the word itself; and the inclusion at the center of the poem – usually reserved for the highest praise of the beloved – of a prize question. ("Preisfrage: 1. Anna Blume hat ein Vogel."). This question conjures up the language of advertising, of market fairs and popular entertainment – the tradition of the people. In a suggestive link to the Romantic tradition, it alludes to Richard Wagner's famous prize song in his opera *Die Meistersinger von Nürnberg* (which similarly makes reference to popular culture) and to the realm of logic. The question is presented as a syllogism: a major premise, a minor premise, and a conclusion. However, the conclusion Schwitters offers cannot be deduced from the premises presented:

1. Anna Blume hat ein Vogel.
2. Anna Blume ist rot.
3. Welche Farbe hat der Vogel?

(Here the English text differs markedly: Instead of a bird, Anna Blume is said to have wheels, and the questions revolve around these wheels the way they do in the German version around the bird.) By giving the conclusion as a question rather than a logical deduction of the two premises, Schwitters makes the syllogism dysfunctional and points to it as a cliché. Schwitters, here, not only truncates the primary, poetic text with unpoetic insertions, he also deepens the sense of fragmentation and the loss of clearly defined literary genres by mocking both the primary and secondary texts.

The discontinuity of the text and exclamatory speech patterns are further enhanced by the rapid enumeration of the primary colors (which together with green, are considered the four basic hues in Germany). Together they evoke a modern urban environment with discordant acoustic and visual impressions and bright, glaring colors. They also make reference to the complementary colors of Expressionist or Fauve painting, favored by those artists for their ability to heighten pictorial expression. Employed in contradictory fashion, as in "Blau ist die Farbe deines gelben Haares" (Blue is the color of your yellow hair), colors also enhance the nonsensical character of the poem. Vivid color contrasts stimulate visual and physiological excitement; in "An Anna Blume," the colors contribute to the impression of multivalence and enhance the quick cinematic cut from image to image.

It is not surprising, then, that Anna Blume herself is presented as the embodiment of multiple sensations and thus of the new – that is, the modern. As indicated by her adjective "ungezählt," she is difficult to fathom, an impression underscored by the subjunctive "du wärest" in line 5. She is also definitely contrary to the norm, or tradition. She is contrasted with "die Leute" – the mass of humanity, which does not know "wie der Kirchturm steht." Schwitters's description of Anna Blume

carrying her hat on her feet and walking on her hands has led one interpreter to declare her a circus acrobat,[29] a reading that is undoubtedly too literal and does little to explain Schwitters's sophisticated linguistic play. The symbol of Anna Blume, does, however, achieve a difficult feat within the structure of the poem: She provides continuity within discontinuity. Schwitters divided the poem into different parts with unrelated text insertions and contradictory statements, which are linked by the figure of Anna Blume. So even though the prize question constituted an unpoetic disruption, aspects of its component parts inform later developments in the poem: The major premise states that Anna Blume had "ein Vogel" (literally, has a bird or, figuratively, is crazy); in line 15 the poetic narrator affirms, "Rot ist das Girren deines grünen Vogels" (Red is the whirl of your green bird [wheels]); and, in another transformation Anna, in line 16, is addressed as a "grünes Tier," green animal. In each case, there seems to be an arbitrary dismemberment of the original statement, or a willful transformation. Later, the fragments are reintegrated into the larger texts through a complex weaving of implied cross-references, which are centered around the figure of Anna Blume.

More important still, the name itself represents the beloved's special contradictory qualities, at once modern and traditional. "Anna" is a palindrome. This recognition leads the poetic narrator to exclaim: "Man kann dich auch von hinten lesen, und du, du Herrlichste von allen, / du bist von hinten wie von vorne." (One can also read you from the back, / And you, you most glorious of all, / You are from the back as from the front.) As a palindrome, the name pivots around itself, suggesting a forward and backward motion in the reading of its syllables. In Schwitters's vocabulary, this type of motion stands for the mechanical and thus the modern.[30] It is joined with an image of the organic – the traditional poetic metaphor of woman as flower (Blume), incorporated in her second name. Her full name therefore not only stands simultaneously for a traditional and a modern vision of women, but in its linking of mechanical motion and organic form (the palindrome and the flower), it is also the abstract representation of her body and the enunciation of his sexual desires (mechanical motion and penetration).

As in many love poems, red as the color of love plays an important role, and here too it serves a poetic function. Anna Blume wears a red dress, is compared to a red flower, and is red. The color reinforces the suggestion of love, penetration, and sexual possession. But red also alludes to politics. Red is the color of the left and was, of course, the emblem of the Bolshevik revolution. The implied linkage of Anna, the modern woman, to the political left creates a suggestive subtext, although one that remains ambiguous in much the same way the allusions to the Bolshevik revolution in "Die Zwiebel" are ambiguous. Women and bolshevism were often joined in the contemporary lore of reactionary soldiers as a common threat; such a danger was embodied in the figure of the Rote Marie, the Red Mary, who enticed soldiers with her seeming innocence only to ensnare them. Schwitters devoted a short poem to her, "Die Rote Marie" (1919). Here the oblique textual

overlay of Anna Blume and bolshevism adds multivalence but not a truly political dimension.[31]

The flower in Anna Blume's name also links her to the Romantic tradition. In German Romantic literature, the blue flower symbolized the quest for spirituality and deeper truth. Schwitters's witty, secular transformation of a metaphor mandating the primacy of interiority into one indicating sexual satisfaction repeats on a small scale the mechanism of changeover that characterizes the poem and the short story as a whole: the ironizing, and thus the modernization, of an established form.

Linking Anna Blume to tradition and the modern, however, is different from linking Alves Bäsenstiel to the same cultural concepts. Alves, though experiencing modern fragmentation as a powerful attack on body and soul, emerges victorious and in a position of superior power; in contrast, Anna Blume, who has been equally linked to fragmentation, is not truly empowered. She has been given the freedom of difference (she wears her hat on her feet and walks on her hands), but it is a limited freedom in comparison with that of Alves. Anna Blume, above all, is being acted upon rather than acting on her own accord. Schwitters expresses this foremost in the striking and memorable ungrammatical dative case of "ich liebe *dir*" instead of the grammatically correct accusative, "*dich*," and in the equally memorable statement "Du bist von hinten wie von vorne" (You are from the back as from the front). In both instances, the poetic narrator extends an action to her. Further denying her the power of self, Schwitters compares Anna Blume to an animal.

Yet there is nothing more revealing about Schwitters's gender-specific approach to modernity than his endowing the poetic narrator with multiple sensory capacities and his insistence on the absence of sense in Anna Blume. Schwitters here expresses in poetic form the commonly accepted beliefs about femaleness popularized by Otto Weininger in his *Geschlecht und Charakter* [Sex and Character] (1903). The book saw its sixteenth printing in the early 1920s; in Germany, it was one of the most commonly read treatises on sexuality in the modern period. Weininger, like many of his contemporaries, believed that modernity was characterized by fragmentation and that the female embodied modernity. In the chapter "The Character of the Female," Weininger assessed the fundamental difference between male and female: "The female does not have sense, only nonsense."[32] Whereas man is governed by reason, woman operates unpredictably on instinct. Woman thus cannot be fathomed with the tools of deduction.

In Schwitters's poem, Anna Blume represents precisely this notion of femaleness: She can neither be "counted" nor clearly captured by description. And because the female is not endowed with rationality, she cannot truly be free – she will, according to Worringer, always be acted upon. Schwitters's love poem may celebrate Anna Blume's unorthodox behavior, but it also perpetuates a traditional notion of femaleness. As we have seen, Schwitters proclaimed his preference for nonsense. Yet if nonsense stands for femaleness and modernity, Schwitters's preference for

both is grounded in a firm belief in male difference and superiority: He is the guarantor of sense and the actor and manipulator of nonsense.

Schwitters pursues the destruction of tradition on the level of content and form. Contextually, he does so by coupling tradition with its opposite, the mechanical; formally, he destroys the coherent unfolding of the text with the inclusion of non-poetic sentences or words culled from everyday speech. The result is Merz: the construction of a multivalent text through the scrambling of literary codes. In his afterword to *Anna Blume Dichtungen*, Schwitters wrote:

Merz poetry is abstract. Like Merz painting it makes use of given elements such as sentences cut out of newspapers or taken down from conversations, drawn from catalogues, posters, etc., with and without alteration. (This is terrible.) Such elements need not suit the meaning, for there is no meaning any more. (This is terrible too.) Nor is there any elephant now, there are only parts of the poem. (This is frightful.) And you? (Buy war bonds!) Decide for yourself where the poem stops and the frame begins.[33]

In this collection of his poetry, Schwitters added the designation "Merzgedicht 1" to the title of "An Anna Blume." The poem did not bear the Merz number when it was first published in *Der Sturm* in August 1919. It may indicate that at first Schwitters did not value the poem as an important departure from his earlier poetic efforts but then discovered its significance later in the same year after its *succès de scandal*. Schwitters applied the term "poem" to both "An Anna Blume" and the short story "Die Zwiebel," an indication of his blurring of literary boundaries; he also classified them both as Merz. He conceived of Merz-poetry, then, as a flexible category, encompassing both poetry and short story. Therefore, it is the process and not the literary form that defines Merz. The process is the making of a composite text: Schwitters's new literary language consisted of the making of textual collages of found and invented parts.

PLAY WITH CHAOS:
THE *AQUARELLE*

Schwitters's rise to national prominence through his publication of "An Anna Blume" and his accompanying attempt at entering the national art market coincided with a change in his personal fortunes. He had grown up in comfortable middle-class circumstances and, even after his marriage to Helma Fischer in 1915, was still supported by his parents. He and his bride were given the third-floor apartment in his parents' house, where they continued to live after the birth of their son, Ernst, in 1918. In the postwar inflationary period, however, Schwitters's economic situation began to erode.[1] Schwitters had not served at the front during the war for medical reasons; he was employed as a machine draftsman at the ironworks in Wülfen near Hannover. He quit his job in the revolutionary period, just at the time when the financial aid extended to him by his parents began to diminish. Having chosen to continue his artistic career, with a family to support, Schwitters had to look to the art market for revenue. As would be expected, he planned assiduously – as any artist would – to ensure the success of his important forthcoming exhibition at Der Sturm in the summer of 1919. We know that he invented the term *Merz* on the occasion of this exhibition. Creating a brand name for his product, Schwitters surely sought to develop an equally recognizable handwriting.

A letter to his soon-to-be friend and publisher Christof Spengemann confirms that Schwitters orchestrated his entry into the art market with extreme care. It seems that in spite of his earlier participation in a group show at Der Sturm in June 1918, he had not yet met Herwarth Walden. He now sought an introduction to him and Blümner through Spengemann, who had close connections to the Sturm circle:

Dear Mr. Spengemann:
 Enclosed please find the catalogue to my exhibition at Der Sturm. You probably know most of the works. Numbers 51 and 55 were shown at the Hannover Secession. At the end of June I'll go to Berlin to introduce myself to Herwarth Walden. May I then call also on your friend at Der Sturm?[2]

A year later, Schwitters had mastered the mechanisms that must be set into motion to ensure financial success and artistic recognition: By then, like other successful artists in the modern period, Schwitters had become a savvy self-promoter. Before the opening of his exhibition at Der Sturm, he sent a letter to the arts editor of *Vorwärts*, inviting him to the opening. He informed him about the kinds of work in the exhibition and pointed out that Merzbilder were going to be shown for the first time in Berlin. He also included the catalog and drew special attention to his own introduction.[3]

Schwitters similarly informed himself about the success of other Der Sturm artists, especially those with whom he was to exhibit and those whom Walden had successfully sponsored in the past. Indeed, Schwitters's work of the period 1918–20 shows a judicious exploration of the different styles and subject matter favored by these recognized artists. In these years, as in the preceding two, Schwitters moved back and forth between different artistic modes in search of clarification of his own ideas, and a personal handwriting becomes ever more apparent. He shaped the form and subject matter of his new art in light of the changed political, social, and cultural conditions of postwar Germany. Schwitters found his own collage style, embodied for the most part in small- to medium-size collages composed of bits of found paper, only by the end of 1919 and the first months of 1920. In the meantime, the large *Merzbilder* (his predominantly abstract mixed media works) coexist with a variety of other works done in different formats and media.

Among these, a group of about forty watercolor drawings that Schwitters linked with the common designation *Aq.* (for *Aquarell*, the German word for watercolor drawing) is particularly instructive. Created almost entirely in 1919, they are of modest scale and, as opposed to the increasingly abstract collages, have more recognizable subject matter. These drawings, usually referred to as Schwitters's Dada drawings because of their bizarre spatial relationships and childlike drawing style,[4] are crucial to understanding his postwar project. In scale, they are the exact precursors of the small collages, which Schwitters significantly termed "Merz-drawings," indicating the carryover of his concerns even to a different medium. Less formal and seemingly more spontaneous than the large-scale *Merzbilder*, these drawings offer a fascinating glimpse of the processes of transformation present in Schwitters's naturalistic works, as well as the development of an abstract style. Most important, these drawings reveal Schwitters's sources and indicate that he carefully studied the artists praised by contemporary German critics or promoted by Herwarth Walden.

The *Aq.* series is experimental. With the exception of *Aq. 1*, and possibly some of the others,[5] they were not included in Schwitters's major exhibitions in the 1920s. Even today the series is still mostly unknown as a complete body of work. Schwitters valued them highly enough, however, to give at least one of them – *Aq. 38* (1918; see Fig. 76) – to his esteemed friend, supporter, critic, and fellow artist Walter Dexel. Indeed, this series plays a key role in Schwitters's career. As opposed to

the *Merzbilder* and *Merzzeichnungen*, the *Aq.* series addresses in a legible language the experience of personal displacement in a period of political, social, and cultural chaos. Here Schwitters describes the trauma of birth and the ensuing struggle for a vocabulary appropriate for the new. The disregard for the conventions of representation and established artistic hierarchies – the drawings are landscape, genre, still life, and portrait all in one – mark the *Aq.* series as the artist's portrayal of his liberation from tradition. Yet, while Schwitters's new worldview is all-encompassing as revealed in his insistent reference to celestial bodies and the earth, the *Aq.* drawings hide a very private struggle for a new language and a new artistic identity. The poem "An Anna Blume" [To Anna Blume] in contrast demonstrates Schwitters's public refashioning into a modern artist and writer.

Whereas Schwitters had pictured his world before 1918 as an essentially stable environment, after the war he depicted in this series of drawings a world in which everything seems destabilized, in flux, and in all respects contrary to the norm. Schwitters presents a world populated by animals; large birds; ordinary, mass-produced objects, such as bottles, coffee-mills, and umbrellas; architectural structures; and human beings, of whom one usually does not see more than fragments – heads, eyes, or disconnected hands. All elements are thrown together in a seemingly haphazard manner, irrespective of scale and perspective, and drawn in an abbreviated, sketchlike manner in a self-conscious reference to children's drawings. There is a pervasive sense of movement in these drawings that Schwitters further accentuates with arrows and overlapping circles.

The drawings come as a surprise in Schwitters's oeuvre. Nothing in his earlier work prepares us for their inventive playfulness, their degree of abstraction, and their radical new style. They plainly indicate Schwitters's knowledge of Futurist painting – promoted by Herwarth Walden already before the war when he brought the entire 1912 Bernheim Jeune Futurist exhibition from Paris to Germany and subsequently sent it to many European cities – and its glorification of mechanical motion, but they also reveal his awareness of the more recent German Expressionist adaptations of the Futurist vocabulary to accommodate apocalyptic visions of destruction.

Among Schwitters's German Expressionist models, Johannes Molzahn (1892–1965) undoubtedly stands out. Schwitters was to exhibit with Molzahn at his forthcoming Der Sturm exhibition, and Molzahn was already closely connected to Walden. Molzahn had exhibited with Der Sturm since 1916 and continued to exhibit there through 1920, becoming well known for his paintings of a universe in turmoil. Inspired by Futurist sources and Robert Delaunay's disks, Molzahn's images radiate out from central circular masses and intersect and collide with other circular bands, often set in dark areas suggestive of starry skies. Rarely anchoring his forms in his compositions and infusing them with a sense of cosmic chaos, Molzahn became known as the "German Boccioni."[6] Some of his paintings, especially those of 1919, not only allude to chaos but also to a cosmic intelligence with the inclusion of eyes in his compositions, images that reappear in Schwitters's watercolor drawings. It

is difficult to say whether Schwitters saw Molzahn's work before their joint exhibition, but he did in the same year dedicate to Molzahn a poem that focuses on images of circular motion. It opens with the lines, "Revolving worlds you / You revolve worlds,"[7] calling to mind Schwitters's assemblage painting *Das Kreisen* [Revolving] of that year (Fig. 30). Moreover, motion was to become a prominent theme in Schwitters's postwar work with the wheel, sometimes included as an actual object in his *Merzbilder*, or simply drawn in a shorthand reference to his dominant subject matter as an abstract geometric form, the circle.

Summarizing his wartime service as a technical draftsman in a machine factory near Hannover, Schwitters resorted to the image of the wheel: "In the war [at the machine factory in Wülfen] I discovered my love for the wheel and recognized that machines are abstractions of the human spirit."[8] It seems to have been in the machine factory, at least in retrospect, that he came to see the mechanical as the expression of modernity. Indeed, Schwitters's preoccupation with movement became pervasive and is a true indicator of his turn toward modernity; as a social and political issue, it was the underlying theme of "Die Zwiebel," and as desire, the psychological focus of "An Anna Blume." Schwitters linked, in fact, Anna Blume explicitly with the wheel in his own English translation of the poem. There he reformulated the prize question into the statement "Anna Blume has wheels," cementing the connection between the modern and movement.

But Schwitters's group of watercolor drawings also attests to other sources of inspiration that reinforced his attraction to the theme of movement. They show at the same time his carefully considered emulation of the most advanced or experimental style of his period, Zurich Dada, as well as the idiosyncratic work of Marc Chagall. We know that Schwitters owned issue number 4–5 of *Der Dada*, the Zurich Dada magazine, and it has rightly been suggested that Schwitters's fascination with the wheel image so prominent in the *Aq.* drawings may derive from Francis Picabia's famous cover design for that issue: his *Réveil-Matin*[9] (Fig. 31). Undoubtedly, the Zurich Dadaists' search for a new language, focusing on collage, the language of fragmentation, and the theme of technology, found resonance in Schwitters's own attempts at innovation. Here Schwitters found a more sophisticated engagement with the theme of technology which was not as unequivocally positive as the position of the Futurists before the war, for the machine's potentially destructive power was acknowledged. The influence of Chagall may account for Schwitters's specific fragmentation of forms and the new decisive drawing style that he began to develop in this group of watercolor drawings. Schwitters acknowledged his admiration for Chagall, as he had done for Molzahn, in a poem written in 1919, "To a Drawing of Marc Chagall: Poem 28," inspired by that artist's *The Drinker* (1913; Fig. 32) in Herwarth Walden's private collection.[10]

Aq. 1, Das Herz geht vom Zucker zum Kaffee [The Heart Goes from Sugar to Coffee] (1919; Fig. 33), the first in this series of experimental drawings that powerfully visualize Schwitters's search for a new pictorial language, bears a title suggestive

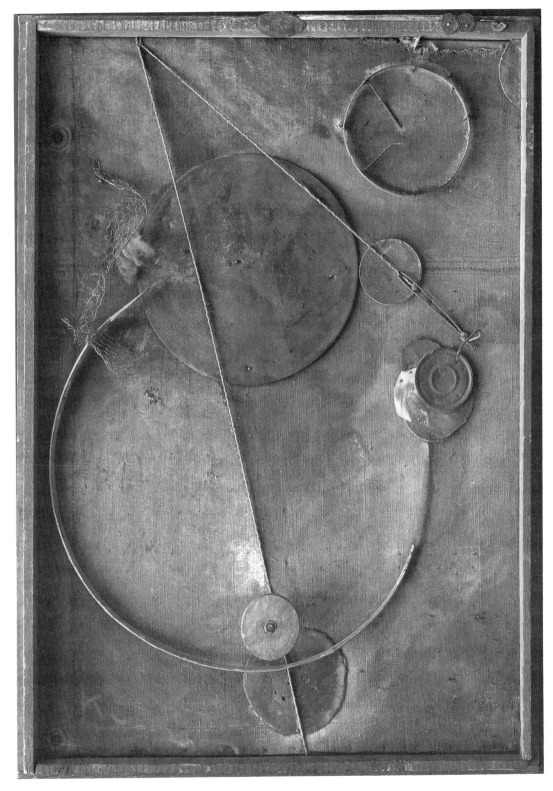

Figure 30. Schwitters, *Das Kreisen* [Revolving], 1919. Assemblage, 122.7 × 88.7 cm. The Museum of Modern Art, New York. Advisory Committee Fund.

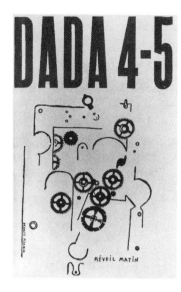

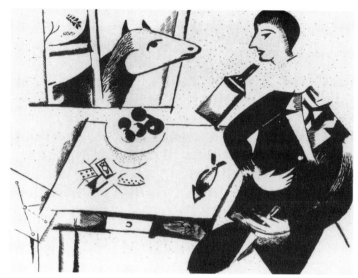

Figure 31. Francis Picabia, *Réveil-Matin*, cover design for *Dada*, no. 4–5, Zurich, 1919. © 1992 ARS, New York/ADAGP, Paris.

Figure 32. Marc Chagall, *Der Trinker* [The Drinker], 1913. Pen, brush, and ink, 21 × 29 cm. Private collection, Stockholm. © 1992 ARS, New York/ADAGP, Paris.

of a tale of desire and enigmatic actions. The action, however, takes place in a world in which the spatial and positional relationships between objects have gone awry and time no longer unfolds in a linear manner. The drawing depicts a still life that belies its name: Although Schwitters represents the paraphernalia of many a still life – a coffeepot and a sugar bowl – he renders the objects as if a turbulence had lifted and tossed them about. The pots are hovering above an upwardly titled table on which abstract shapes, intersecting circles, triangles, and numbers have taken their place. There is a sense of violent displacement. It is underscored by the prominent hand in the upper right, which thrusts out of a sleeve, cut off by the framing edge, and reaches for the pot. Together with the pointed arrow below, the hand lends the composition a directional movement that ends in the leftward pointing spout of the coffeepot. However, a countermovement is created: The pointing finger of a figure is seen in profile in the left foreground; a sweeping circular line bisects this profile's head in much the same way the arrow above has bisected the heart on the sugar bowl; and a triangle points to the right. Schwitters suggests that this turbulent still life represents a microcosm, a small part of a larger world in motion: The overlapping circular forms in the middle left and the half-moon shape in the lower right denote celestial bodies like Saturn and its rings or Jupiter and its moons.

In *Aq. 1, Das Herz geht vom Zucker zum Kaffee,* Schwitters explores his newfound understanding of a world set in motion by technology. Like so many of his contemporaries, he understood technology to be the product of abstract thought. In this

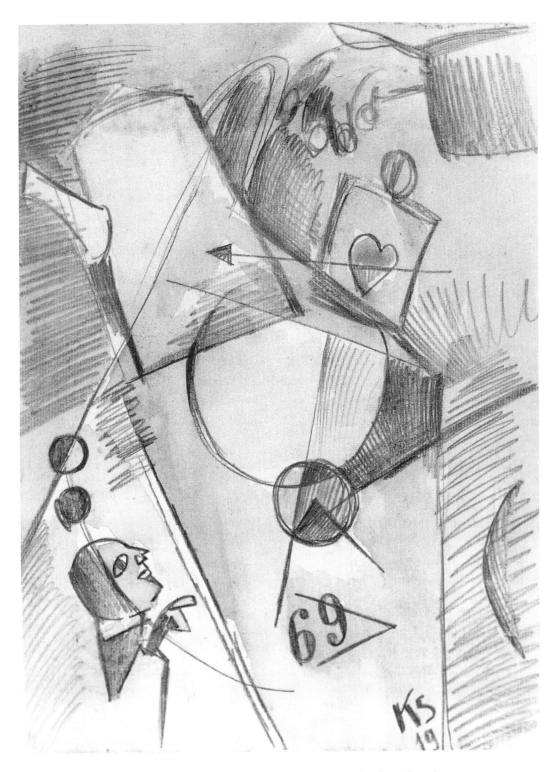

Figure 33. Schwitters, *Aq. 1, Das Herz geht vom Zucker zum Kaffee* [The Heart Goes from Sugar to Coffee], 1919. Watercolor and pencil, 30.2 × 22.3 cm. The Museum of Modern Art, New York. Purchase Fund.

drawing, Schwitters resorts to two artistic languages, one abstract and one representational, that at this time are associated with radically contrasting aesthetic stances: modernity and tradition. The abstract forms and symbols fill the center of Schwitters's composition, whereas the representational forms are pushed to the margins. Schwitters literally makes a void the focus of his composition, enclosed by a circle. All the other forms are arranged in relation to this circle and made to rotate around it. The circle, in turn, is placed on the table surface, so that it becomes a tablet or drawing board on which the abstract shapes are inscribed.

Being placed so prominently in the center of the watercolor drawing that Schwitters designated as the first of the series, the table must be understood as a symbol for a new kind of drawing board, a tabula rasa brushed free of the trappings of representational art to make room for the new language of abstraction. The notion of the table as a tablet containing the symbols of Schwitters's new language is reinforced by the pointing finger of the profile head in the lower left. This figure alludes to the tradition of the *Sprecher* figure, who stood in for the viewer or artist as commentator and observer, so common in earlier art. Schwitters's *Sprecher* points to the signs and symbols of a new mode of communication, in which abstract numbers and graphic symbols replace representation and fill the void left behind by the shattering of tradition. In Schwitters's new definition of art, the artist becomes the creator of signs that are no longer anchored to a fixed system of signification and have thus become multivalent. In the series of watercolor drawings, Schwitters delineates the tension between different systems of signification. Many of the symbols reappear in different contexts, but their meaning is not always as clearly discernible as in *Aq. 1*. They become readable as part of an evolving vocabulary and emphasize Schwitters's insistence on a new language.

Several other drawings in the *Aq.* series also focus on motion, or even turbulence, as in *Aq. 9 (Windmühle)* [Windmill] (1919; Fig. 34). Energized marks delineate the blades of the mill and slice the composition diagonally into different sections. They are like the spokes of a wheel whose hub is placed in almost the exact center of the composition. Two exposed cogwheels below reveal the mechanism inside and accentuate rotational motion. In this drawing, Schwitters evokes the floating forms of Redon's paintings and the weightless figures of Chagall, but reinterprets them in terms of modern technology: A hot-air balloon drifts through the sky. It is revealed between two of the blades as an unsettling presence, for it floats upside down, absurdly holding aloft the basket to which it is tethered. The theme of reversal is repeated in a small figure shown kneeling below the two cogwheels on a strip of its own land, a straight pencil line.

Windmills are included in many of the *Aq.* drawings – *Aq. 3, Das Herz geht zur Mühle* [The Heart Goes to the Mill] (Fig. 35), *Aq. 5, Er und Sie* [He and She] (Fig. 36), *Aq. 10, Ich müßte, du müßtest, er müßte* [I should, you should, he should] (Fig. 37), *Aq. 11, Bild Frau-graus* [Woman-scare] (Fig. 38), *Aq. 16, Porträt E* [Portrait E] (see Fig. 45), *Aq. 22, Der springende Springer* [The Jumping Jumper] (Fig. 39), all from 1919, and *Aq. 24, Der Kopf unter der Mühle* [The Head under

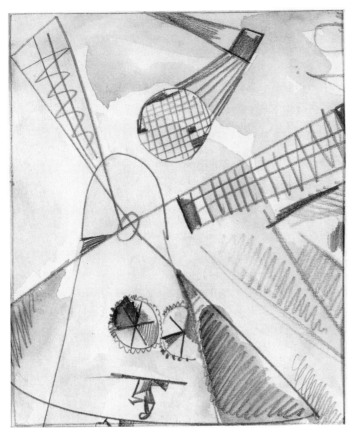

Figure 34. Schwitters, *Aq. 9 (Windmühle)* [Windmill], 1919. Watercolor and pencil, 17.3 × 14.4 cm. Galerie Kornfeld, Bern.

the Mill] (1920; see Fig. 41) – as well as in several drawings related to the *Aq.* series. Motion as physical activity is described in *Aq. 22, Der Springende Springer:* There (Fig. 39), a stick figure (thus reminiscent of Alves Bäsenstiel) is holding on to either a parachute (if one reads this image in relation to *Aq. 9*) or a jump rope. He leaps toward a spire that prominently points to his crotch; behind him is a large windmill perched on top of a steep hill sketched in with a simple diagonal line. A sweeping, curving line below the jumper suggests the curvature of the earth and accelerates the pattern of different movements – as does the prominent arrow that extends from the small church on the left, through the superimposed heart, to the large letter "B" inside the circle on the right. In this drawing, Schwitters evokes motion thematically as well as compositionally with the sharply drawn, intersecting lines, scale discrepancies, and the contrast of hard-edged and rounded forms.

In some of the *Aq.* and related drawings, Schwitters depicts objects that appear to be only momentarily at rest, such as the large umbrella that dominated *Des* [Its] (1919; Fig. 40), about to be gripped by a small figure jumping toward it. Motion in this drawing is agitated and constantly changing: A flashlike arrow zigzags through

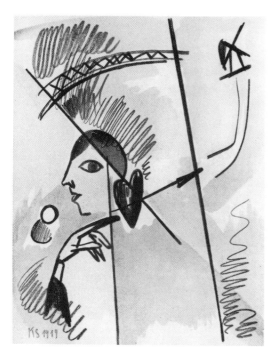

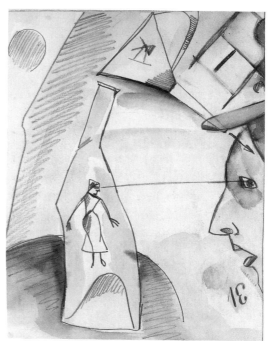

Figure 35. Schwitters, *Aq. 3, Das Herz geht zur Mühle* [The Heart Goes to the Mill], 1919. Watercolor and crayon, 25.6 × 21.5 cm. Private collection.

Figure 36. Schwitters, *Aq. 5, Er und Sie* [He and She], 1919. Watercolor and pencil, 25.5 × 21.5 cm. Marlborough Fine Art, London.

Figure 37. Schwitters, *Aq. 10, Ich müßte, du müßtest, er müßte* [I should, you should, he should], 1919. Watercolor and pencil, 17.3 × 14.4 cm. Galerie Gmurzynska, Cologne.

Figure 38. Schwitters, *Aq. 11, Bild Frau-graus* [Woman-scare], 1919. Watercolor and pencil, 20.9 × 20.4 cm. Galerie Gmurzynska, Cologne.

Figure 39. Schwitters, *Aq. 22, Der springende Springer* [The Jumping Jumper], 1919. Watercolor and crayon, 28 × 22 cm. Marlborough Fine Art, London.

the composition from the upper right to the lower left; a kite is flying above the umbrella and the jumping figure, its long tail trailing behind; and another figure with outstretched arms accentuates the downward movement, for it too is placed upside down in the lower right corner.

Clearly, Schwitters's world in the *Aq.* drawings is chaotic; the entry into that world is a violent, fragmenting birth as described in *Aq. 24, Der Kopf unter der Mühle* (Fig. 41), reminiscent of Alves Bäsenstiel's birth after disembowelment in "Die Zwiebel." A large, hand-cranked coffee mill forms the center of the composition. It is superimposed over a landscape dotted with fields, a church, and several houses. The coffee mill is an invasive body, looming in the sky as if it had been generated by either the windmill or the sun/moon behind it. Its grinding mechanism is exposed much like the mill's cogwheels in *Aq. 9* (see Fig. 34). It is spewing forth a disembodied head, falling out from the drawer like so much ground coffee.

The representation of the mill with the disembodied head functions as a powerful metaphorical device within the series. These images of mechanical motion and chaotic displacement describe the individual as subjected to extreme forces over which he has little, if any, control. The description of a violent birth, in which the child – here an adult man – is propelled out into the world by a relentlessly grinding

Figure 40. Schwitters, *Des* [Its], 1919. Watercolor and crayon, 26 × 20.5 cm. Galerie Gmurzynska, Cologne.

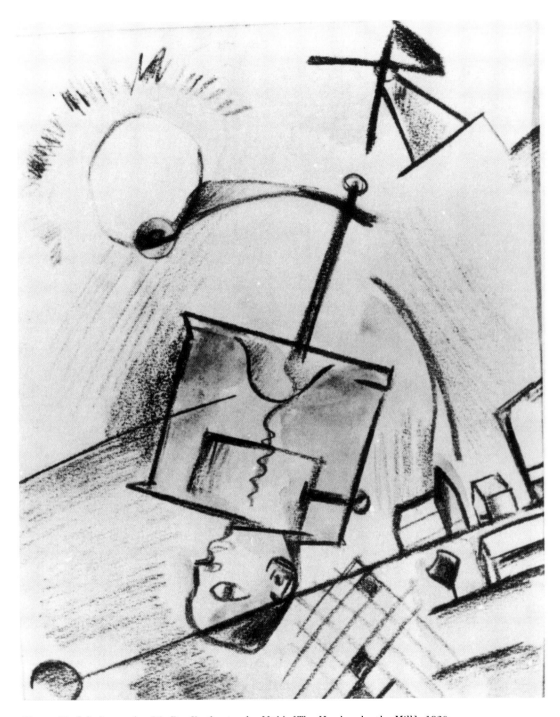

Figure 41. Schwitters, *Aq. 24, Der Kopf unter der Mühle* [The Head under the Mill], 1920.
Watercolor and crayon, 24.2 × 19.7 cm. Private collection.

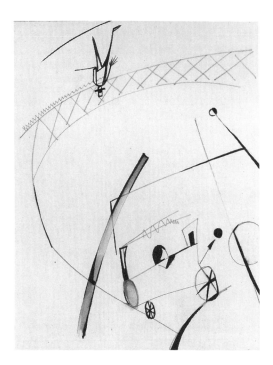

Figure 42. Schwitters, *Aq. 37, Industriegebiet* [Industrial Sector], 1920. Watercolor, ink, and pencil, 23 × 18 cm. Sprengel Museum, Hannover.

machine, recalls both the birth of the Weimar Republic and Schwitters's own artistic birth in the moment of revolutionary turmoil. If *Aq. 1* (see Fig. 33) rendered the battle for dominance between abstraction and representation, between innovation and tradition, then *Aq. 24* shows the experience of shock that propelled the birth of the new language. It also links the new to the mechanical.

Aq. 37, Industriegebiet [Industrial Sector] (1920; Fig. 42) shows that the world depicted in the series is indeed the modern, technological one. Schwitters renders a man with top hat, walking stick swinging, who is strolling upside down along a fence. He is observing a locomotive rolling back and forth (as the arrow and steam indicate) in a thicket of signals. In this representation of the viewer and the viewed – the modern sight, Schwitters engages a typically modern subject, the flaneur. His properly attired witness, a detached observer who strolls through the modern city while taking in its manifold sights, becomes the quintessential flaneur, described in many modernist texts since Baudelaire. Schwitters repeats the modernist theme, this time focusing entirely on the machine, in *Aq. 14, Lokomotive rückwärts* [Locomotive Backwards] (1919; Fig. 43), and returns to it in the cover design for a collection of his own poems, published in 1919 as *Anna Blume Dichtungen* [Anna Blume Poems] (Fig. 44). The design cements the link between Anna Blume and the mechanical. For this cover, Schwitters assembled the various motifs of his *Aq.*

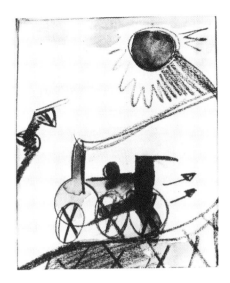

Figure 43 (above). Schwitters, *Aq. 14, Lo-komotive rückwärts* [Locomotive Back-wards], 1919. Watercolor and crayon, 17.3 × 19.1 cm. Private collection.

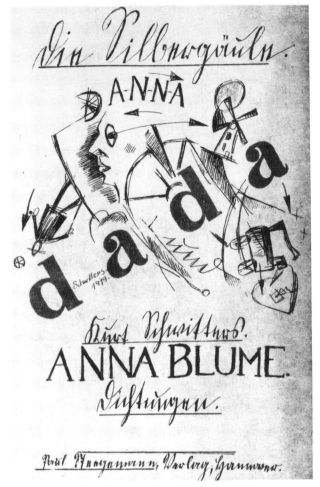

Figure 44 (right). Schwitters, cover design for *Anna Blume Dichtungen* [Anna Blume Poems], 1919. Lithograph, 22.3 × 14.4 cm. Stadtbibliothek Hannover, Schwitters Archiv.

series: the windmill, wheels, coffee mill, hearts, the profile head, and the man walking upside down on his own strip of land. In addition to the word "Anna," the two opposing arrows above and below, and the prominently placed word "dada," he also included the locomotive, which, as in *Aq. 14*, is rolling backward and forward on its own tracks. Schwitters described the cover in his essay "Merz" (1920), implying that to him the modern offers freedom from restrictions:

On the same cover are a windmill, a head, a backwards rolling locomotive, and a man who hangs in the air. That means nothing more than that in the world in which Anna Blume lives, in which people walk on their head, windmills are turning, and locomotives roll backwards, dada exists as well. Not to be misunderstood, I have also written "Antidada" on the cover for my *Kathedrale*. That does not mean that I am against Dada, but that in this world are also currents against Dada. Locomotives roll forwards and backwards. Why shouldn't a locomotive roll backwards for a change?[11]

Schwitters's modern world is, however, not entirely without a regulating structure: It is created and controlled by the artist. *Aq. 16, Porträt E* [Portrait E] (1919; Fig. 45) creates the foil for *Aq. 1* and *Aq. 24:* Whereas one depicted the struggle for a new artistic language and the other the trauma of birth, *Aq. 16* shows the artist at work and in command. Seen in profile, he stands in front of an easel, a heart-shaped palette in one hand and a poised brush in the other. Schwitters's stand-in is rendering the new with the same symbols that Schwitters employed as the vocabulary of the *Aq.* series. The image on the easel – the drawing within the drawing – is a windmill at the end of a length of railroad tracks. The artist points his brush to the hub, the rotational center of the mill and the composition, as if his phallic gesture had set the machine in motion. *Aq. 16* repeats the theme of "Die Zwiebel," celebrating the power of artistic creativity and Schwitters's mastery of a new language.

Schwitters's image of the artist imbuing the machine with life is romantic; it insists on the notion of artistic genius. It is by no means the only work in the series of drawings to address the questions of inspiration and artistic authority. *Aq. 7, Mann Schaaft lilablau* [Manscape/Man-made Purple-blue] (1919; Fig. 46) also depicts a man in profile at the center of the composition. His bowler hat, floating upside down next to his head, connects him to the other hatted figures of the *Aq.* series. That he is also the artist is shown by the funnel above his head, which filters inspiration into his brain, and the large heart, which identifies him as a sensitive being, open to impressions and emotions. A line stretching from his eye – the other locus of inspiration – to the funnel on top of a church in the upper right background implies that his inspiration is being channeled toward the making of form (the architectural structure) and spirituality (the church). If the line is seen as moving in the opposite direction – from the church to the human figure – the artist is shown as receiving divine inspiration. Schwitters also plays with the idea of the artist as creator in the title. The unusual word game of *Mann Schaaft lilablau* conjures the German words "Mannschaft" (team) as well as "Mann schafft" (man creates) and "Landschaft" (landscape); it thus alludes to creation as a male project. The color purple-blue makes a punning reference to the blue flower of German Romanticism, intensifying that color to an even more ethereal hue.

The references are playful and clearly also ironic: Using the funnel, an ordinary household object, to describe divine inspiration is iconoclastic. It draws both on the image of popular lore, the Nürnberger Trichter,[12] and on the notion of the modern as the mechanical. The funnel may also stand for any number of mass-produced objects (it is repeated twice in the composition) and thus points to the modern as a context. It makes yet another veiled reference to the new: the collective as opposed to the individual in both the political and artistic sense. It is implied in the title with its pairing of "man" and "team" as well as with the opposition of the human figure and the mass-produced objects. Schwitters, however, highlights

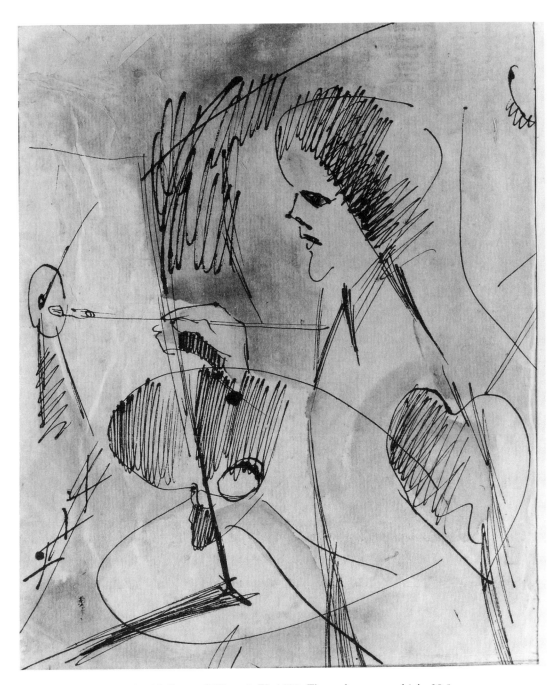

Figure 45. Schwitters, *Aq. 16, Porträt E* [Portrait E], 1919. Watercolor, pen, and ink, 19.3 × 16.3 cm. Marlborough Fine Art, London.

the individual over the collective, and the human being over the mass-produced object, and above all singles out the artist as the divinely inspired creator of form.

The various *Aq.* drawings show Schwitters's engagement with many of the different artistic styles available to him toward the end of the war and in the period immediately following it. The influence of Futurism, Expressionism, and Dada is apparent. Yet it was one artist above all who seems to be Schwitters's unacknowledged source of inspiration and model for his own career: Paul Klee. Eight years older than Schwitters, Klee had become increasingly well established during the war, taking the place of Franz Marc, killed at Verdun in 1916. Klee had, of course, also been part of the Blaue Reiter group, and one of his works had been reproduced in the important *Blaue Reiter Almanach* in 1912; in 1913, his translation of Delaunay's essay "Über das Licht" (On Light) was published in *Der Sturm*. Klee had begun to exhibit regularly to critical acclaim in several cities in Germany. In 1915 the art historian Julius Meier-Graefe included Klee in his *Entwicklungsgeschichte der modernen Kunst*.[13] But it was above all in 1917 and 1918 that Klee became the focus of much publicity. Klee was closely associated with Walden's Der Sturm gallery, and, since 1917, also with the gallery Goltz in Munich (the same two galleries Schwitters relied on in the following years). Walden, who had given Klee a spectacularly successful exhibition in February 1917, again exhibited his work in December of the same year. Although the later exhibition was financially not as successful as the February exhibition, there is no reason for Schwitters to have known that, for Klee's watercolor drawings received much favorable attention in the press. Several of the most respected critics included him in their reviews and discussion on contemporary art, such as Adolf Behne, Theodor Däubler, and Herwarth Walden, the same critics who in the next few years would also single out Schwitters for praise. (In 1918, Walden devoted one of his *Sturmbilderbücher* to Klee, just as he was to do two years later with Schwitters.) Däubler, in his *Berliner Börsenkurier* review of Klee's December exhibition, had praised above all Klee's bird images, among them *Drei schwarze Nachtigallen* [Three Black Nightingales] (1917; Fig. 47). Däubler singled out this work once more in his *Kunstblatt* article on Klee in January 1918.[14]

To Schwitters, Klee must have seemed the exemplar of success and a model to be emulated. Indeed, his *Aq.* drawings suggest that he looked closely at that artist's recently published work. Klee's watercolor drawing *Drei schwarze Nachtigallen* depicts the three birds in a mountainous landscape. The right side of the composition is taken up by a prominent bird silhouetted against the moonlit landscape. On the left are the other two birds, one perched atop a mountain or rooftop drawn in as a dark triangle; the other, an almost perfect mirror image, is standing upside down below the left bird. The large bird on the right and the inverted bird find an almost exact counterpart in Schwitters's *Aq. 23, Koketterie* [Coquettishness] (1919; Plate 3). There, a large bird is perched atop a house, recalling the geometric

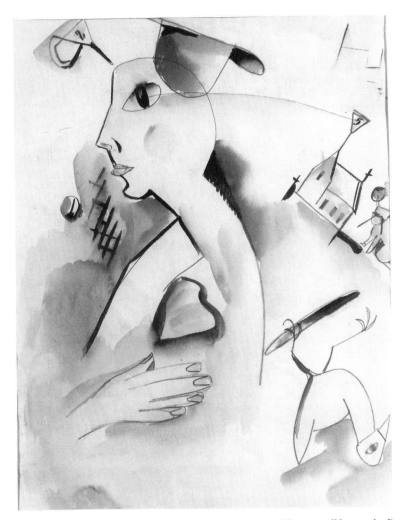

Figure 46. Schwitters, *Aq. 7, Mann Schaaft lilablau* [Manscape/Man-made Purple-blue], 1919. Watercolor and pencil, 24.4 × 31.1 cm. Carus Gallery, New York.

structures at the bottom of Klee's composition. The small inverted man in Schwitters's drawing is situated in almost the exact place as the inverted bird in Klee's; in fact, their forms are strikingly similar: Just as Klee included various small circular shapes and a large half-moon in his composition, Schwitters added a smaller and a larger half-moon shape to his.

The affinity between Klee and Schwitters goes beyond superficial formal similarities. More than anything else, Schwitters seems to have learned a light touch from Klee, a visual playfulness that was not present in his work until then. Moreover, Schwitters, too, had begun to represent a world in which animals were at least as important as humans, if they had not replaced them altogether. In such *Aquarelle* and related drawings as *Aq. 6, Das Schwein niest zum Herzen* [The Pig Sneezes

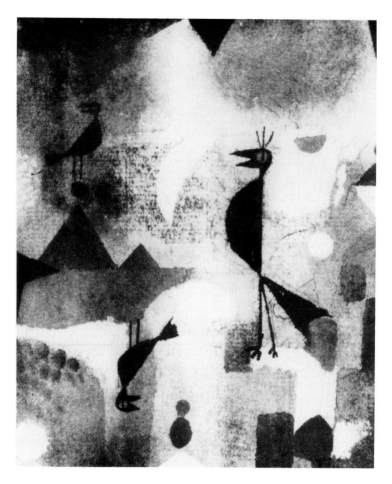

Figure 47. Paul Klee, *Drei schwarze Nachtigallen* [Three Black Nightingales], 1917. Dimensions and whereabouts unknown. Watercolor. © 1992 ARS, New York/Bild-Kunst, Bonn.

Toward the Heart] (Fig. 48), *Aq. 30, Dies ist das Biest das manchmal niest* [This Is the Beast That Sometimes Sneezes] (Fig. 49), and *Komisches Tier* [Funny Animal] (Fig. 50), all from 1919, animals dominate the compositions; even Schwitters's titles show an attempt to mimic those of Klee with their typical mix of poetry and paradox. Schwitters, much like Klee, began to express a preference for small, aesthetically rewarding work. In his case, these began to be his collages rather than watercolors, but significantly, Schwitters called them "Merz-drawings." However, Schwitters's use of Klee-inspired imagery and titles was short-lived. He soon began to apply his brand name systematically to all of his products, and, after the name Merz caught on, to stress the particulars of his brand of collage, of Merz. His work became increasingly abstract, and the deracinated objects of the *Aq.* drawings became the concrete fragments with which he composed his collages.

Most of the drawings depict a world in motion and highlight events that unfold

Figure 48 (above). Schwitters, *Aq. 6, Das Schwein niest zum Herzen* [The Pig Sneezes Toward the Heart], 1919. Watercolor and crayon, 25.5 × 20.3 cm. Galerie Gmurzynska, Cologne.

Figure 49 (above right). Schwitters, *Aq. 30, Dies ist das Biest das manchmal niest* [This Is the Beast That Sometimes Sneezes], 1919. Watercolor and crayon, 23.6 × 18.9 cm. Marlborough Fine Art, London.

Figure 50. Schwitters, *Komisches Tier* [Funny Animal], ca. 1919. Stamp drawing and collage with crayon, 20.4 × 19.5 cm. Private collection.

in unexpected ways. Schwitters treated these drawings as a new kind of space in which he was free to experiment. His insistence on circular forms suggests that he thought of them as images of a new world in which relations between humans, animals, and objects could be rethought. The revolving shapes are clearly inspired by the postwar Expressionist preoccupation with the cosmic, but Schwitters, with his insistence on ordinary objects and beings – the umbrellas, chickens, and coffee mills with which he populated his drawings – recalls Expressionism only to parody it. Seen in the context of postwar Expressionism, such as Molzahn's works of 1919, Schwitters's *Aq.* drawings have a certain bite and irony that is absent or more difficult to discern in his larger works of the same period, such as the 1919 *Das Kreisen* [Revolving] (see Fig. 30).

Although the *Aq.* drawings announce Schwitters's turn towards modernity, they more surprisingly also point to another, more traditional aspect of his work, evident in Schwitters's insistence on the theme of inversion. It is the dominant theme in the watercolor drawings and is similarly the focus in "Die Zwiebel" and "An Anna Blume." The notion of inversion readily evokes the toppling of hierarchical order. Yet the tradition associated with the representation of inversion paints a more interesting and revealing picture, one that reinforces the view of Schwitters as adhering to tradition in spite of his acknowledgment of the modern fragmented self.

In the drawings we find representations of men walking upside down, a fish swimming outside its bowl (*Aq. 27, Der Goldfisch* [The Goldfish], 1919; Fig. 51), and a head falling out of a coffee grinder (*Aq. 24;* see Fig. 41). In the short story, the reversal in the power hierarchy was mirrored in the structure of the text itself, and in the poem, the heroine was not only in all respects contrary to the norm, but became the very embodiment of inversion. Anna Blume wore her hat on her feet – and her name pivoted around itself: the palindrome seen as a figure of inversion.

The representation of a world upside down forms part of a long-established tradition in the visual arts and in literature. Familiar in ancient and medieval times, it is most commonly found in popular prints of the modern period as a broadside theme of the World Upside Down. These broadsheets have been characterized as exceptional for their longevity and geographical contribution, but as David Kunzle notes, "also for the image it conjures up of a world the very opposite of static: one capable of total reversal in all its components."[15] In the modern era, representations of the World Upside Down became systematized with regularly recurring motifs, usually laid out on a grid pattern. Mostly concerned with the inversion of hierarchies, they take the relationships between humans, animals, and objects, and even the elements, as their theme.

The principle of inversion is that there are two parties, the one dominant, the other dominated, whose roles, in some action typifying their relationship, are simply reversed. In all these groups the inversion is hierarchical, involving a power relationship, except in the

Figure 51. Schwitters, *Aq. 27, Der Goldfisch* [The Goldfish], 1919. Watercolor, 11.9 × 17.2 cm. Private collection.

fourth, where elements, usually air and water, are treated as 'opposite but equal' and switched around in respect to the creatures normally associated with them.[16]

According to Kunzle, the most ubiquitous motif is the inversion of male–female roles, which in literature is represented most frequently by the type of the "disorderly woman," a term reserved for women who did not behave according to the norms set by society.

The conceptual reversal of role relationships served a powerful function. It allowed within a predetermined format the playful acting out of fantasies about societal change. The prints, plays, and comedic sketches about inversions of hierarchy thus afforded an outlet for conflicts about authority within the system. Kunzle states:

When wielded by essentially powerless people, they represent an ever-present threat to, and indeed a bid for power over, the real world 'order,' which is really the disorder of injustice. The truly impossible, the 'purely playful' fantasies involving animals, objects, and elements, functions as a masking mechanism for the dangerous, vindictive, anarchic, 'childish,' but otherwise suppressed or unconscious desires which are embodied in the less-than-impossible human reversals.[17]

The broadside of the World Upside Down and the related literary forms served as conceptual spaces of freedom and, at times, even effected a certain spillover into everyday existence.[18] But since the threat against established authority was usually carried out in a highly formalized, contained manner, it went rarely beyond the consumption of the broadsheet imagery or the play itself. More often than not, these images and texts served to reinforce hierarchical structure.

For Schwitters, inversion cut both ways. The *Aq.* drawings served as exceptionally experimental spaces in which he toppled established order and reshaped the world on a cosmic scale. Yet in his apparent delight in chaos, one can also detect a contradictory impulse: The drawings, the short story, and the poem all reconfirm patriarchal rule. In the drawings, next to the representation of men in top hats walking freely through space are images of women imprisoned in bottles (sometimes simply evoked with Anna Blume's name or initials), as in *Aq. 5, Er und Sie* [He and She] (see Fig. 36), *Aq. 11, Bild Frau-graus* [Picture Woman-scare] (see Fig. 38), *Aq. 21, Anna Blume und Ich* [Anna Blume and I] (Fig. 52), *Aq. 30, Das ist das Biest das manchmal niest* (This Is the Beast That Sometimes Sneezes] (see Fig. 49), and *Des* [Its] (see Fig. 40), all from 1919. These female figures are subjected to the male gaze or pointing finger; defined as objects of desire, they reassert traditional male – and artistic – authority over the female body. Alves Bäsenstiel in "Die Zwiebel" replaces the king as a new potentate; he divests the princess of her power, and he does not join the people. Anna Blume seems to have been given an unusually large range for action, but that is contradicted in Schwitters's depiction of her as a flower (Blume), suggestive of restricted motion. The palindromic quality of the name Anna, pivoting and eternally inverting itself, underscores the notion of limited movement. Even as she is adulated as the "most glorious of all," she is praised for being "from the back as from the front," in a sexual metaphor that puts the female back into her traditional position of subordination.

Schwitters's images of inversion offer a space for artistic experimentation, but serve to reconfirm hierarchical order. His chaos is a chaos to be explored and restructured: Arrows join disparate parts, and connectedness is implied in the overarching emphasis on a unifying vision; the observing eye is ever-present. In such a framework, Schwitters's approach to inversion finds a revealing parallel in contemporary science. The discipline of psychoanalysis offers, perhaps, the best parallel of inversion as reaffirmation of hierarchical order. Freud explored the unconscious and decoded its language, but as prescription: In Freudian psychology, the subconscious is scrutinized to bring order to the conscious, rational self. In both Schwitters and Freud, chaos is acknowledged, but only to be controlled. Considering Schwitters's thematic choices in the context of his postwar search for a new audience on the occasion of his Der Sturm exhibition, his treatment of the theme of inversion gains an additional dimension. Kunzle observed a special quality of the broadside representation of the World Upside Down: It could, "without basic changes in its form or content, be made to appeal at once to the political conservative, the dissident, and the lover of fantasy and nonsense."[19] Schwitters's topsy-turvy world could, just like the traditional broadside, be interpreted in different ways. Ambiguities are suggested but playfully kept in check. "The formal confluence of motifs from the popular tradition of nonsense," Kunzle continues "does not so

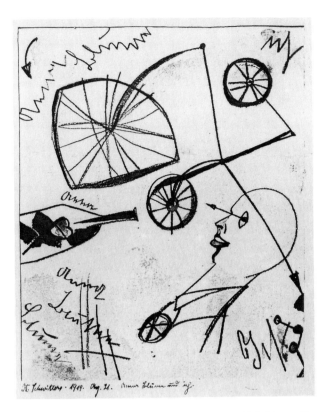

Figure 52. Schwitters, *Aq. 21, Anna Blume und Ich* [Anna Blume and I], 1919. Watercolor and crayon, 21.1 × 17.2 cm. Private collection, Switzerland.

much neutralize the social implications of the WUD [World Upside Down] as it does preserve and enhance its primitive magical function: to exercise control." Schwitters transformed the traditional broadside theme of the World Upside Down into a postwar artistic idiom. Schwitters's new language incorporated chaos without advocating it and extended the reins to the artist to establish a new order.

6

POLITICAL INSCRIPTION

Schwitters made few works that take the political events of his day as their main theme. Those that do – several *Merzbilder* and a few collages from 1919 and 1920 – show none of Grosz's aggressive critique of capitalism, nor are they readable as caricatures. Schwitters neither makes clear references to the events in his titles, nor does he guide the reading of his images with unequivocally explanatory texts. His works are almost completely free from figuration: They are collages made for the most part with nonrepresentational paper fragments. In fact, at first glance, his images seem nothing but a haphazard accumulation of scraps. Although these works do not offer a clear critique of the sociopolitical events, they do show a connection between the historical circumstances of the formative months of the Weimar Republic and Schwitters's collage project and thus play a major role in his postwar artistic development. In each instance, a political event stimulated a pictorial response in which the sociopolitical tension is played off on a pictorial plane as a tension between form and content. In Schwitters's work, the found objects are frequently linked with painted elements; but the fragments retain, like the fragments used by the Berlin Dadaists, the "bloody fingerprint of the murderer," effecting a powerful link between the artistic and the commonplace. Schwitters's understanding of the relationship between art and politics can be traced in the interplay of these two disparate pictorial components.

One of Schwitters's *Merzbilder*, the large *Arbeiterbild* (1919; Plate 4) and a collage, (*Mai 191*) (ca. 1919; Fig. 53) make oblique references to the brutal retaking of Munich on May 1–2, 1919, by government troops to suppress the Bavarian Soviet Republic – the same battle in which Landauer and Leviné-Niessen were killed. As Elderfield stated, "both [works] admit interpretation as sympathetic reactions by the pacifist Schwitters to the brutal suppression of the worker's Soviet in Bavaria on May 1, 1919."[1] But the reference to the May events is only insinuated in the

collage (*Mai 191*), and is even less clear in *Das Arbeiterbild*. Schwitters's reaction to these events can be deduced only with difficulty; there is nothing specific in this composition that permits a clear reading of his political stance. Yet the very choice of materials and their specific arrangement celebrates an assumed kinship between artist and worker. The work has a rough-hewn quality; the various scraps of material are mostly nailed to the surface in an irregular pattern, and the individual pieces are coarse, consisting of buckled plywood, chicken wire, scrap pieces of wood, and rough cloth. This technique, together with the suggestion of machine forms within the composition as a whole, alludes to a worker's environment. The surfaces are in part touched up with paint in the characteristic blue-green hues Schwitters employed during this period, and a few red and brown touches are added here and there. Treating the rough collage materials artistically, Schwitters metaphorically joins the worlds of the worker and artist.

The overall impression is that of an environment of encrusted or crumbling materials. The worker himself is evoked with a paper scrap that bears the word "Arbeiter" (worker) in large red print. It is affixed to a round piece of plywood in the upper right-hand corner, which, in turn, is nailed to a wooden stick. This plywood circle is the dominant form in the composition; it demands visual attention much like a placard held up in a demonstration. Schwitters underscores the allusion to demonstrations with a newspaper fragment placed above the word "Arbeiter" on the plywood circle. In much smaller print one can read here: "Unter diesen Gesichtspunkten sind die meisten letzten Streiks" (From these points of view, most of the recent strikes are).[2]

Schwitters does not tell us what these points of view may be, nor does he single out a specific strike. The print is small, and the text barely decipherable and subordinate to the word "worker." Schwitters seems to be invoking, more generally, strikes organized by the Workers' and Soldiers' Councils all over Germany from the middle of January 1919, in response to the government's attempt to reinstate law and order and to suppress all rebellion. In these clashes between workers and the government forces aided by the Free Corps, many innocent people were killed. The punitive expeditions against strikers destroyed the belief that the cause of the workers would be advanced through democracy and thus made it apparent that the councils were losing their power.[3]

Like Pechstein's *An Alle Künstler* (see Fig. 8), Schwitters's reference to "the worker" moves the Expressionists' New Man into the realm of contemporary politics. Pechstein created an illustration of the desired fusion of artist and worker, in which the image as a public statement functions as an advocate for action, but does not stand as the expression of an actual union. Schwitters, in contrast, achieves a more convincing link. Delineating the artistic process as the artistic equivalent to physical labor, he has accomplished a symbolic fusion between the two disparate spheres of worker and artist. He gives the word "worker" signal character, and simultaneously guides the viewer's glance back to the composition's individual material

components by not allowing a clear reading of the adjacent text. The view of surfaces is microscopic, but the arrangement of the materials suggests a macrocosmic perspective. Much as in the watercolor drawings, and in the large Merzbild *Das Kreisen* [Revolving], also of 1919 (see Fig. 30), the circular and semicircular forms evoke celestial bodies revolving around each other. As in his *Aq.* drawings, Schwitters also kept to a certain degree the universalizing tendency of Expressionism. He embeds his worker and his political concerns – strikes and demonstrations – in a larger context in which he and the events are universalized and function only as signs of a general sense of disruption and chaos.

Schwitters effects a peculiar tension between the tactile quality of his collage materials, the sense of immediacy they provide, and the contradictory impression of distance that their formal arrangement implies. The tension occurs on the thematic level as well. As Schwitters imbues his decayed materials with the aesthetic pleasures of the picturesque, lovingly altering the surfaces with touches of paint, he romanticizes political struggle. Moreover, by employing the notion of organic transformation (the aesthetics of decay) in the representation of highly divisive political events, Schwitters strips political action of its disruptive sting. Schwitters seems to suggest that if time is given a chance to work, discord will abate. The tension between nearness and distance, between the ugly and the aesthetic in terms of organic and artistic transformation, manifests Schwitters emulation of Henri Bergson's view of the passage of time (popularized in Walden's *Der Sturm* magazine) that conceives of the past, present, and future as a constantly evolving totality. In evoking a Bergsonian notion of time, Schwitters's *Arbeiterbild* shows an affinity to French prewar collage; it suggests that he must have been aware of the painters of the Abbaye de Créteil, particularly Henri Le Fauconnier, Albert Gleizes, and Jean Metzinger, and interpreted Picasso's and Braque's collages in terms of Bergson's philosophy.

(*Mai 191*) (Fig. 53) similarly does not have a clear political message, although, by recalling the month of May 191[9], it makes a more direct reference to the strikes organized by the Bavarian Workers' and Soldiers' Council (in response to the murder of Kurt Eisner at the end of February 1919) and the subsequent battle over the Bavarian Soviet Republic on May 1–2. The collage is composed of subtly tinted newspaper fragments of headlines, printed in large gothic type, and other texts in the same typeface. Only a few of the text fragments are clearly legible as complete words: "am" (on), "mai" (May), and "Schule" (school), and the numbers "191" next to them, placed so that one can read them from left to right like any ordinary text. Other letters are less clear because they are either too fragmented or placed on their side. But the words on one scrap of paper are large enough to invite the turning of the viewer's head, who, in turning, is faced with frustration. Individual words can be deciphered and sentences are suggested, but they never develop into meaningful text: Letters are fragmented and words torn apart.

Figure 53. Schwitters, *(Mai 191)*, collage, ca. 1919–20. Collage, 21.6 × 17.1 cm. Marlborough Fine Art, London.

The visual experience of trying to decipher the text can be compared to the acoustic one of catching only every other word of a newscast because of a bad reception of the radio signal. The text is as follows:

Strassenbahn, und lehnt haben, in den Streik abge rden. Die Elektrizitätsarb ag des Metallarbeiterstrei ulegen. Unternehmer gege die esamthei gesamte ärz mittel

111

(Trams, and have refused [the prefix "ab" to "abgelehnt" is to be found at the end of the line] in the strike . . . The electricalwor of the metalworker's strike . . . producers . . . majority.)

This text fragment certainly does not convey a clear message. Because of its incompleteness, the message would surely not incite workers to political action or even lead to increased political awareness; nevertheless, it gives us just enough information to conjure up visually and verbally the important political events of those few days. Once again Schwitters has not illustrated the strikes and political unrest, but rather constructed a pictorial equivalent. His visual and textual collage makes use of individual fragments to demonstrate the breaking apart of traditional discourse and simultaneous attempts to create new political and societal form.

As in the *Arbeiterbild*, the fragmentation and reorganization of form and language is contained in an aesthetic impulse. Schwitters softened the machined look of his fragments by tearing the papers rather than cutting them with scissors, thus giving them a more organic, decorative appearance. The elaborate capital letters of the gothic script underscore the overall decorative impression. Schwitters's addition of a pale blue to the national colors of black, red, and gold similarly sap this political signifier of its authority by introducing and transforming color into ornament. Since early December 1918 a bitter controversy had occurred over the national flag, which had replaced the black, white, and red of the Prussio-German Empire – a conflict that was to prove one of the most divisive issues in the Weimar Republic.[4] Considering the explosive sensitivity of the issue, it is difficult to consider Schwitters's addition of blue as a neutral or accidental gesture. The gesture is ironic in light of the political debate and in the process, perhaps unwittingly, belittles the agenda of the striking workers. The collage invites the viewer to peel back layer after layer of paper in search of a complete image, but the different fragments never gel into a continuous image, nor does the political picture emerge clearly. In spite of its posterlike appearance, this collage shows the absence of closure and thus offers a resigned view of the possibility of analyzing events. Schwitters suggests that we can understand (or are given) only the broadest parameters of a given happening: The colors intimate a historical period, the fragments evoke the newsprint of the day, but even with the close-up look the paper fragments invite us to take, there is no clarity to be gained. Schwitters, then, is not concerned with clear political commentary; his "reshuffling of the self" constitutes in and of itself a political act and is the equivalent of political activism in the public arena.

In the *Merzbild 25A, Das Sternenbild* [The Star Picture] (1920; Fig. 54), Schwitters recalls a central political event of that year that proved to be as destabilizing and fraught with emotional reactions as the other conflicts of the preceding year he addressed in his work: the resignation of Mathias Erzberger, deputy and finance minister of the new Republic since June 1919, and the simultaneous Kapp-Putsch with its conservative backlash.[5] In the *Sternenbild*, Schwitters included bits of

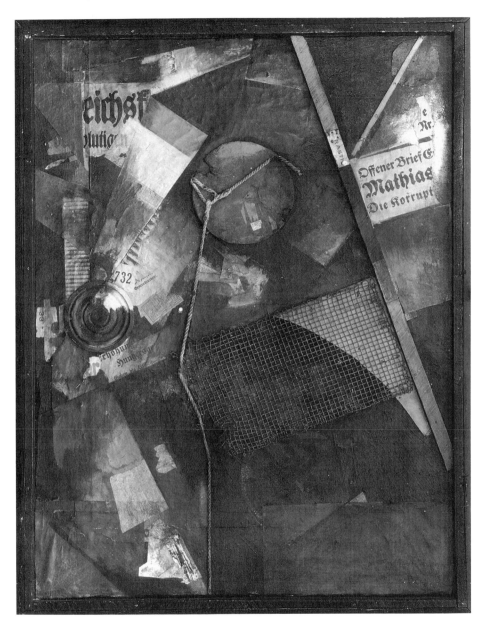

Figure 54. Schwitters, *Merzbild 25A, Das Sternenbild* [The Star Picture], 1920. Assemblage, 104.5 × 79 cm. Kunstsammlung Nordrhein-Westfalen, Düsseldorf.

newsprint rich in political allusion. They include word fragments that can easily be completed: "[R]eichsk[anzler]" (Reichs Chancellor); "blutigen" (bloody) in the upper left; in the lower left, the word "Generalleutnant" (Lieutenant-General) in relatively small print; and below, "Erhöhung" (increase), "Hungersn[ot]" (famine), and "Gegen die Stillegung" (against the closing). In the upper right one can see "Offener Brief E . . ." (Open letter E . . .), "Mathias," and "Die Korrupt[ion]"

(corruption). Although the individual letters can be completed more easily into words than in the other two works, they paint a picture of the political conflict that is as vague as that represented by the text fragments in the other collages. If anything, they seem to express the middle class's dismay at the tax hike and, by linking the name Mathias with corruption, suggest a highly critical view of the finance minister.

The composition seems to derive its title from the characteristic circular formal organization, suggestive, as in the other works, of stellar orbits. Again, Schwitters's application of paint and attention to surfaces negates the possibility of a differentiated, critical reading of the political controversy. There is, however, one important difference in the formal arrangement of the collage material, a difference that lends this work a highly emotional tone: Schwitters tied a length of rope around the central circle, as if to suggest a person who has been hanged. The overall tonal quality of the work is dark and, with the piece of wire mesh strung between the rope and the diagonally placed strip of wood, evocative of a harsh, violent environment. Whether the tied rope alludes to Erzberger or the people affected by the new taxes levied by him is left unanswered.

With its suggestion of a hanged person, the *Sternenbild* recalls a poster designed by Max Pechstein in 1919 for the government campaign, *An die Laterne* [To the Lamppost] (Fig. 55), in which he illustrated a lynching. The poster shows an agitated crowd of many men with raised fists carrying red flags, and the whole left part of the composition is taken up with the image of a hanged man dangling from a lamppost. Pechstein drew the poster for a clear political goal: to warn against anarchy and terrorism. To make his – or the government's – message readily understood, he resorted to a representational, narrative style. Although Schwitters's compositional structure is somewhat similar to Pechstein's, his solution on how to convey a spirit of anarchy or despair is radically different and vastly more progressive. Schwitters does not seek to illustrate his themes; rather, he only hints at these topics in a suggestive manner. His reference to anarchy lies in the material quality of his collage elements, their fragmented, disjointed nature, and not in a clearly drawn image. Schwitters's belief in the expressive possibilities of materials resembles that of the Berlin Dadaists. He, however, imbues his materials with a distinct personal quality that the Berlin Dadaists, in their photomontages especially, studiously avoided. His treatment of materials, predilection for emotionally charged subject matter, and personal attention to expression brings him closer to the Expressionists.

Several other of Schwitters's collages make allusions to political events, among them the *Siegbild* [Victory Picture] of ca. 1920–5 (Plate 5),[6] which questions the notion of victory by linking the words "Zin[n]" (tin) and "Sieg" (victory) and referring with other collage fragments to pyrotechnics. Schwitters does not identify whose victory he is questioning. It is not clear whether it is the Allied victory over Germany or Germany's hoped-for victory or perhaps even his personal victory as a newborn

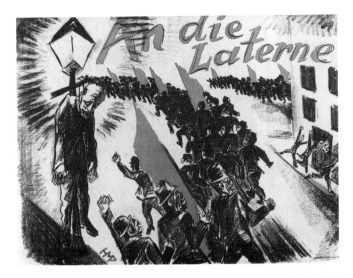

Figure 55. Max Pechstein, *An die Laterne* [To the Lamppost], 1919. Poster, lithograph. Image: 68.6 × 92.1 cm. The Robert Gore Rifkind Collection, Beverly Hills. © Pechstein/Hamburg-Tökendorf.

artist. More to the point seems to be his linkage of victory and capitalism, which emerges as the true topic of this composition. Text fragments at the top of the work relate news about banks and banking. Here again Schwitters represents modernity – materialist society – as a two-sided accomplishment, calling its supreme status into question as a Pyrrhic victory; he underscores his hesitant view with his fragmented materials that are no longer part of a cohesive, unifying environment.

The *Bäumerbild*, a collage of 1920 (Fig. 56), translates the tabula rasa of the 1919 *Aq. 1, Das Herz geht vom Zucker zum Kaffee* (see Fig. 33) into a conference table, and with that into a political allegory. Text forms the base layer of this collage, but it is so overlaid with other pieces of paper that the text is barely legible. There is a reference to the Paris Peace Conference of the preceding year and Wilson's Fourteen Points in words that translate roughly into the following: "refuse to . . . intolerable peace. . . . " Included in boldface is the name of an organization, the Organization for a Just Peace.[7] This collage layer is dominated by two photographs that infuse it with a suggestion of utopianism: One shows Ludwig Bäumer, the author of *Das Wesen des Kommunismus* [The Nature of Communism, 1920]; the other, a woman who is holding a flower. The woman has been identified as Bäumer's lover, the wife of his friend and fellow communist Heinrich Vogeler, the founder of a utopian communist community near Bremen.[8] If Schwitters, as Nill suggests, is celebrating the victory of love over war, then his work offers an odd celebration. The collage is marked by the collusion of fragmented verbal and visual texts as well as representational and abstract elements, none of which seems to be gaining dominance.

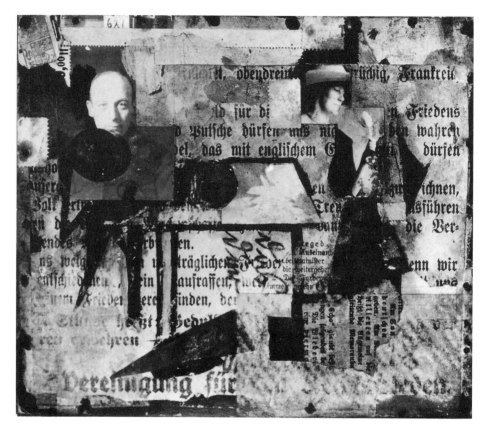

Figure 56. Schwitters, *Das Bäumerbild* [The Bäumer Picture], 1920. Collage, 17.4 × 21.1 cm. Marlborough Fine Art, London.

Among Schwitters's politically informed collages, one work in particular stands out. It is much simpler than any of the other collages and assemblages, and, above all, its political reference is unambiguous; its political meaning, however, is tenuous. *Mz. 170, Leere im Raum* [Void in Space] (1920; Fig. 57) is a small work, measuring about seven by five inches. A stark composition, it is organized around a dark, geometric mass that, with the help of two paper fragments which create a diagonal line, suggests an architectural space. A text fragment stands out prominently as a block of light in this dark mass, spelling out the word "Versaille[s]" in bold, gothic type and set in perfectly horizontal alignment like a newspaper headline.

Whereas Schwitters's other collages made only oblique allusions to different political events, this work highlights one of the most important political events of the twentieth century: the Treaty of Versailles. The treaty declared Germany's war guilt, redefined its borders, and transferred some of Germany's most important industrial areas to the Allies. The agreement also established the occupied zones, reattributed the colonies, and, perhaps most important, saddled Germany with

Figure 57. Schwitters, *Mz. 170, Leere im Raum* [Void in Space], 1920. Collage, 18.1 × 13.4 cm. Private collection.

tremendously steep reparation payments. For most Germans, regardless of their political affiliation, the treaty seemed not only unbearably harsh but also vindictive to an unimaginable degree. It led to a fundamental destabilization of the Social Democratic government and was greeted with a profound – and lasting – conservative backlash.

Schwitters put the treaty into a specific historical perspective: The date on the news clipping is the thirteenth of May. Judging from the text itself, which reports of demonstrations on the Königsplatz in Berlin, we know that it was the day after the National Assembly had convened to discuss the treaty. In that meeting, Prime Minister Scheidemann had denounced the treaty as imprisoning the German people: "What honest man – I will not even say, German, only honest and treaty-abiding man – could agree to such conditions? What hand, thus shackling itself and us, would not shrivel? It is the expressed belief of the government that this treaty is inacceptable."[9] The following day, an outraged and embittered German people staged the mass demonstrations to which the news clipping refers (Fig. 58).

There is probably no other collage in Schwitters's work in which the signal character of a collage fragment is so unequivocally and politically charged. In spite of its lost letter, this fragment clearly has not lost its *Eigengift* – its personality poison, as Schwitters called it, and which he as a rule tried to efface – nor has it been subordinated to general pictorial concerns. Rather, it stands out like a poster, framed by the dark architectural mass, and sets up an emotionally charged relationship between the title and the compositional parts. If we read the collage as a three-dimensional representation, as the contrast of light and dark suggests, then we are given a tunnel vision: Looking into the dark room, we see the back wall with the announcement about the treaty. If one sees the dark mass as receding, then the printed announcement faces us as the foremost piece within the collage. The visual ambiguities set up interpretive ambiguities. Either the treaty is "the light at the end of the tunnel" because it ushers in the end of the war, or it leads into darkness.

Schwitters, then, gives us a highly empathic view of the political situation. He focuses on that moment in history that most profoundly shattered the old order of Wilhelminian society. The Treaty of Versailles created a political and emotional void that was filled for many Germans only with the rise of Nazism. Describing a politically significant event as the Treaty of Versailles in purely emotional terms, as Schwitters does in *Leere im Raum* (in fact, the title underscores emotionality by using two terms denoting emptiness), does not show either a critical distance to the sociohistorical situation or a willingness to engage in rational analysis. The political tenor of the collage is conservative, yet there was hardly anyone in Germany who could muster positive feelings about the terms of the treaty, or "dictate," as it was commonly called.

Harry Graf Kessler, who has been characterized as "eminently well informed and remarkably free from caste prejudice"[10] was so disheartened by the treaty that

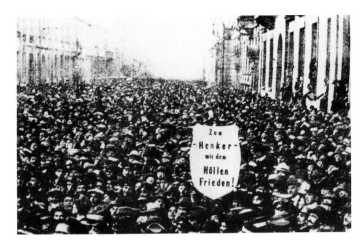

Figure 58. Demonstrations in Berlin on May 13, 1919, against the Treaty of Versailles. The text on the placard translates as "Take this diabolical treaty to the hangman!"

from May 7, 1919, the day the Germans were handed the conditions of peace, to June 12, he wrote nothing in his diary; on June 22, after the resignation of the Scheidemann cabinet, he reported a general mood of "indescribable dejection; as though all life in the soul had died."[11] Resorting to the quintessential Expressionist metaphor for profound existential terror, Schwitters places us in this collage at the edge of a vast, empty space: Versailles as an emotional abyss.

As a fragmented, incomplete statement this collage never purports to be a critical analysis of historical data; it points to ambiguities inherent in any political events, especially events of such magnitude, and their public reception. In Schwitters's work, we experience the circumstances of a historical period — the outside world — as filtered through the sensibilities of a creative individual. At the same time, in another carryover of Expressionist thought, Schwitters demonstrates the interior and exterior spheres as interdependent, for personal experience is reflected back onto the historic events in a public, pictorial statement.

Merzbild 9b, Das große Ich-Bild (1919; Fig. 59), clarifies Schwitters's attitude toward questions of the self in the sociohistorical context. *Das große Ich-Bild* is a typically large Merzbild, composed of collage elements — scraps of newspaper, shipping labels, and admission tickets — linked by thinly brushed areas of predominantly blue-green and brownish hues. The forms are arranged in the overlapping circles and slashing diagonal lines typical of Futurist paintings and of many of Schwitters's Merzbilder of this year. Circular forms dominate the center of the composition; movement seems to radiate from this center and revolve around it, creating a sense of hectic activity. He enhanced the feeling of urgency with a large black clock, placed in the otherwise light-filled center. It is fashioned from a round piece of

paper, its three hands clearly enunciated. The time appears to be just shy of eleven o'clock, the second hand rushing towards the twelve to bring the hour to its completion. Surrounding the clock are signs of city life: A series of large numbers revolve around each other, as if ticking off another sort of time; below, there is a fragment of a classified advertisement, showing the words "2 Last-Autos" (2 trucks), now evoking movement through verbal association. There is a suggestion of an architectural setting in the piling up of rectangular shapes at the margins of the image, set above shapes reminiscent of a viaduct or bridge that spans water – the blue-green area below – and architectural forms alike.

The work derives its title from the word "Ich" (I), inscribed into the work in Schwitters's own hand in blue paint. It is there not just once but twice: once just below the clock, written in his stiff gothic script like a musical annotation on four parallel lines, as if to be sung aloud; the other right below the first, also partly hidden under a layer of wash, but the flamboyant capital "I" clearly visible. The representation of the self is suspended in space below the towering clock and above the advertisement for the trucks. Schwitters locates himself in a setting where nothing is anchored and everything seems in flux. Here fragments are superimposed upon fragments, circles are layered over other circular forms, and even the "Ich" is fragmented and supplanted by the second "I." The work is organized around formal tensions derived from Futurist sources, presumably Carlo Carrà's well-known collage *Patriotic Celebration* (1914). Schwitters plays off circular forms against slashing diagonals, light areas against dark, and juxtaposes the painterly with the machine-made, the handwritten with the printed word. Yet, on a psychological plane, Schwitters does not celebrate modernity in the Futurist manner; instead, he works with the concept of displacement. The "I," partly present, partly absent, is located in the composition in the area of intense motion and destabilization, dominated by the signifiers of a materialist world.

Das große Ich-Bild powerfully visualizes Georg Simmel's observation, made in his 1903 essay "The Metropolis and Mental Life," that "the deepest problems of modern life flow from the attempt of the individual to maintain the independence and individuality of his existence against the sovereign powers of society, against the weight of the historical heritage and the external culture and technique of life." Charting the history of antagonism between the individual and society, Simmel finds a constant:

The same fundamental motive was at work, namely the resistance of the individual to being levelled, swallowed up in the social-technological mechanism. . . . The psychological foundation, upon which the metropolitan individuality is erected, is the intensification of emotional life due to the swift and continuous shift of external stimuli.[12]

Much as he did in the watercolor drawings, Schwitters presents a world in chaos and the self – here now clearly enunciated as such – displaced by the signifiers and actual fragments of materialist society. His use of collage material thus differs

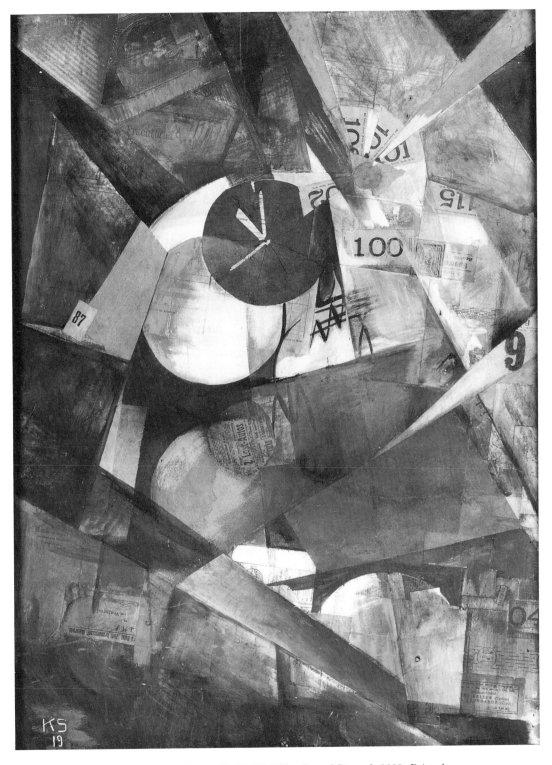

Figure 59. Schwitters, *Merzbild 9b, Das große Ich-Bild* [The Great I-Picture], 1919. Painted collage, 96.8 × 70 cm. Museum Ludwig, Cologne. Photo: Rheinisches Bildarchiv, Köln.

fundamentally from the Berlin Dadaists' use of the "new materials." It may be useful to consider a Berlin Dada collage of the city in conjunction with Schwitters's *Das große Ich-Bild*, George Grosz's and John Heartfield's collaborative *Das Leben und Treiben in Universal-City um 12 Uhr 5 mittags* [Life and Events in Universal-City at 12:05 noon] (ca. 1919; Fig. 60). It concretizes Heartfield's dictum, derived from a thorough appreciation of modernity and rejection of traditional easel painting, that the "newspaper, street, and advertisement" should serve as the new sources for art. The two artists employ the metaphor of the street twice, once as actual location of their representation, the other as a temporal metaphor as symbol for the unfolding of events in film. Like so many collages, this too is built up vertically, so that a visual movement is achieved through the pictorial arrangement of the different collage elements, and a physical, yet equally symbolic movement from a bottom to a top layer. The center of the composition is taken up with one of Grosz's caricature drawings of urban-militaristic aggression. Here one can make out angry faces, police helmets and uniforms, all indicative of a street brawl and urban chaos. Surrounding that dense central image of interlocking figures are more loosely arranged text fragments and film clips that seem to be set in motion by a large wheel placed in the foreground of the composition. References to American Westerns are placed next to Hollywood and advertising beauties and architectural and mechanical forms.[13] Image and text join the diverse activities of film, theater, and Dada and show them as closely interdependent.

In this city of make-believe ("Universal-City" refers to the UFA Berlin film studios) different realities and different modes of representation are reflected upon each other, but photomontage is the dominant mode – "Photoplays" announces one sign within the composition, an idea more humorously expressed with the photograph of a male leg clad in garters (just below the words "The Firefl") administering a kick to the delineated chaos of the street. The leg pushes back the traditional craft of drawing, yet it also establishes a link between the two distinct areas of the composition. Thus it declares chaos to be endemic to both. It is significant, though, that the world of the cinema and mass media is shown as more open – in spite of allusions to racism in the combination of advertisement copy ("The Sun Bleaches Old Bleach") and a photograph of three blacks – and, with the emphasis on American words and images, put in opposition to the "decaying culture of Europe." Most important, reality is not experienced directly by a sensitive self, as in Schwitters, but as a secondhand construct fabricated for mass consumption. Thus, Schwitters uses materials gleaned from mass culture, but imbues them with personality and hides them under thin layers of paint, whereas Grosz and Heartfield underscore in their choice of advertising photographs the lack of individual differentiation. Schwitters reclaims the fragments of mass culture for the individual; Grosz and Heartfield replace the individual with the objectified images of mass culture. The Berlin Dadaists use collage to explode the structures of bourgeois society; Schwitters uses his found materials to comment on an explosion that – to his mind – has already

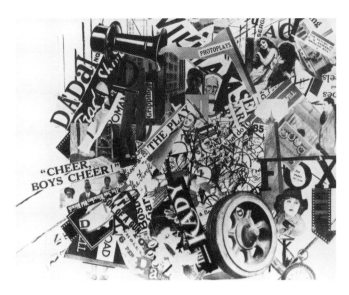

Figure 60. George Grosz and John Heartfield, *Das Leben und Treiben in Universal-City um 12 Uhr 5 mittags* [Life and Events in Universal-City at 12:05 noon], ca. 1919. Dimensions and whereabouts unknown.

taken place. In Schwitters's collage the self is shown in tension with the materialist world; and although the self seems to be in danger of being effaced by the chaos surrounding it, there is an attempt at overcoming the crisis, to salvage and reaffirm the importance of the self through the act of inscription.

Merzbild 5b, Rot-Herz-Kirche [Red-Heart-Church] (1919; Fig. 61) creates a link between the representation of the self as in *Das Große Ich-Bild* and the collages addressing political topics. It is a work that has grown over time, for Schwitters added several collage elements and painted over other parts at a later stage.[14] Once again, he fashioned a composition around circular elements, here a circular form placed slightly to the left of center. It is painted on top of several overlapping newspaper clippings, which together form an inclined rectangle reminiscent of the tabletop in *Aq. 1.* Indeed, several other images within the composition link this work to the watercolor series: a church, a heart crossed by an arrow, and a flowerlike geometric abstraction next to it, as well as the number 69, all outlined in red. Even the geometric forms, such as the circles and triangle, are evocative of the earlier drawings. The pictorial elements define the image as part of the Anna Blume theme; the newspaper clippings, however, ascribe this Merzbild to the series of politically inspired collages.

The long, narrow strip of newsprint cutting across the upper right-hand corner bears the date of March 22 [1919], and the text reports on the formation of a revolutionary government in Hungary.[15] Significantly, the newspaper relates in German that the events in Hungary are still evolving, "a confirmation of this alarming

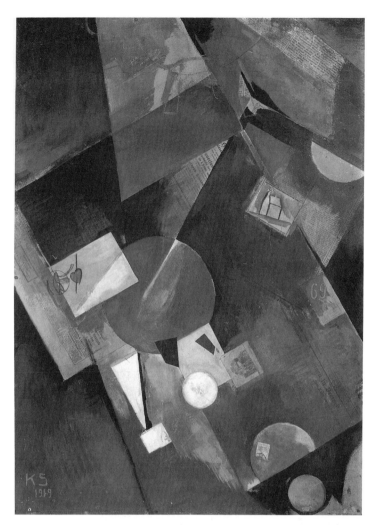

Figure 61. Schwitters, *Merzbild 5b, Rot-Herz-Kirche* [Red-Heart-Church] (final version), 1919. Painted collage, 83.5 × 60.2 cm. Solomon R. Guggenheim Museum, New York.

Figure 62 (facing). Schwitters, *Merzbild 5b, Rot-Herz-Kirche* (early version).

Figure 63 (below). Schwitters, *Merzbild 5b, Rot-Herz-Kirche* (detail of early version).

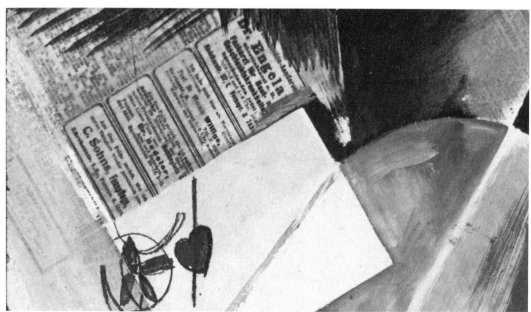

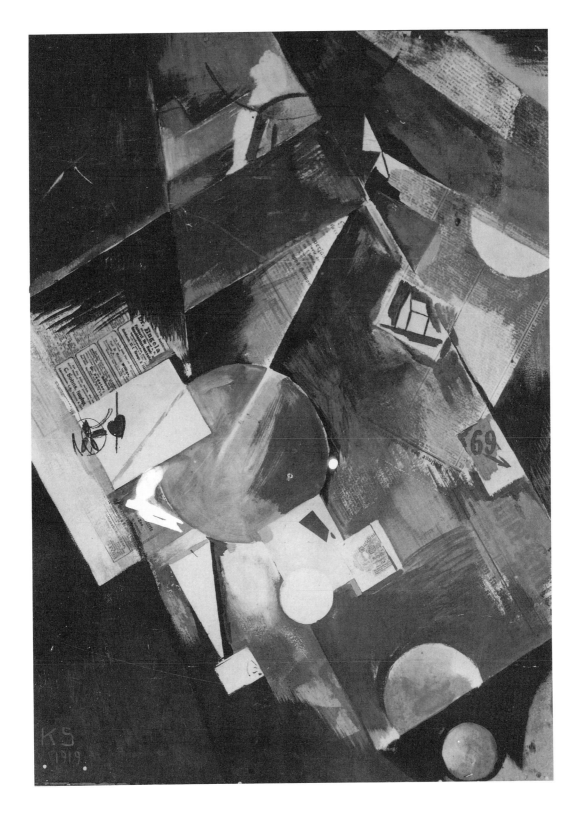

news from Hungary has not yet. . . . " The large clipping on the lower right-hand side stems from a front page of the *Hannoverscher Kurier*, a local Hannover paper. It reports another communist-related event: the arrival of government troops in the city of Bremen on Tuesday, February 9th, to bring an end to Soviet rule there.[16] That Schwitters brought together temporarily separate but politically related events – in fact, that he would keep a news clipping for at least six weeks – indicates that he considered the Hungarian erection of a communist government important enough to reconsider it in light of the toppling of a communist government by government troops at home. Playing off one event against the other – the formation of one communist government against the demise of another – Schwitters introduces into this composition the theme of inversion that had formed such a prominent part of the Anna Blume series. The ideological dimension of inversion is clearly spelled out: Inversion may create chaos, but reconfirms, in Schwitters's vocabulary, the status quo.

Schwitters undermines even further the power of the political news about revolution and counterrevolution with the inclusion of more humorous or pedestrian information. This is more clearly seen in the earlier version of the work (Fig. 62). There, the drawing of the church, which is inserted on a small piece of cardboard into a window cut into the newspaper clipping, is surrounded by a text reporting the latest news from Hannover's shop windows, in which the "picture of the day" may be admired.[17] Here, Schwitters plays one of his favorite games with meaning and perception. Presenting a text that tells of shop windows in which pictures are displayed, Schwitters cuts a rectangle into the text and shows his own, self-made picture within the text. He engages in a related, but less obvious game in the left-hand side of the composition. There, Schwitters placed several classified advertisements culled from the newspaper next to his rendering of a heart and flower; among these is an advertisement placed by a medical specialist for skin and sexual diseases and a second by a neurologist (Fig. 63). Schwitters locates his signifiers of desire next to texts that suggest a possible negative outcome of sexual desire: disease. This play is reminiscent of similar verbal/visual plays in several of Picasso's earlier collages, especially his *Guitar*, 1913, in which he engaged in a closely related visual/psychological game. Schwitters hid these allusions in the later stage of his work under a layer of paint, further increasing his game of hide-and-seek with the viewer. There is no need to assume a direct influence; rather, this similarity in approach indicates how collage lends itself readily to verbal and visual game playing, in which play is explored and advertised as a vital component in the creative rethinking and transformation of the self and, by extension, society.

In contrast to the watercolor drawings and also to the political collages, *Rot-Herz-Kirche* is woven together with fragments taken from many different spheres. The political and the private inform each other, and in the center of the composition, surrounded by the circular elements, the different elements fuse. In *Mz. 170, Leere im Raum*, Schwitters offers a political vision filtered through his personal emotions;

in *Rot-Herz-Kirche*, he mingles political news with banal announcements and takes an ironic look at his own desires. This Merzbild announces Schwitters's worldview: For him everything is interconnected; the political is a mere extension of the private. For Schwitters, the political is not the primary focus. When he does address a political issue, the specific reference functions only as a starting point, after which the topic is moved quickly to another plane and in the process voided of its specificity. Formally, this happens in the process of subordinating the newsprint fragment to the larger structure of the collage, where it is considered as just another (pictorial) event among many. The aesthetic is the organizing principle and denies the political its specificity and bite. Consequently, the collage element functions as an indicator of both nearness and distance: It provides material, political immediacy, but after having been transformed into a pictorial element, also points to the timeless.

Schwitters's method of playing off, as he called it, "sense against nonsense," which is particularly apparent in *Rot-Herz-Kirche* in the contrasting of the political with the banal and jocular, is indebted to Expressionism. It is particularly reminiscent of the Expressionist poetic devices developed before the war by Jacob van Hoddis, one of the poets Schwitters admired. Kurt Pinthus chose van Hoddis's well-known poem, "Weltende" [The End of the World] (1911), as the opening lyric in his epochal 1920 anthology of expressionist poetry, *Menschheitsdämmerung*:

> The hat flies off the citizen's pointed head,
> All zones of air resound, as if with screaming.
> Roofingmen fall off and break in half,
> And on the coast, you read, the tide is rising.
>
> The storm is there, and savage oceans skip
> Upon the land to squash thick dams to bits.
> Almost everyone is plagued by sniffles.
> Railroad trains are falling off the bridges.[18]

This poem, often considered the first prototypical Expressionist poem, was tremendously influential when it first appeared. Johannes R. Becher, another Expressionist poet (later the poet laureate of the German Democratic Republic) recalled: "These two stanzas, these eight lines, seem to have transformed us into different beings, to have carried us up out of a world of an apathetic bourgeoisie which we despised and which we did not know how to leave behind."[19] It describes the apocalyptic end of a stable, well-ordered universe, but in an ironic, consciously antipoetic manner.

In "The End of the World" different realms of consciousness clash: By being contrasted with such banal observations that most people suffer colds, the news of impending disasters is seen ironically and devalued. Each line offers a brief, distinct observation quite unrelated to the preceding one, and with one exception, each line is a distinct syntactical unit; the result is the overriding impression of simul-

taneity. In this poem, as one critic described it, "heterogeneity is raised to the organizing principle, and thus the individual elements are lowered to a common denominator."[20] Johannes R. Becher considered the poem's simultaneity its most remarkable feature: "We seemed to be in the grip of a new universal awareness, namely the sense of the simultaneity of events. 'The End of the World' shows that ultimately everything in the universe is related to everything else."[21]

Schwitters, in his collages, seems to be giving van Hoddis's associative literary style concrete visual form. The collage elements function like van Hoddis's independent syntactic units, and much as the poet devalued his apocalyptic messages of trains falling off the bridges with such important news as hats flying off people's heads, so Schwitters devalues the important political news contained in his collages by placing them next to the banal.

Van Hoddis and Schwitters both implicate the press as the source of simultaneous experiences. The poet does so with the quick parenthetical insertion "you read"; the artist, with his use of newsprint. With this shorthand allusion to the contemporary fascination with the news media – and the news media's power of determining experiences – both describe simultaneity as a distinctly modern phenomenon. The Berlin Dadaists, of course, also saw in the newspaper a representative icon of modernity and targeted the headline as the source for their pictorial material, but employed it in a different manner and for different purposes. It is indeed in the use of the newspaper fragment that one can see most distinctly the difference between Schwitters's and the Berlin Dadaists' use of collage. As we have seen, the Berlin Dadaists resorted to the fragments of modern media culture to undermine the status of bourgeois art – aestheticism and the fabrication of illusionary realities – and to attack societal ills and individual complacency with punchy texts inserted into their images like so many headlines.

Van Hoddis, too, seems to set up the bourgeoisie for criticism. In fact, a recent critic has suggested that the poem is not concerned with the end of the world at large, but only the end of the bourgeois world.[22] Yet van Hoddis softens his critique of bourgeois perception with his gentle irony. Similarly, in Schwitters, irony defuses the political. Neither a critique of bourgeois perception or behavior nor a review of the political is allowed to unfold, for he subsumes all of his different observations, represented by his diverse collage materials, within the aesthetic. Although he uses the newspaper fragment and the collage medium and thus acknowledges fragmentation as a given, he employs the medium to develop a new aesthetics of transformation that would incorporate the experience of rupture and loss, but at the same time lessen its blow.

In many a statement Schwitters acknowledged the primacy of art over politics and other concerns. In his article "Merz" of 1920, he even addresses the issue twice: "Art is an Ur-principle; exalted like a deity, inexplicable like life, indefinable and without purpose."[23] Considering Merz in relation to Dada, Schwitters continued, after quoting from the 1918 Dada Manifesto and from several texts on Dada by

Richard Huelsenbeck, to denigrate Dada's partisan cause. Playing with Huelsenbeck's name to underscore the association with an empty shell or husk ("Hülse"), Schwitters states:

Husk-Dadaism [*Huelsendadaismus*] is politically oriented, against art and against culture. I am tolerant and let everybody have his *Weltanschauung*, but I must state that such considerations are alien to Merz. Merz aspires, as a matter of principle, only to art, because nobody can serve two masters at the same time.[24]

In 1923, Schwitters formulated his position in favor of art even more strongly in the so-called Manifest Proletkunst. Cosigned by Tristan Tzara, Hans Arp, and Theo van Doesburg and published in the second issue of his *Merz* magazine, it polemicized against political art:

Art is a spiritual function of man, which aims at freeing him from life's chaos (tragedy). Art is free in the use of its means in any way it likes, but is bound to its own laws and to its laws alone. The minute it becomes art it becomes much more sublime than a class distinction between proletariat and bourgeoisie.[25]

The issue of a politically engaged art as opposed to pure art was clearly troubling to Schwitters, for he returned to it again in the same issue of *Merz:*

I compared Dadaism in its most serious form with Merz and came to this conclusion: whereas Dada merely poses antitheses, Merz reconciles antitheses by assigning relative values to every element in the work of art. Pure Merz is art, pure Dadaism is non-art; in both cases deliberately so.[26]

The antithesis of Dada and Merz, which is based on the contrasting definitions of art as political and aesthetic activity, is made strikingly apparent in a small collage that Schwitters paired with his emotionally powerful *Mz. 170, Leere im Raum.* Where he offered a resigned view of the self in the face of overwhelming political events in that collage, he presented a positive notion of artistic activity in *Mz. 169, Formen im Raum* [Forms in Space] (Plate 6). Even in its title it is diametrically opposed to *Leere im Raum.* Where there was emptiness and dread in that collage, there is fullness and activity in this work, implying a positive relationship to space. The German word "Formen," as the plural of "Form" (form) has several connotations, ranging from "form" and "model" or "mold" to "usage" and also "behavior." "Formen" is also a verb, and its lexical field includes "composing," "shaping," and "modeling," so that Schwitters suggests in his title either a space filled with forms or, metaphorically, a model, or the process of creating as forming. The collage amply fulfills what the title suggests. The pictorial space is filled with many different shapes: Triangles, rectangles, and polygons of rich and varied textures and color create a busy, yet ordered, composition. The execution literally suggests the opposite of *Leere im Raum* and its sparse composition. Here Schwitters builds up the surface with many overlapping layers of transparent, semitransparent, and opaque materials.

Although composed of fragments, the collage is harmonious in design. There are no abrupt changes in scale or color; textures are chosen to complement each other, as for instance the broad-weave netting on the right-hand side and the strip of narrow-weave netting on the left. Where individual forms threaten to tumble into space, as in the center of the composition, they are arrested and securely affixed to the supporting plane with a thin layer of tissue paper. The three horizontal bars at the middle of the lower margin, with their curlicue decoration on the lowest bar, elegantly block the fragments into the confines of the composition. The fragments are chosen from a variety of sources, but they are so carefully balanced against each other and subjugated to an ordering hand and eye that one is barely aware of their different origins.

The joining of disparate elements and the positive transformation of space ("Raum") are the main themes of this collage. Because the individual fragments as found and reconstituted objects are carriers of history, Schwitters's process of joining and reshaping is a metaphorical reshaping of history. *Formen im Raum* stands in contrast to the resigned, empathic view Schwitters takes of history in *Leere im Raum*. In this collage, Schwitters suggests that we can take an active part in the shaping of our historical situation. He takes the refuse of his contemporary society as his artistic material and subjects it to a process of transformation, turning the debris into form or, metaphorically speaking, models of positive change.

The collage *Formen im Raum* illustrates that Schwitters thought of the various collage elements as contributors to a larger whole, as building stones to a newly defined *Gesamtkunstwerk* (total work of art). That he considered his various fragments merely as triggers in the pursuit of artistic production is clarified in another statement in his "Merz" article from 1920:

My aim is the total work of art [*Gesamtkunstwerk*], which combines all branches of art into an artistic unit. . . . First I combined individual categories of art. I have pasted together poems from words and sentences so as to produce a rhythmic design. I have on the other hand pasted up pictures and drawings so that sentences could be read in them. I have driven nails into pictures so as to produce a plastic relief apart from the pictorial quality of the paintings. I did so as to efface the boundaries between the arts.[27]

The effacing of boundaries to achieve a new, larger totality (the *Gesamtkunstwerk*) reveals a revolutionary impulse. Transformation is Schwitters's aim — not a transformation that will turn societal structures upside down, but rather a transformation that will alleviate differences between opposites. Schwitters, following Kandinsky, envisions the effacing of boundaries as a comprehensive project that includes all branches of art. Schwitters's *Das Und-Bild* [The Und (and)-Picture] (1919; Fig. 64) is the pictorial announcement of his goal of linking disparate parts. In this Merzbild, the conjunction "and" creates a verbal and visual link between an odd assortment of found objects and bits of text. A fragment itself, it functions, however,

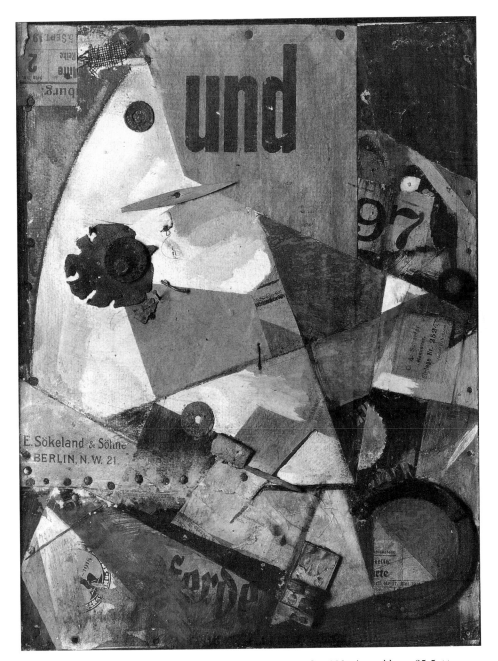

Figure 64. Schwitters, *Das Und-Bild* [The Und (and)-Picture], 1919. Assemblage, 35.5 ×
28 cm. Staatsgalerie Stuttgart.

as the integrating element within a work composed of fragments and invites the viewer to playfully construct connections with the other text fragments, numbers, torn papers, colors, or textures assembled in this work. As a concrete bit of material reality, it effects a link between the work of art and the external world.

Schwitters's emphasis on accommodation and reconciliation and his essentially moral definition of art stands in sharp contrast to that of the Berlin Dadaists, who proclaimed the utmost erosion of societal cohesion as their goal. Collage, for Schwitters, was a constructive rather than a destructive medium. The most radical wing of the Berlin Dadaists – Huelsenbeck, Grosz, and Heartfield – sharply criticized Schwitters for his artistic tendency and called him a latter-day Romantic. Said Huelsenbeck after a visit to Schwitters:

He lived like a lower middle class Victorian. . . . To me, at that time a very unruly and intolerant fellow, he was a genius in a frock coat. We called him the abstract Spitzweg, the Kaspar David Friedrich of the Dadaist revolution.[28]

Nor did Huelsenbeck's estimate change:

Such was Schwitters: the highly talented petit bourgeois, one of those rationalizers of genius who give off a whiff of the stew on the back of the stove as they emerge from the German forest or make their way down the Spitzweg past gingerbread houses.[29]

Schwitters himself was keenly aware of the differences between Merz and Dada. He saw, however, that not all Dadaists were alike and discerned similarities between himself and other Dadaists. To strengthen his own position, Schwitters devised the term *Kerndadaist* (the kernel or core dadaist – as opposed to the husk), implying that there was a superior or somehow truer form of Dada, and described himself as closely connected to such "Core-Dadaists" as "Tzara, Arp, Picabia, Ribemont-Dessaignes and Archipenko" [sic]:

Tristan Tzara, the leader of the Core-Dadaists, wrote in the Manifest Dada in 1918: "Everybody makes art according to his own liking" and "Dada is the mark of abstraction." I must state that Merz has much in common with this kind of Core-Dadaism and maintains a close artistic friendship with [these] Core-Dadaists. . . . Merz rejects energetically and as a matter of principle Mr. Richard Huelsenbeck's inconsequential, dilettantish views on art.[30]

Collage, then, in postwar Germany was defined in rich and different ways. Schwitters's aesthetic reintegration of fragmented materials into a pictorial context stands in contrast to some of the Berlin Dadaists' self-conscious use of the newspaper fragment or the photograph culled from an illustrated magazine as antiaesthetic material employed to undermine aesthetic and artistic conventions. Whereas Schwitters sought to rid each of his elements of their *Eigengift* – their personality poison – the most radical Dadaists scrupulously kept that quality intact. Yet even within one artist's work, predetermined standards are not always adhered to, and deviations from the ideal occur. An analysis of those of Schwitters's collages that address the

political issues of his day clarifies that content cannot be separated from the form or the medium. In his works, content informs the medium and vice versa. Together they permit us to place Schwitters within a progressive field – as indicated by his consistent use of collage in its various forms – but also reveal his traditional, that is, purely artistic, tendencies. In Schwitters, tradition survives precisely in the interaction of form and content.

REFASHIONED TRADITIONS

Employing collage for his varied artistic productions, both literary and visual, from 1918–19 until his death in 1948, Schwitters abandoned the representation of the external world in favor of increasingly abstract constructions. In the process, the human figure that had such a strong presence in Schwitters's precollage work disappeared almost entirely from his art. When it did appear as a ready-made image on a collage fragment – as, for example, in *Mz. 26, 41, okola* (1926; Fig. 65) – it was most often marginalized, treated as no more significant than any other image; or it was represented through a linguistic sign, as the name Oscar in *Mz. 313, Otto* (1921; Fig. 66) or through synecdoche, as when the sole of a shoe stood for the entire person in the late collage *Once upon a time, 47/8* (1947; Fig. 67). In hiding the human figure and substituting prefabricated signs for its artistic representation, Schwitters emphasized the break with tradition and the ascendancy of a new visual language.

Schwitters, however, did execute a group of collages, about twenty in number, between 1920 and 1923 for which he took as his subject the human figure, especially the female. We do not know whether he conceived of these collages as a group; however, they are clearly related by subject matter, the type of material used, and formal solutions. In spite of their focus on so traditional a subject matter, these collages in fact underscore Schwitters's break with tradition and highlight his turn toward modernism, for they depict women in terms of their modern mass cultural representations via the mannequin, the fashion plate, film, and even pornography. Calling attention to the cultural suppression of individuality in favor of the creation of types, this collage series comments on the commodification of life – in particular, of social relations – in Weimar Germany. Love was no longer described as desire for the beloved, but as desire for an artificial construct, the commodity.

Yet these collages also betray Schwitters's ambiguous attitude toward modern women, and in doing so, reveal the multifaceted nature of modernism in Weimar Germany. Although Schwitters described himself in 1930 as "freed" and proclaimed

Figure 65 (right). Schwitters, *Mz. 26,41, okola,* 1926. Collage, 17.7 × 13.8 cm. Private collection.

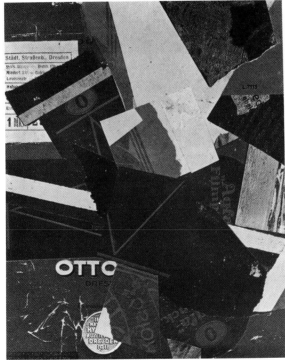

Figure 66. Schwitters, *Mz. 313, Otto,* 1921. 17.8 × 13.8 cm. Marlborough Fine Art, London.

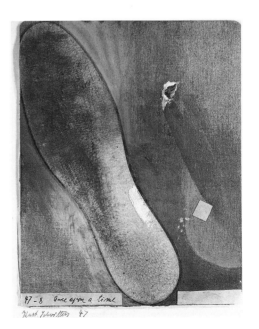

Figure 67 (right). Schwitters, *Once Upon a Time,* 47/8, 1947. Collage, 22.5 × 18.2 cm. Private collection.

that "everything had broken down in any case,"[1] his collages of women plainly show an inversion of socially determined attitudes before and after the war: His works, as well as the more outspokenly misogynist efforts of some of the Berlin Dadaist and New Objectivity artists are, in fact, much more sexist than are artworks from the late 1890s and early 1900s. Their antimodernist subtexts stand in seeming contradiction to the modernist medium employed. In this group of works, we find another example of the conflicting political, social, and cultural trends – the simultaneous embrace and rejection of the new – that characterized life in the Weimar Republic in general and Schwitters's work in particular.

Schwitters's prewar representation of women focused almost entirely on his wife Helma, whom he had married in 1915. She served as his model for several genre paintings and a series of psychologically probing renderings, for example *Vision* [Vision] (see Fig. 19) or *Trauernde* [Mourning], both of 1916–17.[2] The thickly brushed oil portrait, *Helma Schwitters mit Blume* [Helma Schwitters with Flower] (1917; Fig. 68), typifies the painting of Schwitters's precollage period. Although the figure is somewhat stylized, particularly in the gesture of holding a flower, Schwitters's emphasis on facial expression, above all the eyes and the mouth, clearly reveals his effort to capture the sitter's personality. Based on an earlier artistic model, Paula Modersohn-Becker's *Selbstbildnis mit Kamelienzweig* [Self-Portrait with Camelia] of 1906–7 (Fig. 69), this somber portrait of Helma was self-consciously placed in an art-historical context.[3] Thus Schwitters described painting in general and ratified his own work in particular, as part of an artistic genealogy.

Not so his collage, *Mz. 180, Figurine* of 1921 (Fig. 70). Although there is a vague and, most likely, chance resemblance to the portrait of Helma in the prominence of the figure's gesture, all similarity ends there. Inspired not by an artistic precursor but by contemporary popular culture, *Figurine* illustrates a radical break within Schwitters's artistic production and comments on a changed relationship between the artist and his product. This relationship is brought into sharper focus by the text fragment "Alleiniger Lieferant" (exclusive purveyor) in the lower left, where one would expect to find the artist's signature. Schwitters's evocation of exclusivity ironically addresses the traditional status of the artist as the creator of unique objects; adopting the language of commerce as well as prefabricated and mass-produced materials in order to construct an object rather than craft a painting, he contradicts the message of uniqueness and authenticity that a signature implies. The artist playfully likens himself here to a merchant, a deliverer of goods that could be duplicated on demand. At the same time, Schwitters seems to be making an autobiographical pun, subtly pitting himself as the creator and sole purveyor of Merz against the more numerous products of Dada, and in so doing, salvages the status of the artist as a special being.

This small collage is expressive of Schwitters's conflicting needs. It tellingly reveals his self-conscious modeling of his artistic persona and indicates that Schwitters investigated his artistic precursors in light of the changed conditions of modern

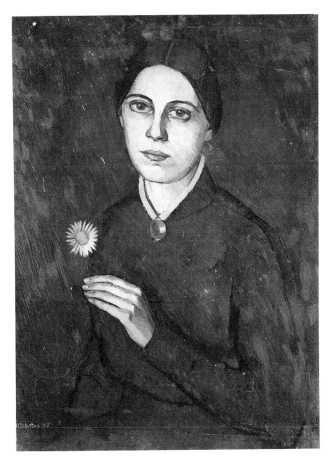

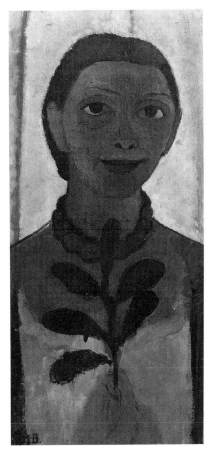

Figure 68. Schwitters, *Helma Schwitters mit Blume* [Helma Schwitters with Flower], 1917. Oil on board, 66 × 48.9 cm. Marlborough Fine Art, London.

Figure 69. Paula Modersohn-Becker, *Selbstbildnis mit Kamelienzweig* [Self-Portrait with Camelia], 1906–7. Oil on board, 62 × 30 cm. Museum Folkwang, Essen.

artistic production. Schwitters's remaking of Helma into a paper doll is reminiscent of his Expressionist forebears, such as Klimt, who wove his representations of his female models into a tapestry of abstract designs and in the process denatured and robbed his sitters of their individuality, and also of many of his contemporaries' fascination with dolls and mannequins. In keeping with postwar aesthetics, Schwitters, however, shifts his focus from the decorative to the machine-made. His urgent search for a new way of relating to social reality – his quest for modernity – expressed itself in an increased formalism, and he, like Klimt, extended his quest for dominion to the female body.[4]

Schwitters's substitution of a mannequin for a life model, his wife Helma, points to many issues that will preoccupy him in his construction of femaleness. If the artist is here a merchant, his product is not a specific woman but rather a type and, more pointedly, a commodity whose exchange value and disempowerment are

implicitly revealed by the artist's exploration of substitution and repetition. Even the title confirms that Schwitters is no longer concerned with the representation of individuality: The word "figurine" does not describe a person, but a mannequin, a man-made and infinitely reproducible product stamped by machine.

Schwitters evokes a paper doll cutout in this collage, not only in this use of paper fragments but in his arrangement of forms. He cut the head and limbs from an illustration of dress patterns, a feature recently added to the new woman's page of the local newspaper, the *Hannoverscher Kurier*. A bit of newsprint, its outline shaped not by the artist's brush but by a precision instrument – a pair of scissors – creates the fabric of the skirt. Hence the final image is a seemingly arbitrary composite, one of many possibilities available to the artist. Schwitters even invites the viewer to participate in the completion or elaboration of his *Figurine*, with a directive written below the collage: "Papier ist die grosse Mode. Besatz Holz. Ecken abrunden." (Paper is big in fashion. Trimming wood. Smooth the edges.) In the period of shortages after the war, paper had become a scarce commodity and was thus as desirable as any fashion item. For the artist Schwitters, moreover, paper was "big in fashion" indeed, because found and reused pieces had become his foremost artistic material. His call for an act of substitution, the trimming of wood instead of the usual fur or lace, is in jest but identifies his *Figurine* as utterly contemporary.[5] By inviting the viewer to collaborate in this emphasis on appearances and fashion, Schwitters characterizes the modern woman as a passive agent for the use and pleasure of others.

Schwitters's implicit representation of woman as a paper doll finds a more explicit parallel in a contemporary cartoon, Karl Arnold's *Die Dame der eleganten Welt zum An- und Ausziehen* [A Lady of the Elegant World to Dress and Undress] (Fig. 71), which was published in the satirical magazine *Der Simplicissimus* in 1921.[6] The caricaturist surrounds a paper doll with numerous items of elegant apparel, ranging from lingerie to coat and hat and including all the necessary accessories to complete a modern fashion look. Clearly Arnold is implying that female identity is a matter of role-playing, of construction, and that it can be changed as readily as a costume. Each change of clothing defines another role, but one taken on only on the level of appearances. It is just one of the many – all versions of the same – played by a woman of leisure: promenading, riding, entertaining. These roles, Arnold suggests, are interchangeable, and their function is limited to providing visual and theatrical pleasure. Arnold denies woman real presence or functions in society, for he reduces the wearer of these different fashions to the status of a paper doll, dressed by someone else for another person's enjoyment. His society lady is a plaything without identity. Women, according to both Arnold's and Schwitters's representations, can try on new roles, but only those fashioned for them by somebody else; denied expression of an interior or intellectual life – of personal needs or desires – they derive their identity only through the activity of others.

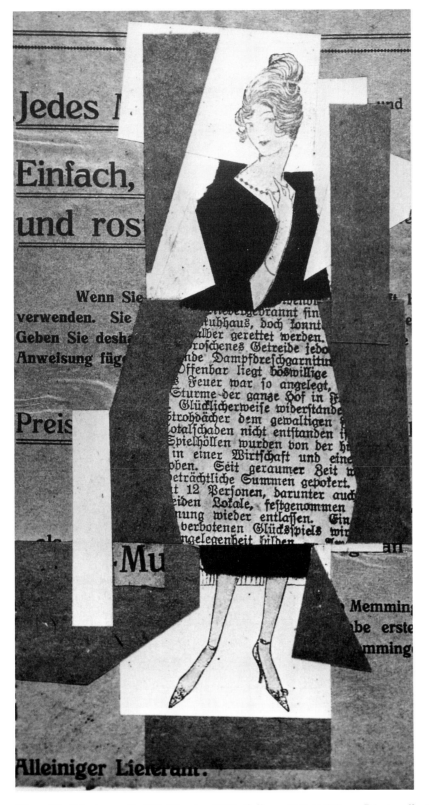

Figure 70. Schwitters, *Mz. 180, Figurine*, 1921. Collage, 17.3 × 9.2 cm. Private collection.

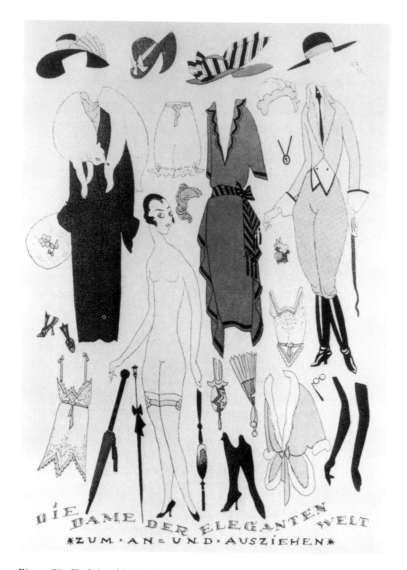

Figure 71. Karl Arnold, *Die Dame der eleganten Welt zum An- und Ausziehen* [A Lady of the Elegant World to Dress and Undress]. *Der Simplicissimus* 26 (33):436, 1921. © 1992 ARS, New York/Bild-Kunst, Bonn.

With *Zeichnung I6, Mode I* [Drawing I6. Fashion I] (1920; Fig. 72), Schwitters elevates reproduction to artistic status. The work is a ready-made image, apparently a trial print salvaged from the Molling factory, a local printing company, and taken over unaltered; he turned it into a work of art by giving it a title and signing and dating it.[7] As such it is inspired by Marcel Duchamp's ready-mades and partakes in the contemporary discussion about the function of art in a period dominated by mechanical production and reproduction.[8] Schwitters called such ready-made images "i-drawings" and described the limits of his role in their creation: "The only act of the artist in the case of *i* is the metamorphosis of a given object by singling

Figure 72. Schwitters, *Zeichnung 16, Mode I* [Drawing 16, Fashion I], 1920. i-Zeichnung (i-drawing), 14 × 10.3 cm. Marlborough Fine Art, London.

act of the artist in the case of *i* is the metamorphosis of a given object by singling out a part that is rhythmic in itself."[9] Schwitters's i-drawings are thus his most rigorous collages. In the case of *Zeichnung 16*, Schwitters effected the metamorphosis of the image through selection, the trimming of the found object to reveal its most meaningful part. Schwitters's claim for his i-drawings is formal, yet his singling out of a significant detail reintroduces the possibility of content within a

"rhythmic" fragment. He further emphasized this possibility by giving the work a descriptive title, "Fashion I." Stressing the role of the artist as selector of significant passages, Schwitters, almost in spite of himself, reintroduces the traditional perception of the artist as a trained eye. His selections are not random, but the result of artistic acumen. As is so typical of his collage work, Schwitters here too worked with multiple layers of meaning, which is precisely the issue: the contradiction between stated goal and actual pictorial solution. Schwitters sought to emphasize form over content, but in this series of collages he did not suppress content. In his choice of the ready-made image and fashion as subject matter, he reveals a fundamental conflict between innovative and traditional approaches to art making and reasserts artistic traditions within the new methods. By definition, fashion embodies the forever new and thus points to the modern, but fashion also, as Georg Simmel observed, "renders possible a social obedience"[10]; it perpetuates the commodification of women and thus of traditional social mores. In addressing the modern woman as the wearer of fashion rather than as the newly emancipated citizen she had become in Weimar Germany, Schwitters suppresses woman's newfound political and social prominence.

Zeichnung 16 uses a lithograph depicting a fashionably attired man in the foreground and an equally elegant couple strolling under trees in the background. Superimposed over the image is a fragmented text, printed sideways, so that it appears on first glance simply as an overlying structure. This ready-made i-drawing, transforming into a postwar idiom the theme of urban man that Schwitters had already depicted in 1918, delineates the drastic change collage initiated in Schwitters's work. In such an earlier work as *Z. 42, Der Einsame* [The Lonely One] (1918; Fig. 73), the artist rendered a state of deprivation – the isolation felt by a man without a companion in an urban crowd. He conveyed this emotion in an Expressionist manner with angular lines and heavy shading that articulate distinct areas in the composition and contribute to a profound sense of separation and lack of communication. In his i-drawings, Schwitters reinterpreted the psychology of social relations in terms of the contemporary preoccupation with both fashion (the image) and cost-effectiveness (the text). The formal presentation of the elegantly dressed couple and single male, in conjunction with the superimposed text reporting on calculations of construction costs, accentuates Schwitters's concern with questions of artistic form and effectiveness. The theme of fashion itself draws attention to Schwitters's abandonment of his past and his own new "clothes" as an avant-garde artist.

Obviously drawn to this lithographed image that served as the ground for *Zeichnung 16*, Schwitters used it again as the support for a collage in 1920: *Mz. 158, Das Kotsbild* [The Vomit Picture] (Plate 7). In this work, however, the focus shifts to the relationship between the sexes and reveals in rich complexity how Schwitters perpetuated, in fact, politically conservative views of women. Using a larger section

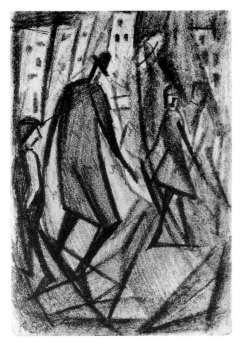

Figure 73. Schwitters, *Z. 42, Der Einsame* [The Lonely One], 1918. Black chalk on paper, 16 × 11 cm. Galerie Stangl, Munich.

of the lithograph than in *Zeichnung 16*, Schwitters both manipulated and obscured the image with the application of collage elements. The man who was in the right foreground of *Zeichnung 16*, here Janus-faced in an accident of the printing press, forms the vertical axis of the composition. He is surrounded by visual and verbal references to women that range from a glimpse of erotically exposed ankles and faces casting alluring glances, to references to women's professions. Although woman is shown as ever-present and tempting in her pictorial manifestations, verbal references in the collage's text fragments point to her more threatening aspects, which elicit feelings of anxiety and disgust. The word "Frauenberufe" (women's professions), directly below the domineering image of the man, is surrounded by such words as "Kots" (phonetic spelling of "Kotz" = vomit) and "Hundehalsbänder, speziell runde und halbrunde Würger" (dog collars, especially round and half-round choke collars), evoking gagging and choking. The collage further abounds with references to money, all of which are tied to the representation of woman: the centrally placed banknote with its repetition of two female heads, the word "Pfennig" (penny) and a torn money bill under the transparent paper below the words "Anna Blume," and several discount coupons ("Rabattmarken") along the left margin of the composition.

143

The name Anna Blume refers to Schwitters's poem "An Anna Blume" (1919; see Chapter 4), his parody of love poetry, and evokes the many paradoxical qualities of its heroine and Schwitters's complex relationship with her. In the poem Schwitters linked Anna Blume to the mechanical ("Anna Blume has wheels"); now he relates Anna's mechanical properties to the collage process itself, creating a clear visual equation between the female, the modern, the mechanical, and the artistic process. In the poem, Anna also symbolizes desire; but we remember that on a different plane the name came to symbolize Schwitters's own success, for the poem had propelled him almost overnight to international fame. Schwitters skillfully exploited the fame of his best-known product. He began to advertise his visual works with references to Anna Blume, glued stickers with Anna Blume's name on walls, trams, and any other surface, and formulated the equation "Kurt Schwitters = Anna Blume." In the collage, various text fragments (including the Anna Blume sticker) evoke commercial exchanges with references to price, receipt, and the good value of a product. Such references, in a work where ready-made images are substituted for the traditional craft of the painter, imply that for Schwitters the transition from a precapitalist to a capitalist society was complete and mirrored in male–female relationships, now reduced to a matter of commodity exchange.

"Frauenberufe" refers to the working woman, or New Woman, and points to a pressing social and political issue that functioned as another barrier to the union of men and women as modern, equal partners. During the war, women were incorporated into the work force in ever-increasing numbers to fill men's positions. In 1913, women formed 22 percent of the industrial work force; by 1918, their ranks had swelled to 35 percent.[11] Women had gained suffrage with the birth of the Weimar Republic, but public opinion about the role of women in the new society was decidedly mixed. The German woman's movement itself was conservative, advocating moderation and only gradual change so as not to arouse opposition.[12] But even the low-key approach to women's rights created strong opposition within the conservative population. After the war, sentiment against women focused especially on women in the labor force and the professions, when women were pressured to give up their jobs to provide work spaces for the returning veterans. "Frauenberufe" – women's jobs – were exchanged for "Männerberufe" – men's jobs. Those women who chose to keep their newly gained positions were increasingly seen as posing a threat to men, preventing them from regaining their "just" place in society and thereby subverting their masculinity.

In Schwitters's collage, the word "Kots" and the reference to choke collars in connection with "women's professions" powerfully allude to women as dangerous beings who need to be dominated. Although women were capable of providing pleasure, company, and status (the strolling couple), Schwitters, too, described them as potentially threatening, repeating an age-old metaphor that had found new credence in recent avant-garde literature, such as Frank Wedekind's *Lulu* or Kokoschka's short play of 1909, *Murderer, Hope of Women* (prominently presented in

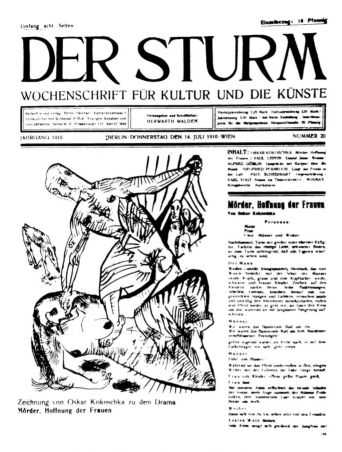

Figure 74. Oskar Kokoschka, *Murderer, Hope of Women*, 1909. Pen and brush, published as the title illustration for the play in *Der Sturm* 1(20)(14 July):155. © 1992 ARS, New York/ Pro Litteris, Zurich.

Der Sturm in 1910 with Kokoschka's own illustration on the cover page of a woman brutally attacked by a man (Fig. 74). Schwitters similarly evokes images of domination and brutality by making another reference to animals, this time to animal hides – the "useful," butchered animal – in the words "Sämischgares Rindleder" (chamois cowhide).

Through his mix of images of women as the embodiment of love and desire along with signs of commodity exchange, Schwitters links fashion and women to prostitution. This link is underscored by the specific representation of women in the collage as prefabricated types whose bodies and individual features are arranged for visual consumption and pleasure. Man projects a solid, almost immutable identity: His carefully delineated, realistically modeled face, doubled to survey both left and right, asserts his governing presence in the composition. Women, in contrast, line the margins of the image; they are fragments cut from fashion plates

145

without any suggestion of real presence. The only "complete" female figure is accompanied by a man, as if it were he who had given her presence. Lacking man's completion and solidity, women are represented only as abstracted and fetishized visions of the male imagination. But again, Schwitters presents us another perspective on male–female relations in the small untitled collage *Mz. 163* (1920), in which the idea of the woman once more suddenly appears very real. The collage itself is an abstract design, but Schwitters affixed a subtitle to it, following his Merz number and placed under his signature: "Mit Frau, schwitzend" (with wife/woman, sweating). On the most immediate plane, these words refer undoubtedly to collaboration, but they also suggest a powerful subtext that reveals women as dangerous, capable of producing in the man a psychological and physiological state of anxiety. More significantly among the text fragments in *Mz. 163*, one word stands out – the Dutch "Beroemde" (famous) – calling to mind Schwitters's occasional characterization of Anna Blume as "die Berühmte" (the famous). A comparison between *Mz. 163* and *Figurine* thus reveals an act of substitution that we shall witness again in other collages: Schwitters replaced his wife Helma with his own construction, either in the form of Anna Blume or the figurine. Schwitters's act is reminiscent of the behavior of Oskar Kokoschka who, after having been rejected by his mistress Alma Mahler-Werfel, redirected his lost control to a life-size effigy of his former lover, which he carried around town.

Schwitters gives us a less threatening but equally ambiguous view of women and the role of tradition in a later collage, *Die Handlung spielt in Theben und Memphis zur Zeit der Herrschaft der Pharaonen* [The Action Takes Place in Thebes and Memphis at the Time of the Rule of the Pharaohs] (ca. 1922; Fig. 75).[13] This more rectilinear work is dominated by a selection of heads offering a cross section of the representation of women in Western art since the late Middle Ages. It includes one of the angels of Rheims cathedral and the madonna from Stefan Lochner's *Madonna in the Rose Bower*. Schwitters contrasts these art-historical images with those of several decoratively coiffured women culled from contemporary fashion plates. Although the collage appears at first to represent the development of women and the changes in their status through time, there is a curious similarity between the appearance of the old and the new woman. They have the same elongated, delicate features, regardless of whether they represent an angel, a madonna, or a modern woman. Halo, crown, and hat frame the head in the same decorative manner. Through profile, three-quarter view, or downcast eyes, each avoids engaging the eye of the viewer. Even the gaze of the most contemporary figure at the lower right is screened by a veil. Using iconic representations of women – the madonna and her modern counterpart, the mannequin – Schwitters shows that they are products of the artist's and, by implication, society's imagination, and that they are related in their artificiality and universality as models of values and behavior.

Schwitters, who was an avid moviegoer and even considered making films himself, endowed this work with a filmlike sense of unfolding time. He adapted the film

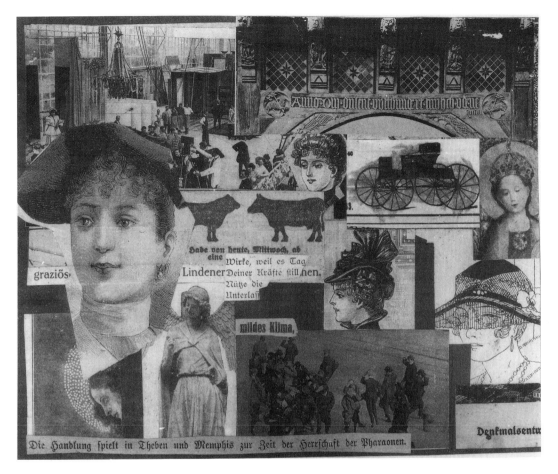

Figure 75. Schwitters, *Die Handlung spielt in Theben und Memphis zur Zeit der Herrschaft der Pharaonen* [The Action Takes Place in Thebes and Memphis at the Time of the Rule of the Pharaohs], ca. 1922. Collage, 16.2 × 20 cm. Private collection.

technique of cutting from frame to frame to create the impression of episodes, thus of distinct moments in time. These separate incidents are contrasted with the sense of continuity, the forever unchanging representation of women. Schwitters here gave visual form to what his contemporary, the philosopher Ernst Bloch, termed *Ungleichzeitigkeit* – by which he meant the experience of time as somehow asymmetrical, the sensation of being at two places or in two different time periods at the same time. Bloch thought that the news media in general and photographic imagery in particular could create a sense of simultaneity of totally unrelated realms of experience (a concept also explored by the Futurist artists and writers). Schwitters evoked simultaneity with the disparate and contrasting images imprinted on the individual collage elements.

That Schwitters is concerned with the imaging of women – particularly in the modern media and film – as yet another episode in the history of representation is

indicated by the cutout scene in the upper left of the collage, which shows a woman on a stage set performing for the camera. Although film, the modern mode of reproduction, will make her look real and lifelike, her image will in fact be as contrived and encoded as that of the other women in this collage. Significantly, both the crew and onlookers are male. In this collage, as in others in the series, Schwitters represents women as directed by men and performing for male visual pleasure; woman is given a narrowly defined realm for her activities, whereas man is shown as in command, actively defining the spaces in which he moves. A photograph, included in the lower center, enhances that impression: It depicts a group of contemporary men, some in uniform, holding on to their hats in a gust of wind but moving freely in the street. Schwitters's mixing of images of modern women, madonnas, and angels disclose a sense of continuity in man's perception and representation of women, a continuity that belies the modern era's subversion of tradition. The text, "the action takes place in Thebes and Memphis at the time of the rule of the Pharaohs," transports us back to ancient Egypt, but also forward to contemporary mass culture. These references create a link between past and present that underscores the sense of continuity created by the representation of women in this collage. In pointing to continuity, Schwitters demonstrates that he, too, is engaged in the age-old artistic pursuit of the construction and reconstruction of tradition. Even though Schwitters had declared his own break with the artistic traditions of the past, this collage indicates that the break was not complete; his perspective is one of historical connectedness, rather than rupture. Although Schwitters depicts modernity as an infinite succession of newly created images, these images are products of tradition that reflect the same stereotypes active in earlier periods.

Schwitters's representation of women as undifferentiated is indicative of a perception of women commonly held in this period. It was not only Otto Weininger who saw women as fundamentally different from men; it was a view of woman deeply embedded in the social psyche of the period. One finds it expressed in mass cultural journals, and even by progressive sociologists as, for example, Georg Simmel. In his essay "Prostitution" Simmel stated, "Women in general are more deeply embedded in the species type than are men, who emerge from the species type more differentiated and individualized."[14] It comes as no surprise, then, that Schwitters set forth a similar view of women in his collages, while reserving for men a dominant position as observers and surveyors of goods.

Schwitters's linkage of fashion to women's identities and professions, coupled with his dual view of men as both controlling and threatened, expresses a desire to destroy the modern woman's newly found status. To visualize this destructive aim, Schwitters seized, much like his contemporary Simmel, upon a characteristic of fashion. Simmel observed that fashion, because of its emphasis on the ever new, is "an aesthetic expression of the desire for destruction."[15] In addition, the various

processes of production evoked in the collages – the call for the viewer to complete the image, the reaffirmation of the artistic act in designating a ready-made image as a work of art – reveal Schwitters's bid for the survival of certain artistic traditions with their emphasis on male authority.

However profound the change in their formal arrangement and medium, these works suggest that Schwitters's break with tradition was superficial. In fact, he seems to have redirected his destructive impulse from tradition to signs of modernity. Equating modernity with the political and cultural aftermath of the November Revolution and the founding of the Weimar Republic, and describing it as liberating, he must nevertheless have felt threatened by the chaos engendered by the political events. The newfound freedom was achieved at the expense of traditional order and societal organization and a sense of personal destabilization. Liberation also represented a loss. Schwitters looked to art to bolster his dominion. Here one observes a striking resemblance in conservative and progressive attitudes – Schwitters, as did so many of his contemporaries, expressed the experience of loss through the female body.

In the modern period, the feminine was also evoked in the discussion about mass culture to indicate mass culture's inferior status in comparison to traditional, or "high" culture. Technological advances and changing sociopolitical structures threatened the survival of high culture, which was predicated on the notion of the unique work of art – the masterwork as the expression of artistic genius – and a cultural elite that saw its own elevated status reflected in the rarefied work of art. The modernist work of art, it has been argued, in spite of its effacement of "content" (the erasure of subjectivity and authorial voice) perpetuated the separation between "high" and "low" culture, as it claimed autonomy and separation from the realm of mass culture and everyday life.[16] Theodor W. Adorno, for example, formulated the notion of "the great divide," the presumably necessary and insurmountable barrier separating high art from popular culture in capitalist societies. Mass culture was perceived as a threat to tradition.

As the female is seen as the quintessential embodiment of loss – according to Freud, the castrated male – she became a ready symbol for modernity and mass culture. In the discourse about mass culture, the female fulfilled two functions: In symbolizing castration anxiety, she represented the fear of fragmentation and loss of male authority; but in representing that fear through the female body, she, as a fetishized object, also offered the possibility of the reassertion of male authority. In Schwitters one rarely finds direct statements about the political and social concerns of his time. Instead, one detects his involvement with commonly shared issues in little verbal asides, typically in puns. In his study of jokes, Freud has demonstrated how punning permits a playful engagement with a particular topic while ensuring a controlling distance. Schwitters's phrase, "Das Weib entzückt durch seine Beine, ich bin ein Mann, ich habe keine." (Woman enchants with her legs;

I am a man, I do not have any) – a jocular transformation of Freud's theory of castration anxiety – seems innocent enough, but reconfirms the experience of loss or lack.

In one of his watercolor drawings, *Aq. 38 (für Dexel)* (1918; Fig. 76) Schwitters drew on Anna Blume's other existence as "komisches Tier" (strange animal) to express castration anxiety with the prototypical image of a *vagina dentata*, or toothed vagina. The watercolor depicts an animal's head, its mouth threateningly opened to reveal its large fangs. The head is repeated once more, so that the two set of fangs dominate the composition. Below, Schwitters placed the animal's enormous claws, which are perched over a head that is quickly recognized as the male profile head of the *Aq.* watercolors. This head is repeated, too, but as one continuous phallic form, ending just between the animal's claws. The animal is without any doubt Anna Blume's stand-in, for it is surrounded by several of her attributes: the church, superimposed as an icon over the animal's jaw; the number 31; and the windmill above its head. The whole image forcefully conveys a powerful threat, but also a sense of turbulence and chaos. Significantly, Schwitters dated the drawing 1918, although its high number within the sequence of drawings would suggest a later date of 1920. (*Aq. 37, Industriegebiet*, for example, is dated 1920. More remarkably still, no other drawing in the *Aq.* series is dated 1918.) Whether he misdated the image consciously or unconsciously, his dating forges a suggestive link between the threat expressed in this image and a particular date. The year 1918 brought, of course, the November Revolution, the time Schwitters identified as his decisive break with the past and new beginning as a collage artist. It gives the drawing added poignancy because it links the experience of political chaos with its loss of tradition to the female body and castration anxiety.

Schwitters in his 1930 autobiographical statement quoted in Chapter 1 described the November Revolution and his artistic reorientation not only in terms of liberation, but also of loss: "Then suddenly the glorious revolution was upon us. I don't think highly of revolutions... It is as though the wind shakes down the unripe apples, what a shame... [Merz] was like an image of the revolution within me, not as it was, but as it should have been."[17] He ascribes to his collage project, to Merz, a corrective function: Merz was to embody the "good" revolution (as it should have been); it was conceived as an agent of control that would undo the damage of uncontrolled revolutionary change and create order out of chaos. In the collages of women, Schwitters symbolically represents the act of control in his derision of women (dog's choke collars = women's professions) and espousal of tradition through the elevation of artistic power: the ability to manipulate form and to create an image according to his own desires.

The theme of control in relation to women and modernity is further developed in a small collaged work of 1923, for which the artist used a promotional postcard of

Figure 76. Schwitters, *Aq. 38 (für Dexel)*, 1918. Watercolor and crayon, 24 × 19. Private collection.

one of his earliest paintings, a religious work entitled *Stilleben mit Abendmahlskelch* [Still Life with Chalice] (1909; Fig. 77). The still life, which survives only in the photograph reproduced here, depicted a vase, a bottle of wine, a chalice, and an open bible arranged on a table. In the collage (Fig. 78), Schwitters effected a revealing substitution: He replaced the bottle of wine with the cutout illustration of a woman's head gleaned from a now familiar type of fashion plate. He then inscribed the pages of the book in his own handwriting, maintaining the grammatically incorrect "Dir": "Ich liebe Dir, Anna" (I love you, Anna), words from "An Anna Blume." The placement of the modern woman on Schwitters's altar next to the inscriptions identifies her as a representation of the fictitious beloved, of Anna Blume herself. The religious painting has thus been transformed into a celebration of earthly love and desire as well as a private discourse about artistic self-representation.

The symbolic representation of the body of Christ has been replaced by the fragmented representation of a woman and the sacred text transposed into a ritualistic refrain, written to conjure up an icon, Anna Blume, who has become a fetish and as such fills the void left behind by the demise of religion. In linking fashion, religion, and Anna Blume as the icon of his remarkable success at the beginning of his postwar career as a modernist artist, Schwitters brings the adulation of the commodity to its proper conclusion as the celebration of his own artistic prowess. Using his own earlier work as the basis of the collage, Schwitters ultimately declares himself the maker and transformer of images. In control of transformation itself, he holds a position of power, if only a tenuous and threatened one, in a period of shifting political and cultural values. However, the word "Hummel" (bumblebee) placed so prominently above Schwitters's altar to Anna Blume – and therefore also to himself – parodies both the religious tradition underlying Schwitters's image as well as his own self-adulation. The word formed part of a popular insult addressed to water carriers who, with their two buckets suspended from their shoulders, were thought to resemble a bumblebee carrying pollen. In this four-word refrain, "Hummel, Hummel" evoked the response "Mors, Mors" (in Northern German dialect the word for one's buttocks) from the water carrier, who would point to his bottom. In this small collage, Schwitters, then, found a way to shock and amuse by simultaneously breaking down and asserting the power of icons.

To clarify the processes of transformation and substitution, it is useful to take another look at Schwitters's earlier portrait of his real-life beloved, his wife Helma. *Vision* (1917; see Fig. 19) depicts his wife with an inward-directed glance in a moment of religious transcendence. Being shown in a moment of private contemplation, she does not engage the viewer's or even the artist's eye, and as such is removed from visual consumption. By elevating the modern woman, the mannequin, to the status of religious icon, Schwitters removes her too from the possibilities of sexual consumption to the safer realm of religious adulation. Schwitters directs his distancing effort at both a real woman, Helma, and his modern fabrication, the mannequin, defusing either female's threat. Schwitters finds control in the act of

Figure 77 (right). Schwitters, *Stilleben mit Abendmahlskelch* [Still Life with Chalice], 1909. Lost.

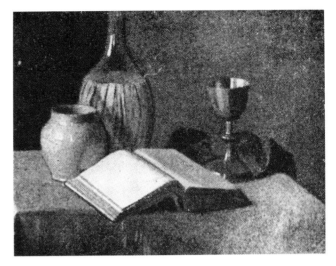

Figure 78 (below). Schwitters, *Collaged Postcard over "Stilleben mit Abendmahlskelch"* [Still Life with Chalice], 1923. Collage, 14 × 9 cm. Galerie Gmurzynska, Cologne.

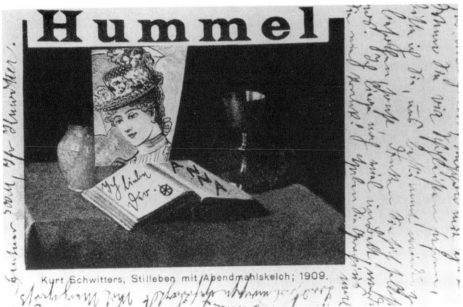

substitution; subjecting even his own work to transformations gained from substitution manifests an enduring need to reassert his own artistic power.

Schwitters formalizes his typical processes of substitution, transformation, and control in regard to modernity and the representation of women in one of his large *Merzbilder*, the *Konstruktion für edle Frauen* [Construction for Noble Ladies] (1919; Plate 8). This work is dominated by the circular forms of metal lids and wooden wheels and a prominent vertical and two diagonals created by some wooden planks. Schwitters inserted into this composition one of his own oil paintings, an earlier portrait of Helma.[18] Schwitters entitled his postwar assemblage "construction," and

Figure 79. Schwitters, *Konstruktion* [Construction], 1919. Ink, 18.5 × 15.2 cm. Private collection.

indeed, the work's individual components with their obvious reference to the world of machinery construct a specific place for the woman who is also once again identified with a piece of "past" (outmoded) art. She is inserted into the composition as the only illusionistic element, and the structural elements are literally super-imposed on her. In other words, Helma, or women in general, are made subordinate to a man-made structure, symbolic of technology as controlled by men. Helma loses her identity in the process and is transformed into "Anna," a transformation clarified by a little pen drawing of the same year, entitled *Konstruktion* [Construction] (Fig. 79). Here we see the same wheels and wild diagonals that characterized the larger assemblage. Schwitters then inscribed the work with two names: Anna Blume and Franz Müller.[19] Not only has Helma become Anna, but Helma's admirer has also been replaced by a pseudonym. Once again, the creation of substitutes comments on the anonymity of modern life, although it also allows Schwitters to distance himself and to systematize his private emotions. Helma has been transformed into a fetish; love, no longer a threat, can be safely consumed in the form of desire. This treatment of desire is reminiscent of his watercolor drawing, *Aq. 1, Das Herz geht vom Zucker zum Kaffee* (1919; see Fig. 33). That composition shows a strong similarity to the *Konstruktion für edle Frauen* (Plate 8), with its overlapping circular forms and slashing diagonals. Above all, Schwitters substituted a fetish for the female: Desire has been rechanneled from the woman's body to the coffee pot.

Yet Schwitters's image is typically ambiguous. It is dedicated to "noble women," thus expressing an act of admiration. Schwitters, then, plays off fear and admiration; similarly, the possible reference to St. Catherine in the combination of female

Figure 80. Schwitters, *Mz. 151, Das Wenzelkind* [Knave Child], 1921. Collage, 17.1 × 12.9 cm. Sprengel Museum, Hannover. On extended loan from Marlborough Fine Art, London.

imagery and machine/wheel (see, for example, also Max Ernst's *Katharina On-dulata*, 1920) suggests both an adulatory and destructive impulse.

Fashion plays an important function in the substitution of a fetish for the desired object. Simmel defined envy as an integral part of the language of fashion. He declared that "the fashionable person is regarded with mingled feelings of approval and envy" and that this envy included a "species of ideal participation in the envied object itself," which leads "to a quiet personal usurpation of the envied property."[20] The representation of fashion enabled Schwitters to address his desire for the new while at the same time asserting his wish for ownership and control. As these desires are acted out for the most in rather inconspicuous collages and veiled in irony, Schwitters's ambiguous relationship with the modern (i.e., mass culture) and his assertion of control are not immediately apparent. As we have seen, however, the mechanisms of playful substitution and exertion of control are present in his small and large works alike.

In *Mz. 151, Das Wenzelkind* [Knave Child] (1921; Fig. 80), Schwitters effected a linkage between Raphael's *Sistine Madonna* and the fetishes of modernity: fashion (the madonna's head has been replaced by one culled from the typical fashion plates); America (evoked with a small text fragment inserted at the upper margin, which reads, "Amerika ist angenehm berührt" [America is pleasantly touched]); sports (the race horse affixed to the right); money (a piece of paper spelling "3 Pf."); and technology (a large wheel at the bottom, below the madonna). Elderfield suggests that Schwitters may be satirizing the Old Master models;[21] he surely is, but there is more than mere debunking of past artistic traditions. The new is carefully inserted into the traditional object, which remakes it much as Duchamp's addition of a mustache and allusive title remade Leonardo's *Mona Lisa*. In so doing, the modern master asserts his dominance over the old and defines himself in relation to the past achievements in the history of art. There is an unmasking of the icons of art history, but never a belittling of artistic creativity or the traditions of art making. In satirizing the past the artist makes himself part of that tradition, for he demands to be seen in relation to it.

In *"Damenkonfektion"* [Woman's Ready-to-Wear] (Fig. 81), a small collaged postcard of 1921, Schwitters once more links the themes of fashion and desire. For this occasional work, Schwitters used a photo of himself, a promotional postcard printed by his publisher. Instead of giving his correspondent the full benefit of his face, Schwitters covered up his eyes with the large print of the word "Damenkon-fektion" and surrounded his head with pieces of cutout text referring to items of women's clothing, such as blouses and aprons. He then covered the bottom part of the postcard with another fragment of text, from which one can gather that "today is the day of his life in which he celebrates that which the hand of man could create and has created." The text ends again with a reference to commerce: "I have decided to sell cheaply these outstandingly beautiful wares." Significantly, Schwit-ters cut the text so that it ends with an adulation of the commodity: "schöne Ware

– sehr billig abzugeben" (beautiful wares, sold cheaply). By covering his eyes with the word for another commodity, *Damenkonfektion* – that is, by literally putting *Damenkonfektion* into his line of sight – he declares the predominance of the commodity but also puts himself into a special relationship to it.[22]

This relationship is clarified by his addition of the name Anna, printed in red, referring once again to his heroine of desire, who at the same time represents modernity. In placing "Anna" next to the word *Damenkonfektion*, Schwitters relates fashion, consumption, and modernity. Much as *Damenkonfektion* is the product of a designer, so Anna is a construction and attests to the artist's mastery. In all of these collages, the ever-present threat of the modern women – and modernity – underlies the images. Fragmenting the woman and then reconstructing her according to his own desire affords ultimate control over her – and repeats, of course, the countless similar acts of representing the female through brutal deformation and mutilation typical of early twentieth century modernist art, from Picasso's *Les Demoiselles d'Avignon* (1907) to Duchamp's or Picabia's representations of woman-as-machine; putting her over his eyes as an abstract construct implies the ulterior motive of controlling her through sight, the most powerfully ordering sense of all.

This small collage shows Schwitters's constructive use of play. The simple gesture of substitution allowed him to "try on" women's clothes, to try on modernity. Schwitters repeated – and intensified – the play in another collaged postcard, *"Anna Blume"* (1921; Fig. 82), in which he employed his same publicity photograph but superimposed only an Anna Blume sticker over his eyes. Here, then, Schwitters takes on Anna Blume's identity to see the world through female eyes. This masquerade extends male identity to include its other, the female self. It is reminiscent of Marcel Duchamp's contemporaneous creation of an alter ego, his Rrose Sélavy, who, albeit in a more teasing and intellectually more satisfactory manner, also embodied eternal desire: "eros c'est la vie." However, Schwitters's play took place only within the relatively safe realm of art, not as a public masquerade. A third collaged postcard, *"Wheel,"* (1921; Fig. 83) created with his publicity photograph completes the connection from fashion to modernity, for here Schwitters simply drew a wheel over his forehead. His eyes are left uncovered; no longer does he look at the world through the signs of femaleness – or modernity. There is no masking, no playful trying on of new roles, only the indication that technology has been brought under control and internalized. Placed directly over his forehead as a small and clearly delineated form, the wheel is now associated with rational thought and intellectual empowerment.

In a series of substitutions, Schwitters effected a transition from the experience of the female and the modern as threat to their sublimation in the fetishized object and final subjugation through incorporation. In actuality, this transition did not develop as this account would make us believe. The three postcards, for example, were not executed in this sequence and thus do not support the notion of a linear development. The self-portrait with the wheel was, in fact, the earliest in the series,

Figure 81. Schwitters, *Collaged Postcard with Photograph of Schwitters: "Damenkonfektion"* [Woman's Ready-to-Wear], 1921. Collage, 14 × 9 cm. Galerie Gmurzynska, Cologne.

dating from March 5, 1921; it was followed by the altered postcard with the Anna Blume sticker of May 27, 1921; and the *Damenkonfektion* was the last in this series, dating from November 4, 1921. Similarly, the other representations of femaleness do not follow a neat temporal development indicative of greater or lesser acceptance of modernity. Rather, there was a constant back and forth between different positions, reflective of Schwitters's search for identity in a period of shifting cultural and political values. All of these images share one important facet: Schwitters's assertion of control through the act of playful substitutions. Here, modern studies of children's play may help us to see Schwitters's characteristic play in its larger significance. The psychologist D. W. Winnicott, who studied the function of play in children, described playing as an organizational activity expressive of a need for control: "Organized nonsense is already a defense just as organized chaos is a denial of chaos."[23] In Schwitters, playful substitutions operate as a mechanism of control over the chaos of modernity.

Schwitters formalized the theme of control in a larger work of 1921, entitled *Mz. 239, Frau-Uhr* [Woman-Watch] (Fig. 84). Instead of using small cut-outs of women's heads, he carefully cut out and glued down the entire image – which is nevertheless only a truncated representation – of a provocatively reclining female nude, presumably gleaned from a pornographic magazine and clearly suggestive,

Figure 82. Schwitters, *Collaged Postcard with Photograph of Schwitters: "Anna Blume,"* 1921. Collage, 14 × 9 cm. Galerie Gmurzynska, Cologne.

Figure 83. Schwitters, *Collaged Postcard with Photograph of Schwitters: "Wheel",* 1921. Collage, 14 × 9 cm. Galerie Gmurzynska, Cologne.

as many such images, of all the reclining nudes of past art from classical water nymphs to Ingres's *odalisques*. Superimposed on the divan against which she leans is a man's hand stretching out from a sleeve that bears the imprint of an allusive male name, "Herr Erich Stock" (translated as "Mr. Eric Stick"), evocative of Schwitters's hero, Alves Bäsenstiel. Its emphasis on the aggressive power of masculinity is reinforced by additional imprints on the sleeve, "Herrn," "Inhalt," and "Hannoverscher Verlag" (Men, Contents, Hannover Publishers), which similarly engage issues of male authority and authorship. The male hand holds a pocket watch over the woman's body, literally superimposing his time on her. We are thus made to understand that the nude woman is a natural object of desire on whom man, significantly clothed, constructs his concepts and over whom he commands.[24] A symbol of tradition, this nude in Schwitters's collage is the foundation and the shard upon which time or modernity is building its new structure. This impression is underscored by the tags hanging from the man's sleeves, tags that seemingly tell us the exact date and time of an encounter that nevertheless remains timeless: "Sonnabend 5" (Saturday 5).

159

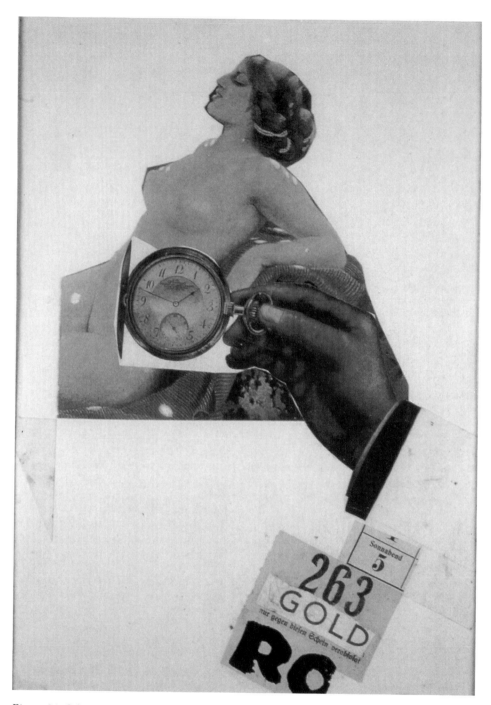

Figure 84. Schwitters, *Mz. 239, Frau-Uhr* [Woman-Watch], 1921. Photo collage, 31.2 ×
22.2 cm. Mr. Philippe-Guy Woog, Vésenaz.

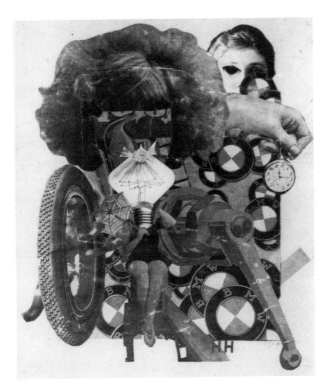

Figure 85. Hannah Höch, *Das schöne Mädchen* [Pretty Girl], 1920. Photo collage, 35 × 29 cm. Private Collection. © 1992 ARS, New York/Bild-Kunst, Bonn.

This collage, the most powerful expression of male control in Schwitters's work, is one of his very few photomontages. For the most, photographic material played a minor role in his collages, as opposed to the emphasis on the photograph in Berlin Dada. Here Schwitters exploits the so-called objectivity of the photographic image to reassign woman emphatically to her traditionally ascribed status not only as an object of male desire, but as the object of men's making. Woman, here, is seen as she has always been in the history of representation, through the eyes of the male creator of images. Comparing this collage with a work by Hannah Höch emphasizes the difference between male visual control and the female experience of being controlled by that very gaze.

In *Das schöne Mädchen* [Pretty Girl] (1920; Fig. 85), Höch placed a woman in a bathing suit, sitting at the end of a diving board facing the viewer, so that her head is right in the center of the composition. She is surrounded by signs of technology: numerous circular forms created with the BMW emblem, a large tire, and a crank. This environment of the signifiers of modern technology extends to the woman's body, for her head has been replaced by a giant light bulb that could, so the compositional arrangement suggests, be illuminated with a turn of the large crankshaft in the foreground. Höch placed the crudely cutout photograph of a modern

woman's bobbed hair above the lightbulb, so that the woman seems to exist twice, once as a diminuitive version on the diving board, the other as a large machine constructed of the various machine parts. Yet that woman has not been given facial features either, only some lettering from an advertisement. There is, though, a frontal photograph of a woman's head inserted in the upper right of the composition.

Again, this woman is not given a true identity: A large eye has been superimposed over her own. It functions much like Schwitters's superimpositions as a mask, but with an important difference. For Schwitters, the mask constituted an empowerment. For Höch, the mask is a shield behind which to hide. Woman, so Höch implies, is merely a construct of the viewer's gaze and is not permitted her own identity, nor can she effectively take on another identity through masquerade. Eternally an object – Höch powerfully accentuates that statement with the figure of the boxer placed next to the wheel and extending his gloved fists through the wheel to the woman on the diving board – she cannot develop her own identity. Man can move freely, as is implied by the boxer and by the emblems of modern machines, whereas woman is confined – an object to be constructed and reconstructed.

Höch, tellingly, allows her woman to peek out at the viewer. In the frontal photograph of the woman's head in the upper right-hand corner, she left the second eye intact, barely visible behind the BMW sign placed over her face, in the only suggestion of a "real woman" behind the mask. But this image only perpetuates the game, for the evident personality is again a form of representation – the product of a controlling gaze.

Both Schwitters and Höch describe essentially the same theme: woman controlled by man. Höch, however, offers a resigned view of the possibility of female identity formation, whereas for Schwitters it becomes an opportunity for the reaffirmation of male authority. The issue of control brings a curious, if revealing, focus to Schwitters's series of women and fashion imagery. Although such works as *Die Handlung spielt . . .* (See Fig. 75) and *Figurine* (See Fig. 70) in part questioned stereotypes about women, *Frau-Uhr* openly stresses the persistence of traditional behavior and power relationships. In method and subject matter, Schwitters described the modern woman in ambiguous terms, at times in terms of desire, and at other times in terms of a threat that, like modernity with its chaos, must be confined. Drawing on the themes of fashion and prostitution, Schwitters was able to comment simultaneously on modernity and the persistence of traditions. An observation made by Simmel suggests why Schwitters may have seized upon fashion to represent the paradox of the persistence of tradition within modernist innovation. "Fashion as a phenomenon," Simmel said, "is immortal. Only the nature of each individual fashion is transitory. The fact that change itself does not change endows each of the objects which it affects with a psychological appearance of duration."[25] Schwitters drew repeatedly on subject matter that symbolized continuity in the guise of the new. It permitted him to articulate his need for control in a historical moment characterized by the absence of control, chaos, and the loss of tradition. Thus

simultaneously embracing and rejecting modernity for the empowerment and disempowerment it had engendered, Schwitters focused in this series of works on the female body in order to reaffirm control. He disassembled his beloved, Helma, and her modern equivalent, the mannequin, to reassemble both according to his own needs and desires. In the process, he proclaimed man the creator of his environment. In so doing, Schwitters expressed a desire for a traditional, patriarchal power structure. In this sense, Schwitters's work both mirrored and illuminated the social and political changes that characterized life in the Weimar Republic. History has shown that many of the social changes brought about by the November Revolution were not, in fact, fundamental because they permitted many of the old norms to survive. Schwitters's collages show that, in art as in politics, control is engendered through adherence to tradition.

8

THE *MERZBAU*; OR, *THE CATHEDRAL OF EROTIC MISERY*

Schwitters's most ambitious collage project was his *Merzbau* [Merzbuilding] (Fig. 86), the transformation of his studio and adjacent spaces in his house in Hannover at Waldhausenstrasse 5 into an all-encompassing, ever-expanding collage environment. He considered it the summa of his work, the concretization in architectural form of his Merz theory, and conceived it as a model for social and cultural transformation. Situated in the very center of artistic activity – the studio – the *Merzbau* points to Schwitters's understanding of the artist as instigator of change through the systematic application of creativity to problems of form. If the structure appeared disturbing to some of its visitors, Schwitters would have ascribed its strangeness to the times, rather than considering it endemic to the *Merzbau*, for he thought of artistic expression as an accurate barometer of a given historical moment. In 1930, when discussing the function of art, he wrote: "What we express in our works is neither humbug nor subjective play, but the spirit of the times, dictated by time itself. We, the creative artists, who are the most impressionable of all people, are the first to feel its effects."[1]

The *Merzbau*, also known as the *Kathedrale des erotischen Elends* [The Cathedral of Erotic Misery], or *KdeE* for short, combines the elements of architecture and sculpture, and even the decorative arts, and is rich in themes and allusions. It consisted essentially of two parts: an inner core of collage material, a more or less formless accumulation of things discarded, and a hand-fabricated exterior shell of clear architectural forms created with traditional building materials, wood and plaster of paris, painted white with a few color accents, mostly red, scattered throughout. The controlled and structured shell contrasts with the chaos within, but is dependent on it because it grew with the accumulation of objects on the inside. The interior refers, as did his two-dimensional collages, to modernity. The exterior, in contrast, is characterized by such time-honored materials as wood and plaster, and by established methods of construction, and recalls the traditional notion of architecture as craft.

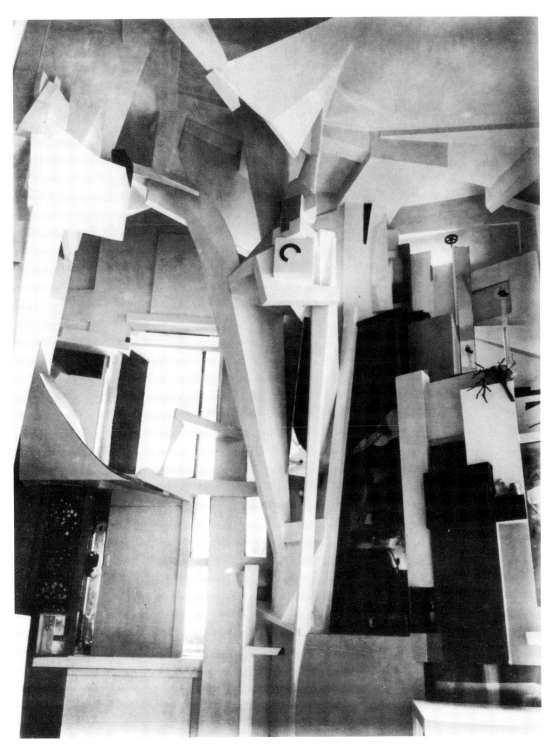

Figure 86. Schwitters, *Merzbau* [Merzbuilding], general view with *blaues Fenster* (Blue Window), photographed ca. 1930. Destroyed.

The image of the cathedral to which Schwitters alludes in his alternate name for the Merzbau furthermore ties his project to the contemporary fascination with the medieval cathedral. In the postwar period, the cathedral was evoked as a charged symbol of societal and artistic form: It was thought to typify *Gemeinschaft* (community) rather than *Gesellschaft* (society), an example of collaboration at its best, leading to the creation of a total work of art. One thinks, for example, of the Bauhaus Manifesto of 1919, which called for the building of a new cathedral for the future; its cover showed a woodcut designed by Lyonel Feininger of a gothic cathedral, the so-called *Cathedral of the Future* or the *Cathedral of Socialism.*[2] In choosing the composite name *Merzbau* for his construction, Schwitters simultaneously alluded to its modern and traditional components: "Merz" as the new, and "bau" as the traditional means for the creation of architectural form.

Although the exterior existed in a symbiotic relationship with the interior, in later stages the shell seems to have gained a certain independence as sculptural-architectural elements were added without the earlier collage and assemblage "filler" within. However, even the more homogeneous shell was constructed according to the dynamic, additive collage principle. Every addition demanded a readjustment of the entire form to accommodate the new. Thus, the entire structure remained forever in flux, a condition to which Schwitters referred when he described the *Merzbau* as "dynamic"; he elevated the unfinished nature of his work to doctrine: "It is unfinished out of principle."[3] Constant transformation became the *Merzbau*'s formative principle. The organicist emphasis is the clearest indication of the survival of prewar artistic traditions in Schwitters's postwar collage work.

From a sculptural point of view, the *Merzbau* must be considered a major accomplishment in twentieth-century sculpture. Here Schwitters attempted to overcome the limits of time and place thought to be the inherent condition of sculpture and as so many other artists did during this period, he tried to extend sculpture into the fourth dimension. Sculpture defined by the *Merzbau* is not a single, separate object, but part of a larger architectural project in which the boundaries between the one and the other are no longer clearly demarcated. In activating the relationship between interior and exterior form, the *Merzbau* also participates in a contemporary sculptural debate that was expressed, for example, in the exploration of transparencies in many constructivist works. With the construction of the exterior shell, the *Merzbau* took on the appearance of solid architecture. Even its inherent mobility became increasingly obscured. Sliding doors opened the interior for inspection, but only to the initiated: The stuff of life was hidden behind the seemingly impermeable wall. Yet Schwitters offered glimpses of his building stones in special places throughout the *Merzbau*. He opened the shell at various places to create passageways between the exterior and interior in the form of glass enclosures or niches, which he termed grottoes or caves. These functioned much like museum displays or shop windows: They created artificial environments displaying the wares – the collage

building stones – as special objects taken out of circulation. Displaying discarded commodities for contemplation, the grottoes are referents to desire and may give us a hint of the meaning of Schwitters's alternate title for his structure, the *Cathedral of Erotic Misery.*

Schwitters's *Merzbau* is indeed all-encompassing: It spans the gap between inorganic architecture and the organic, between the modern and the traditional, between the public and the private. It is a work that demands close analysis but has resisted it, in part because it has always been essentially inaccessible. Over the years of its growth, fewer rather than more visitors were let in, surely in part to guard against possible reverberations in a political and cultural climate increasingly hostile towards experimental art;[3] situated in Schwitters's studio, it functioned above all as a private space that even included his bed. To the post–World War II generation, the *Merzbau* became a quasi-mythical structure, known only through a few photographs (it was destroyed during the war) and intriguing accounts, such as in Hans Richter's *Dada: Art and Anti-Art*, Robert Motherwell's *The Dada Painters and Poets*, and Kate Steinitz's *Kurt Schwitters: A Portrait from Life*. Today, the *Merzbau* has lost some of its mystery. Studies by Dietmar Elger, John Elderfield, and others have traced its developmental stages in careful detail and helped to separate fact from fiction.[5] In addition, a replica, based on the existing photographs of the *Merzbau*'s studio section – its core – has been constructed with the help of modern imaging tools and is now installed in the Sprengel Museum in Hannover.

The *Merzbau*'s earliest beginnings can be dated to about 1919, the time of Schwitters's first experimentation with collage. An early photograph taken in Schwitters's studio in 1919–20 (Fig. 87) shows a columnar sculpture, constructed of found objects and crowned by a plaster head topped with a long-haired wig. Placed in the corner of the room, the sculpture seems to have been conceived as part of a larger environment, for the surrounding walls are covered with the same kind of materials with which it was built. The construction of the *Merzbau* continued from 1923 on in a different room, where the column was apparently reconstructed and took on a slightly different configuration. Known as the *Merzsäule* [Merz-column], it is well documented with a photograph taken in about 1923 (Fig. 88). The expansion of the column into an all-encompassing room sculpture occupied Schwitters throughout the 1920s and 1930s. Schwitters abandoned the ever-growing *Merzbau* in 1937, when he emigrated to Norway to escape Nazi persecution as a "degenerate artist." By then the sculpture had grown to truly architectural proportions and expanded beyond the confines of the studio into the adjacent spaces in Schwitters's house, including the hallway and areas below and above the room.

Schwitters began work on a second *Merzbau* in Norway, and after fleeing that country, started work on a third one in England, his so-called *Merz-barn*. The building of the *Merzbau* thus preoccupied Schwitters for most of his artistic career and must be considered a major part of his work.[6] The Hannover *Merzbau* is fairly

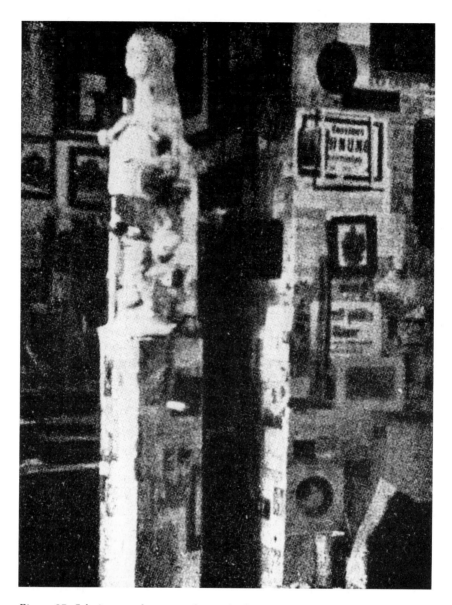

Figure 87. Schwitters, columnar sculpture (early version of *Merz-column*), ca. 1919/20. Destroyed.

well documented, with photographs taken at the different stages of its construction and accounts by visitors and Schwitters himself. Although this reconstruction gives a good impression of the architectural dimension of Schwitters's sculpture within the confines of his studio, it neither reveals its complex interior nor its organic growth within and beyond the studio walls. It does, however, provide a good indication of scale and outward appearance. Together the archival and architectural reconstructions permit an interpretation of its method of construction, form, and function.

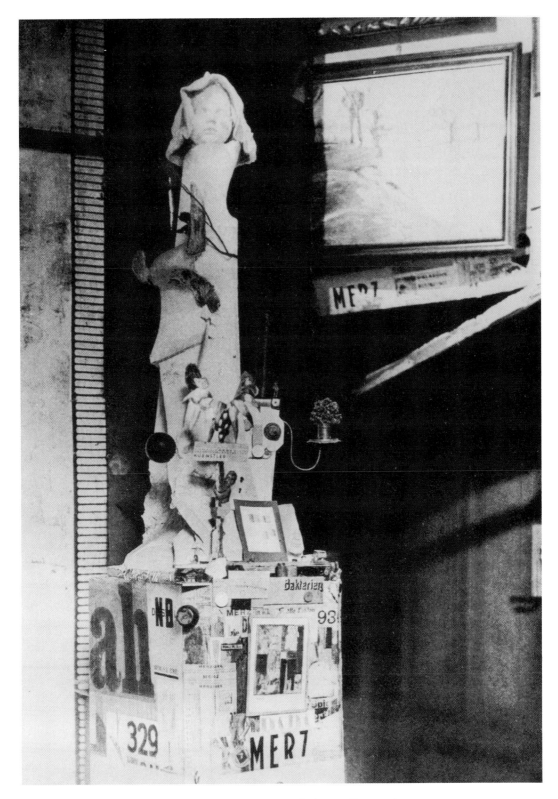

Figure 88. Schwitters, *Merzsäule* [Merz-column], photographed 1923. Destroyed.

It is difficult to be certain of the *Merzbau*'s facets, especially its rich interior, but there are several early sculptures (unfortunately surviving only in photographs) that help us gain access to the ideas expressed in the larger structure and to explicate its themes. Two small sculptures in particular predict the subject matter and formal solutions that Schwitters developed within the *Merzbau: Haus Merz* [House Merz] (1920; Fig. 89), and *Schloß und Kathedrale mit Hofbrunnen* [Castle and Cathedral with Courtyard Well] (ca. 1922; Fig. 90). In light of the larger architectural project that followed them, both sculptures may be regarded as architectural models; they are ambitious in their subject matter – both partake in the contemporary debate about the cathedral – and comprehensive in scope. Although both are assemblages composed of disparate materials, they differ significantly in approach to form. Together they stand as two diametrically opposed views of architecture that are later articulated and played off against each other within the *Merzbau*.

Haus Merz is an important early sculpture. It concerns itself with the transformation and reformulation of a traditional form: the church/house and the interior defined by it. It is composed of children's building blocks; a spinning top forms the spire and a simple button the clock. The whole construction is mounted on a rough wooden plank inscribed and dated, "Haus Merz 20. K. S." Schwitters left the nave of his church/house open to reveal its interior, filled not with people or the implements of religious worship but with a set of cogwheels that occupy the entire space and turn it into a machine housing. The sculpture's modest size, only a few inches (as indicated by the size of the top spin and the button) belies its ambitious program. Schwitters effected a major transformation: The house of God – the church or the cathedral – has been transformed into a house for Merz. Thus Merz is declared a new religion. The cogwheels as bits of machinery, and therefore of modernity, define Merz itself as modern. Nevertheless, Merz is housed in a traditional structure, a church or cathedral, although it is a building constructed with uncommon materials. Merz, then, is shown as linking traditional form, here the architectural shell of a church, with innovative method and content, the collage materials and the cogwheels of a modern technological world. As such, *Haus Merz* prefigures the interconnectedness of interior and exterior that was to become one of the most important features of the *Merzbau*. More specifically, this small sculpture predicts the major components of the *Merzbau*: The *Merzbau* itself takes on the character of a cathedral with its alternate title, the *Cathedral of Erotic Misery*. Its interior remains a quasi-religious space for withdrawal and creative activity. It, too, is filled with the signifiers of the technological world, the collage elements, while its outer shell conforms to specific architectural forms. The *Merzbau*, like *Haus Merz*, remains a mixture of private home and public structure and, in becoming the large-scale model of Merz, it reinforces the understanding of Merz as a new religion.

Schwitters clearly considered his small sculpture more significant than its small scale and playful materials would indicate. In his 1920 essay "Merz," he repeats

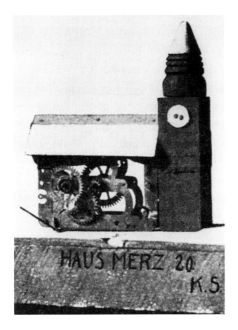

Figure 89. Schwitters, *Haus Merz* [House Merz], 1920. Lost.

Figure 90. Schwitters, *Schloß und Kathedrale mit Hofbrunnen* [Castle and Cathedral with Courtyard Well], ca. 1921. Architectural model. From *Frühlicht* 1(3), Spring 1922. Destroyed.

almost verbatim Christof Spengemann's words (which may very well have been his own in the first place) in a postcard to Adolf Behne:

In *Haus Merz* I see the cathedral: the Cathedral. No, not church architecture, but building as the expression of a truly spiritual vision of the kind that lifts us to the infinite: absolute art. This cathedral cannot be used. Its interior is so filled with wheels that no room is left for people. . . . This is absolute architecture, the only meaning of which is artistic.[7]

Haus Merz may have been Schwitters's first three-dimensional articulation of the cathedral theme, which played such a prominent role in the watercolor drawings of 1919. It links securely the theme of technology with the search for new form (absolute architecture), which is revealed in the accompanying text as a search for a new spirituality.

Schloß und Kathedrale mit Hofbrunnen seems in all respects the opposite of *Haus Merz.* Rather than presenting just one building, it presents three: dwelling, religious building, and utilitarian structure in intimate proximity. Whereas *Haus Merz* revealed its mechanistic interior, this sculpture is composed of closed forms. Here the geometric, rational forms of the earlier sculpture have given way to the organic materials of driftwood and cork, whose surfaces seem ravaged by time, suggesting slow decay and a state of ruin. The circular arrangement of the buildings accentuates

the sense of organic closure and with that the suggestion of community and cohesion. This sculpture was published in Bruno Taut's *Frühlicht* magazine in 1922.[8] Taut, who had founded during the war the Gläserne Kette, an association of architects concerned with utopian projects and the exploration of architecture in the service of societal transformation, was part of the Arbeitsrat für Kunst. He began publishing his magazine in 1920, first as an addendum to his *Bauzeitschrift*, then by itself as a forum for new architectural ideas. It thus establishes an important link between Schwitters and the circle of architects within the Arbeitsrat für Kunst, one of the artist organizations formed in the wake of the November Revolution.

The erotic theme of Schwitters's *Kathedrale des erotischen Elends* is prefigured in his "Anna Blume" poem and the accompanying watercolor drawings. The transformation of the found object and the theme of desire into political allegory is accomplished in an assemblage sculpture, *Heilige Bekümmernis* [Holy Affliction] (ca. 1920; Fig. 91) – like the Merzbau, surviving only in a photograph. The sculpture is not an architectural model, but rather a transformation of that quintessential sculptural form, the human body. *Heilige Bekümmernis* is a collaged mannequin, a female tailor's dummy mounted on a wooden stool, with a lightbulb for a head and a Christmas tree ornament for an arm. Around its neck Schwitters strung two cords, one supporting a tablet imprinted with the admonishment "Gebt und spendet reichlich für Oberschlesien!" (Give and donate generously for Upper Silesia), the other a box that suggests a street vendor's tray, as well as a hand organ (hurdy-gurdy), as it has a handle attached to its side. The sculpture clearly evokes the then common sight of a war cripple engaged in small-scale street commerce, a topic favored by socially engaged artists (e.g., Otto Dix, *Match Seller* [1920]; George Grosz in many of his postwar works[9]) and suggests that Schwitters may have created his sculpture to stimulate a dialogue with other avant-garde works. The box also bears imprinted announcements, evidently culled from contemporary newspapers, as well as several images. The words "Oberschlesien" (Upper Silesia) are repeated in the center cavity of the box, which also displays the words "Fröhliche Weihnachten" (Merry Christmas) in front, topped in turn by the exclamation "Wahnsinn" (craziness). As in *Haus Merz*, Schwitters is concerned with the transformation of a religious icon into political allegory. The sculpture takes its name, in slightly altered form, from a fifteenth-century saint, *Heilige Kümmernis*, the Christian daughter of a heathen king who legend has it asked Christ that she be disfigured to avoid marriage to a heathen suitor. Her prayers were answered; she sprouted a beard and, thus disfigured, could thwart the desire of prospective suitors.

Schwitters uses his statue to debunk contemporary political and popular preoccupation with nationalism. Upper Silesia, rich in coal, imperial Germany's second largest industrial district next to the Ruhr, was, in the wake of the Treaty of Versailles, subject of a plebiscite that was to decide whether the area was to be ceded to Poland or, because of its predominantly German population, stay within

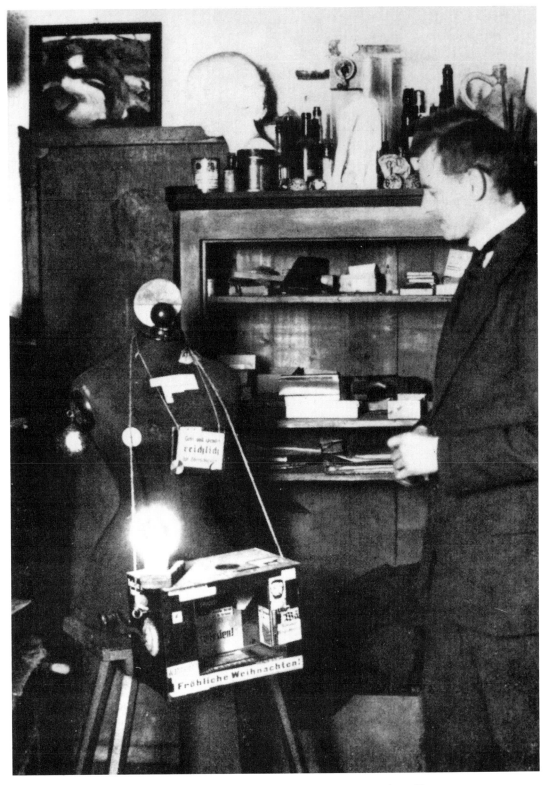

Figure 91. Schwitters, *Heilige Bekümmernis* [Holy Affliction], ca. 1920. Assemblage. Destroyed.

the German boundaries (Fig. 92). National feeling was deeply aroused over the future of this area, and led to bloody clashes between Polish and German Free Corps troops.[10] In linking political slogans with the notion of insanity and a saint who symbolizes fervent determination to pursue a cause (her marriage to Christ as opposed to marriage to a heathen for which she had, however, to renounce her true identity as a woman), Schwitters questions the support of nationalistic causes and the pursuit of an idealized vision of Germany – the larger, pre-Weimar Reich.

Schwitters turns the saint's troubled encounter with eroticism into a political parable in which she is at once the actor and the acted upon. As a headless and armless mannequin she cannot speak for herself: Her "voice box" – that is, the placards on her vendor's tray – have to be activated by someone else through the turning of the crank. In the process of being acted upon, she also becomes an object of devotion or desire. With her tray, on which Schwitters placed a candle, his *Heilige Bekümmernis* is also a religious icon, a small altar with lit candles. Significantly, the only photo that survives of this sculpture shows Schwitters himself in a dialogue with his modernized saint. In suggesting adulation of a female saint by a male worshipper, Schwitters interprets the political in terms of unfulfilled desire – the female, defaced as the legend has it, is therefore no longer capable of quenching desire.

Heilige Bekümmernis illuminates the bankruptcy of postwar German society in its futile attempt to redefine itself out of the rubble of its own past, symbolized here in the discards with which the sculpture has been constructed. Yet the sculpture also embodies a quasi-religious yearning for values that seem no longer attainable: It was presumably the hand-organlike box Schwitters referred to in a late text about the *Merzbau*. He describes a small organ that by the time of his writing had already disappeared into the vast cavities of the Merzbau. Once it played "Come Ye Children," but after the handle was broken had to be cranked counterclockwise before it would then play "Silent Night, Holy Night." Once again Schwitters works with the idea of inversion, and once again his inversion points to continuity rather than disruption of the norm: As Christmas songs, the organ's new and old songs are essentially the same. Even the breaking of the organ's handle – the breaking of form – does not, Schwitters suggests, create entirely new forms, but simply a minor readjustment in the existing structure.

The assemblage makes a political statement in which Schwitters draws on the possibilities of collage and assemblage to comment on the experience of modern fragmentation and discontinuities, poking fun at the contemporary involvement with traditional political causes, such as nationalism. He draws on traditional artistic subject matter, religion and the erotic, to debunk both with his use of collage and found objects and texts. In this work one recognizes Schwitters's awareness of the political possibilities of collage. As a discontinuous medium, collage permits the pointing of fissures and cracks within traditional subject matter and thus enables the artist to use the medium as a counterpoint to the depiction of icons.

Heilige Bekümmernis reveals Schwitters's sense of humor in regard to the political

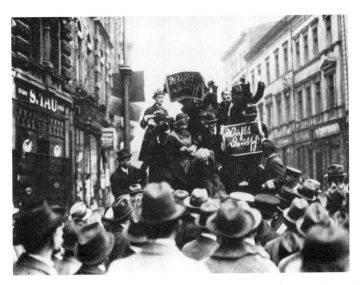

Figure 92. Silesians demonstrating in Berlin for the plebiscite, Spring 1921. The placards read, "Vote German!"

issues of his day; it also introduces the theme of eroticism into his three-dimensional work. More important still, in *Heilige Bekümmernis* and *Haus Merz* Schwitters uses the collage medium in an entirely modern manner. There is no trace of the organic in either of these works; instead, both thematize technology and thus unequivocally declare it as the origin of collage. They thus establish an important counterpoint to such works as *Schloß und Kathedrale mit Hofbrunnen* (see Fig. 90); *Heilige Bekümmernis*, in particular, participates in the modernist discourse about the city (as it was first formulated in Paris by writers and artists in the wake of its extensive transformation under Napoleon III), as a place of entertainment, but also estrangement and dislocation, frequently thought to be embodied in the mannequin or the prostitute.

Schwitters's *Heilige Bekümmernis* is crowned with a dark-colored lightbulb, which the photograph seems to suggest may have been red, turning the modernized saint into a prostitute while also identifying her as a reconfigured Anna Blume, who, after all, was red. The lightbulb underscores the sculpture's theme of frustrated sexuality and clarifies the artist's political criticism, in which nationalistic desires are linked to frustrated sexual desires. In linking his female saint to the representation of the mechanical (the ready-made form, the fragmented mannequin), Schwitters follows in the steps of many of his contemporaries who describe the modern in terms of the female, where the female body is likened to a machine, to be controlled by a man. In linking the notion of either frustrated or rechanneled sexual desires, as symbolized by the saint, with political desires, Schwitters offered a sharp-eyed critique of German nationalism. In *Male Fantasies*, a comprehensive study of German Free Corps literature, Klaus Theweleit has shown how over and

175

over again, conservative political behavior was (and is) linked to a fear of female sexuality.

The *Merzsäule* (Merz-column) (see Fig. 88) displays little of the architecturally closed solidity expected from a column. Rather, it is composed of disparate bits of papers and objects, the debris of materialist society seemingly heaped at random upon each other. Yet despite its apparent formlessness, the *Merz-column* reveals some structural articulation. The work comprises a base and an amorphous sculptural body linked conceptually and formally through the found objects. The four sides of the base are pasted over with the printed matter of machine production – newspaper clippings, photographs, large numbers and letters – like an advertising kiosk. The texts themselves are largely illegible, and therefore anonymous. Where base and body meet, references to newsprint diminish. Here, one is reminded of Karl Arnold's junk heap: children's toys, broken plaster casts, a little figurine of a black boy climbing a post, a candlestick or light socket transformed into a flower vase, and bits of wood and metal brought together in a loose arrangement. To the upper end of the *Merz-column* are affixed the more organic materials: dried flowers in the candlestick, an animal's horn embedded in the plaster, and a twig extending back into space. A doll's head covered by a loosely draped cloth surmounts the column.

Even though it is uncertainly located within established artistic categories, the theme of the column is dominant. It gives the work artistic and cultural significance. By applying the word "column" to a discontinuous composition of fragments, Schwitters makes an irony of the classical notion of the column as an expression of perfected beauty and formal completion; in presenting the column as a ruin, he calls into question the very survival of the classical tradition in a historical moment felt as a fundamental break with the past. A collage pasted to the lower base of the *Merz-column* – identified as *Der erste Tag* [The First Day] (Fig. 93), one of Schwitters's earliest, possibly dating to 1918–19 – reinforces, and extends, the theme of the column. Unlike the images and texts that surround it, it is framed, set apart as a special object, an artistic icon. Its focal point is a photographic reproduction of a column, bounded by images of putti and a section of drapery taken, like the material in *Die Handlung spielt in Theben* (see Fig. 75), from Lochner's painting *Madonna in the Rose Bower*. In the collage, Schwitters has placed the column under the word *Kunst* (art), its last letter "t" just cut off; in turn, this word is placed beneath the reproduction of a piece of the cloak of Lochner's madonna. Itself a composite form – shaft, fluted capital, and animal protome (bust), apparently a lion's head, perched on top – the column stands next to a female figure whose outstretched arm rests against it. One cannot be certain from the reproduction whether Schwitters appropriated the image of the column and figure as a ready-made photomontage or brought them together himself; regardless, their proximity and stylistic contrast underscore the composite character of the entire collage. Surrounded by textual and visual

Figure 93. Schwitters, *Der erste Tag* [The First Day], ca. 1918–19. Collage. Destroyed.

references to art, singled out as an object of reverence by the multitude of putti, the image of the column becomes an icon within the icon of the framed collage. Juxtaposing this image with the title of the collage, which translates as *The First Day* – an evocation of divine creation – Schwitters seems to imply that the column (that is, tradition) forms the basis of all art. Even if the column is also represented ironically in this strangely incongruous collage, such exaltation poses a striking contrast to the demise of the column articulated by the formal discontinuities within the *Merz-column* as a whole. The *Merz-column* thus reveals contradictory readings:

one of history as discontinuous moments, surviving only in fragments; the other of history as a continuum, perpetuating itself in social and cultural forms.

"It happens frequently that after a victorious battle a memorial or a column is erected at the place where the enemy was vanquished in order to commemorate the event and to inform posterity what the enemy was like," noted Albrecht Dürer in 1525 in his *Painter's Manual*.[11] Columns have long provided an ideal form for representing authority – no matter whether that of the military, state, church, or the individual. Dürer's elaborate design for a *Triumphal Arch for Emperor Maximilian* (Fig. 94), its columns bearing portraits of venerated ancestors and past rulers, exemplifies this form.[12] At times of political change, columns have been toppled to literally shatter the ideology they embody – for example, the column on the Place Vendôme during the French Commune (Fig. 95). Dürer himself showed how readily the column lends itself also to subversive treatment. Satirizing the ennobling function of the memorial column, he proposed a design for a *Memorial to a Drunkard* (Fig. 96), composed, in part, of a beer barrel and board game and surmounted by a basket filled with bread, butter, fruit, and cheese.[13] Emil Schaudt's popularly acclaimed *Bismarck Monument* in Hamburg of 1902 (Fig. 97), the various design proposals for a *Germania Column* in 1904, and Vladimir Tatlin's dynamic *Monument to the Third International* of 1919–20 are just a few of the many interpretations of the column in the twentieth century.[14] Behrens, Olbrich, and Hoffmann all began to incorporate classical columns into their designs, and as late as 1922, the year of the *Chicago Tribune* competition, submitted a design for a tower that took the form of a giant Doric column. In the Germanic countries, in fact, the column had become such a prevalent architectural form in the early years of the century that one could say with Reyner Banham that "the new architecture of the twentieth century was born under the sign of the Doric column."[15] This interest in the column revolved around a widespread debate, one side of which saw the Doric column as the supreme example of classical rationality, order, structure, and perfected beauty, in opposition to the supposedly irrational and decadent organic forms of the Jugendstil. Embedded in the discourse was, predictably, a continued gendering of form that posited Art Nouveau as feminine and the Doric column as masculine.

Schwitters had studied architecture for a brief period in 1918–19 at the Technische Hochschule in Hannover and maintained a lifelong interest in the discipline, evident not only in his *Merzbau* but in his association with a number of architects and architectural critics and, above all, his publication in 1925 of Ludwig Hilberseimer's *Großtadtbauten* as of no. 18/19 *Merz*. It is more than likely that during his architectural studies Schwitters encountered the debate about columns. He did not, of course, resurrect the Doric column either in *Der erste Tag* or in the *Merzcolumn* itself. The column as prototypical artistic form provided a conceptual focus for the artist, but as we have seen, he seemed to have embraced two different positions at once. Thematically, Schwitters elevated the column; representationally,

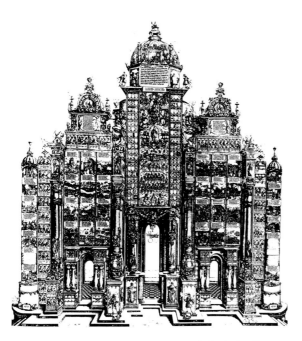

Figure 94. Albrecht Dürer, *Triumphal Arch for Emperor Maximilian.* Woodcut, 1515. 330 × 287.5 cm.

Figure 95. Léonce Schérer, lithograph showing the toppling of the Place Vendôme column, Paris, during the French Commune. Published in *Souvenirs de la Commune*, 4 August 1871.

Figure 96. Dürer, *Memorial to a Drunkard.* 1525. Published as an illustration in Dürer's *The Painter's Manual.* Transcribed by Walter L. Strauss (New York: Abaris Books, 1977), p. 236.

Figure 97. Emil Schaudt, design for the *Bismarck Monument*, Hamburg, 1902.

he demoted the classical form to a state of ruin or else displaced it in favor of a preclassical column. These conflicting positions must be further untangled to situate Schwitters more clearly within the larger cultural debate over tradition and modernity, of which the arguments about the primacy of the Doric column were but a part. The central terms in this debate – which intensified with the rise of industrial capitalism – were *Zivilisation* (civilization) and *Kultur* (culture). *Zivilisation*, declared Oswald Spengler – author of *Der Untergang des Abendlandes* (Decline of the West) first published in 1918[16] – developed from urbanism and pervasive materialism, the world of commerce and abstract thought. Characterized by chaos, *Zivilisation* signaled a moment of cultural decline. *Kultur*, by contrast, defined an economic world of production rather than commerce and implied the reign of the soul over the intellect. Characterized by organic unity and unbroken tradition, it described a moment of cultural cohesion. According to Spengler, then, *Zivilisation* was experienced in terms of fragmentation, *Kultur* as a period of wholeness.

Schwitters's *Merz-column* makes use of similar dichotomies. The materials affixed to the base of the *Merz-column* are not the ancestral portraits that Dürer proposed for Maximilian's arch, but bits of newsprint. Arranged on a grid, these fragments suggest the machine – in particular, the modern printing press – and convey an impression of anonymity, flatness, and geometry. The large letters, numbers, and disjointed images evoke an urban environment, with its sensory overload of competing information reduced to quickly processed symbols. These materials are progressively displaced by objects gleaned from a more craft-oriented and organic environment. Read vertically, the *Merz-column* can be seen as moving from a representation of the world of modernity, of *Zivilisation*, to that of a preindustrial world, of *Kultur*.

Yet, just as he did within the small collage *Der erste Tag* and the representation of the column, Schwitters here too blurs distinctions, superimposing a second reading on the first. Rather than separate the categories, he effects a gradual transition from one to the other. Moreover, the hierarchy of the *Merz-column*'s forms (the sculptural body on top of the pedestal) constitutes an inversion of temporal succession. In a linear view of history, *Zivilisation* followed *Kultur* and derived its form from *Kultur*'s transformation. In Schwitters's column, however, the products of *Kultur* rest on the products of *Zivilisation*. This reversal is reinforced by the activation of the base as an integral part of the entire sculpture. One is reminded of similar strategies employed by Constantin Brancusi in his contemporaneous reinterpretation of sculptural form and base and his insistence on their interdependent, even inverse, relationship. Schwitters, then, while appearing to celebrate and elevate *Kultur* over *Zivilisation*, in fact suggests a reading of mutual dependence. It thus becomes increasingly clear that Schwitters, despite his use of collage as a technique of modern production and his self-perceived liberation from the past, articulated an intermediate position, embracing modernism, but allowing, indeed advocating, the survival of tradition.

Schwitters's position becomes more evident still in another subtext of the *Merz-column*. We have seen that he posed the issue of modernism's relation to tradition in terms of the organic (traditional craft) and inorganic (modern production). Schwitters, however, extended his inquiry to the sphere of the public and the private. It was, after all, in the changed relationship between the public and the private that cultural modernism found one of its most important expressions.

The bits of newsprint on the base of the *Merz-column*, with their evocation of anonymous production methods, are not as void of personal life or anecdote as they at first appear. The artifacts of modernism recount a private history that is also a public history: Schwitters's own life as an avant-garde artist. The numerous references to his artistic and intellectual associations within the international avant-garde of the 1920s make the base something of a personal bulletin board that is at the same time a public advertising column. Schwitters included several pages from the inaugural "Holland Dada" issue of *Merz* (Magazine), published in January 1923, which carried the report of his successful Dada performance tour with Theo van Doesburg, Nelly van Doesburg, and Vilmos Huszár. He chose the front cover, pasted below the collage *Der erste Tag*, and the words "Merzidee Merz Merzidee," pasted to its left. He also incorporated the cover of *De Stijl* (the "Anthologie Bonset" [4:11]), published in November 1921.[17] Likewise, the word "Dada" peeks out from behind the word "Merz." Inserted among these references to avant-garde movements are an advertisement for a Caruso concert and one for men's fashion, underscoring the status of the modern artist as public performer. If, as Dürer wrote, the victory column was erected to commemorate the battle that had vanquished the enemy, then Schwitters, in his column, celebrates the artistic self that has vanquished obsolete artistic traditions. It is the triumph of modern artistic practice as a collaborative, international enterprise. The *Merz-column* may be a ruin of the classical column, but in its modernist base Schwitters invests it with authority. He reaffirms as well the value of creative prowess.[18]

Yet given Schwitters's work with reversals, oppositions, and transitions, it should come as no surprise that the upper half of the *Merz-column* commemorates a different self: one without control over his fate and whose ties are the traditional ones of family. The doll's head on top of the column, in fact, is not a doll's head at all, but the death mask of Schwitters's second son.[19] The *Merz-column* in this reading is no longer a victory column but a funereal monument, a monument to a profound private loss that topples the authority of the self as expressed in terms of procreative powers. Indeed, it seems precisely to compensate for the lost filial relationship that Schwitters emphasized the base of his column.[20] The artist, then, built a monument to the totality of his existence. In using the very fragments of his life as the building stones of his column, Schwitters prevents these fragments from turning into anonymous shards. The construction of the *Merz-column* and of the larger *Merzbau* was an act of defiance, a lifelong salvaging operation to reclaim personal wholeness and control in the face of fragmentation and chaos.

Formally, Schwitters's *Merz-column* strikingly recalls Johannes Baader's *Das Große Plasto-Dio-Dada-Drama* (1920; Fig. 98), shown at the First International Dada Fair in Berlin in that year. Baader, a member of the Berlin Dada group, closely identified with Kurt Hiller's activism; he sought, much like Hiller and the Rat geistiger Arbeiter, to reform society at its roots. The present, according to Baader, was characterized by the power of the mass media to shape perception and consciousness. Identifying himself as the modern Christ, Baader defined his role as that of the builder of a new society; architecture was to play a special role in his scheme: firmly grounded in the present, it was to direct the spirit into the future.

In his architectural column (possibly influenced, as Stephen Foster suggests, by Schwitters's two early sculptures, the *Kultpumpe* and *Lustgalgen* exhibited at Der Sturm in 1919),[21] Baader joined references to mass culture and himself as Savior. His column, much like Schwitters's, is organized along several levels; at the bottom are the emblems of a new language as represented by several of Raoul Hausmann's poster poems which he composed of disconnected vowels and consonants pictorially arranged without, however, ever forming recognizable words. These are followed, in turn, by mementoes of Baader's own Dada activities (such as his declaration that he was the president of the world), various found objects (machine parts, a cogwheel and chain, a small wire cage and a building block in the form of a classical arch), as well as the bust of a mannequin (which can be identified, with the help of one of his collages, as his own stand-in), surrounded in turn by the front pages of several newspapers. The whole construction is topped by a stove pipe leading the eye to the uppermost section, where Baader affixed the front page and title of two Dada publications that he either edited (*Die freie Straße*, vol. 10, December 1918) or in which he participated (*Die Pleite*), thus specifically singling out Dada and himself as the governing spirits of the future.

Schwitters's *Merz-column* and Baader's *Das große Plasto-Dio-Dada-Drama* are formally surprisingly similar. Both focus on the artist in his contemporary environment and celebrate the mass media and found objects as new artistic materials. Both fuse language with the visual arts (sculpture and design) into a new whole expressive of a critique of contemporary life: Yet Baader, identifying himself as a catalyst for social change, directs attention from the present into the future; Schwitters, in contrast, connects in the *Merz-column* the present with the past with his emphasis on personal history and the relations of *Kultur* and *Zivilisation*.

Schwitters's *Merz-column* is characterized by a persistent doubling and redoubling of texts. It is an allegorical work and, as such, it articulates the problematics of tradition and its demise. Paraphrasing Walter Benjamin, a contemporary critic defined allegory as an attempt "to rescue from historical oblivion that which threatens to disappear."[22] Benjamin, in his study of allegory in German tragic drama, described the fragment as the allegorical material par excellence: a literal representative of the past and, at the same time, an embodiment of the process of decay

Figure 98. Johannes Baader, *Das Große Plasto-Dio-Dada-Drama: DEUTSCHLANDS GROESSE UND UNTERGANG* [Great Plasto-Dio-Dada-Rama: GERMANY'S GREATNESS AND DECLINE], 1920. Assemblage, Destroyed.

that the unfolding of time inevitably effects.[23] Allegorical imagery is therefore always appropriated imagery.[24] The *Merz-column* fits the terms of allegory precisely. Schwitters's use of fragments and individual objects lifted from their context, his attempt to reassert and elevate the experience of the self, and his advocacy, however ambiguous, of *Kultur* over *Zivilisation* emerge in response to an estrangement from tradition and reveal "a desire to redeem the past for the present."[25]

Allegory lends itself to the doubling of texts in relation to modernist art. Within the discourse of modernism, and geometric abstraction in particular, allegory has been decried as outmoded. The view of allegory as a vestige of tradition reinforces the reading of the upper part of the *Merz-column* as an embodiment of *Kultur* and

the description of Schwitters as a traditionalist who broke only superficially with the past. In its elevation of the fragment, however, allegory can also be seen as a quintessentially modern idiom. Schwitters played out this contradiction within the allegorical mode to emphasize the problem of tradition and authority. In the process, he created a new type of column, one that collapses typological differentiation in favor of a composite, all-encompassing form. It may be useful, in this regard, to return to the column depicted in *Der erste Tag*. With its lion protome perched on top, it could be an Egyptian column, possibly from Karnak, or it could come from the Mesopotamian site of Persepolis.[26] As a free-standing pillar without a fluted shaft, it is particularly reminiscent of columns popular in India in the Maurya period – especially during the rule of Aśoka, who in the mid-third century B.C. introduced from Western Asia the lion as a royal symbol, which was incorporated into the sculptural program of columns. Whether it derives from an archaeologically identifiable site or is an image of Schwitters's own making is difficult to say. More important, as previously pointed out, this column is not Doric. Instead, it suggests the earliest column forms in Western culture. Evoking in its title the dawn of Western civilization and artistic activity, *Der erste Tag* presents a kind of Ur-column – part of Schwitters's search for a prototypical language, as formalized, for example, in his *Ursonata*.[27]

By contrast, the larger *Merz-column* reveals a civilization at the end of its historical development. Yet this entire span of Western civilization, from primitive to modern industrialized society, may be hidden within the column of *Der erste Tag* itself. The image of column and female figure suggests a theatrical mise-en-scène, and it is possible that the column is actually a film prop. This reading is supported by the closely related collage *Die Handlung spielt in Theben* (see Fig. 75), which also borrowed from Lochner's *Madonna in the Rose Bower*. Alluding, we remember, in its title to Lubitsch's film *The Love of the Pharaoh* (released in 1921), this collage includes an image of the filming of an interior scene, the set placed in the open air, next to one of the film's props, a wall of heavy columns in the Egyptian style.

The *Merz-column*, then, encompasses the historical trajectory of Western civilization and the range of artistic activity from production to reproduction. Schwitters's conception is all-inclusive, but highlights the fragmentation of cultural products, past and present. As the *Merz-column* is later integrated into the *Merzbau*, it becomes itself a fragment, treated like any other building stone within the larger structure. Although the *Merz-column* functions as a narrative element within the *Merzbau*, it never achieves closure: It is discontinuous, insisting on the rupture that Schwitters described as so liberating. Even though he creates a distance between the column and the historical values it projects, in his sculpture Schwitters ultimately reinforces the power of authority and tradition and erases the experience of rupture. The *Merz-column* is the embodiment of Merz – "the building with fragments" – but in building with fragments, Schwitters attempts to conquer the very process of fragmentation.

The *Merz-column* is, like the other early sculptures, constructed with fragments. In these three-dimensional works, in contrast to his *Merzzeichnungen*, and his larger mixed media works, his *Merzbilder*, Schwitters seems freer and less concerned with an aesthetic and controlled reintegration of found objects into an artistic form. Nevertheless, even when more spontaneous, Schwitters reflects on the same issues and arrives at related formal solutions as he did in his seemingly more structured visual and literary works: The role of the mechanical, tradition and innovation, the erotic, the political, and, above all, the self, are all discussed in terms of inversion and fragmentation. Yet once he had built up sculptural forms out of fragments, Schwitters turned these new forms themselves back into fragments when he used them as building stones for the *Merzbau* – the *Merz-column* was incorporated into the *Merzbau* (Figs. 99 and 100) and, presumably, so was *Heilige Bekümmernis*. In Schwitters's hands, the very act of building is also an act of fragmentation. Destruction and construction are presented as eternally interwined in one organic process of transformation, in which the fragment plays a central role.

Within the *Merzbau*, the grotto is the most significant artistic form. A grotto establishes the foundation of the *Merzbau* and, piercing the shell at many places, grottoes create a conduit between interior and exterior and are singled out as special forms (Figs. 101 and 102). Above all, the grottoes as miniature exhibits fulfill a symbolic function, for it is here that Schwitters displays the different uses of the fragment. When visitors had strong reactions to the *Merzbau*, it was usually not to the structure as a whole, but to the curious displays in the grottoes. The *Merzbau* grottoes were Schwitters's most controversial works of art. Although his two-dimensional collages were at times criticized for the overt aestheticism they displayed,[28] his grottoes did not elicit such benign responses. Alexander Dorner, for example, sometime president of the Kestner-Gesellschaft and from 1922 director of the Niedersächsisches Landesmuseum, a strong supporter of modern art and admirer of Schwitters's *Merzbilder*, could not muster any positive feelings toward the grottoes. He had described the *Merzbilder* as "positive pioneering experiments," but critiqued the *Merzbau* as "the free expression of the socially uncontrolled self [that] had here bridged the gap between sanity and madness. . . . a kind of fecal smearing – a sick and sickening relapse into the social irresponsibility of the infant who plays with trash and filth."[29]

Although Schwitters's building material – the fragment – remained nameless in the interior at large, in the grottoes it is given clear signifying power. Each grotto has a name, so that dolls' heads and bits of hair, brassières, or coal are elevated from the anonymous heap of the junk pile to the status of signifiers. Pencil stubs now refer to Goethe's genius as a writer and poet, a charcoal briquette is meant and understood to signify the mining areas of Germany, small reproductions of Michelangelo's paintings and sculptures symbolize art exhibitions. In Schwitters's grottoes, objects capture a moment in personal or universal cultural history. Within

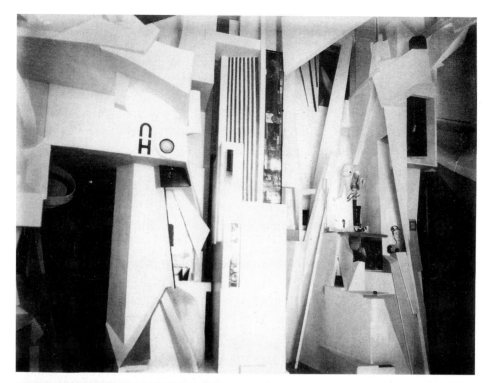

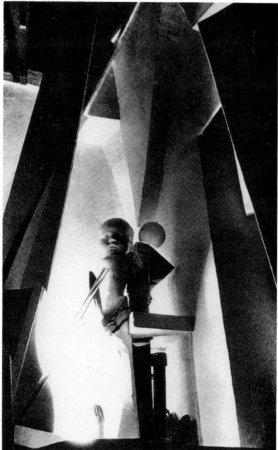

Figure 99 (*above*). Schwitters, *Merz-bau with Integrated Merz-column*, photographed ca. 1930.

Figure 100 (*left*). Detail of *Merz-column* as incorporated into the *Merz-bau*, ca. 1930.

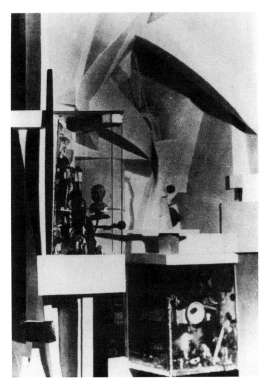

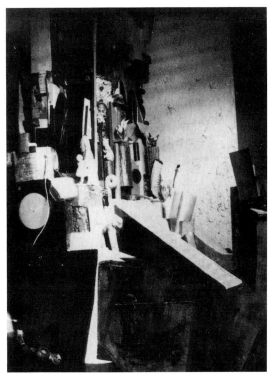

Figure 101. Schwitters, *Die Goldgrotte* [The Gold Grotto] in the *Merzbau*, photographed ca. 1932.

Figure 102. Schwitters, *Merzbau: Kathedrale des erotischen Elends (KdeE)* [Cathedral of Erotic Misery], photographed 1928.

the *Merzbau*, the individual grotto is also the only clearly defined structure, isolated from its more organic surroundings as a strictly bounded form. As the shrine to the fragment – reminiscent of the hurdy-gurdy and the vendor's tray in the *Heilige Bekümmernis* – the grotto is, however, also treated as a fragment itself. We know from visitors' and Schwitters's own accounts that many grottoes disappeared much like the *Merz-column* in the expanding *Merzbau*. Schwitters described this act of disappearance matter-of-factly as having to step over the dead bodies of details:

[The *KdeE*] grows like a city; somewhere a house must be constructed and the building commission has to ensure that this new house will not ruin the looks of the entire city. When I find an object and know that it belongs in the *KdeE* I take it along and glue it on, cover it with plaster and paint it according to the impression of the whole. And one day, a new direction develops, which steps totally or in part over the object's corpse. In this process things that are entirely or partly obsolete remain as proof that they have lost their value as independent elements of the composition. As the ribs of the architecture grow, new valleys, hollows, grottoes come into being that again have a life of their own within the whole of the construction.[30]

A friend of Schwitters, the artist Rudolf Jahns, described it in simpler terms, and interestingly referred to the *Merzbau* itself as a grotto: "Later I have seen the

grotto [*Merzbau*] once more. Everything was changed. Many caves were nailed shut and the total impression was that of a more closed structure."[31] Hans Richter, who had visited Schwitters in 1925, observed:

But this was more than a sculpture; it was a living, daily changing document on Schwitters and his friends. He explained it to me, and I saw that the whole thing was an aggregate of hollow space, a structure of concave and convex forms which hollowed and inflated the whole sculpture.[32]

Richter returned to Hannover in 1928 and reported on the changes in the *Merzbau*:

All the little holes and cavities that we had formerly "occupied" [by proxy, through personal mementoes] were no longer to be seen. "They are all deep down inside," Schwitters explained. They were concealed by the monstrous growth of the column, covered by other sculptural excrescences, new people, new shapes, colors and details.[33]

Like all the other components of Schwitters's work, the grottoes, too, oscillate between nearness and farness, but in some respects, this oscillation is here more intense because it takes places on both an actual and conceptual plane. Although Schwitters rarely described his works in any detail, he did offer fairly extensive accounts of several of his grottoes. Yet some of the accounts sound so extraordinary, are such outbursts of fantasy, that one can never be sure of their actual existence.

As they occur in nature, grottoes, like caves, have long exerted a fascination on mankind as special places located at the juncture between the wilderness and the tamed, cultured landscape. Often not readily accessible, they have served as shelter and retreat, but with their frequently confusing interior spaces, they have also been reminders of the unpredictable and uncontrollable character of nature. Throughout history, man has duplicated the strange spaces of natural grottoes and caves and created artificial, miniaturized versions of the natural form. These grottoes as man-made products were quickly imbued with symbolic meaning and invested with special functions. In Christian art and writing, the grotto became a sacred place (as in the cave of the Nativity and the grotto of St. Anthony); during the Renaissance, grottoes became secular spaces as an integral part of the garden landscape. There was a difference, though: Whereas the garden represented nature in its idealized form, open and accessible, the grotto functioned as a reminder of nature in its original state as a mysterious, dark force, essentially inaccessible. Yet both garden and grotto were equally artificial, symbolic spaces and, despite their being inversions of each other, served similar functions as miniaturized landscapes for display and the staging of spectacles, or as passageways between nature and culture.[34]

In postwar Expressionist film set and stage design, grottoes were reformulated into the haunting chambers of society's outcast, the angled retreats of the likes of Dr. Caligari and Dr. Mabuse. Grottoes and caves were also reinterpreted by contemporary architects as public spaces, as in the stalactites of Hans Poelzig's Großes Schauspielhaus in Berlin (1919; Fig. 103), a former circus building remodeled for

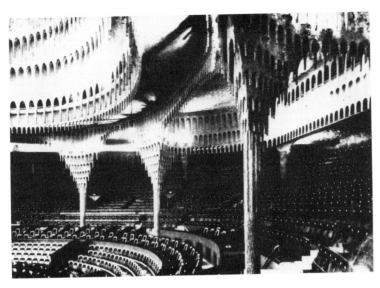

Figure 103. Hans Poelzig, Großes Schauspielhaus (Grand Theater), Berlin, 1919.

Max Reinhard's theater, and Walter Würzbach and Rudolf Belling's Dance Casino at the Scala Palast, Berlin (circa 1920). This more cavelike approach to the contruction of public spaces is echoed in Schwitters's *Merzbau* as well, not so much in the individual grottoes as in the appearance of the *Merzbau* at large, within the confines of the studio – yet another play with inversion (the exterior becomes another interior within the larger setting of the house) and yet another transformation of a seemingly complete form into a fragment.

Judging from Schwitters's own accounts, there were at least thirty to forty grottoes, and probably even more. They can be classified into grottoes symbolizing either *Kultur* or *Zivilisation,* for they use as themes eros, friendship, and historical or political events. In a short, humorous text, "Das große E" [The Big E] from about 1930, Schwitters clarifies the importance of the grottoes as an integral part of the entire structure. Here we learn that their position is planned during the construction of the larger shell, but not their specific content. As their final form is left undetermined and will be decided only when appropriate material is found – ideally through a collaborative effort – they take on a particular position within the larger structure. The grottoes, then, embody an intermediate step between the interior and exterior in their mode of construction and their signifying function.

The *Big E* is finished. All that remains to be done is the detail in a few places and for that I need material. I therefore turn to you. Important artists have already collaborated on essential parts, artists like Walden, Hannah Höch, Vordemberge-Gildewart, and others. I should be very much obliged if you, too, would donate material for a small grotto. Large grottoes are still available as well. The only thing missing in these grottoes is material of international importance, such as tram tickets, coat checks, calling cards, election ballots, play-bills, business announcements, and, above all, photographs. I especially need suitable

189

photos of you, the esteemed members of your family, and of your work. Already there a many important people represented in the *Big E*, people like Haarmann, Hitler, Hindenburg, all the Roman gods, Captain Dreier of the sunken Monte Cervantes, Conrad Veidt, Mussolini, my wife and I, my son, Professor Wanken and his son Punzelchen, Mrs. Elisabeth Klenner, and many, many others. Please consider donating something for the *Big E* from that arena of your life that is dearest to you, art, kitsch, whatever you like. Next to the *Big E* is the *Collection E* designed to give information about the new in art.[35]

Schwitters's *Merzbau* grottoes are, like their historic predecessors, also miniaturized cultural and political landscapes, which were to embody as time capsules the events and obsessions of his era. Much as the shards of mirror and seashells in the famous grotto at Twickenham, built by Alexander Pope during the 1720s and 1730s, endlessly reflected themselves, Schwitters's fragments, too, reflected each other – not least in the mirror shards installed throughout the *Merzbau*, but also as a mirror to the larger political and cultural landscape from which they were derived. This landscape is the landscape of mass culture. His listing of the lofty to the banal – "the internationally important" tram tickets and calling cards, the reactionary and fascist leaders Hindenburg, Hitler, and Mussolini, the mass murderer Haarmann, as well as the anonymous, generic youngster, the professor's son Punzelchen – paints a vision of contemporary society in which anything and everything is equally important or unimportant. Schwitters singles out the photograph as the icon and signifier of mass culture, seizing upon photography as the medium that most readily and visibly shatters tradition. Photography isolates an image and through mechanical reproduction makes it infinitely transportable and available for simultaneous, collective consumption. Walter Benjamin in his often quoted essay "The Work of Art in the Age of Mechanical Reproduction" characterized photography and its temporal extension, film, as a technique of reproduction that

detaches the reproduced object from the domain of tradition. By making many reproductions it substitutes a plurality of copies for a unique existence. And in permitting the reproduction to meet the beholder or listener in his own particular situation, it reactivates the object reproduced. These two processes lead to a tremendous shattering of tradition which is the obverse of the contemporary crisis and renewal of mankind. Both processes are intimately connected with the contemporary mass movements.[36]

Grosz and Herzfelde in 1925, eleven years before Benjamin's and five years before Schwitters's essays were written, similarly described contemporary society as ruled by the media, in particular the photograph. They, too, defined the photograph as shattering tradition, and Schwitters's text resonates with their wording:

With the invention of photography the twilight of art began. Art lost its function as reportage. The romantic longings of the masses are satisfied in the cinema; there the quest for love, ambition, the unknown, and nature finds plenty of nourishment. And he who loves actualities and historical pomp will find satisfaction too: the sovereign with or without top-hat, the robber and murderer Haarmann, sportsfests and momument inaugurations, our good old Greens – everyone is there. Hindenburg's sorrow-lined face is not preserved for

humanity by a Rembrandt or Dürer and Dempsey's muscles are not recorded by Michelangelo.[37]

The grottoes, then, seem to have been conceived as a museum of mass culture, their content arbitrarily elevated to the status of display. Whether alluding to private tragedy or issues of national importance, in the grottoes, as in mass culture, everything and everyone can become "a Roman god." In fact, Schwitters's description of the use of photographs in "Das große E" is simply another voicing of his Merztheory – identified then as a theory of mass culture – in which all materials are treated as equals regardless of their provenance. His request for materials rescinds the Berlin Dadaists' call for a new and critical art based on the lead article or the illustrated paper:

The Dadaists acknowledge as their only program the duty to make today's event in time and space the subject of their images; that is why they don't derive their inspiration from 'Thousand and One Nights' or 'Pictures from India,' but from the illustrated newspaper and the lead article in the daily press.[38]

The illustrated paper also provides the material for Schwitters's work. Both the Berlin Dadaists and Schwitters use the photograph to explode the bourgeois notion of art. Schwitters, enshrining the materials from the illustrated paper in his grottoes, also alludes to the process of consumption, in which the news items become the substitute and modern equivalent of the "Thousand and One Nights."

Schwitters's systematization of mass culture and its display in the form of artifacts is reminiscent of (and contemporaneous with) Walter Benjamin's comprehensive project *Passagenwerke* [Arcades Project], which occupied him from 1927 until his death. The *Passagenwerke* was Benjamin's effort to write a comprehensive sociocultural history of nineteenth-century France inspired by the shopping arcades of the French capital. Quoting from a mid-19th-century guidebook, Benjamin illuminates his project:

These arcades, a new contrivance of industrial luxury, are glass-covered, marble-floored passages through entire blocks of houses, whose proprietors have joined forces in the venture. On both sides of these passages, which obtain their light from above, there are arrayed the most elegant shops, so that an arcade is a city, indeed a world in miniature.[39]

For Benjamin, social experience is inscribed in the discrete fragments of everyday existence. Considering each fragment as a representative of the larger culture, he reassembled them in his critical essays in a collage-like structure that in its entirety was to offer an overview and cross-section of the culture of modernity. This process, Michael Jennings argues,

reflects the two major themes of Benjamin's theory of criticism: the conviction that truth, the hint of redemption, is present to the modern world in hidden and fragmentary form and the corresponding conviction that this truth can be revealed only by a destructive process that purges the cultural objects of their mythical, or dehumanized, character.[40]

Schwitters's approach to modern culture largely parallels Benjamin's. He, too, singled out the fragment as the representative of culture and gave it its own "arcade shop window" in his *Merzbau*. Yet Schwitters understood himself as a funnel through which modern culture was filtered: He was not an objective observer standing on the outside. Because Schwitters saw culture with the eyes of the suffering I, his assessment of modernity rarely achieved the critical distance of Benjamin's work. Indeed, Schwitters's description of some of the grottoes in the *Merzbau* at large suggests that he did not treat all material identically but, as throughout his work, simultaneously collapsed and maintained divides. This is how he offers us a glimpse of these mostly hidden spaces in his text "Ich und meine Ziele" of 1931. As so often in Schwitters's writing, it is difficult in this text to differentiate between fact and fiction; nevertheless, certain organizational tendencies can be discerned:

Each grotto derives its character from the one or the other of its main components. There is the *Nibelungenhort* [Treasure of the Nibelungen] with its glittering treasure, the *Kyffhäuser* with the stone table, the *Göthegrotto* with one of his legs as reliquary and many pencil stubs, the submerged personal-union city of *Braunschweig-Lüneburg* with houses from Weimar made by Feininger, a Persil advertisement, and my design of the official emblem of the city of Karlsruhe; the *Lustmordhöhle* [Sex-Crime (or Lustmurder) Cave] with the abominably mutilated corpse of an unfortunate young girl, painted with tomato juice, and adorned with many votive offerings; the *Ruhrgebiet* [Ruhr District] with authentic brown coal and authentic gas coke; the *Kunstausstellung* [art exhibition] with paintings and sculptures by Michelangelo and myself, whose only visitor is a dog outfitted with a train [*ein Hund mit Schleppe*]; the *Hundezwinger* [Dog Kennel] with lavatory and a red dog; the *Orgel* [Organ], which one has to turn anticlockwise to play "Silent Night, Holy Night" but which used to play "Come Ye Little Children"; the *10%tigen Kriegsbeschädigten* [10% Disabled War Veteran] who no longer has a head but otherwise is still well preserved, with his daughter; the *Monna Hausmann*, consisting of a reproduction of the Mona Lisa with the pasted-on face of Raoul Hausmann covering her stereotyped smile.[41]

Schwitters continues to describe a different type of grotto – his most controversial one:

[There is] the *Bordell* [Bordello] with a lady with three legs, created by Hannah Höch, and the great *Grotte der Liebe* [Grotto of Love]. The Grotto of Love alone takes up approximately ¼ of the base of the column; a wide outside stair leads to it, underneath stands the *Klosettfrau des Lebens* [Female Lavatory Attendant of Life] in a long narrow corridor with scattered camel dung. Two children greet us and step into life; owing to damage only part of a mother and child remain. Shiny and fissured objects set the mood. In the middle is a couple embracing: he has no head, she no arms; between his legs he is holding a huge blank cartridge. The big twisted-around child's head with the syphilitic eyes is warning the embracing couple to be careful. This is disturbing, but there is reassurance in the little bottle of my own urine in which Immortelles [everlasting flowers] are suspended.[42]

From other accounts we also know about grottoes dedicated to his friends that contain objects either lost by or filched from their owners; Schwitters further describes a *Goldgrotte* [Gold Grotto], an area "highlighted with special lighting and

color treatment and constructivist forms," and the *Lutherecke* [Luther Corner] that "has disappeared inside the column."

Although Schwitters began his own list with grottoes indicative of the realm of *Kultur*, he made the grottoes of perverted sexuality with their mutilated and diseased occupants the physical and conceptual foundation of the *Merzbau*. These must have been the most memorable grottoes within the *Merzbau*, for several visitors commented on them as well. Rudolf Jahns, for example, remembers a box, about 50 cm long, partly nailed shut with a board, partly covered with chicken wire:

> In it, bedded on straw, were two strange creatures with large, dirty-white bodies and heads. Each had only a single s-shaped, bent black leg. There was a mysterious muted darkness in the box that barely revealed these creatures. They were two large porcelain insulators of the kind one sees on top of telegraph wires along the railroad tracks.[43]

Kate Steinitz recalls the *Lustmordhöhle* [Lustmurder Cave] as the Cave of the Murderers, "where little plastic figures were bleeding with lipsticks."[44] In these grottoes, sexuality is shown as commodified desire, available for purchase as something grotesque (the brothel) or coupled with violence (the *Lustmordhöhle*, which may have been the grotto described in the *Big E* as dedicated to the mass murderer Haarmann). Love itself has become ruinous (even children are already infected with syphilis) and love making mechanical and fraught with danger (the firecracker between the legs). Schwitters has transformed the theme of love into a representation of the wrongs of modern society, where in the wake of urbanization and industrialization human interactions have become mechanical and devoid of meaning. These grottoes find their thematic extension in the other grottoes representing the destructive facets of *Zivilisation*, as in the disabled war veteran and the other mutilated bodies.

With the *Lustmordhöhle* and the *Grotte der Liebe*, Schwitters returns to the representation of the human figure. In the mannequin images, Schwitters disassembled and reassembled the female body to assert control; in these two grottoes, the mutilation of the female body serves similar purposes, but here Schwitters participates in the contemporary fascination with aberrant sexual behavior and along with that asserts a more problematic view of male–female relationships.

After the war, the rate of sex crimes saw a marked rise. The progressive Berlin sexologist Magnus Hirschfeld, who had founded the *Institut für Sexualforschung* in Berlin in 1919 and later wrote a sexual history of the postwar period, linked the rise in these crimes to the war. The deprivation of the soldier during the war, he argued, and trench warfare in particular, produced pathological and perverse sexual behavior and "unchained atavistic impulses."[45] The psychological disorientation of the veteran was aggravated on his return home because he was confronted by a radical shift in male–female relations in the family and at the work place, where the newly emancipated woman was seen as overly aggressive; in the conservative

press, the liberated New Woman was described as the embodiment of cultural decadence, becoming a ready target for male aggression. Hirschfeld reported instances of violence committed by veterans against their wives; but he too saw the New Woman as threatening, for he charged women with sexual aggressiveness that elicited violent male response.[46]

Sexual violence became an obsessive topic not only in the popular press and film, but, more surprisingly, also in avant-garde artistic circles. Having called — as had the *Rat geistiger Arbeiter* — for sexual liberation in their program, the Berlin Dadaists showed nevertheless remarkably strong misogynist tendencies. Raoul Hausmann and George Grosz, for example, were both avid readers of Otto Weininger who, in his *Geschlecht und Charakter*, disavowed women of all intellectual capacity, and they asserted their superiority in their relationships with women.[47] More disturbing and relevant to the discussion of Schwitters's sex caves, the Berlin Dadaists, George Grosz, Otto Dix, and Rudolf Schlichter, in particular, all depicted sex crimes in studied detail.[48] Otto Dix, for example, during 1918–25 created nine oil paintings, twenty-seven drawings, and sixteen watercolors depicting violence, death, and sexuality; thirteen of these were sex murders.[49] In his *Lustmord* [Sex Murder] (1922), Dix based his depiction of two mutilated corpses on police photographs published in a book by Erich Wulffen on sexual deviance that Dix owned.[50] The accurate depictions of disembowelment and dismemberment, the showing of the tools, and the frequent self-identification with the murderer cannot be explained alone by the Dadaists' desire to explode bourgeois behavior; rather, they attest to a deeply troubled view of male–female relations typical of the period. Above all, the Dadaist preoccupation with sexual crimes creates a link with the prewar Expressionist writers, but under the impact of the war they gave a particularly brutal twist to misogyny.[51]

Schwitters's caves dedicated to deviant sexuality reflect, then, on current obsessions and social problems. Placing the representation of modernity at its most abject at the core of the *Merzbau* and linking it to other depictions of reproduction as processes of mutilation (*Monna Hausmann* as the disfigured Mona Lisa, or the Art Exhibition with its dilapidated reproductions of well-known works of art) declares modernity as a form of dismemberment and loss of identity. The symbolic representation of *Zivilisation* in the *Grotte der Liebe* creates, as Schwitters describes it, a vast hollow space at the bottom of the *Merzbau*. In his early collage *Leere im Raum* [Void in Space] (1920; see Fig. 57) Schwitters depicted the psychological abyss created by Germany's status as the vanquished as a black, empty space. In the *Merzbau*, this abyss is repeated in the form of the large, quasi-subterranean Grotto of Love with its negative representation of civilization. In 1927 Freud, as we remember, defined fetishism as a psychic mechanism fueled by a disavowal of castration and a substitution through vision of an image for the woman's missing penis. This double action, disavowal and substitution, occurs simultaneously and is then repeated in

future viewings of the fetish object.[52] In these grottoes, Schwitters's fragments may be seen as fetishes, the substitutes for a political loss. The conceptual conflation of the political (Germany's demise as a nation) with the moral (the demise of *Kultur*) offers a key to the interpretation of Schwitters's work. For in spite of his evident parody of bourgeois propriety in these caves, the larger conceptual link between the political moment and social situation resonates with the rhetoric of Germany's conservatives.

Several other grottoes that Schwitters described in "Ich und meine Ziele" establish a significant counterpoint to the grottoes of decadent love. These grottoes conjure up the epoch of *Kultur*, much as the organic materials in the *Merz-column* had created an opposition to the machine-age parts. Here one finds the *Göthegrotte* as a shrine to Germany's uncontested hero of *Geist* and *Kultur*; the *Lutherecke*, dedicated to the great reformist, the other best-known figure in Germany's Mount Olympus; and, most significantly, several grottoes concerned with myths of national destiny and transformation – the *Nibelungenhort* and *Kyffhäuser*, the grotto devoted to Barbarossa. In the *Merz-column*, the signifiers of *Kultur* were located in the middle section of the column; in the *Merzbau*, the grottoes thematizing *Kultur* comprise geographically the central area of Germany, and intellectually and philosophically its very heartland.

Goethe, of course, had turned the city of Weimar into the intellectual capital of Germany (and Schwitters romantically recalls old Weimar in the *Merzbau* with Feininger's wooden-toy set depicting the city's half-timbered houses that he had designed for the Bauhaus). Goethe himself staged the central scene of his most famous work in the heart of Germany: the "Walpurgisnacht" or Witches' Sabbath, in his *Faust* plays on the Brocken, a mountain in the Harz mountain range.

As the key figure of the Protestant reformation, Luther holds an equally important position in German intellectual history. Geographically, he too is associated with Germany's central region: Wittenberg, where he posted his ninety-five theses; the Wartburg, where he translated the bible; and slightly further to the West, the city of Worms, where he upheld in front of the Reichstag his repudiation of the Papal ban. Of these three, in most Germans' minds, the Wartburg is most closely associated with Luther. Located near Eisenach in Thuringia, it is geographically not far from the Kyffhäuser mountain range – to which Schwitters had devoted a grotto – said to be the resting place of Barbarossa.

Barbarossa – King Friedrich I of Hohenstaufen, who reigned from 1152–90 – is intimately connected to German dreams of national destiny and greatness. Barbarossa was revered principally for two reasons: for his imperial ideal of uniting all the German lands and for having taken up the cross during the Third Crusade. After his death by drowning on the way to the Holy Land, his life was quickly idealized and eventually shrouded in myth. For generations after him, German conservatives saw in Barbarossa the hero of a glorious imperial past and interpreted his vision of political unification as an embodiment of national destiny. The myth

placed him in the Kyffhäuser mountain, where he is said to be awaiting his return, to once again lead Germany to greatness. In the nineteenth century, Barbarossa was recalled with renewed fervor. In the years of Napoleonic rule, he served as a reminder of a more glorious past, but even during the revolutionary era, Hegel had pointed to Barbarossa as one of the ancient heroes who needed to be reclaimed. He was evoked in numerous poems, and in 1846, Richard Wagner wrote a sketch for a five-act spoken tragedy with music, to be called *Friedrich I*, idealizing Barbarossa's reign. Wagner abandoned this project two years later, but reformulated the figure of Barbarossa into that of Siegfried – to whom Schwitters alludes in his evocation of the treasure of the Nibelungs.[53]

After the unification of Germany in 1870, Wilhelm I was celebrated for reembodying the spirit of Barbarossa, and in 1896, a monument was erected for him on the Kyffhäuser mountain. Here Barbarossa, Wihelm I, and national identity were symbolically united in one giant column. Erected not far from the so-called Barbarossa Grotto, the monument could be reached by a long flight of outside stairs. Having climbed to its colonnaded base, one could admire Barbarossa enshrined in a niche in the lower part of the column and modeled after Michelangelo's *Moses*. Above him towered Wilhelm I on horseback, attended to by a voluptuous female History figure. The entire column was topped with a gigantic imperial crown.[54] Not surprisingly, the Barbarossa legend was reclaimed once again by German conservatives in the 1920s as an expression of their hope for a reunited and politically restrengthened Germany. The Nibelungs were equally the focus of renewed attention in the wake of Fritz Lang's immensely popular *Die Nibelungen* (1924). The mission of the film, according to Lang, was to offer something strictly national, something that, like the Lay of the Nibelungs itself, might be considered a true manifestation of the German mind.[55] Lang, so Kracauer explains, defined the film as a national document fit to publicize German culture all over the world.[56]

Schwitters showed a keen eye for politically and culturally sensitive issues in the plan for his *Merzbau* grottoes. His evocations of Goethe, Luther, Barbarossa, the Nibelungen, and Wagner all focus on the formation of nationalist ideologies, reiterated in the topography and in the furnishing of the individual grottoes themselves. In his description of the *Kyffhäuser* grotto, for example, he makes explicit reference to the mythical emperor's "stone table." It is visible in a photograph of the *Goldgrotte* (see Fig. 101) and appears to be a small, white dollhouse table. He implicitly refers to the modern Barbarossa cult with his *Nibelungenhort* grotto, which on his list immediately precedes the *Kyffhäuser* grotto. Likewise, the *Göthegrotte* follows in the list and is a strong reminder of the Goethe revival that, as an expression of nationalist pride, accompanied the Barbarossa revival in the 1920s. (Interest was fueled by Friedrich Gundolf's best-selling, adulatory study of Goethe, first published in 1916 and quickly reissued in several printings.)[57]

The references to Barbarossa are manifest not only in individual grottoes, but

in the architecture itself. The grand staircase in the *Merzbau* leading to the *Grotte der Liebe* recalls a similar staircase in the Kyffhäuser Monument, which transports the visitor via various grottoes to the heart of the nationalist shrine in which the present and former emperors are symbolically joined. The *Merz-column*, then, should also be read in terms of the Kyffhäuser Monument. Providing a private subtext to the larger structure that highlights contemporary public issues, it links and compares the formation of private and public mythologies, declaring them related and complexly interwoven processes.

As one would expect in Schwitters's work, the boundaries between *Kultur* and *Zivilisation*, between the past and the present, the private and the public, are frequently fluid and the relationship at times inverted. In the *Merz-column*, organic materials referred to the preindustrial period; here, in contrast, this function is fulfilled by modern, mass-produced materials: Feininger's Bauhaus toys and the pared-down, miniature dollhouse table, which is meant to evoke Barbarossa's mythical stone table and which certainly stands in stark contrast to the heavily ornamented Kyffhäuser Monument. The objects in Schwitters's grottoes of *Kultur* are modern; they refer to tradition only by association through the name Schwitters bestowed upon each grotto. Judging from the few photographs and Schwitters's description, it seems that the difference between the objects in the two different types of grottoes may have been their state of preservation. The various grottoes of sexuality as the signifiers of modernity are filled with broken or maimed forms, the "fissured objects" surrounding the mother and child – both "in ruin" – in the space below the *Grotte der Liebe*, or the pair of lovers, of whom the man "had lost his head and the woman her arms." In contrast, objects in the grottoes of *Kultur*, such as the pencil stubs and doll's leg in the *Göthegrotte*, are imbued with the patina of personal use or elevated to the status of reliquaries. It seems irrelevant whether Schwitters designed the grotto himself or not, for he characterized the objects in his own grottoes in similar terms: The charcoal briquettes in the *Ruhr* grotto, for example, are "genuine."

A third type of grotto offers another vision of community and society and also a different use of the fragment. Although the found object in the interior of the *Merzbau* remained anonymous building material, it was given signifying power within the grottoes. In the grottoes devoted to friendship, the found object is imbued with a special power. All the objects which Schwitters lists in these grottoes, or which are listed in descriptions by visitors to the structure, are objects filched from their owners. They thus have a direct association with specific people and function as their fetishized representatives. Kate Steinitz recounts that "Schwitters built into [the *Merzbau*] a lost key of mine which I had been searching for desperately. He placed the key next to a medical prescription written by Dr. Steinitz and the box of pills Schwitters bought but never took."[58] Hans Richter, too, was impressed with the contents of the individual grottoes:

He cut off a lock of my hair and put it in my hole. A thick pencil, filched from Mies van der Rohe's drawing-board, lay in *his* cavity. In others there were a piece of a shoelace, a half-smoked cigarette, a nailparing, a piece of tie (Doesburg), a broken pen.[59]

Imbedded in the *Merzbau*, this odd selection of objects gains a curious stature. Standing in for their many owners — Schwitters's friends from the international avant-garde of the 1920s — they symbolize the international presence of spirited, adventuresome artists, writers, and architects in opposition to the nationalist discourse set up by the grottoes of *Kultur*. The stranded keys, brassières, ties, socks, and locks of hair are more than witnesses of Schwitters's misguided sexual urges, as some critics have seen them; rather, they play an extremely important conceptual role and give us an indication of the signifying nature of the *Merzbau* as a whole. In the *Merzbau*, Schwitters creates an inventory of fragments. He organized them by type, explored their individual characteristics, and demonstrated their power to signify. Seeing the various fragments as representatives of the different aspects of contemporary culture at large, it becomes apparent that they were not simply conceived as polar opposites, but together, as building stones for a new, greater whole. In this regard, the fragments in the friendship grottoes play an important role. They are presented as alternative, positive fragments, symbolic of the desirable transformative processes brought about through collaboration and the disregard of nationalist concerns. In his essay "An alle Bühnen der Welt" Schwitters declares Merz as the equalization of differences:

I demand the total fusion of all artistic forces to achieve a total work of art. I demand on principle the total equality of all materials, equality between able-bodied people, idiots, whistling wiremesh and brainpumps. I demand the total fusion of all materials from welding torches to violins. I demand the most scrupulous rape of technology for the attainment of this fusion.[60]

The *Merzbau*'s shell typifies even more than the grottoes the idea of an encompassing and idealized transformation (Fig. 104). Schwitters characterized the shell in a brief passage in his essay "Ich und meine Ziele":

As the ribs of the architecture grow, new valleys, hollows, grottoes come into being, which again have a life of their own within the whole construction. Crossing directional lines are connected with planes, creating screwlike winding forms. The entire construction is covered over with a system of severe geometrical cubes, bent or dissolving forms, and forms pushed to their total dissolution.[61]

Lines, planes, cubes, and spirals — the architect's complete vocabulary — are brought together in one totality in a process that sees destruction and construction as interdependent. Transformation is the key; it is dynamic and organic. Comparing Merz to a shell that has grown out of different materials within, Schwitters declares Merz as a comprehensive project of organic transformation. The *Merzbau* is indeed a model for societal reorganization. Remaining "forever in flux," it can take into account any changes that occur as societies develop. Schwitters defined architecture

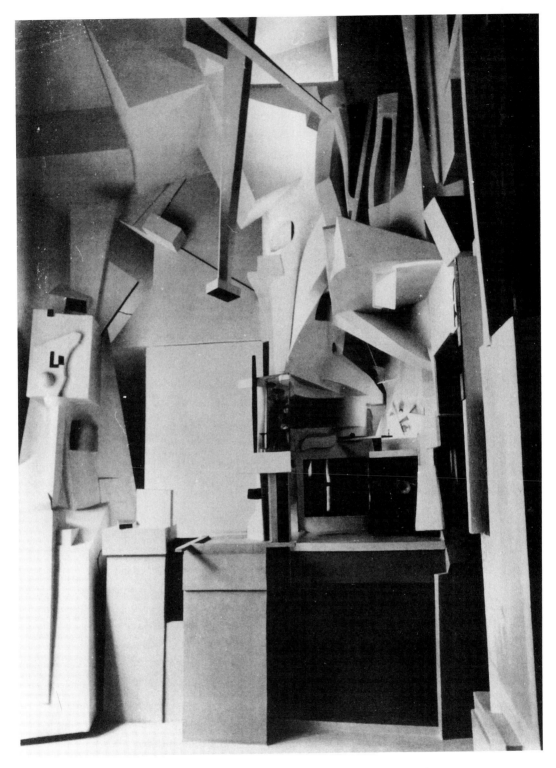

Figure 104. Schwitters, *Merzbau*, view with Gold Grotto, Big Group, and movable column, photographed ca. 1930.

as "the most comprehensive work of art. It comprises all the arts. Merz does not want to form, Merz wants to transform." ("Merz will nicht bauen, Merz will umbauen.")[62] The *Merzbau,* like the *Merz-column* on a smaller scale, spans the trajectory from the past to the future; it includes the conflicting phenomena of the present and suggests that anything and everything has to be brought together to develop a more harmonious and dynamic whole. Schwitters intimates in his model building that differences should be acknowledged (put on display in their different grottoes); but instead of leading to opposition and separation, they should be constructively employed for the creation of a new, more encompassing and thus better whole (the grottoes disappear into the *Merzbau* and become building stones to its dynamic shell). Schwitters's concept of the *Gesamtkunstwerk,* the total work of art, is a social one, and the *Merzbau* is its organic model.

Looking back to *Schloß und Kathedrale mit Hofbrunnen* we see that Schwitters already envisioned an all-inclusive, transformative program for that sculpture, reinforcing its interpretation as precursor to the *Merzbau.* In the text accompanying the reproduction of his work in Taut's *Frühlicht* magazine in 1923, Schwitters explained that his sculpture was indeed an architectural model and had a dual function: the one as blueprint for a new kind of architecture, the other as a model for the transformation of architecture itself into *Gestaltung* (design) based on the Merz-principle of organic transformation: "1. Merz-design for architecture. 2. The Merz-like use of architecture for *Gestaltung.*" After announcing that the use of any and all materials serves to enrich fantasy, Schwitters asserts that of all the different arts, architecture was most readily adapted to Merz:

Merz denotes, as we know, the use of the old as the material for the new. The architect, because of the inherent inflexibility of his building materials, must by necessity reuse the old and incorporate it into his new design. In this manner, when the architect does not merely copy the style of the old building, but subsumes it in the notion of a new total work of art, immensely rich and beautiful buildings have been created. This is, for example, how our cities should be reconstructed. Cities could be transformed into giant Merz works of art through the judicious tearing down of the greatest eyesores and the incorporation of both the ugly and beautiful houses, as well as the careful setting of accents, in a larger rhythmic whole.[63]

In this text, Schwitters draws partly on the dual concepts of *Formzertrümmerung* and *Formenaufbau* (destruction and construction of form), popularized by the art historian Otto Grautoff in lectures, essays, and his book of the same title (published in 1919)[64] and uses the term *Gestaltung,* employed particularly by Bruno Taut. Grautoff voiced the prevailing opinion that materialism had destroyed creativity and spirituality, but claimed that World War I was the expression of a widespread inner resistance to materialism and the wish to overcome its power. Grautoff saw a role for the individual artist as creator of new forms that could fill the vacuum created by the "destruction of militarism and the failure of socialism":

The unconscious forces of entire populations seek to destroy that which has been created by the old social orders and that which politically, militarily, economically, and culturally has not stood the test of time. The present time recognizes as its goal the destruction of the existing order and the spiritual purification of mankind. A second goal is the creation of a social order, in which a morality will become dominant that is not based purely on materialism, but instead on the melding of materialism with idealism.[65]

Grautoff advocated the construction of new structures expressive of these new social ideals as the preeminent task of artist and architect alike: "When a place lies in ruin, the first task is not to paint pictures that will adorn the walls of houses whose foundations have not yet been laid. The reconstruction of greater and more fundamental values is in question."[66] The question of what precisely were to be these "fundamental values" lay at the origin of so many of the postwar conflicts. Grautoff's writings blend various political and cultural discourses and reject things French, but do embrace a new internationalism, a critique of socialism and a cautious turn toward bolshevism. The key to the creation of the new society, according to Grautoff, was the melding of opposites into a new and better totality. In his book's first chapter, "Duality in Artistic Intention," he advocated a new, synthetic art that would be a mixture of opposites (the abstract and the concrete, the rational and the intuitive, plastic, painterly) and organic motifs, all united in a new higher totality. Although Grautoff's views were not uncontested – in a book review published in *Das Kunstblatt*, the art dealer and critic Wilhelm Uhde, for one, severely criticized the author for confused thinking and inelegant language and for "allowing everything to run into a porridge-like mass"[67] – they are nevertheless typical of any number of activist writers, artists, and architects during this period, as evident in the many new programs for reform and the manifestoes of the postwar period.

The architect Bruno Taut looked more specifically at the possibility of the creation of new societies through architectural means. Echoing the literary political activism of the circle around Kurt Hiller, he saw the architect as the creator not only of new dwellings, but of entire cities crowned by new types of religious buildings. Hiller had argued that the new man was not a "socialist" but a *Literat*, a literary person, a fusion of polemical writer and politician in the largest sense.[68] The *Literat*, according to Hiller, had a prophetic, messianic function: "His entire intellect will lead him to action. He is the summoner, the realizer, the prophet, the leader."[69] Adopting Georg Simmel's concept of activism, he declared that the creative power of the individual could synthesize the objective and subjective elements of culture into a higher reality.[70]

Taut, too, rejected the materialist base of society and set out to achieve the new "higher reality" with the means of destruction and reconstruction. Inspired by Paul Scheerbart's prewar writings, in which the fantastic was blended with the practical in expansive visions of a new architecture in service of a new society and transformed

individual, Taut advocated colored glass to imbue the building with spirituality and suggested that in order to obtain a pure form the mechanical and functional parts of a building should be hidden. In the immediate postwar period, in such publications as *Alpine Architektur* or *Die Stadtkrone*, Taut envisioned the creation of buildings in which both the interior and exterior spaces had been redesigned to encourage new, positive attitudes and a new spirituality in their inhabitants. He favored organic or more geometric crystalline forms, in which the crystal was understood as the organic *Urform*. In his applied designs and theoretical writings of the early and mid-1920's Taut still pursued the same goal of societal transformation, but now on a practical scale.

In his little-known small treatise *Die neue Wohnung* [The new home] (1924), Taut conceived of transformation on a small scale within the confines of the home as the first step towards a more encompassing transformation of society. In a text that brings to mind Schwitters's metaphor of Alves Bäsenstiel as a cleansweep, he advised his readers to get rid of all unnecessary items and suggested, "The same applies to the uncontrolled growth of children's toys which with good reason is one of the greatest annoyances for the housewife. Once a year one should reward children with a new toy to make them get rid of half of their old toys. To organize is just another form of cleaning."[71] Taut advocated design schemes that were all-encompassing; he eschewed decoration (the placement of a vase on a table or even the making of independent works of art). *Gestaltung*, the encompassing approach to design, as opposed to decoration, would integrate the reorganized, cleansed interior and exterior spaces in a larger whole. Only from the consistent application of the principle of *Gestaltung* could a new man and a new society arise.

The concepts of *Formenaufbau* and *Gestaltung* are related: Both imply the transformation and expansion of art into a socially more useful form – the active reordering of the environment, from the home to the city, under the aegis of architecture. The critic Adolf Behne, one of Taut's cofounders of the *Arbeitsrat für Kunst* and later a supporter of Schwitters, contributed to the popularization of Taut's ideas. He, too, advocated architecture and *Gestaltung* as the most important artistic activities. In his *Wiederkehr der Kunst*, written in 1918 and published in 1919, he praised architecture for its freedom and infinite possibilities: "Architecture," he proclaimed, "will do away with the compartmentalization of the world."[72] He then referred to the biologist Jacob van Uexküll and his concept of a world in which everything is understood as complexly interwoven rather than existing as separate entities. Behne proposed that Uexküll's view should be applied to architecture and the creation of a new type of *Gesamtkunstwerk*, not Richard Wagner's total work of art, but one that was created out of "inner necessity" and that would have cosmic dimensions: "We want an inner transformation of all art, so that an artistic cosmos may arise out of the chaos of our times. This is what we see as the real mission of art."[73]

His text makes clear that he modeled his notion of a new total work of art on Taut's *Stadtkrone*, on the concept of a spiritual, social architecture. Schwitters's

postcard to Behne about his *Haus Merz* — in which he announced that "In *Haus Merz* I see . . . the expression of a truly spiritual vision of the kind that lifts us to the infinite: absolute art"[74] — was written in response to this rhetoric; the sculpture itself emulated Taut's and Behne's ideas in making technology subservient to spirituality, to *Geist*. The *Merzbau* with its encompassing program is indeed an ambitious expansion of this small sculpture. Here Schwitters placed the fragments of a materialist world at the base of an all-encompassing structure, in which each successive part was integrated in an evergrowing and complexly interwoven whole and the many opposite components finally subsumed under a dynamic, organic-crystalline, cathedral-like shell, the new architecture. Schwitters, too, was inspired by Scheerbart's writing on colored glass and included a blue window in his *Merzbau*. Once again, his use of color and materials speaks of his desire to meld opposites: The blue window is contrasted with the clear panes of glass reminiscent of display cases of the individual grottoes; one points to Romanticism and spiritual transcendence, the other to modernity and rational transparency (the disembodied fragment in the display cases of ethnographic museums or modern shop windows). Both are joined in the unifying molded shell, in which even color has been suppressed in favor of white, defined by Schwitters's spiritual forebear Kandinsky as "a pure color."[75]

The notion of fragmentation and rebuilding finds a ready application in collage. In subscribing to the concepts of *Gestaltung* as well as *Formzertrümmerung* and *Formenaufbau* (the destruction of form and the construction of form), Schwitters infuses collage with utopian idealism, echoing at the same time Herwarth Walden's program for Der Sturm: "constant metamorphosis from the roots up." For Schwitters, collage represents a method for the reorganization of reality. It is capable of fulfilling this lofty program because of the special characteristics of its building material. The fragment does not reflect reality, but is part of it. Thus, the creative process is not relegated to a separate sphere but intimately linked with everyday life. In this definition, the artist is indeed an active reformer of reality. Defining collage as a process of organic transformation, Schwitters offers a collage theory radically different from that of Bertolt Brecht, who also saw collage and montage as means for societal reform but like the Berlin Dadaists defined the method in strict opposition to organic modes of representation.

Schwitters placed the *Merzbau* in his studio, making the artist's place of work the center of social transformation. The grottoes achieved on a small scale what the *Merzbau* set out to do on a grand scale: the interpenetration of the street and the bourgeois interior. In his home, the studio became a place of multiple inversions and interconnections that blurred the boundaries between public and private spaces. The *Merzbau*, as we know, extended beyond the confines of the studio — in fact, Schwitters had transformed the adjacent dining room into a modernist space, outfitted with Bauhaus furniture and painted starkly in black and white,[76] thus linking the architectural project of his *Merzbau* with the concept of *Gestaltung*. He reserved,

however, the very center of the *Merzbau* for himself, as a place of contemplation, to which he referred as the "black hole."[77] Here, another inversion took place: The psychological abyss created by the confluence of political and private upheavals and losses was conquered and transfigured into a nourishing womb, a source of creative energy. Schwitters had invited Rudolf Jahns to experience the *Merzbau*'s center by himself, and he reports:

Schwitters asked me to go alone into the center of the grotto and, after a few moments of immersion, report my thoughts in a book deposited there on a wooden table. I entered the site which resembled with its many turns both a snail-shell and a cave. The path leading to the center was very narrow, since new sections and constructions, together with the already existing Merz-reliefs and caves, grew into the empty space. Immediately to the left of the entryway hung a bottle with Schwitters' urine in which floated Immortelles [everlasting flowers]. Then came grottoes of different types and sizes, whose entries were not always on the same level. When one had walked all the way around, one finally came to the center, where there was a seat on which I sat down. I was overcome by a strange sensation of rapture. This room had its own special existence. The steps one took were barely audible, and all around was total silence. Only the grotto's form circled around me and led me to find words about the absolute in art.[78]

In the *Merzbau*, Schwitters reveals himself a follower of Nietzsche, who declared that man at the edge of the abyss sees the potential for freedom, but frightened, can only glance at it surreptitiously, although only glancing can garner some of the freedom the abyss offers. The *Merzbau* with its manifold building stones and enshrined array of bizarre, frightening, and ordinary objects, represents a controlled space in which one is to contemplate and to conquer the abyss – in which modernity is brought under control. As such, the *Merzbau* is also a monument to Schwitters's himself, to his own desires and anxieties, a monument, as Richter described it, to the "ongoing project of his life." The bottle of Schwitters's own urine is the encapsulation – ironic, to be sure – of his own essence, united with the symbol of his desire, the everlasting flowers as the symbolic representatives of Anna Blume herself. Placed in the *Merzbau*, Schwitters declares the artist in the activist sense of Simmel, Hiller, and Taut as the creative, privileged, and even healing individual at the center of societal transformation, while simultaneously parodying the notion of the masterwork. In "Ich und meine Ziele," right after his account of the Grotto of Love with its mutilated couple and the child with the twisted-around head and syphilitic eyes, Schwitters informs the reader about the bottle with his urine: "But then again, the small, round bottle with my urine in which Immortelles are dissolving, is a placating presence."[79] As the artist identifies himself with his product – his slogan reads "Kurt Schwitters = Merz" – the *Merzbau* is also a celebration of artistic achievement: "The great secret of Merz lies in its evaluation of unknown factors. Thus, Merz extends control over that which cannot be controlled. It being so, Merz is greater than Merz."[80]

The architect and associate of Schwitters, Ludwig Hilberseimer, who also wrote art criticism, characterized the work of art as "a unity. The unfolding and realization

of an idea. Independent of chance. A wellspring of enormous spiritual needs. The making accessible of unknown possibilities. Expression of something that only the artist in his own specific ways can express as a personal world view."[81] The *Merzbau* discloses that Schwitters subscribed to a similar definition of art. This structure, which bears intimate witness to Schwitters's artistic growth, is indeed a powerful wellspring; it attests to deep-rooted psychological needs, but also makes manifest his personal definition of art as an agent of spiritual and societal advancement. Schwitters's constant restructuring of the *Merzbau* is an almost obsessive act repeated again and again: the attempt at creating order out of chaos and of redefining oneself in the face of personal loss as well as gain, experienced in a political environment of extreme instability. Schwitters's fragmentary monument to himself, the *Merz-column*, which he embedded in the *Merzbau*, affirmed death – the loss of his son – as a central experience only to be countered through the act of creation, his own rebirth as an avant-garde artist. Art, for Schwitters, is an intensely personal act but, as the integration of the *Merz-column* into the *Merzbau* implies, complexly linked to society at large. Schwitters declared the self as also rooted in the past; yet history has shown, so both the Dadaists and the Expressionists have claimed, that this past prevented the realization of man's true potential. Materialism, nationalism, bourgeois morality, these and other signs of the past had to be destroyed to make growth possible. Art, then, has to be an act of destruction and reconstruction. Ludwig Hilberseimer's definition of Dada seems coined for Merz, not Berlin Dada: "Dada wants to free the Self from ineffective systems, to make it independent and active, so that it can meld with the cosmos and recreate the unity that bourgeois morality has destroyed."[82] Though destroyed, Schwitters still calls upon the past to bear witness to itself with its own fragments incorporated into his *Merzbau* and his collages. His is an act of control: Although the continuity between the past and the present has been severed and thus the power of the past over the present conquered, their interdependence is nevertheless acknowledged (and subordinated to the artist's forming hand).

Schwitters expressed a deeply felt, bitter irony in his alternate name for the *Merzbau* – *Die Kathedrale des erotischen Elends* [The Cathedral of Erotic Misery]. Eros, here, is more than sexuality or love; it implies the force of love in all its manifestations. Eros, the god, was pictured by some as born from chaos. Schwitters used the metaphor of chaos three times to describe his own birth as an artist: once after the destruction of his garden, once after the war, and once, more subtly acknowledged, after his son's death. The creative urge was for Schwitters the longing for wholeness; its most comprehensive material manifestation, the *Merzbau*. Yet the *Merzbau* is a monument to unfulfillable desire, expressed in the use of discarded commodities as its building stones, and to the artist's inability to extend the ever-expanding structure beyond the larger confines of the studio.

EPILOGUE

Schwitters adopted collage in response to the war and the experience of rupture with the past as a distinctly modern medium: "I felt myself freed and had to shout my jubilation out to the world. . . . One can even shout with refuse, and this is what I did, nailing and gluing it together."[1]

In contradiction to the antiaesthetic and revolutionary impulse expressed in this quotation, Schwitters employed collage for aesthetic and, as the *Merzbau* reveals, also for reformist ends, appropriating a modernist medium for conservative goals. We remember that he continued his account with a modifier: "[Merz] was like an image of the revolution within me, not as it was, but as it should have been." His attitude towards collage seems to parallel the attitude on the part of certain German thinkers and literati toward technology – the embracing and transformation of technology as a component of alien, Western *Zivilisation* into an organic part of German *Kultur*. Jeffrey Herf, who coined the term "reactionary modernism" to describe this phenomenon, declared that these thinkers "combined political reaction with technological advance."[2] He summarizes:

[Reactionary modernism] incorporated modern technology into the cultural system of modern German nationalism, without diminishing the latter's romantic and anti-rational aspects. The reactionary modernists were nationalists who turned the romantic anticapitalism of the German Right away from backward-looking pastoralism, pointing instead to the outlines of a beautiful new order replacing the formless chaos due to capitalism in a united techno-logically advanced nation. . . . These thinkers viewed themselves as cultural revolutionaries seeking to consign materialism to the past.[3]

Herf takes among others Oswald Spengler as an example. Spengler, in *Das Untergang des Abendlandes* [The Decline of the West] delineated a morphological approach to history. Rather than seeing history as a temporal, linear development, Spengler proposed to study history as an organic phenomenon in which cultures rose and declined according to their own life cycles. This view permitted a new

kind of simultaneous vision, allowing for the coexistence of different cultures at different stages of their development.

"Mankind" is a zoological expression, or an empty word. But conjure away the phantom, break the magic circle, and at once there emerges an astonishing wealth of *actual* forms – the Living with all its immense fullness, depth and movement – hitherto veiled by a catchword, a dry as dust scheme, and a set of personal "ideals." I see, in place of that empty figment of *one* linear history which can only be kept up by shutting one's eyes to the overwhelming multitude of the facts, the drama of *a number* of mighty Cultures, each springing with primitive strength from the soil of a motherregion to which it remains firmly bound throughout its whole life-cycle; each stamping its material, its mankind, in *its own* image; each having *its own* idea, *its own* passion, *its own* life, will and feeling, *its own* death.[4]

Or, more concisely, "How, *from a morphological point of view*, should our 18th Century be more important than any other of the sixty centuries that preceded it?"[5] This totalizing view also permitted Spengler to include advanced technology – usually considered a strictly modern phenomenon – in his organic world picture as yet another expression of the human mind. In so doing, Spengler achieved a major feat: He stripped technology of its alienness and threat and made it accessible.

It could be argued that Schwitters's organicist approach to collage, his totalizing approach to all materials and concepts similarly has a conservative objective: To make the alien, modern medium of collage as an indicator of the machine age accessible to a traditional (and naturalist) discourse. Yet does that make him a reactionary modernist?

Instead of reactionary modernism, one should, perhaps, speak more correctly of the generally conservative nature of postwar German modernism. In the early years of the Weimar Republic, the rhetorics of the left and right overlapped in significant parts. Both claimed German Romanticism as their ancestors – the left in its search for universalism, the right in its celebration of nationalism and the self. It was in particular Romantic Occasionalism – the belief that everything, the political, nature, and so on, can become occasions for the development of the self – that contributed to a confusion between different ideological positions. Occasionalism was still present in the early twentieth century in Germany and can be seen in the writings of Georg Simmel and later in Walter Benjamin, whose concept of *Erlebnis* (the experience of the world) is translated into the experience of shock in the modern urban environment and serves as an occasionalist moment; for Schwitters, too, the trauma of the war and the November revolts of 1918 become occasionalist moments that lead through the experience of shock to his maturation – his birth as a collage artist.

If Schwitters claims the period of political turmoil of the inception of the Weimar Republic as an occasionalist moment, so does the self-proclaimed spokesman and chronicler of the Berlin Dadaists, Richard Huelsenbeck. When looking back in

1964 at Berlin Dada, Huelsenbeck significantly entitled his essay "Dada and the Meaning of Chaos" and spoke of the Dadaists as people who had experienced a deep inner chaos, but who, "because of their innate sensitivity comprehended the nearness of chaos and tried to overcome it."[6]

The vocabulary and the opinions blur. No longer can we tell whether this is a Berlin Dadaist speaking or Kurt Schwitters or even a "reactionary modernist." It is evident that in a period of political and societal crisis and transformation, vocabularies are shared by different groups. Values, in these moments, are not fixed, and consequently both the emerging rhetorics as well as the critical responses are in flux. Superimposing our own present-day values contributes to further confusion. It is not necessarily the vocabulary, the use of the medium or material, or the attitude toward technology that inform about an artist's progressiveness, but rather the specific mixture of these different components. In Ernst Jünger, the celebration of technology is coupled with a celebration of the heroic self, the male body capable of withstanding multiple assaults; in Spengler, a fairly positive attitude toward technology is combined – if only in the last section of his book – with a decidedly protofascist bent, which forces us to reread the earlier part in light of the later. In Schwitters, the whole-hearted engagement with things technological is counterbalanced with his advocation of the organic – but the concept is tied to a genuine avant-garde impulse and the belief in internationalism.

The difference here lies, above all, in the sense of irony and self-mockery, the willingness to play with concepts and assumptions, that sets Schwitters apart from a reactionary modernist like Jünger. In Jünger, there is an unbroken belief in the superiority of man, in the mind over the body, reinforced by a nationalist discourse; the Dadaists, including Schwitters, debunk these beliefs as the pitiful farce of a totalizing tradition. Acknowledging the demise of tradition, they propose a new program: a play with the shards that in its open-endedness, its reliance on irony, inversion, and laughter, might function as a tool in the critique of society and its institutions, but also propose through its playful reorganization of materials a new way of looking at reality, a new political, social, and cultural optics. The reshuffling of the self manifests itself, even within the progressive field, in a variety of positions; within the Dada community, it is the call for freedom that defines their project as fundamentally different from that of the "reactionary modernists."

Schwitters's belief in the possibility of societal change through artistic play is, however, increasingly pessimistic; his focus and radius of action shift from the public at the beginning of his career to the private in the later years of his life. Yet already in about 1919 or 1920, he drew on the Romantic notion of the artist as a specially endowed individual and ironically described the artist – or rather his stand-in, Alves Bäsenstiel – in the first chapter, "Ursachen und Beginn der großen glorreichen Revolution in Revon," of his unfinished novel *Franz Müllers Drahfrühling*[7] as the instigator of revolution, who could create and fuel political upheaval through inactivity merely by standing motionless in a public square.

Schwitters defined himself, however, as an active proselytizer of personal transformation, who with visual and verbal plays would enact for his audience the experience of shock. His Dada performance tours, the frequent artistic matinées in his own house, the playful, yet biting rebuttal of his conservative critics in the public forum of *Der Sturm* and his own *Merz* magazine, his plans for a *Merzbühne* (Merztheater), all attest to his definition of art as public play. Increasingly, though, and in response to a changing political and cultural climate, Schwitters's focus would shift away from public performance to the making of works of art (the artist in his traditional role) and graphic design (the artist in his modernist function). Yet the possibility of *Erlebnis*, the shocking encounter with the modern that Benjamin described as fundamental to the development of the self, is encoded, if in ever more aestheticized form, in both his collages and graphic designs. In these manipulated encounters each individual work enacts the contentious relations between the organic and the inorganic, the traditional and modern. Schwitters's exploration of the marginal as that area in which the avant-garde has always found its inspiration affirms his belief in the new; but his definition of Merz acknowledges the power of tradition to survive, even if only in shards. The possibility of liberation exists in the act of play. In a letter written in 1946 from his exile in England to his Hannover friend Christof Spengemann, Schwitters once more defiantly declared:

We play until Death knocks on the door.[8]

NOTES

A note on the translations: Translations from German-language sources are the author's own except where the Bibliography shows the source already to be in translation or where otherwise noted.

INTRODUCTION

1. Greenberg (1961), p. 103. See also the extensive discussion of modernist theory in Francis Frascina (1985).

2. Ernst Nündel (1981), pp. 112–14.

3. Annegreth Nill (1981a,b, 1984, 1986).

I. POLITICAL AND CULTURAL CHAOS AND THE FORMATION OF MERZ

1. Karl Arnold, "Das Ende vom Lied," May 13, 1919, in *Der Simplicissimus.* Founded by Albert Langen in Munich in 1896 as an oppositional, satirical magazine, *Der Simplicissimus* set out "to subject evidence of serious and honest endeavor in art and literature to equally serious and honest criticism" (vol. 1, no. 13, 1896). *Der Simplicissimus* was published until 1944 and counted among its staff the famous caricaturists Th. Th. Heine, Olaf Gulbransson, Bruno Paul, and Karl Arnold.

2. Kurt Schwitters, "Kurt Schwitters," 1930, in Friedhelm Lach (1977–81), vol. 5, p. 335. Hereafter references made to Lach's edition of Schwitters will be abbreviated as follows: *L,* followed by volume number and pagination. Translated by Werner Schmalenbach (1967, p. 32).

3. See Herta Wescher (1968), chap. 1 and pp. 138, 142–3; Dawn Ades (1968), chap. 1. For the early sources of photomontage in advertising, see Robert Sobieszek (1978) and Sally Stein (1981). For a discussion of prewar collage in terms of its political rather than formal content, see Patricia Leighton (1989).

4. Quoted in Dawn Ades (1976, p. 27). Vladimir Tatlin (1865–1953?) was a Russian painter who turned to sculpture in 1913 and later founded Constructivism.

5. Benjamin Buchloh (1981). For a detailed study of the return to order in French art, see Kenneth Silver (1988). In Germany, a similar spirit was visible in the painting of the Neue Sachlichkeit artists with their emphasis on traditional subject matter and realistic representation, as well as the acceptance of Expressionism by museums and private collectors and its subsequent institutionalization. See Joan Weinstein (1990a).

6. Walter Benjamin (1969), pp. 257–8. "Theses on the Philosophy of History" was written in 1940 and first published in *Neue Rundschau* (vol. 61, no. 3, 1950).

7. Philipp Scheidemann, quoted in Ritter and Miller (1975), pp. 77–8. Translated by the author.

8. Karl Liebknecht, quoted in Ritter and Miller (1975), pp. 78–90. Translated by the author.

9. For an excellent, detailed, and balanced account of the political events, see Hajo Holborn (1982, vol. 3, pp. 509–78). Among the many thorough studies on this survival of tradition in Weimar Germany, see, for example, George Mosse (1964); Fritz Stern (1965); Kurt Sontheimer,

(1968); and Peter Gay (1968). Recent books include Jeffrey Herf's *Reactionary Modernism: Technology, culture, and politics in Weimar and the Third Reich*.

10. The new parliamentary Republic featured an upper and a lower house, adult suffrage (including women for the first time), proportional representation, and extensive civil liberties and social welfare guarantees. It also guaranteed equal rights and responsibilities for citizens of both sexes and promised protection of the family and decent work and housing for all Germans. In Article 48 of the new constitution, the president was given emergency powers to set aside the basic law, a provision that became crucial after 1930. (It was used over 250 times in later years by men who supported neither the Weimar Republic nor democracy.)

11. Renate Bridenthal (1984), p. 5.

12. Harry Graf Kessler (1971a), p. 53 (entry of January 6, 1919).

13. Schwitters, "Merzbühne," 1919, in *L*, vol. 5, pp. 42–3. Translated by John Elderfield (1985, pp. 108–10).

14. Ibid.

15. Schwitters, "Kurt Schwitters Herkunft, Werden und Entfaltung," 1920/21, in *L*, vol. 5, p. 83.

16. Schwitters, "Erklärungen meiner Forderungen zur Merzbühne," 1919 (*L*, vol. 5, p. 37). Translated by John Elderfield (1985, pp. 50–1).

17. Schwitters, "Merzmalerei," 1919, in *L*, vol. 5, p. 37. Translated by John Elderfield (1985, pp. 50–1).

18. Schwitters, "Merz," 1920, in *L*, vol. 5, p. 79. Translated by John Elderfield (1985, p. 44).

19. Schwitters, "Watch your Step," 1923, in *L*, vol. 5, p. 167.

20. Schwitters, "Banalitäten," 1923, in *L*, vol. 5, p. 148.

2. ART AFTER THE WAR: EXPRESSIONISM AND DADA

1. Walter Laqueur (1974), p. 144.

2. Ludwig Rabiner, "Der Kampf mit dem Engel," in *Die Aktion*, no. 16/17 (1917), col. 213, as cited by Barbara Drygulski Wright (1983, p. 83).

3. Kurt Hiller, "Philosophie des Ziels," in *Das Ziel* (1916, vol. 1, p. 205) as cited by Wright (1983, p. 95).

4. Hiller, ibid., p. 206, in Wright (1983, p. 96).

5. [Die Novembergruppe]. *An alle Künstler!* (Berlin: [Kunstanstalt Willi Simon], 1919).

6. Kurt Hiller as cited by Iain Boyd Whyte (1982, p. 96).

7. Ibid.

8. Bruno Taut, "An die sozialistische Regierung," *Sozialistische Monatshefte* (24, LI [26 November 1918], pp. 1050–1), as cited by Whyte (1982, p. 97).

9. Taut, ibid., p. 1051.

10. Helga Kliemann (1969), p. 56.

11. Joan Weinstein (1990b), p. 181. See also her excellent extensive study of the subject, *The End of Expressionism: Art and the November Revolution in Germany*. For a concise account of some of the artists' groups, see Ida Katherine Rigby's *An alle Künstler! War–Revolution–Weimar* (1983).

12. For a detailed discussion of the Expressionism Debate, see Hans-Jürgen Schmitt, ed., *Die Expressionismusdebatte: Materialien zu einer marxistischen Realismuskonzeption*.

13. Joan Weinstein (1990a), pp. 51–9.

14. Max Pechstein, "Was Wir Wollen," 1919, as cited by Rigby (1983, pp. 20–2). Translated by Joan Weinstein (1990a, p. 55).

15. Ludwig Meidner, "An alle Künstler, Dichter, Musiker," 1919, as cited by Rigby (1983, p. 7). Translated by Joan Weinstein (1990a, p. 57).

16. Meidner, ibid., as cited by Rigby (1983, p. 10).

17. Joan Weinstein (1990a), p. 58.

18. Ibid., p. 32.

19. The *Aufruf der Novembergruppe* (Appeal of the Novembergruppe), published December 13, 1919, opens as follows: "The future of art and the seriousness of the present hour force us, the revolutionaries of the spirit (Expressionists, Cubists, Futurists), to unite and join forces. We therefore urgently call upon all those artists who have broken the traditional mold of art to declare their adherence to the *Novembergruppe*." See Helga Kliemann, *Die Novembergruppe*, p. 55, as translated in Eberhard Roters, "Prewar, Wartime, and Postwar: Expressionism in Berlin from 1912 to the Early 1920s," in Stephanie Barron (1988, p. 48).

20. Adolf Behne, "Unsere moralische Krise," *Sozialistische Monatshefte* (January 20, 1919) as quoted by Iain B. Whyte (1982, p. 115).

21. Sitzung der Kommission für Reformvorschläge der Akademie, Berlin, February 3 and March 26, 1919. Akademie der Künste, Berlin, Registratur 3, no. 693a, as cited by Joan Weinstein (1990b, p. 182). Weinstein traces the transformation of Expressionism into the official style of the Weimar Republic in *The End of Expressionism: Art and the November Revolution in Germany 1918–19*.

22. The slogan reads: "Konsumenten! Vereinigt Euch in der Konsumgenossenschaft Vorwärts-Bremen. Gemeinwirtschaft = Sozialismus. Genossenschaft. Im wirtschaftlichen Kampfe sind die Konsumgenossenschaften ein wichtiger Faktor auf dem Wege zum Sozialismus, zur Gemeinwirtschaft."

23. Stephanie Barron (1988), p. 33.

24. The journal *Menschen*, for example, published on its front page on January 15th, the day of the murders, a woodcut by Felixmüller depicting Liebknecht and a brief text accusing the "revolutionary" government of murder: "Karl Liebknecht und Rosa Luxemburg hielten als Einzige dieser vier Jahren die Fahne der Revolution hoch. Sie wurden heute durch die Maßnahmen der 'revolutionären' Regierung ermordet." (Karl Liebknecht and Rosa Luxemburg were the only ones who during these four years held high the banner of the revolution. Today they were murdered because of measures taken by the 'revolutionary' government.)

25. For a study of this group, see Neue Gesellschaft für Bildende Kunst, Berlin, *Politische Konstruktivisten. Die "Gruppe Progressiver Künstler" Köln*, and Uli Bohnen and Dirk Backes, *Der Schritt, der einmal getan wurde, wird nicht wieder zurückgenommen. Franz Seiwert Schriften*.

26. For a brief history of the Bavarian Soviet Republic, see Hajo Holborn (1982, vol. 3, pp. 531–2).

27. Kunstamt Kreuzberg, Berlin and Institut für Theaterwissenschaft der Universität Köln, *Weimarer Republik* (Berlin and Hamburg: Elefanten Press, 1977), p. 146, as cited by Rigby (1983, p. 48). It can be argued that it was a sense of martyrdom and commitment that cost Liebknecht and Luxemburg, and also Landauer and Leviné-Niessen, their lives. They decided to stay with the protesting masses during the bloody battles with government troops – Lenin never considered that kind of comradeship necessary.

28. George Grosz and Wieland Herzfelde, "Die Kunst ist in Gefahr," 1925, as quoted in Peter Hielscher (1977, p. 299).

29. Raoul Hausmann, "Pamphlet gegen die Weimarische Lebensauffassung," 1919, in Karl Riha (1977, p. 52).

30. George Grosz, "My New Pictures," 1920, in Richard Hertz and Norman Klein (1990, p. 165).

31. Eva Grosz, the wife of George Grosz, also studied art but pursued commercial interests after her marriage, opening a small design store.

32. Rigby (1983), p. 16.

33. Alexander Dückers, *George Grosz: Das druckgraphische Werk* (Berlin, Propyläen Verlag, 1979), p. 193, as quoted in Rigby (1983, p. 16).

34. Kurt Tucholsky, "Dada," in Karl Riha (1977, p. 126). This review of the First International Dada Fair was originally published on July 20, 1920, in the *Berliner Tageblatt*.

35. Tucholsky, "Dada-Prozess," in Riha (1977, p. 129). Originally published in *Die Weltbühne* (1921, vol. 17, p. 454).

36. Ibid. See also Hanne Bergius (1978, p. 3/72).

37. Rigby (1983), p. 65.

38. Richard Huelsenbeck (1920c), p. 38.

39. Hausmann (1920), p. 2.

40. Hausmann, "Synthetisches Cino der Malerei" (1918). "In Dada werden Sie Ihren wirklichen Zustand erkennen: wunderbare Konstellationen in wirklichen Materialien, Draht, Glas, Pappe, Stoff, organisch entsprechend Ihrer eigenen, geradezu vollendeten Brüchigkeit, Ausgebeultheit. . . . Durch die Vorzüglichkeit der Schlagkraft unserer Materialverwertung als letzter Kunst einer in Bewegung begriffenen, fortschreitenden Selbstdarstellung mit Aufgeben der traditionellen Sicherungen der umgebenden Umherstehenden, als einverleibter Atmosphäre," in Karl Riha (1977), pp. 31–2.

41. Grosz (1979), p. 47.

42. Wieland Herzfelde, catalog to the Erste Internationale Dada Messe (Galerie Burchard, Berlin, 1920).

43. Strictly speaking, most of Berlin Dada's photomontages are photo collages. The term "photomontage," properly applied, designates a photograph whose final appearance is the result

of the manipulation of the negative (the technique of collage applied in the darkroom), but whose surface is uniform, as for example John Heartfield's political photomontages of the late 1920s and 1930s. The Dadaists preferred the term "Klebebild" (pasted picture = collage) for their products.

44. Grosz and Herzfelde, "Die Kunst ist in Gefahr" 1925, in Uwe Schneede, ed., *Die zwanziger Jahre. Manifeste und Dokumente deutscher Künstler* (1979), p. 137 as cited and translated by Beeke Sell Tower (1990, p. 72).

45. Carl Einstein, *Die Fabrikation der Fiktionen*, edited by Sibylle Penckert (Reinbek: Rowohlt, 1973), p. 272, as cited by Hanne Bergius, (1989, p. 214). The essay was never published during Einstein's lifetime.

46. Hausmann, "Alitterel Delitterel Sublitterel," *Der Dada*, (1919, vol. 1), in Karl Riha (1977, p. 55).

47. Grosz, "The Song from the Golddiggers," from Hans Hess, *George Grosz*, 2nd ed. (New Haven:

Yale University Press, 1974), p. 62, as cited by Tower (1990, p. 10).

48. The work is undated but bears a dedication to Kurt Schwitters, dated April 4, 1921: "Lieber Kurt Schwitters. Dem Merz vertraut Dada das Herz. Auf ewig Dein! DadaRaoul Hausmann." (Dear Kurt Schwitters. Dada dedicates its heart to Merz. Forever yours! DadaRaoul Hausmann.)

49. Hausmann, "Synthetisches Cino der Malerei," 1918, in Karl Riha (1977, pp. 30–1).

50. The title is variously listed as "Küchenmesser" (kitchen knife) and "Kuchenmesser" (cake knife). In the catalog to the First International Dada Fair it is given as "Kuchenmesser."

51. Hausmann, "Pamphlet gegen die Weimarische Lebensauffassung," 1919, in Karl Riha (1977, p. 52).

52. Einstein, "Absolute Kunst und absolute Politik. Aus der Einleitung für den Russischen Maler," in *Alternative*, 75 (December 1970), p. 254, as cited by Bergius (1989, p. 217).

3. MERZ AND EXPRESSIONISM

1. Ernst Ludwig Kirchner, Erich Heckel, and Karl Schmidt-Rottluff were among the founding members of Die Brücke. By 1908 Max Pechstein, one of the members of the group, had settled already in Berlin, but only by 1911 had all the Brücke artists moved there.

2. Kurt Schwitters, letter to Richard Schlösser, in Nündel (1974), p. 19.

3. Schwitters, "Merz," 1920, in *L*, vol. 5, p. 76.

4. Kate Steinitz (1968), p. 7.

5. Paul Erich Küppers, the director of the Kestner-Gesellschaft reviewed the Garvens collection for *Das Kunstblatt* in 1919. The collection did not offer a complete overview of the development of modern art from Courbet to Kandinsky, he declared, but a sensitive, insightful interpretation of the period. Artists included were Archipenko, Braque, Chagall, Courbet, Grosz, Jawlensky, Kandinsky, Kokoschka, Kubin, Klee, Modersohn-Becker, Nolde, Rousseau. See Rischbieter (1962), pp. 61–81.

6. For a complete listing of the various cultural personalities and activities, see Rischbieter (1962).

7. Donald E. Gordon (1982), pp. 76–89.

8. Wassily Kandinsky (1982), pp. 194, 205–6.

9. Rose-Carol Washton Long (1980) demonstrates the hidden imagery in Kandinsky's abstract art.

10. Wilhelm Worringer (1953), p. IX.

11. Friedrich Wilhelm Schelling developed these thoughts in his early writings, among them his *Erster Entwurf eines Systems der Naturphilosophie* (1799) and *System des transcendentalen Idealismus* (1800).

12. Worringer (1953), p. 6.

13. Ibid., p. 4.

14. Ibid., p. 4.

15. Ibid., p. 47.

16. Apparently, none of the *Expressionen* has survived, but they are known to us from photographs: *G Expression 1. (Der Wald)* [The Forest], *G Expression 2. (Sonne im Hochgebirge)* [Sun in the High Mountains], and *G Expression 3. (Die Liebe)* [Love], all 1917.

17. Worringer (1953), p. 4.

18. John Elderfield (1985), p. 22.

19. Schwitters, "Merz," 1920, in *L*, vol. 5, p. 76.

20. Worringer (1953), p. 36.

21. Wassily Kandinsky (1982), p. 165.

22. Elderfield (1985), p. 26.

23. Schwitters's son estimates that Schwitters's total output consisted of about 4,000 naturalistic oil

paintings, 4,000 collages and mixed media works, and 400 sculptures.

24. Schwitters, "Kurt Schwitters," 1927, in *L*, vol. 5, p. 250.
25. Ibid., pp. 253–4.
26. Christof Spengemann (1919b), pp. 573–82.
27. Ibid., pp. 573–4.
28. Elderfield (1985), p. 19. Schwitters's son, as cited by Elderfield (1985, p. 386, note 1.8), has attributed this statement to his father: "No man can create from his fantasy alone. Sooner or later it will run dry on him, and only by the constant study of nature will he be able to replenish it and keep it fresh."
29. Worringer (1953), p. 28.
30. Ibid., p. 45.
31. Ibid.
32. Ibid., p. 37.
33. Schwitters, "Merz," 1920, in *L*, vol. 5, p. 74.
34. Schwitters, "Kurt Schwitters Herkunft, Werden und Entfaltung," 1921, in *L*, vol. V, p. 83.
35. Ibid.
36. Ibid. The *[Sächsisch/]Böhmische Schweiz* is the so-called *Elbsandsteingebirge*, a mountainous

region of the upper Elbe in Saxony and Bohemia.
37. The painting was first exhibited at the Hannoversche Sezession in February 1918 and then included in the June 1918 exhibition at Der Sturm, retitled *Erhabenheit* [Sublimity] (Elderfield 1985, p. 387, notes 1.37 and 1.39). Elderfield (1985, p. 20) was the first to have drawn attention to a possible connection between the subject of the painting and the childhood garden.
38. This observation finds support in A. Nill's conclusion that several of Schwitters's collages refer to the Dresden Romantic School. *Mz. 38*, a collage of 1920, and *Merz. 301* (1921), contain motifs from the *Sächsisch-Böhmische Schweiz*. In particular in *Merz. 301*, Nill (1986, pp. 39–40) sees a direct allusion to a painting by one of the Dresden Romantic painters, Ludwig Richter's *Überfahrt am Schreckenstein* (1837).
39. Kurt Schwitters to Margaret Miller, December 11, 1946. Archives of the Museum of Modern Art, New York. Cited by Elderfield (1985), p. 56.

4. THE INVENTION OF A NEW LANGUAGE

1. In this study, I shall use the term "collage" for all of Schwitters's work composed with found materials, including literary texts and three-dimensional objects, as they are all based on the same theoretical considerations as formulated in his Merz theory.
2. See the reception of Schwitters's poem "An Anna Blume," discussed in the next chapter.
3. Friedhelm Lach, "Vorwort: Die Prosa von Kurt Schwitters," in *L*, vol. 2, p. 17.
4. Ibid., p. 7.
5. The narrative was first published as part of a group of writings, entitled *Anna Blume Dichtungen*, vol. 39/40 of the series entitled *Die Silbergäule* (Hannover: Paul Steegemann, 1919): 16–27; *Der Sturm* 10(7):99–103 (October 1919). The collection *Anna Blume Dichtungen* was republished in a second edition of 11,000 to 13,000 copies in 1922. See *L*, vol. 2, pp. 22–7, n. 5 pp. 381–2.
6. John Elderfield (1985), p. 100.
7. Published as "Franz Müller's Drahtfrühling. Erstes Kapitel. 'Ursachen und Beginn der grossen glorreichen Revolution in Revon,' " in *Der Sturm* XIII(11):158–66 (Nov. 1922). See *L*, vol. 2, pp. 29–38; n. pp. 383–91. In 1927 an English translation by Eugene Jolas was published

in *Transition* 8:60–76 (November). Lach mentions an undated version written in shorthand, presumably dating to 1919/20.
8. Kurt Schwitters, "Die Zwiebel," 1919, in *L*, vol. 2, p. 22.
9. Ibid.
10. Ibid.
11. Ibid.
12. Ibid., p. 26.
13. Ibid.
14. Ibid.
15. Elderfield (1985), p. 101.
16. The four male assistants to the butcher are former Russian prisoners of war. Just before Alves requests the singing of the "Arbeiterlied," Schwitters inserts the parenthetical remark: "Schau auf zum Stern!" The moment before the butcher raises his club, Schwitters evokes the October Revolution, and when the king wants to drink the victim's blood, Schwitters again inserts a reference, now clearly ironic, to revolution. Workers' soviets and capitalism are invoked simultaneously: "Rätegenossenschaft für kapitalistischen Aufbau, Berlin." When Alves is disemboweled, the parenthetical insertion reads: "Alles für die Rote Armee." Later, slogans such as "Für die Ideale des Sozialismus"

and "Wählt sozialistisch!" appear, and the story ends with the remark: "Sozialismus heißt arbeiten."

17. Schwitters, *Die Zwiebel*, in *L*, vol. 2, p. 27.
18. The name of the story incorporates the image of the eye as well; the core of an onion is referred to as an "eye."
19. Schwitters, *Die Zwiebel*, in *L*, vol. 2, p. 24.
20. Schwitters, "An Anna Blume," 1919, published in *Der Sturm*, 10(5):72 (August). A first version of the poem, the so-called "Urfassung," was published in *Der Sturm* 13(12):176 (December 1922). Translations in French, English, Hungarian, etc. appeared within months. See *L*, vol. 1, pp. 291–4.
21. Several of the letters written in response to Schwitters's poem were published by Paul Steegemann in 1920 as "Das enthüllte Geheimnis der Anna Blume," in *Der Marstall* (Zeit-und Streitschrift des Verlages Paul Steegemann, vol. 1/2, Hannover 1920). In the same year Christof Spengemann returned to the controversy over the poem in his *Die Wahrheit über Anna Blume*. A psychiatrist, for example, wrote: "Lieber Herr Schwitters! Sie müssen bei fortgesetzter Übung dieser Form zu denken, am Ende sich selber schaden. Daß jemand Satzform und gebräuchliche Ideenassoziationen so sehr lockert, daß er mit geradezu schmerzhafter Wollust weite Gedankensprünge macht, um gänzlich Fremdes, ja sogar Feindliches aneinanderzukoppeln und zusammenzuwürfeln, daß muss ja auf die Dauer zu Störungen des normalen Denkens führen." (See "Das enthüllte Geheimnis," p. 14.) The poem was so well known that it became the focus of a story entitled "Skandal im Reichstag!" for the carnival number of a Berlin newspaper, in which a delegate asked for police protection for "die Braut eines gewissen Dadaismus [sic], die bekannte Anna Blume . . ." and created a scandal when he quoted allusive passages from the poem: "Anna, man kann dich auch von hinten – Bei diesen Worten erhebt sich auf den Tribünen, wo eine große Schar Dadaisten und Anna Blume erschienen sind, ein furchtbarer Skandal. . . . Anna wird ohnmächtig in den Saal gebracht, wo die eingesetzte Riechkommission feststellt, daß der Dadaisten-Dichter in höchster Liebes-Ekstase gedichtet habe: Anna, man kann dich auch von hinten *lesen*. Sie könne dabei nichts Verdächtiges riechen und beantrage, den Antrag Brummer abzulehnen. . . ." (undated clipping, identified in Schwitters's hand as "Faschingsnummer der Berliner [illegible]

Nachrichten" *Schwarzes Notizbuch VII*, p. 230. Schwitters Archiv, Hannover).
22. Christof Spengemann (1919), p. 61.
23. The English translation can be found in Themerson (1958, p. 25).
24. A clipping of a poem and commentary in Schwitters's *Schwarzes Notizbuch VII*, p. 174, suggests another possible and very likely source for the particular form and verbal play of this poem. It is Jacob van Hoddis's *Hymne*, an Expressionist poem first published (next to a poem by Blaise Cendrars on Marc Chagall) in *Der Sturm*, 4(198/199), February 1914, p. 183. In this clipping the lyric is held up as an example of misguided poetry of the kind sponsored by Walden, bound to produce laughter. Van Hoddis's poem is typically funny, joining the commonplace with the lofty and playing with the psychology of dreams. It begins: "O dream, digestion of my soul!", culminates in the exclamation: "O you my firearm" at the end of the first stanza and ends with the two lapidary words: "Gick! Gack!" The commentator added: "Da es sicherlich nicht viele gibt, die diese Art Kultur begreifen, so erkennt man unschwer, wie weit die Welt noch unter dem Niveau der Futuristen, Kubisten und anderer Isten steht. Sie scheinen ihre Gedichte grundsätzlich so zu fassen, daß man sich nichts dabei denken kann. Da Denken immer eine lästige, für manche sogar sehr anstrengende Arbeit ist, wird man für solche Gaben stets dankbar sein, zumal sie einen Lachreiz ausüben, der vielleicht die Verdauung, insbesondere der Seele, wohltätig beeinflußt."

> *Hymne*
> O Traum, Verdauung meiner Seele!
> Elendes combination womit ich vor Frost
> mich schütze!
> Zerstörer aller Dinge die mir feind sind;
> Aller Nachttöpfe,
> Kochlöffel und Litfaßsäulen . . .
> O Du mein Schießgewehr.
>
> In purpurne Finsternis tauchst du die Tage
> Alle Nächte bekommen violette Horizonte
> Meine Großmama Pauline erscheint als
> Astralleib
> Und sogar ein Herr Sanitätsrat
> Ein braver aber etwas zu gebildeter
> Sanitätsrat
> Wir mir wieder amüsant
> Er taucht auf aus seiner efeuumwobenen
> Ruhestätte
> – War es nicht soeben ein himmelblauer
> Ofenschirm

(He Sie da!)
Und gackt: "Sogar . . .
(Frei nach Friedrich Schiller)

O Traum, Verdauung meiner Seele
O du mein Schießgewehr.
Gick! Gack!

25. Bernd Scheffer (1978), p. 75.

26. Schwitters, "Merz," 1920, in *L*, vol. 5, p. 77.

27. Richard Huelsenbeck (1920b), p. 39.

28. It is not clear why Schwitters chose to poeticize the English "you" into the outmoded "thee," etc.; one assumes he did so for the phonetic quality. It lends the poem an old-fashioned touch not present in the same passage in the German version.

29. Armin Arnold (1972), p. 18. In keeping with his circus metaphor, Arnold suggests that the poem's poetic I is a young stagehand. He interprets the prize question as an ironic attack on the critics who cannot abide alogical statements and then links the question to the stagehand's limited intellectual capacity as someone whose schooling never went beyond similarly phrased algebraic questions.

5. PLAY WITH CHAOS: THE *AQUARELLE*

1. Werner Schmalenbach (1967), p. 27.

2. Kurt Schwitters, letter to Christof Spengemann, June 6, 1918, Ernst Nündel (1974 p. 20). The friend of Spengemann to whom Schwitters refers must have been Rudolf Blümner, best known for his dynamic recitations of Expressionist poetry. H. G. Scheffauer (1924, p. 106) describes him as "the institution of Der Sturm. . . . Before his fiery conversion to Expressionism, Blümner was a well-known actor and reciter of the intellectual school. Since then, he has become the dynamic interpreter and champion of expressionistic art – an uncompromising, impregnable champion, fortified with a plangent voice that is like a tocsin (*sic*), a torrential pen forever on the offensive, and a face gouged hollow and burned out with the intensity of his aesthetic fanaticism." Blümner, on Spengemann's invitation, had given a poetry reading at the Kestner-Gesellschaft in Hannover in January 1918. See Hennig Rischbieter (1962, p. 27). Schwitters was to become close friends with Blümner and in 1919 dedicated a poem to him, "Porträt Rudolf Blümner. Gedicht 30" (*L*, vol. 1, p. 68).

3. Schwitters, letter to John Schikowski, June 27, 1919, in Ernst Nündel (1974, pp. 21–2).

4. See Schmalenbach (1967, p. 106); John El-

30. The cover drawing for *Anna Blume Dichtungen*, a selection of Schwitters's poems published in 1919, shows next to the words "Anna Blume" a wheel and a locomotive on a length of tracks; in "Merz," 1920, Schwitters describes the locomotive as being able "to move forward and backward" (see Fig. 44). A drawing entitled *Konstruktion*, which was published alongside the poem "An Anna Blume" in *Der Sturm* in 1919, shows a set of cogwheels, explicitly linking Anna Blume to mechanical and thus also sexual motion (see Fig. 79).

31. The poem is reprinted in *L*, vol. 1, p. 69. For a revealing discussion of the "Rote Marie" in soldiers' lore, see Klaus Theweleit (1987), vol. 1, pp. 183–90.

32. Otto Weininger (1903), p. 343: "Das Weib ist weder tiefsinning noch hochsinnig, noch schwachsinnig, es ist überhaupt nicht sinnig, sondern unsinnig."

33. Schwitters, *Anna Blume Dichtungen*, 1919, vol. 39/40 of the series entitled *Die Silbergäule* (Hannover: Paul Steegemann, 1919). Translated by Werner Schmalenbach (1967), p. 201.

derfield (1985, p. 45) and Sprengel Museum (1986, p. 102).

5. It has not been possible to establish the exhibition history of all of these works. *Aq. 3, Das Herz geht zur Mühle* (1919) and an untitled drawing of the *Aq.* series were reproduced (both without classification number and title, simply identified as *Zeichnung* [drawing]) in Christof Spengemann (1919b, pp. 579 and 581).

6. Robert L. Herbert et al., eds. (1984), p. 469.

7. Schwitters, "An Johannes Molzahn. Gedicht 37," 1919, in *L*, vol. 1, p. 66. The original lines are as follows: "Kreisen Welten Du. / Du kreist Welten. . . . "

8. Schwitters, in *Sturm Bilderbuch IV* (Berlin: Der Sturm, 1921), p. 2.

9. Francis Picabia, *Réveil-Matin*, 1919, cover design for *Der Dada*, 4–5, May 15, 1919. See John Elderfield (1985, p. 47). In a letter to Tristan Tzara in October 1919, Schwitters writes: "Können Sie mir nicht als Mitarbeiter Ihre früheren Publikationen schicken? Ich kann die Preise hier (9,80 M) nicht bezahlen für Dada I, II, III. IV – V besitze ich schon." (Could you not send me as contributor [to a planned Dada issue of *Der Zeltweg*, edited by Tzara] your earlier publications? I can't afford to pay the 9.80 M asked

here for Dada I, II, III. I already have IV – V.) Bibliothèque Littéraire Jacques Doucet, Paris.

10. *L*, vol. 1, p. 70. See also John Elderfield (1985, n. 3.18), who notes: "The work is listed in the checklist *Sammlung Walden: Gemälde, Zeich-nungen, Plastiken* (Berlin, Oct. 1919), which mentions that the collection is open to the public for four hours each day. It can also be seen hanging in Walden's apartment in a photograph reproduced in Walden's *Der Sturm, Eine Ein-führung* (Berlin, 1918), opp. p. 9, a photograph reprinted in several studies of *Der Sturm*, most recently Brühl (1983), p. 52. In Oct. 1917, there was a Chagall exhibition at Der Sturm, and in July–Aug. 1918 a Chagall–Kandinsky–Wauer exhibition." In addition, the writer and critic Theodor Däubler, closely associated with Der Sturm, singled out this work by Chagall in his book on contemporary art *Der neue Stand-punkt*. Däubler had given a lecture with the same title in December 1917 in Hannover, apparently a reading from his new book. Schwitters poem "An eine Zeichnung Marc Chagalls" follows in specific details the interpretation Däubler offers of the same work.

6. POLITICAL INSCRIPTION

1. John Elderfield (1985), p. 73.
2. A photo of this work published in an article by Christof Spengemann, "Kurt Schwitters" (1919b, p. 577), shows that there used to be a small wheel affixed to the peg above the text, thus intensifying the overall movement and strengthening the reference to the machine world.
3. Hajo Holborn (1982), vol. 3, pp. 530–1.
4. Ibid., p. 558.
5. Forced to raise money for reparation payments, Erzberger instituted a tax reform in the fall of 1919. These new tax laws hit the middle and upper-middle classes particularly hard. Worried about their financial survival, they started a campaign against Erzberger. The politician Karl Helfferich, leader of the Deutsche Nationale Volkspartei – a party of the far right – held Erzberger in contempt as an irresponsible politician whose activities had harmed the country and whose character had been tainted by mixing personal financial gains with politics. The subsequent libel suit aroused strong feelings in all political camps, in particular after there was an assassination attempt on Erzberger by a former ensign. The lawsuit was settled on March 12,

11. Schwitters, "Merz," 1920, in *L*, vol. 5, p. 78.
12. The Nürnberger Trichter (Nuremberg Funnel) humorously describes a rather direct teaching method: A funnel is used to channel knowledge into somebody's brain. It derives its name from the title of Georg Philipp Harsdörfers' 1648 *Poetischer Trichter*.
13. Julius Meier-Graefe (1915), pp. 666 ff.
14. O. K. Werckmeister (1989) demonstrates in revealing detail Klee's marketing strategies.
15. David Kunzle (1978), p. 39.
16. Ibid., pp. 41–2.
17. Ibid., p. 89.
18. Natalie Z. Davis has demonstrated with examples how the representations of inversions in broadsheet and text could function as positive, reinforcing models to the "unruly woman" in particular, and thus indeed further subversion of the norm: "The holiday rule of the woman on top confirmed subjection throughout society, but also promoted resistance to it." See Davis's essay "Woman on Top: Symbolic Sexual Inversion and Political Disorder in Early Modern Europe," in Barbara Babcock (1978, pp. 147–90).
19. Here and below, Kunzle (1978), p. 88.

1920, but the court action was politically motivated. The court imposed a small financial penalty on Helfferich for libel while finding that the major accusations against Erzberger had been proved correct. Erzberger had to resign, hoping to find justice in a court of appeals. On the same day, Wolfgang Kapp with his right-wing Ehrhardt brigade, took over the government in Berlin, declared himself chancellor, and forced the government into exile. The general strike that ensued was broken only with much bloodshed and terror politics. See Hajo Holborn (1982), vol. 3, pp. 578–84.

6. The date of this work is unclear, and it seems that Schwitters himself was unsure of it. According to Werner Schmalenbach (1967, p. 248, n. 103): "The picture has on the back the date 1925, to which Schwitters himself affixed a question mark. It presumably dates from an earlier year, but after 1920." John Elderfield (1985, p. 402, n. 26) dates the work to circa 1925 and points out, besides citing Schmalenbach's note, that the museum owning this work chooses to retain the 1925 date. The 1925 date seems rather late for the execution and subject matter of this work. In the Sprengel Museum checklist

(1986, p. 272, n. 190), the work is dated "ca. 1920 (until now, ca. 1925)" without further explanation.

7. According to Annegreth Nill, this organization did not exist, although there were many anti-peace treaty organizations with similar names. See Nill (1984).

8. Ibid., p. 30.

9. "Wer kann als ehrlicher Mann, ich will gar nicht sagen als Deutscher, nur als ehrlicher, vertrags-treuer Mann solche Bedingungen eingehen? Welche Hand müsste nicht verdorren, die sich und uns in solche Fesseln legte?" See F. A. Krummacher and Albert Wucher (1965), p. 78. In her essay "Schwitters' Das Bäumerbild" Annegreth Nill (1984, p. 23) briefly refers to this collage and suggests that Schwitters "indicts the Majority Socialists of Berlin by cleverly insin-uating that 'Versaille[s]' belongs to them." That reading is possible, but Schwitters above all stresses the treaty's emotional impact.

10. Peter Gay (1968), p. 16.

11. An entry in Schwitters's scrapbook, his *Schwarzes Notizbuch VII*, p. 176, attests to his own powerful emotions concerning the treaty. It consists of two clippings of news items which, although five months apart, are brought together in a meaningful and suggestive man-ner, pasted next to a number of short articles on the arts: One, dating to June 28 – Schwit-ters added in his own hand the year 1919 – reported the signing of the peace treaty; the other, pasted above, to January 28, 1919. This clipping was an advertisement of the local Free Corps calling on Germany's men to enlist to defend the fatherland: "Deutsche, macht Deutschland stark! Deutsche Männer!... Wollt ihr unser Vaterland untergehen lassen? ...Wir müssen unser Vaterland vor dem Schlimmsten bewahren. Das ist unsere Pflicht! Auf, meldet Euch freiwillig.... Freikorps Hül-sen, Werbestelle Hannover."

12. Georg Simmel, "The Metropolis and Mental Life," 1903, in Donald N. Levine (1971), pp. 324–5. Originally published as "Die Großstadt und das Geistesleben."

13. The celebration of American culture typical of Berlin Dada during and especially after the war is a curiously late phenomenon and must be considered in light of German politics (see Beeke Sell Towers, *Envisioning America*, ex. cat. [Cambridge, Mass.: Busch-Reisinger Mu-seum, Harvard University, 1990]). It expressed an opposition to the official anti-American stance during and Weimar bourgeois propriety after the war. The Parisian artists equally cel-ebrated modernity via American culture, but they did so before the war and no longer con-sidered it a vital theme after the war.

14. I am grateful to Vivian Barnett and Nancy Spec-tor of the Solomon R. Guggenheim Museum, New York, for having related information to me about an earlier state of this work and for having shared their documentary material; they also provided me with photographs of various details. The verso of a photograph of the earlier version bears an inscription in Schwitters's hand: "K Merzbild K 4/2x/(Bild rot Herz-Kirche)." Pho-tograph courtesy gallery Helen Serger/La Boe-tie, New York.

15. Bela Kun took over the government the preced-ing day and declared the Hungarian state a So-viet Republic (which survived for less than a year).

16. The Hanseatic city of Bremen was governed by a Workers' and Soldiers' Council from the time of the November revolts of 1918 until February 1919. On January 29, the government sent 1,500 troops to Verden, a small town nearby, and threatened to take over the city of Bremen. Negotiations between the Soviet Council and the government in Berlin failed. On February 4, 1919, the government troops marched into Bre-men and declared victory after a day of heavy street fighting. On February 9th, the government troops marched into Bremerhaven, the port of Bremen, and defeated the Workers' and Sol-diers' Council there (Herbert Schwarzwälder [1975–85] vol. 3, pp. 15–86, especially pp. 73–86.

17. "Beilage des Hannoverschen Tage..." Above the church one reads: "neue Bilder vom Tage. In den Schaufenstern unseres Geschäftshauses in der Gr. Wallstr. 2..."; and below the church, "der Kleinhandel bei den heutigen Ver-hältnissen mit 20% Unkosten zu rechnen hat ...Sowie in den Fenstern unserer Filialen am Klagesmarkt 7A und Luisenstrasse 1 (Theater-platz) sind folgende Bilder ausgestellt..."

18. Jacob van Hoddis, "The End of the World," translated by Stanley Corngold (1988), p. 261. The work was first published in 1911 in Franz Pfemfert's *Die Aktion*.

19. Johannes R. Becher as cited by Mark Ritter,

"The Unfinished Legacy of Early Expressionist Poetry: Benn, Heym, Van Hoddis and Lichtenstein," in Stephen E. Bronner and Douglas Kellner (1983), p. 160.

20. Mark Ritter, (1983), p. 160.

21. Ibid., p. 160.

22. Silvio Vietta, ed., *Lyrik des Expressionismus* (Tübingen: Max Niemeyer, 1976), pp. 89–91 as cited by Mark Ritter (1983), p. 160.

23. Schwitters, "Merz" (Für den *Avavat* Ageschrieben 19. Dezember 1920), in *L*, vol. 5, p. 74.

24. Ibid., pp. 77–8.

25. Schwitters, "Manifest Proletkunst," 1923, in *L*, vol. 5, p. 143. Translated by John Elderfield (1985), p. 42.

26. Schwitters, "Banalitäten," 1923, in *L*, vol. 5, p. 84. Translated by John Elderfield (1985), p. 67.

27. Schwitters, "Merz," 1920, in *L*, vol. 5, p. 78.

28. Richard Huelsenbeck, "Dada and Existentialism," in Willy Verkauf (1975), pp. 35–6.

29. Huelsenbeck (1975), n. p. Translated by Weiner Schmalenbach (1967), p. 13.

30. Schwitters, "Merz," 1920, in *L*, vol. 5, p. 78.

7. REFASHIONED TRADITIONS

1. Kurt Schwitters, "Kurt Schwitters," 1930, in *L*, vol. 5, p. 335.

2. *Trauernde* (Portrait Helma Schwitters), 1916. Oil. Lost. Illustrated in Werner Schmalenbach (1967, fig. 6).

3. Paula Modersohn-Becker's work, including the *Self Portrait*, was exhibited to much acclaim at the Kestnergesellschaft in Hannover in 1917; the exhibition was accompanied by the publication of her letters and diaries. (John Elderfield [1985], p. 386, n. 21).

4. Carl E. Schorske (1981), p. 267.

5. The Hannover viewer may have been reminded of an article published in the *Hannoverscher Kurier* at the end of the war. It reported that a Berlin firm had announced a pending patent for a new textile fiber developed from wood, whereby it hoped to overcome the shortages of textiles.

6. Karl Arnold, "Die Dame der eleganten Welt zum An- und Ausziehen," 1921, in *Der Simplicissimus* 26(33):436 (full page).

7. For an account of Schwitters's paper-salvaging operations at the Molling factory in Hannover, see Kate Steinitz (1968), pp. 38–9.

8. John Elderfield (1985), pp. 188–9, points out that Schwitters's i-drawings lack Duchamp's anti-aesthetic intent.

9. Schwitters, "Die einzige Tat des Künstlers bei *i* ist entformeln . . . ," 1924, in *Merz 8/9*. *Nasci* (April/July): 85. Translated by John Elderfield (1985), p. 188. Schwitters chose the letter "i" for these "drawings" to indicate the quickness of their production and cited a refrain taught to children when learning to write (the old-fashioned German script): "rauf, runter, rauf, Pünktchen drauf." (up, down, up, top with a dot.)

10. Georg Simmel, "Fashion," 1904, in Donald N. Levine (1971), p. 305.

11. During the war, of all the Western industrialized nations, Germany sustained the largest proportional increase of women in the industrial labor force. In March 1917, women first outnumbered men at work, and their number grew until the end of the war. The increase was particularly steep in defense-related industries. Krupp, for example, which hired no women in 1913, reported 28,302 of them on payroll in 1918; roughly three-fifths of the metal industries in Rhineland-Westphalia introduced women for the first time during the war. In light industry women predominated by up to 75 percent in many plants during the war, and in those of heavy industry, they often reached 25 percent. Backlash was evident as early as the winter of 1917, when the war ministry, preparing for demobilization, established guidelines for women to relinquish their jobs to returning veterans. With the worsening economic situation of the early 1920s, tension between the sexes over jobs increased. Women were either sent home or released into the economic custody of their husbands or fathers or brothers, placed in domestic service, or retrained in some traditionally feminine work like sewing. Those who retained their jobs suffered a revived discrimination in wages. See Renate Bridenthal and Claudia Koonz, "Be-

yond *Kinder, Küche, Kirche:* Weimar Women in Politics and Work," in Bridenthal (1984), pp. 48–9.

12. See Richard Evans's *The Feminist Movement in Germany, 1894–1933.*

13. The collage is untitled, but as is true of most of Schwitters's untitled collages, it is referred to by the text contained on a paper fragment in the collage. John Elderfield (1985, p. 77) dates it to ca. 1918–19, but the inclusion of a film still and the reference to Ernst Lubitsch's film, *The Love of the Pharaohs,* released in 1921, suggest a date of ca. 1921–2.

14. Simmel, "Prostitution," 1907, in Donald N. Levine (1971), p. 123.

15. Simmel, "Fashion," 1904, in Levine (1971), p. 311.

16. Andreas Huyssen (1986), pp. 53–4.

17. Kurt Schwitters, "Kurt Schwitters," 1930, in *L,* vol. 5, p. 335.

18. Gisela Zankl-Wohltat (1986, p. 35) suggests, correctly I believe, that the inserted portrait represents Helma. She also points out this Merzbild was reproduced as a horizontal format in *Der Ararat. Glossen, Skizzen und Notizen zur neuen Kunst* 2 (Munich, 1921), p. 19. If indeed meant to be a horizontal format, the portrait would be in the upper right and the superimposed planks could then be read as a large letter "A."

19. Franz Müller was the main character for Schwitters's planned collaborative novel, *Franz Müllers Drahtfrühling,* which he began to write with Arp but never developed beyond the first fragmentary chapter.

20. Simmel, "Fashion," 1904, in Donald N. Levine (1971), p. 304.

21. Elderfield (1985), p. 78.

22. Schwitters's references to commerce and "schöne Ware" (beautiful product) are also typically self-deprecating and playfully veil his ever-present concern with the marketing of his own work and his acute awareness of the art market. His notebooks are stocked with newspaper clippings about the financial success of artists like Hans Thoma or Wilhelm Leibl or artist recipients of grants or prizes. That his own collage work did not measure up financially to the work of these naturalist painters must have been only too obvious to him. One is tempted to speculate that his continued pursuit of his own naturalist painting skills may have been in part the result of his obsession with Thoma's pecuniary success.

23. D. W. Winnicott (1971), p. 56.

24. Carol Duncan, in her important article on the sexist implications in Expressionist and Cubist paintings, observes: "More than any other theme, the [female] nude could demonstrate that art originates in and is sustained by male erotic energy. This is why so many 'seminal' works of the period are nudes. When an artist had some new or major artistic statement to make, when he wanted to authenticate to himself or others his identity as an artist, or when he wanted to get back to 'basics,' he turned to the nude" ("Virility and Domination in Twentieth-Century Painting," 1973, in Richard Hertz and Norman Klein [1990], p. 227). Schwitters's work shows that this prewar artistic attitude extends into the postwar period.

25. Simmel, "Fashion," 1904, in Donald N. Levine (1971), p. 319.

8. THE *MERZBAU*; OR, *THE CATHEDRAL OF EROTIC MISERY*

1. Kurt Schwitters, "Ich und meine Ziele," 1930: "Was wir in unseren Werken zum Ausdruck bringen, ist weder Idiotie noch ein subjektives Spielen, sondern der Ausdruck unserer Zeit, diktiert durch die Zeit selbst, und die Zeit hat uns freie Künstler, die wir am beweglichsten sind, zuerst beeinflußt" (*L,* vol. 5, p. 346).

2. Karen Koehler in a forthcoming Princeton dissertation, *Great Utopias and Small Worlds: Bauhaus Prints in Context, 1919–1925,* discusses at length the image of the cathedral on the Bauhaus Manifesto.

3. Schwitters, "Ich und meine Ziele," 1931: "Ausserdem ist sie unfertig, und zwar aus Prinzip" (*L,* vol. 5, p. 343).

4. On several occasions Schwitters stated that there were only three people who truly understood his structure: Herwarth Walden, Siegfried Giedion, and Hans Arp. See Schwitters's "Ich und meine Ziele" (*L,* vol. 5, p. 345). In a letter to Katherine S. Dreier he expressed confidence that she could be counted among these few select people as well. (Letter, K. Schwitters to Katherine S. Dreier. The Archives of the Société Anonyme, Beinecke Rare Book Library, Yale University.)

5. Dietmar Elger (1984), *Der Merzbau.* John Elderfield (1985), "Phantasmagoria and Dream Grotto," in *Kurt Schwitters,* Chap. 7, pp. 144–71. See also Rosemarie Haag Bletter (1977) and the articles by Elger (pp. 248–54) and Harald

Szeemann (pp. 256–7) in Sprengel Museum (1986). Peter Bissegger, "Arbeitsbericht: Die Rekonstruktion des MERZbaus," ibid., p. 259.

6. The Hannover *Merzbau* was destroyed in October 1943 in an Allied bombing of Hannover during World War II; the second Merzbau in Norway survived until the early 1950s, when it was accidentally burnt down by children playing near it; and the third Merzbau was only in its earliest stages of construction when Schwitters died in 1948. It consists essentially of one wall now installed in the museum in Newcastle upon Tyne.

7. Schwitters, "Merz," 1920, in *L*, vol. 5, p. 79. (Postcard to Behne in *Sturm Archiv*, Staatsbibliothek, Berlin.) For Spengemann's evaluation of the *Merzbau*, see his "Merz – die offizielle Kunst" (1920a, pp. 40–1).

8. *Schloß und Kathedrale mit Hofbrunnen* (ca. 1922), now destroyed, was published in *Frühlicht*, 1(3) (Spring 1922).

9. Georg Grosz and John Heartfield exhibited a sculpture of a mannequin given a light bulb as a head at the First International Dada Fair at the Galerie Burchard in Berlin. John Elderfield (1985, p. 144) rightly suggests this work as a possible influence on Schwitters. The Grosz–Heartfield work is, however, clearly a male figure, dressed in military uniform, decorated with military honors and adorned with exaggerated sexual organs, whereas Schwitters's *Heilige Bekümmernis* is a female figure, and its immediate function is therefore not to satirize militarism. The Grosz–Heartfield figure is clearly visible in one of the photos taken at the exhibition, in which Heartfield and Grosz hold up a poster with the famous slogan: "Art is dead. Long live Tatlin's new machine art." That sculpture was listed as no. 143 in the catalog to the Dada Fair as *Grosz-Heartfield mont.: Der deutsche Dummkopf in der Welt voran. Reklameplastik* (The German Blockhead ahead of everybody. Advertising Sculpture). See reprint of the catalog in *Stationen der Moderne* (Cologne: Walther König, 1988).

10. Polish attempts to seize Upper Silesia by force apparently took place with the tacit agreement of the French occupation forces, further stirring German outrage. The defeat of the Polish insurgents by German Free Corps troops before and after the plebiscite of March 20, 1921, which resulted in a 60 percent majority in favor of Germany, seemed to German eyes to ensure the full return of the province to Germany. The League of Nations, however, ruled that Silesia was to be partitioned in accordance with the local results of the election. Germany had to cede about 40 percent of the area, which contained most of the coal deposits, to Poland (Hajo Holborn, 1982, vol. 3, pp. 601–2).

11. Albrecht Dürer (1977), p. 236, as quoted by Stephen Greenblatt (1983, p. 1).

12. On Dürer's design for the *Triumphal Arch*, in which he explored the illustrative function of the column, see Erwin Panofsky (1971, pp. 176–9).

13. Stephen Greenblatt (1983), p. 3.

14. Ernst Spindler (1902) discussed Schaudt's Bismarck Monument at length in "Das Bismarckdenkmal für Hamburg," *Berliner Architekturwelt* (4:412–17). He particularly praised the integration of architecture and sculpture and the gradual transformation of column into human figure. The Germania Column proposals were published in 1904 in *Berliner Architekturwelt* (6:408ff.). Schwitters could have learned of Tatlin's Monument in Ilya Ehrenburg's article "Ein Entwurf Tatlin's" (1921–2). A reproduction of Schwitters's sculpture *Schloß und Kathedrale* appeared in the same issue. The Russian constructivist artist Ivan Puni, who had moved to Berlin in 1920 and like Schwitters exhibited at Der Sturm, may also have been a source of information about Tatlin. Schwitters also visited the exhibition of Soviet Art at the Galerie Diemen in Berlin in 1922. See Lach (1971, p. 55).

15. Reyner Banham, as quoted by Robert Judson Clark (1970, p. 273).

16. See Oswald Spengler, *Der Untergang des Abendlandes* (1918–22).

17. See Elderfield (1985), p. 400, n. 18.

18. In his reaffirmation, Schwitters took the position in the ongoing debate that the column form was a masculine "antidote" for a decadent, effeminate art. Schwitters's reaffirmation of male authority is also apparent in the penislike horn with which he endowed the head on top of the column. It remained prominently in place even when the column was later incorporated into the *Merzbau* and most of the other details had disappeared (see Fig. 100).

19. This information comes from Ernst Schwitters, as quoted in Elderfield (1985, p. 159). Nowhere in the literature are there any other references to Schwitters's second son, except in Huelsenbeck's account of his visit to Schwitters. He mentions that Helma was "putting the two children to bed." Ernst Schwitters reconfirmed his statement in a conversation with me in Lysaker, Norway, in October 1988.

20. For an elaboration of this argument, see Edward Said, in *The World, the Text, and the Critic* (1983). Said develops the concept of affiliation as a phenomenon of modernism in opposition to filiation.

21. Stephen Foster, "Johannes Baader: The Complete Dada," in Foster (1985, pp. 266).

22. Craig Owens (1984), p. 203.

23. See Walter Benjamin, *The Origin of German Tragic Drama* (1977).

24. Owens (1984), p. 205.

25. Ibid., p. 203.

26. I am grateful to William Childs, John Kenfield, T. Leslie Shear, and Yoshiaki Shimizu for having offered their archaeological expertise in identifying the column. Unfortunately, the surviving reproduction of the collage is so poor that a precise identification has so far proven impossible.

27. The *Ursonata* announces in its name a search for a primeval form; however, the process that Schwitters employed in composing this sonata was also a composite one. Schwitters took as his basic unit a modern fragment, a one-line abstract sound poem by his friend Raoul Hausmann that reduces language to disconnected phonemes; from this series of sounds he developed a twenty-minute sound poem in the classical sonata form.

28. See, for example, the review by Paul F. Schmidt (1920, p. 621): "[Schwitters] zeigt durchweg neuere Materialarbeiten, die ihn noch kultivierter, farbig von einem unübertrefflichen Feingefühl zeigen und eine Gefahr seiner Merzmalerei leise heraufdämmern lassen: daß sie zu einer exquisiten Geschmackskunst für Feinschmecker werde." ([Schwitters] exhibits without exception more recent collages, which show him to be even more cultivated and demonstrate his unmatched coloristic sensibilities. Yet they begin to suggest a danger for his Merz painting: that it will become an exquisitely tasteful art for gourmets.)

29. Samuel Caumann, *The Living Museum: Experiences of an Art Historian and Museum Director, Alexander Dorner* (1958), p. 36, as cited by John Elderfield (1985, p. 162).

30. Schwitters, "Ich und meine Ziele," 1931, in *L*, vol. 5, pp. 343–4.

31. Rudolf Jahns (1986), p. 261.

32. Hans Richter (1965), p. 152.

33. Ibid., pp. 152–3.

34. Susan Sontag (1983), pp. 96–102, 156–8.

35. Schwitters, "Das Große E," 1930–1 in *L*, vol. 5, pp. 338–9.

36. Walter Benjamin, "The Work of Art in the Age of Mechanical Reproduction," 1936, in Hannah Arendt, ed., *Illuminations* (1969), p. 221.

37. Georg Grosz and Wieland Herzfelde, "Die Kunst ist in Gefahr," 1925, in Diether Schmidt (1964), pp. 342–3.

38. Wieland Herzfelde, "Zur Einführung," *Erste Internationale Dadamesse*, Kunsthandlung Dr. Otto Burchard, 1920. Reprinted in Eberhard Roters, ed., *Stationen der Moderne* (1988), n.p.

39. Benjamin (1980), vol 5., p. 45, translated by Michael Jennings (1987), p. 16.

40. Michael Jennings (1987), p. 12.

41. Schwitters, "Ich und meine Ziele," 1931, in *L*, vol. 5, pp. 344–5.

42. Ibid., p. 345.

43. Jahns (1986), p. 261.

44. Kate Steinitz (1968), p. 90.

45. Magnus Hirschfeld (1937), p. 21, and also chaps. 17 and 18.

46. Ibid., chaps. 2 and 11.

47. The correspondence between Höch and Hausmann, her lover, amply attests to his need to dominate. Although she participated in the 1920 First International Dada Fair, Höch's work (and she herself) was always belittled. (Correspondence in Hannah Höch Archiv, Berlinische Galerie, Berlin.) Similarly, Eva Peters, George Grosz's wife, complained that she could never establish a relationship between equals with her husband. Grosz, in a letter to Otto Schmalhausen characterized women as such: "Between you and me, I shit on profundity in women. Usually they combine it with an ugly abundance of masculine characteristics, boniness and lack of thighs; I think like Kerr [the critic], 'I am the only one who has intellect.' " (Grosz 1979, p. 58)

48. Beth Irwin Lewis (1990) demonstrates the many instances of the representation of sexual violence within Berlin Dada. She places the Dadaists' preoccupation with sex crimes in a broader cultural context and reveals misogynist tendencies in contradiction to their goals of sexual liberation, as stated in the Dada program published by Hausmann and Huelsenbeck in *Der Dada* in 1919. My reading of the Dadaist material is indebted to hers.

49. Lewis, op. cit. lecture.

50. Erich Wulffen, *Der Sexualverbrecher: Ein Handbuch für Juristen, Verwaltungsbeamte und Ärtze mit zahlreichen kriminalistischen Originalaufnahmen* (1910) as related by Lewis, op. cit.

51. Lewis, op. cit.

52. Sigmund Freud, "Fetishism," 1927, in James

Strachey, ed., *The Standard Edition of the Complete Psychological Works of Sigmund Freud* (London: Hogarth Press, 1961), vol. 21, pp. 151–7.

53. For a concise history of the Barbarossa myth, see Arno J. Mayer (1988, pp. 218–22), who also discusses its extension into Nazi politics (pp. 223–75).

54. See Monika Arndt (1978), pp. 75–126.

55. Fritz Lang, "Worauf es beim Nibelungen-Film ankam," *Die Nibelungen*, p. 15, as cited by Siegfried Kracauer (1974, p. 92).

56. Ibid.

57. Friedrich Gundolf, *Goethe* (Berlin: G. Bondi, 1916). Gundolf himself belonged to the conservative literary circle of Stefan George, on whom he published a study, *George* (Berlin: G. Bondi), equally popular, in 1920.

58. Steinitz (1968), pp. 90–1.

59. Richter (1965), p. 152.

60. Schwitters, "An alle Bühnen der Welt," 1919, in *L*, vol. 5, p. 39.

61. Schwitters, "Ich und meine Ziele," 1931, in *L*, vol. 5, p. 344.

62. Schwitters, "Die Bedeutung des Merzgedankens in der Welt," 1923, in *L*, vol. 5, p. 134.

63. Schwitters, "Schloß und Kathedrale mit Hofbrunnen," in *Das Frühlicht*, 3 (1923). Reprinted in Bruno Taut (1963, pp. 166–7).

64. Otto Grautoff, *Formzertrümmerung und Formenaufbau in der bildenden Kunst* (Berlin: Wasmuth, 1919). See also Grautoff's essay "Die Auflösung der Einzelform durch den Impressionismus" (1919a).

65. Grautoff, (1919b), pp. 85–6. Grautoff's rhetoric is tinged with the cultural nationalism of the war years and the stereotypical elevation of "Germanic" art (i.e., the Gothic, particularly Grünewald, and Expressionism) as opposed to "French" art (i.e., classicism).

66. Ibid., p. 86.

67. Wilhelm Uhde (1919), pp. 317–19.

68. Iain Boyd Whyte (1982), p. 64.

69. Kurt Hiller, "Der Bund der Geistigen," 1915, as cited by Whyte (1982, p. 65).

70. Georg Simmel, *Brücke und Tür*, as cited by Whyte (1982, p. 65).

71. Bruno Taut (1924), p. 34.

72. Adolf Behne (1919), p. 40.

73. Ibid.

74. See Schwitters, "Merz," 1920, in *L*, vol. 5, p. 79.

75. It seems that Schwitters was also concerned with the psychology of color and color therapy. A clipping in his notebook reports on the medical successes of color therapy. Schwitters marked a passage reporting that color therapy was particularly useful in the treatment of skin and nervous disorders and, possibly, mental disorders. He also underlined a passage in which red was discussed as a tonic for blood circulation, the stomach and kidneys, and blue as an aid in treating congestion and rheumatism, whereas in general light colors mixed with much white would create a sense of well-being and happiness. (*Schwarzes Notizbuch VII*, pp. 174–5. Schwitters Archiv, Hannover.) Schwitters painted the shell of the *Merzbau* white and distributed red and yellow color accents throughout the structure. He used the same red hue that he had employed in the *Aquarelle* drawings, associated in those works with Anna Blume and the theme of love.

76. Apparently, Schwitters modernized the oriental rug in his dining room by painting it black. The living room (see frontispiece), in contrast, was furnished with the family heirloom Biedermeier furniture crafted by one of Schwitters's grandfathers as his masterpiece. (Ernst Schwitters in a conversation with the author, Lysaker, Norway, October 1988.)

77. Related to the author by Ernst Nündel (as conveyed to him by Schwitters's friends) in a conversation (Aachen, October 1981).

78. Jahns (1986), p. 261.

79. Schwitters, "Ich und meine Ziele," 1931 in *L*, vol. 5, p. 345.

80. Schwitters, "Die Bedeutung des Merzgedankens in der Welt," 1923, in *L*, vol. 5, p. 133.

81. Ludwig Hilberseimer (1919), p. 273.

82. Hilberseimer (1920), p. 1120.

EPILOGUE

1. Kurt Schwitters, "Ich und meine Ziele," 1931, in *L*, vol. 5, p. 335.

2. Jeffrey Herf (1984), pp. 1–2.

3. Ibid., p. 2.

4. Oswald Spengler (1918–22), vol. 1, p. 21 in the 1932 translation.

5. Ibid., p. 17.

6. Richard Huelsenbeck (1964), p. 9.

7. *L*, vol. 2, pp. 29–38.

8. Schwitters, Letter to Christof Spengemann, 24 July 1946, in Ernst Nündel (1974), p. 210.

BIBLIOGRAPHY

UNPUBLISHED MATERIAL

Archives of the Société Anonyme, Beinecke Rare Book Library, Yale University, New Haven.
Bibliothèque Littéraire Jacques Doucet, Paris.
Ernst Schwitters, Lysaker, Norway.

Hannah Höch Archiv, Berlinische Galerie, Berlin.
Schwitters Archiv Hannover, Hannover, Germany.
Der Sturm Archiv, Staatsbibliothek Preußischer Kulturbesitz, Berlin.

SCHWITTERS

Selected Primary Literature

Kurt Schwitters Merzhefte als Faksimile-Nachdruck, 1975. (Bern and Frankfurt). Facsimile edition of *Merz* magazine, with an introduction by Friedhelm Lach.

Lach, Friedhelm, ed., 1973–1981. *Kurt Schwitters: Das literarisches Werk*. Vol. 1, Lyrik; vol. 2, Prosa 1918–1930; vol. 3, Prosa 1931–1948; vol. 4, Schauspiele und Szenen; vol. 5, Manifeste und kritische Prosa (Cologne: DuMont).

Nündel, Ernst, ed., 1974. *Kurt Schwitters: Wir spielen, bis uns der Tod abholt – Briefe aus fünf Jahrzehnten* (Frankfurt: Ullstein).

Schwitters, Ernst, ed., 1965. *Anna Blume und Ich: Die Gesammelten "Anna Blume"-Texte* (Zurich: Verlag der Arche).

Schwitters, Kurt, 1919. *Anna Blume Dichtungen*, vol. 39/40 of the series entitled *Die Silbergäule* (Hannover: Paul Steegemann).

ed., 1923–32. *Merz*, nos. 1–24 (Hannover: Merz-Verlag).

Watts, Harriet, ed., 1974. *Three Painter-Poets: Arp, Schwitters, Klee. Selected Poems* (Harmondsworth: Penguin).

Selected Secondary Literature

Arnold, Armin, 1972. "Kurt Schwitters' Gedicht 'An Anna Blume': Sinn oder Unsinn," *Text und Kritik* 35/36:13–23 (October).

Arp, Hans. 1956. "Franz Müllers Drahtfrühling," *Quadrum* 1:88–94.

Berggruen et Cie (Paris), 1954. *Kurt Schwitters: Collages* (ex. cat.).

Bergius, Hanne, 1985. "Kurt Schwitters: Aspects of Merz and Dada. 'In the Elysian Fields of the Inventory,'" in Christos Joachimides, Norman Rosenthal, and Wieland Schmied, eds., *German Art in the 20th Century: Painting and Sculpture 1905–1985* (Munich and London: Prestel Verlag and Royal Academy of Arts), pp. 444–9.

Bletter, Rosemarie Haag, 1977. "Kurt Schwitters' unfinished rooms," *Progressive Architecture* 58 (9):97–9 (September).

Brookes, Fred, 1969. "Schwitters' Merzbarn," *Studio International* 177(911):224–7 (May).

Danieli, Fidel A., 1965. "Kurt Schwitters," *Artforum*, 3(8):26–30.

Dietrich, Dorothea, 1986. "The Fragment Reformed: The Early Collages of Kurt Schwitters," Ph.D. dissertation, Dept. of the History of Art, Yale University.

1991a. "The Fragment Reframed: Kurt Schwitters's *Merz-column*," *Assemblage* 14:82–92 (April).

1991b. "Refashioned Traditions: Kurt Schwitters' Collages of Women," *Yale University Art Gallery Bulletin 1991*: 68–85.

Doehl, Reinhardt, 1969. "Kurt Merz Schwitters," in W. Rothe, ed., *Expressionismus als Literatur* (Bern and Munich: Francke).

Elderfield, John, 1969. "Kurt Schwitters' last Merzbarn," *Artforum* 8(2):56–65 (October).

1970. "Merz in the Machine Age," *Art and Artists*, 5(4):56–9 (July).

1971a. "Schwitters' Abstract 'Revolution,' " *German Life and Letters*, n.s., 24(3):256–61 (April).

1971b. "The Early Work of Kurt Schwitters," *Artforum* 10(3):54–67 (November).

1977. "On a Merz-Gesamtwerk," *Art International* 21(6):19–26 (December).

1985. *Kurt Schwitters* (New York: Museum of Modern Art).

Elger, Dietmar, 1982. "Zur Entstehung des Merzbaus," in M. Erlhoff, ed., *Kurt Schwitters Almanach* (Hannover: Postskriptum).

1984. *Der Merzbau: Eine Werkmonographie* (Cologne: Walther König).

1986. "Der MERZbau," in Sprengel Museum (1986), pp. 248–54.

Erlhoff, Michael, ed., 1982–1987. *Kurt Schwitters Almanach* (Hannover: Postskriptum).

Fundacion Juan March (Madrid), 1982. *Kurt Schwitters* (ex. cat.).

Galerie Chalette (New York), 1963. *Kurt Schwitters* (ex. cat.).

Galerie Gmurzynska, (Cologne), 1978. *Kurt Schwitters* (ex. cat.); with texts by Hans Bolliger, Werner Schmalenbach, Ernst Schwitters.

Giedion-Welcker, Carola, 1948. "Schwitters: or the Allusions of the Imagination," *Magazine of Art* 41(6):218–21 (October).

Grand Palais, (Paris, FIAC). 1980. *Kurt Schwitters* (ex. cat.). Organized by the Galerie Gmurzynska (Cologne).

Gröttrup, Bernhard, 1920. "Ein Besuch bei Anna Blume," *Die Pille* 1(7):149–52 (October).

Hirscher, Heinz E., 1978. *Der Merz-Künstler Kurt Schwitters und sein Materialbild* (Stuttgart: Collispress).

Jahns, Rudolf, 1986. "Notizen zum MERZbau," in *Kurt Schwitters 1887–1948* (ex. cat.) (Hannover: Sprengel Museum).

K. Révue de la Poésie, 1949. no. 3 (May). Special issue, "Hommage à Kurt Schwitters," with contributions by Arp, Giedion-Welcker, and Schwitters.

Kestner-Gesellschaft (Hannover), 1956. *Kurt Schwitters* (ex. cat.); introduction by Werner Schmalenbach.

Konstsalongen Samlaren (Stockholm), 1965. *Kurt Schwitters* (ex. cat.); with texts by Ernst Schwitters et al.

Lach, Friedhelm, 1971. *Der Merz Künstler Kurt Schwitters* (Cologne: DuMont-Dokumente).

Last, Rex W., 1973. *German Dadaist Literature: Kurt Schwitters, Hugo Ball, Hans Arp* (New York: Twayne Publishers).

Lavin, Maud, 1985. "Advertising Utopia: Schwitters as Commercial Designer," *Art in America*, 73(10):134–9 (October).

Liede, Alfred, 1963. "Der Surrealismus und Kurt Schwitters' Merz," in *Dichtung als Spiel. Studien zur Unsinnspoesie an den Grenzen der Sprache* (Berlin, Walter de Gruyter & Co.).

London Gallery (London), 1950. *An Homage to Kurt Schwitters* (ex. checklist).

Lords Gallery (London), 1958. *Kurt Schwitters* (ex. cat.).

Marlborough Fine Art (London), 1963. *Schwitters* (ex. cat.); introduction by Ernst Schwitters.

1972. *Kurt Schwitters* (ex. cat.); introduction by C. Giedion-Welcker.

1981. *Kurt Schwitters in Exile: The Late Work 1937–1948* (ex. cat.); contains essays on the late work by Nicholas Wadley.

Marlborough-Gerson Gallery (New York), 1965. *Kurt Schwitters* (ex. cat.); introduction by Werner Schmalenbach, "Kurt Schwitters and America" by Kate T. Steinitz.

Mehring, Walter, 1919. "Kurt Schwitters im 'Sturm,' " *Der Cicerone* 11(15):462 (July).

Modern Art Gallery (London), 1944. *Painting and Sculpture by Kurt Schwitters (The Founder of Dadaism and Merz)* (ex. cat.); introduction by Herbert Read.

Moholy, Lucia, 1966. "Der dritte Merzbau von Kurt Schwitters," *Werk* 53(3):110–1 (March).

Muche, Georg, 1961. "Ich habe mit Schwitters gemerzt," in *Blickpunkt: Sturm, Dada, Bauhaus, Gegenwart* (Munich: A. Langen–G. Müller), pp. 175–80.

Nill, Annegreth, 1981a. "Rethinking Kurt Schwitters, Part One: An Interpretation of Hansi," *Arts Magazine* 5(15):112–18 (June).

1981b. "Rethinking Kurt Schwitters, Part Two: An Interpretation of Grünfleck," *Arts Magazine* 5(15):119–25 (June).

1984. "Weimar Politics and the Theme of Love in Kurt Schwitters' *Das Bäumerbild*," *Dada-Surrealism* (13):17–36.

1986. "Die Handlung spielt in Dresden," in *Kurt Schwitters 1887–1948* (ex. cat.) (Hannover: Sprengel Museum), pp. 36–41.

1990. *Decoding Merz: An Interpretive Study of Kurt Schwitters' Early Work. 1918–1922.* Ph.D. dissertation, Art History Department, University of Texas at Austin.

Nündel, Ernst, 1974. *Kurt Schwitters: Wir spielen, bis uns der Tod abholt. Briefe aus fünf Jahrzehnten* (Frankfurt: Ullstein, 1974).

1981. *Kurt Schwitters in Selbstzeugnissen und Bilddokumenten* (Reinbek bei Hamburg: Rowohlt).

Pasadena Art Museum, 1962. *Kurt Schwitters* (cat. for the circulating exhibition organized by the Museum of Modern Art, New York).

Passuth, Krisztina, 1978. *Schwitters* (Budapest: Corvina).

Pierce, Harry, 1953. "Die letzte Lebenszeit von Kurt Schwitters," *Das Kunstwerk* 7(3–4):32–5.

Pinacotheca Gallery (New York), 1948. *Kurt Schwitters* (ex. cat.); introduction by Naum Gabo and mimeographed statement (Katherine Dreier, "Kurt Schwitters: the dadas have come to town.").

Reichardt, Jasia, ed., 1962. *Pin* (London: Gaberbocchus Press); text by Raoul Hausmann and Kurt Schwitters.

Scheffer, Bernd, 1978. *Anfänge experimenteller Literatur: Das literarische Werk von Kurt Schwitters* (Bonn: Bouvier).

Schmalenbach, Werner, 1956. "Zur Ausstellung," in *Kurt Schwitters* (ex. cat.) (Kestner-Gesellschaft: Hannover).

1965. "Introduction," in *Kurt Schwitters Retrospective* (ex. cat.) (New York: Marlborough-Gerson Gallery).

1967. *Kurt Schwitters* (London and New York: Abrams).

Schmidt, Paul, F., 1920. "Schwitters, Schlemmer, Baumeister," *Der Cicerone* 12:621–2.

Seibu Museum of Art and Museum of Modern Art (Tokyo), 1983. *Kurt Schwitters* (ex. cat.).

Sheppard, Richard, 1984. "Kurt Schwitters and Dada. Some preliminary remarks on a complex topic," in *Dada-Constructivism* (ex. cat.) (London: Annely Juda Fine Art), pp. 47–51.

Sidney Janis Gallery (New York), 1956. *57 Collages by Kurt Schwitters* (ex. cat.); introduction by Tristan Tzara.

1959. *Schwitters. 75 Collages* (ex. cat.).

Spengemann, Christof, 1919a. "Der Künstler. An Kurt Schwitters," *Der Sturm* 10(4):61 (July).

1919b. "Kurt Schwitters," *Der Cicerone* 11(18): 573–81.

(S. Sp.), 1920a. "Merz–die offizielle Kunst," *Der Zweemann* 1(8–10):40–1 (June–August).

1920b. *Die Wahrheit über Anna Blume: Kritik der Kunst/Kritik der Kritik/Kritik der Zeit* (Hannover: Der Zweemann).

Sprengel Museum (Hannover), 1986. *Kurt Schwitters 1887–1948* (ex. cat.), edited by Joachim Büchner and Norbert Nobis.

Städtische Kunsthalle (Düsseldorf), 1971. *Kurt Schwitters* (ex. cat.); with essays by Werner Schmalenbach, Ernst Schwitters, Dietrich Helms, et al.

Stadtbibliothek (Hannover), 1986. *Schwitters-Archiv Hannover: Bestandsverzeichnis*.

Steegemann, Paul, 1920. "Das enthüllte Geheimnis der Anna Blume," *Der Marstall* (1/2):11–31.

Steinitz, Kate, 1962. "K. Schwitters 1919," *Bulletin of the Los Angeles County Museum of Art* 14(2):4–14.

1968. *Kurt Schwitters. A Portrait from Life* (Berkeley and Los Angeles: University of California Press); introduction by John Coplans and Walter Hopps. (An expanded English edition of *Kurt Schwitters: Erinnerungen aus den Jahren 1918–30* [Zurich: Verlag der Arche, 1963]).

Der Sturm, *Sturmbilderbuch IV* (Berlin: Der Sturm 1921).

Szeemann, Harold, 1986. "Die Geschichte der Rekonstruktion des MERZbaus (1980–1983)," in Sprengel Museum (1986), pp. 256–7.

Tate Gallery (London), 1985. *Kurt Schwitters* (ex. cat.); text by Richard Humphreys.

Text + Kritik, no. 35–36, Oct. 1972 (special edition devoted to Kurt Schwitters); includes articles by Helmut Heißenbüttel, Armin Arnold, Hans Burkhard Schlichting, Helgard Bruhns, Bernd Scheffer, Hans-Georg Kemper, Friedhelm Lach, Otto Nebel, and Ernst Nündel.

Themerson, Stefan, 1958. *Kurt Schwitters in England* (London: Gaberbocchus Press).

Thomas, Edith, 1950. "Kurt Schwitters," in Michel Seuphor, ed., *L'Art Abstrait: Ses Origines, ses Premiers Maîtres* (Paris: Maeght), pp. 311–13.

XXX Biennale internazionale d'arte (Venice), 1960. *Kurt Schwitters* (ex. cat.).

Tzara, Tristan, 1964. "Kurt Schwitters, 1887–1948," *Portfolio*, 8:66–71 (Spring).

Vahlbruch, Heinz, 1953. "Kurt Schwitters: Maler und Dichter," *Das Kunstwerk* 7(3–4):27–30.

Vordemberge-Gildewart, Friedrich, 1948. "Kurt Schwitters," *Forum* (12):356–62.

Wallraf-Richartz-Museum (Cologne), 1963. *Kurt Schwitters* (ex. cat.); with text by Gert van der Osten.

Zankl-Wohltat, Gisela, 1986. "Gedanken zum Frühwerk von Kurt Schwitters," in *Kurt Schwitters 1887–1948* (ex. cat.) (Hannover: Sprengel Museum).

SELECTED BACKGROUND MATERIAL

Art and Culture

Ades, Dawn, 1976. *Photomontage* (London: Thames and Hudson).

Akademie der Künste (Berlin) 1977. *Tendenzen der Zwanziger Jahre. 15. Europäische Kunstausstellung unter den Auspizien des Europarates* (ex. cat.).

1980. *Arbeitsrat für Kunst, Berlin 1918–1921: Ausstellung und Dokumentation* (ex. cat.); edited by Walter Rossow and Uli Bohnem.

Annely Juda Fine Art (London), 1978. *The Twenties in Berlin.* (ex. cat.)

1984. *Dada-Constructivism* (ex. cat.).

Arbeitsrat für Kunst (Gropius, Bruno Taut, Behne), 1919a. *Ausstellung für unbekannte Architekten* (Berlin: Graphisches Kabinett I.B. Neumann).

1919b. *Ja! Stimmen des Arbeitsrats für Kunst in Berlin* (Charlottenburg: Photographische Gesellschaft).

Arndt, Monika, 1978. "Das Kyffhäuser Denkmal: Ein Beitrag zur politischen Ikonographie des Zweiten Kaiserreiches," *Wallraf-Richartz Jahrbuch* 40: 75–126.

Arts Council of Great Britain (London), 1978. *Dada and Surrealism Reviewed* (ex. cat.).

Babcock, Barbara, ed., 1978. *The Reversible World* (Ithaca and London: Cornell University Press).

Bahr, Hermann, 1925. *Expressionism*, trans. by R. T. Gribble (London: Frank Henderson).

Bance, Alan, ed., 1982. *Weimar Germany: Writers and Politics* (Edinburgh: Scottish Academic Press).

Banham, Reyner, 1960. *Theory and Design in the First Machine Age* (London: Architectural Press).

Barr, Alfred H., 1936. *Fantastic Art, Dada, Surrealism* (New York: Museum of Modern Art).

Barron, Stephanie, ed., 1988. *German Expressionism 1915–1925: The Second Generation* (Munich: Prestel and Los Angeles County Museum of Art).

Barthes, Roland, 1967. *Writing Degree Zero* (New York: Hill and Wang).

1977. *Image, Music, Text* (New York: Hill and Wang).

Barzun, Jacques, 1943. *Classic, Romantic and Modern* (Boston: Little, Brown and Company).

Behne, Adolf, 1919a. "Alte und Neue Plakate," in *Das Politische Plakat* (Charlottenburg: Verlag Das Plakat).

1919b. "Unsere moralische Krise," in *Sozialistische Monatshefte* 25(52):34–8 (January 20).

1919c. "Werkstattbesuche: Jefim Golyscheff," *Der Cicerone* 11(22):722–6 (November).

1919d. *Die Wiederkehr der Kunst* (Leipzig: Kurt Wolff).

1921. "Die neue Aufgabe der Kunst," *Sozialistische Monatshefte* 58:813–15 (September 19).

Benjamin, Walter, 1969. *Illuminations*, edited by Hannah Arendt (New York: Schocken Books).

1977. *The Origin of German Tragic Drama*, trans. by John Osborne (London: New Left Books). (Orig. publ. 1925.)

1980. *Gesammelte Schriften*, 12 vols. (Frankfurt: Suhrkamp).

Berger, John, and Jean Mohr, 1982. *Another Way of Telling* (New York: Pantheon).

Bergius Hanne, 1978. "Dada Berlin," in *Dada in Europa* (ex. cat.) (Frankfurt: Städtische Galerie. Städelsches Kunstinstitut).

1989. *Das Lachen Dadas* (Giessen: Anabas).

Bergson, Henri, 1956. "Le Rire," in Wylie Sypher, ed., *Comedy* (New York: Doubleday), pp. 61–190.

Billeter, Erika, 1973. *Die zwanziger Jahre: Kontraste eines Jahrzehnts*, ex. cat. (Zurich: Kunstgewerbemuseum).

Bletter, Rosemarie Haag, 1973. *Bruno Taut and Paul Scheerbart's Vision. Utopian Aspects of German*

Expressionist Architecture, Ph.D. dissertation, Fine Arts Department, Columbia University.

1975. "Paul Scheerbart's Architectural Fantasies," *Journal of the Society of Architectural Historians* 34(2):83–97 (May).

Bloch, Ernst, 1918. "Zur deutschen Revolution," *Revolution* 2:11 (November).

1918. *Geist der Utopie* (Munich and Leipzig: Duncker & Humblot).

1973. *Erbschaft dieser Zeit* (Frankfurt: Suhrkamp).

Boberg, Jochen, Tilman Fichter, and Eckhart Gillen, eds., 1986. *Die Metropole: Industriekulturen in Berlin im 20. Jahrhundert* (Munich: C. H. Beck).

Bohnen, Uli, 1976. *Das Gesetz der Welt ist die Änderung der Welt: Die rheinische Gruppe progressiver Künstler, 1918–1933* (Berlin: Karin Kramer).

Bohnen, Uli, and Dirk Backe, 1978. *Der Schritt, der einmal getan wurde, wird nicht wieder zurückgenommen* (Berlin: Karin Kramer).

Bronner, Stephen Eric, and Douglas Keller, eds., 1983. *Passion and Rebellion: The Expressionist Heritage* (Mount Holyoke: J. F. Bergin).

Brühl, Georg, 1983. *Herwarth Walden und Der Sturm*. (Cologne: DuMont).

Buchloh, Benjamin, 1981. "Figures of Authority, Ciphers of Regression: Notes on the Return of Representation in European Painting," *October* 16(Spring):39–68.

1982. "Allegorical Procedures: Appropriation and Montage in Contemporary Art," *Artforum* 21(1):43–56 (September).

1990. "From Faktura to Factography," in R. Hertz and N. Klein, eds., *Twentieth Century Art Theory* (Englewood Cliffs, N.J.: Prentice Hall), pp. 81–111.

Bürger, Peter, 1974. *Theorie der Avantgarde* (Frankfurt: Suhrkamp).

Camfield, William, 1974. *Francis Picabia* (Princeton: Princeton University Press).

Cauman, Samuel, 1958. *The Living Museum: Experiences of an Art Historian and Museum Director, Alexander Dorner* (New York: New York University Press).

Caws, Mary Ann, 1970. *The Poetry of Dada and Surrealism: Aragon, Breton, Tzara, Éluard, Desnos*. (Princeton: Princeton University Press).

Centre National d'Art et de Culture Georges Pompidou (Paris), 1978. *Paris-Berlin 1900–1933* (ex. cat.).

Clark, Robert Judson, 1970. "The German Return to Classicism After Jugendstil," *Journal of the Society of Architectural Historians* 29(3):273.

Clement, Catherine, 1983. *The Lives and Legends of Jacques Lacan*. (New York: Goldhammer).

Corngold, Stanley, 1988. *Franz Kafka: The Necessity of Form* (Ithaca: Cornell University Press).

Däubler, Theodor, 1919. *Der neue Standpunkt* (Leipzig: Insel-Verlag).

Davis, Natalie Z., 1978. "Women on Top: Symbolic Sexual Inversion and Political Disorder in Early Modern Europe," in B. A. Babcock, ed., *The Reversible World* (Ithaca and London: Cornell University Press).

Delcourt, Marie, 1956. *Hermaphrodite: Myths and Rites of the Bisexual Figure in Classical Antiquity* (London: Studio Books).

deMan, Paul, 1979. *Allegories of Reading* (New Haven: Yale University Press).

Derrida, Jacques, 1978. *La Vérité en Peinture* (Paris: Flammarion).

Donaldson, Ian, 1970. *The World Upside Down: Comedy from Jonson to Fielding* (Oxford: Oxford University Press).

Dückers, Alexander, 1979. *George Grosz, Das Graphische Werk* (Berlin: Propyläen Verlag).

Duncan, Carol, 1990. "Virility and Domination in Twentieth-Century Painting," in R. Hertz and N. Klein, eds., *Twentieth Century Art Theory* (Englewood Cliffs, N. J.: Prentice Hall).

Durkheim, Emile, and Marcel Mauss, 1972. *Primitive Classification*, translated with an introduction by Rodney Needham (Chicago: University of Chicago Press).

Eagleton, Terry, 1981. *Walter Benjamin or Towards a Revolutionary Criticism* (New York: NLB).

1986. *Against the Grain* (London: Verso).

Eberle, Mattias, 1985. *World War I and the Weimar Artists: Dix, Grosz, Beckmann, Schlemmer* (New Haven and London: Yale University Press).

Egbert, Donald Drew, 1970. *Social Radicalism and the Arts: Western Europe – A Cultural History from the French Revolution to 1968* (New York: Knopf).

Ehrenburg, Ilya, 1921–2. "Ein Entwurf Tatlins," *Frühlicht* 1(3):92–93.

Ehrmann, Jacques, ed., 1968. *Game, Play, Literature* (No. 41 of *Yale French Studies*).

Einstein, Carl, 1973. *Die Fabrikationen der Fiktionen*, edited by Sibylle Penckert (Rheinbek: Rowohlt).

1980. *Werke*, vols. 1–3; edited by Rolf-Peter Baacke (Berlin: Medusa).

Elderfield, John, 1970. "Dissenting Ideologies and the German Revolution," *Studio International* 180(927):180–7 (November).

1984. "On the Dada-Constructivist Axis," *Dada-Surrealism* (13):5–16.

Emboden, William A., and J. Kaplan, 1982. *Kate Steinitz: Art and Collection: Avant-Garde Art in*

Germany in the 1920s and 1930s, ex. cat. (San Bernadino, Calif.: California State College Art Gallery).

Fechter, Paul, 1914. *Der Expressionismus* (Munich: Piper).

Foster, Hal, ed., 1983. *The Anti-Aesthetic*. (Port Townsend, Washington: Bay Press).

Foster, Stephen C., 1985. "Johannes Baader: The Complete Dada," in S. Foster, ed., *Dada/Dimensions* (Ann Arbor: UMI Research Press).

— ed., 1985. *Dada/Dimensions* (Ann Arbor: UMI Research Press).

Foster, Stephen C., and Rudolf E. Kuenzli, eds., 1979. *Dada Spectrum: The Dialectics of Revolt* (Iowa City: University of Iowa).

Foucault, Michel, 1970. *The Order of Things* (New York: Vintage Books).

— 1984. "What is Enlightenment?," in Paul Rabinow, ed., *The Foucault Reader* (New York: Pantheon Books), pp. 32–50.

Franciscono, Marcel, 1971. *Walter Gropius and the Creation of the Bauhaus in Weimar* (Urbana: University of Illinois Press).

Frascina, Francis, ed., 1985. *Pollock and After: The Critical Debate* (New York: Icon Editions).

Frecot, Janos, Johann Friedrich Geist, and Diethart Kerbs, 1972. *Fidus 1868–1948* (Munich: Rogner & Bernhard).

Freud, Sigmund, 1900. *Die Traumdeutung*. Reprint. (Frankfurt: S. Fischer, 1981).

— 1905. *Der Witz und seine Beziehung zum Unbewußten*. Reprint (Frankfurt: S. Fischer, 1981).

— 1923. *Das Ich und das Es*. Reprint (Frankfurt: S. Fischer, 1980).

— 1961. "Fetishism," in J. Strachey, ed., *The Standard Edition* (London: Hogarth), vol. 21, pp. 151–7. Originally published in 1927.

Galerie Otto Burchard (Berlin), 1920. *Erste Internationale Dada-Messe*. [Cat. to the Erste Internationale Dada-Messe]; article by John Heartfield.

Galerie van Diemen und Co. (Berlin), 1922. *Erste russische Kunstausstellung Berlin 1922* (ex. cat.).

Gallery Helen Serger/La Boetie (New York), 1985. *Kurt Schwitters: Words and Works* (ex. cat.).

Gay, Peter, 1968. *Weimar Culture. The Outsider as Insider*. Reprint (New York: Harper Torchbooks, 1970).

Giedion-Welcker, Carola, ed., 1946. *Poètes à l'Écart: Anthologie der Abseitigen* (Bern-Bümplitz: Benteli).

Gombrich, E. H., 1982. *The Image and the Eye: Further Studies in the Psychology of Pictorial Representation* (Ithaca: Cornell University Press).

Gordon, Donald E., 1966. "On the origin of the word 'Expressionism,' " *Journal of the Warburg and Courtauld Institutes* 29:368–85.

— 1982. "Content by Contradiction," *Art in America* 70(11):76–89 (December).

Grautoff, Otto, 1919a. "Die Auflösung der Einzelform durch den Impressionismus," *Der Cicerone* 12: 248–55.

— 1919b. *Formzertrümmerung und Formenaufbau in der bildenden Kunst: ein Versuch zur Deutung der Kunst unserer Zeit* (Berlin: Wasmuth).

Greenberg, Allan C., 1979. *Artists and Revolution. Dada and the Bauhaus, 1917–1928*. (Ann Arbor: UMI Research Press).

Greenberg, Clement, 1961. "Modernist Painting," *Arts Yearbook* 4:101–8.

Greenblatt, Stephen, 1983. "Murdering Peasants: Status, Genre, and the Representation of Rebellion," *Representations* 1(1):1–29.

Gropius, Walter, 1919a. "Die neue Baukunst," *Das hohe Ufer* 1(4)87–8 (April).

— 1919b. *Programm des Staatlichen Bauhauses in Weimar* (Berlin).

Grosz, George, 1979. *Briefe 1913–1959*. Edited by H. Knust (Reinbek bei Hamburg: Rowohlt).

— 1983. *A Little Yes and a Big No* (New York: Dial Press).

— 1990. "My New Pictures," in R. Hertz and N. Klein, eds., *Twentieth Century Art Theory* (Englewood Cliffs, N.J.: Prentice Hall).

Guenther, Peter W., 1988. "A Survey of Artists' Groups: Their Rise, Rhetoric, and Demise," in Stephanie Barron, ed., *German Expressionism 1915–1925: The Second Generation* (Munich: Prestel and Los Angeles County Museum of Art), pp. 99–115.

Haug, Walter, ed., 1978. *Formen und Funktion der Allegorie* (Stuttgart: Metzler: Symposium Wolfenbüttel).

Hausmann, Raoul, 1920. "Dada in Europa," *Der Dada* 3: n. p.

— 1958. *Courrier Dada* (Paris: Le Terrain Vague).

— 1971. "Dada riots, moves and dies in Berlin," *Studio International* 181(932):162–5 (April).

— 1972. *Am Anfang war Dada* (Steinbach/Gießen: Anabas).

— 1977. "Pamphlet gegen die Weimarische Lebensauffassung," in K. Riha, ed., *Dada Berlin: Texte, Manifeste, Aktionen* (Stuttgart: Reclam).

Haxthausen, Charles W., and Heidrun Suhr, eds., 1990. *Berlin: Culture and Metropolis* (Minneapolis: University of Minnesota Press).

Heller, Reinhold, 1981. *The Earthly Chimera and the*

Femme Fatale (Chicago: University of Chicago Press).

1990. *Art in Germany 1909–1936: From Expressionism to Resistance. The Marvin and Janet Fishman Collection* (Munich: Prestel).

Helms, Dietrich, 1963. "The 1920s in Hannover," *Art Journal* 22(3):141–4 (Spring).

Herbert, Robert L., Eleanor S. Apter, and Elise Kenney, eds., 1984. *The Société Anonyme and the Dreier Bequests at Yale: A Catalogue Raisonné.* (New Haven: Yale University Press).

Hermand, Jost, 1984. *Literarisches Leben in der Weimarer Republik* (Stuttgart: Metzler).

Hermand, Jost, and Frank Trommler, 1978. *Die Kultur der Weimarer Republik* (Munich: Nymphenburger Verlagshandlung).

Herzfelde, Wieland, 1920. "Zur Einführung," *Erste Internationale Dadamesse,* Kunsthandlung Dr. Otto Burchard. Reprinted in Eberhard Roters, ed., *Stationen der Moderne* (Cologne: Walther König, 1988).

1971. *John Heartfield: Leben und Werk* (Dresden: Verlag der Kunst).

Hielscher, Peter, 1977. "Politische Plakate," in *Wem Gehört die Welt?* (Berlin: NGBK).

Hilberseimer, Ludwig, 1919. "Paul Scheerbart und die Architekten," *Das Kunstblatt* 3(9):271–4.

1920. "Dadaismus," *Sozialistische Monatshefte* 26:1120–2.

Hirschfeld, Magnus, 1937. *The Sexual History of the World War* (New York: Falstaff Press).

Huelsenbeck, Richard, 1920a. *En Avant Dada: Eine Geschichte des Dadaismus* (Hannover: P. Steegemann).

1920b. "Dadistisches Manifest," in *Dada Almanach* (Berlin: Erich Reiss).

1920c. "Was Wollte der Expressionismus," in *Dada Almanach* (Berlin: Erich Reiss).

1957. *Mit Witz, Licht und Grütze: Auf den Spuren des Dadaismus* (Wiesbaden: Limes Verlag).

1974. *Memoirs of a Dada Drummer,* edited by Hans J. Kleinschmidt (New York: Viking Press).

1975. "Dada and Existentialism," in Willy Verkauf, ed., *Dada: Monograph of a Movement* (London: Academy Editions; New York: St. Martin's Press), pp. 31–7.

ed., 1964. *Dada! Eine literarische Dokumentation* (Reinbek bei Hamburg: Rowohlt).

Huyssen, Andreas, 1986. *After the Great Divide* (Bloomington: Indiana University Press).

Iowa Museum of Art (Iowa City), 1978. *Dada Artifacts* (ex. cat.); edited by Stephen C. Foster and Rudolf E. Kuenzli.

Jameson, Fredric, 1971. *Marxism and Form: Dialectical Theories of Literature* (Princeton: Princeton University Press).

1972. *The Prison House of Language* (Princeton: Princeton University Press).

1981. *The Political Unconscious: Narrative as a Socially Symbolic Act* (Ithaca: Cornell University Press).

Jennings, Michael, 1987. *Dialectical Images: Walter Benjamin's Theory of Literary Criticism* (Ithaca: Cornell University Press).

Jones, Malcolm, 1977. "The Cult of August Stramm in *Der Sturm,*" *Seminar* 13(4):257–69.

Jürgens-Kirchhoff, Annegret, 1984. *Technik und Tendenz der Montage in der Bildenden Kunst des 20. Jahrhunderts* (Giessen: Anabas).

Kaes, Anton, ed., 1981–3. *Weimarer Republik: Manifeste und Dokumente zur deutschen Literatur, 1918–1933* (Stuttgart: J. B. Metzler).

[Kahnweiler], Daniel Henry, 1919. "Merzmalerei," *Das Kunstblatt* 3 (11):351.

Kandinsky, Wassily, 1912. *Über das Geistige in der Kunst,* 2nd ed. (Munich: Piper).

1982. *Complete Writings on Art,* edited by Kenneth Lindsay and Peter Vergo (Boston: G. K. Hall).

Kemper, Hans-Georg, 1974. *Vom Expressionismus zum Dadaismus: eine Einführung in die Dadaistische Literatur* (Kronberg/Taunus: Scriptor Verlag).

Kessler, Harry Graf, 1971a. *The Diaries of a Cosmopolitan 1918–1937,* translated and edited by Charles Kessler (London: Weidenfield and Nicolson).

1971b. *In the Twenties: The Diaries of Harry Kessler* (New York: Holt, Rinehart and Winston).

Kisch, E. Heinrich, 1904. *The Sexual Life of Women in its Physiological and Hygienic Aspect* (New York: Medical Arts Society, 1916). Originally published as *Das Geschlechtsleben des Weibes in physiologischer und hygienischer Beziehung* (Berlin, 1904).

1917. *Die sexuelle Untreue der Frau: Eine sozialemedizinische Studie* (Bonn: Marcus).

Kliemann, Helga, 1969. *Die Novembergruppe* (Berlin: NGBK).

Kolb, Eberhard, Eberhard Roters, and Wieland Schmied, 1985. *Kritische Grafik der Weimarer Zeit* (Stuttgart: Klett-Cotta).

Kolinsky, Eva, 1970. *Engagierter Expressionismus: Politik und Literatur zwischen Weltkrieg und Weimarer Republik. Eine Analyse expressionistischer Zeitschriften* (Stuttgart: J. B. Metzler).

Kracauer, Siegfried, 1974. *From Caligari to Hitler* (Princeton: Princeton University Press).

Kunstamt Kreuzberg and Institut für Theaterwissen-schaft der Universität Köln, eds., *Theater in der Weimarer Republik* 1977. (Berlin and Hamburg: Elefanten Press).

Kunsthaus Zürich, 1985. *Dada in Zürich*, ex. cat. edited by Hans Bolliger, Guido Magnaguagno and Raimund Meyer.

Kunstverein für die Rheinlande und Westfalen (Düsseldorf), 1958. *DADA: Dokumente einer Bewegung* (ex. cat.).

Kunzle, David, 1973. *The Early Comic Strip: Narrative Strips and Picture Stories in the European Broadsheet from 1450 to 1825* (Berkeley and Los Angeles: University of California Press).

1978. "World Upside Down: The Iconography of a European Broadsheet Type," in B. A. Babcock, ed., *The Reversible World* (Ithaca and London: Cornell University Press).

Lacan, Jacques, 1977. *Écrits* (New York: Norton).

Lane, Barbara Miller, 1968. *Architecture and Politics in Germany, 1918–1945* (Cambridge, Mass.: Harvard University Press).

Laqueur, Walter, 1974. *Weimar: A Cultural History 1918–1933* (London: Weidenfeld and Nicolson).

Leighton, Patricia, 1985. "Picasso's Collages and the Threat of War, 1912–1913," *Art Bulletin* 67(4):653–73 (December).

1989. *Re-ordering the Universe: Picasso and Anarchism, 1897–1914* (Princeton: Princeton University Press).

Lemaire, Anika, 1977. *Jacques Lacan* (London; Boston: Routledge & Kegan Paul).

Lewis, Beth Irwin, 1971. *George Grosz. Art and Politics in the Weimar Republic* (Madison: The University of Wisconsin Press).

1990. "*Lustmord:* Inside the windows of the Metropolis," in Haxthausen and Suhr (1990), pp. 111–40. (Orig. "The Dadaist: Murderer of Vampires," lecture given at the German Studies Association, Philadelphia, October 7, 1988.)

Lewis, Beth Irwin, and Sidney Simon, 1980. *Grosz-Heartfield: The Artist as Social Critic* (Minneapolis: University of Minnesota Press).

Lindahl, Göran, 1959. "Von der Zukunftskathedrale bis zur Wohnmaschine," *Idea and Form* (Uppsala Studies in History of Art) 1:226–82.

Linse, Ulrich, 1983. *Barfüßige Propheten. Erlöser der zwanziger Jahre* (Berlin: Kramer).

Lippard, Lucy, 1971. *Dadas on Art* (Englewood Cliffs, N.J.: Prentice Hall).

Lissitzky-Küppers, Sophie, 1968. *El Lissitzky* (Greenwich, Conn.: New York Graphic Society).

Long, Rose-Carol Washton, 1980. *Kandinsky: The De-velopment of an Abstract Style* (Oxford: Clarendon Press; New York: Oxford University Press).

Lukács, Georg, 1934. "Größe und Verfall des Expressionismus," *Internationale Literatur* 1:153–73.

Mann, Philip, 1990. "Symmetry, chance, biomorphism: a comparison of the visual art and poetry of Hans Arp's Dada Period (1916–1924)," *Word & Image* 6(1):82–99 (January–March).

Mansbach, Steven, 1980. *Visions of Totality* (Ann Arbor: UMI Research Press).

Meier-Graefe, Julius 1915. *Entwicklungsgeschichte der modernen Kunst*, 2nd. ed. (Munich: Piper).

Meisel, Victor H., ed., 1970. *Voices of German Expressionism* (Englewood Cliffs, N.J.: Prentice Hall).

Menninger, Karl, 1969. *Number Words and Number Symbols. A Cultural History of Numbers* (Cambridge: MIT Press).

Merleau-Ponty, Maurice, 1962. *Phenomenology of Perception* (London: Routledge).

1968. *The Visible and the Invisible*, translated by Alphonso Lingis (Evanston, Ill.: Northwestern University Press).

Meyer, Reinhardt, et al., 1973. *Dada in Zürich und Berlin 1916–1920* (Kronberg/Taunus: Scriptor Verlag).

Middleton, J. Christopher, 1961. "Dada versus Expressionism, or The Red King's Dream," *German Life and Letters*, n.s. 15(1):37–52 (October).

1962. "'Bolshevism in Art': Dada in Politics," *Texas Studies in Literature and Language* 4(3): 408–30 (Autumn).

Moholy-Nagy, Laszlo, 1947. *The New Vision* (New York: Wittenborn).

Moholy-Nagy, Sibyl, 1950. *Moholy-Nagy: Experiments in Totality* (New York, Harper).

Moi, Toril, 1985. *Sexual/Textual Politics: Feminist Literary Theory* (London and New York: Methuen).

Motherwell, Robert, ed., 1951. *The Dada Painters and Poets: An Anthology* (New York: Wittenborn).

Museum Ludwig (Cologne), 1985. *Kurt Schwitters: Die späten Werke* (ex. cat.); with texts by Siegfried Gohr, Dietmar Elger, Ernst Schwitters.

Museum of Fine Arts (Dallas), 1977. *Berlin-Hannover: The 1920s* (ex. cat.).

Museum of Fine Arts (Montreal), 1991. *The 1920s: Age of the Metropolis* (ex. cat.).

Neue Gesellschaft für Bildende Kunst, 1975. *Politische Konstruktivisten: Die "Gruppe Progressiver Künstler" Köln* (Berlin: NGBK).

1977. *Wem gehört die Welt? Kunst und Gesellschaft in der Weimarer Republik* (Berlin: NGBK).

Neue Nationalgalerie, Akademie der Künste, Große

Orangerie des Schlosses Charlottenburg (Berlin), 1977. *Tendenzen der Zwanziger Jahre* (ex. cat.).

Nietzsche, Friedrich, 1967. *The Birth of Tragedy: The Case of Wagner*, translated by Walter Kaufmann (New York: Viking).

Ortner, Sherry B., 1974. "Is Female to Male as Nature is to Culture?" in Michelle Zimbalist Rosaldo and Louise Lamphere, eds., *Women, Culture, and Society* (Stanford: Stanford University Press), pp. 67–87.

Owens, Craig, 1983. "The Discourse of Others: Feminists and Postmodernism," in Hal Foster, ed., *The Anti-Aesthetic* (Port Townsend, Wash.: Bay Press), pp. 57–82.

1984. "The Allegorical Impulse: Toward a Theory of Postmodernism," in B. Wallis, ed., *Art After Modernism: Rethinking Representation* (Boston: Godine), pp. 203–35.

Pehnt, Wolfgang, 1973. *Die Architektur des Expressionismus* (Teufen: Niggli).

Philipp, Eckhard, 1980. *Dadaismus: Einführung in den literarischen Dadaismus und die Wortkunst des "Sturm"-Kreises* (Munich: W. Fink).

Pinthus, Kurt, 1920. *Menschheitsdämmerung* (Berlin: Ernst Rowohlt).

Plottel, Jeanine P., ed., 1983. "Collage," *New York Literary Forum*, nos. 10–11.

Poggioli, Renato, 1968. *The Theory of the Avant-Garde* (Cambridge, Mass.: Harvard University Press), originally published as *Teoria dell'arte d'avantguardia* (Bologna: Il Mulina, 1962).

Pollock, Griselda, 1988. *Vision and Difference* (London: Routledge).

Raabe, Paul, ed., 1974. *The Era of German Expressionism* (Woodstock: Overlook Press).

Remmert, Herbert and Peter Barth, ed., 1982. *Hannah Höch: Werke und Worte* (Berlin: Fröhlich & Kaufmann).

Richter, Hans, 1965. *Dada: Art and Anti-Art* (London and New York: McGraw-Hill).

Ricoeur, Paul, 1970. *Freud and Philosophy* (New Haven: Yale University Press).

Rigby, Katherine Ida, 1983. *An alle Künstler! War–Revolution–Weimar: German Expressionist Prints, Drawings, Posters & Periodicals from the Robert Gore Rifkind Collection* (San Diego: San Diego State University Press).

Riha, Karl, ed., 1977. *Dada Berlin. Texte, Manifeste, Aktionen* (Stuttgart: Reclam).

1987. *Tatu Dada* (Hofheim: Wolke).

Rischbieter, Henning, ed., 1962. *Hannover: Die zwanziger Jahre in Hannover* (ex. cat.).

ed., 1978. *Hannoversches Lesebuch*, vol. 2, 1850–1950 (Hannover: Friedrich Verlag).

Ritter, Mark, 1983. "The Unfinished Legacy of Early Expressionist Poetry: Benn, Heym, Van Hoddis and Lichtenstein," in S. E. Bronner and D. Kellner, eds., *Passion and Rebellion: The Expressionist Heritage* (Mount Holyoke: J. F. Bergin).

Roters, Eberhard, 1982. *Berlin 1910–1933* (New York: Rizzoli).

1988a. "Prewar, Wartime, and Postwar: Expressionism in Berlin from 1912 to the Early 1920s," in S. Barron, ed., *German Expressionism 1915–1925: The Second Generation* (Munich: Prestel and Los Angeles County Museum of Art).

1988b. *Stationen der Moderne: Kataloge epochaler Kunstausstellungen in Deutschland 1910–1962.* (Cologne: Walther König).

Rothe, Wolfgang, 1974. *Die deutsche Literatur in der Weimarer Republik* (Stuttgart: Reclam).

Rowell, Margit, 1979. *The Planar Dimension, Europe 1919–1932* (ex. cat.) (New York: Solomon R. Guggenheim Museum).

Rubin, William S., 1969. *Dada and Surrealist Art* (New York: Abrams).

Ryder, A. J., 1967. *The German Revolution of 1918* (Cambridge: Cambridge University Press).

Said, Edward, 1983. *The World, the Text, and the Critic* (Cambridge, Mass.: Harvard University Press).

Sanouillet, Michel, 1965. *Dada à Paris* (Paris: J. J. Pauvert).

Scheerbart, Paul, 1909. "Dynamitkrieg und Dezentralisation," *Gegenwart* 76:905–8 (November).

1914. *Glasarchitektur* (Berlin: Verlag der Sturm).

Scheerbart, Paul, and Bruno Taut, 1972. *Glass Architecture and Alpine Architecture*, edited by Dennis Sharp (London: November Books).

Scheffauer, Herman Georg, 1924. *The New Vision in the German Arts* (New York: Huebsch).

Scheffler, Karl, 1913. *Die Architektur der Großstadt* (Berlin: Bruno Cassirer).

Schelling, Friedrich Wilhelm, 1799. *Erster Entwurf eines Systems der Naturphilosophie* (Jena: C. E. Gabler).

1800. *System des transcendentalen Idealismus* (Tübingen: Cotta).

Schippers, K., 1974. *Holland Dada* (Amsterdam: Querido).

Schmidt, Diether, ed., 1964. *Manifeste, Manifeste: 1905–1933* (Dresden: VEB Verlag der Kunst).

Schmied, Wieland, 1966. *Wegbereiter zur modernen Kunst: 50 Jahre Kestner-Gesellschaft* (Hannover: Fackelträger-Verlag).

Schmitt, Hans-Jürgen, ed., 1973. *Die Expressionismusdebatte: Materialien zu einer marxistischen Realismuskonzeption* (Frankfurt: Suhrkamp).

Schneede, Uwe, ed., 1979. *Die zwanziger Jahre: Manifeste und Dokumente deutscher Künstler* (Cologne: DuMont).

Schorske, Carl E., 1981. *Fin-de-Siècle Vienna* (New York: Vintage).

Schrader, Bärbel, and Jürgen Schebera, 1988. *The "Golden" Twenties: Art and Literature in the Weimar Republic* (New Haven and London: Yale University Press).

Schreyer, Lothar, 1956. *Erinnerungen an Sturm und Bauhaus* (Munich: Langen).

Schuppan, Peter, 1973. "Hauptentwicklungslinien der Kultur in der Weimarer Republik," *Jahrbuch Volkskunde und Kulturgeschichte* 1:92–141.

Schwarzwälder, Herbert, 1975–85. *Geschichte der Freien Hansestadt Bremen* (Bremen: Rorer).

Sedlmayr, Hans, 1955. *Verlust der Mitte* (Frankfurt: Ullstein).

Selz, Peter, 1957. *German Expressionist Painting* (Berkeley: University of California Press).

Sewell, Elizabeth, 1952. *The Field of Nonsense* (London: Chatto and Windus).

Sheppard, Richard, ed., 1980. *Dada: Studies of a Movement* (Chalfont St. Giles, Buckinghamshire: Alpha Academic).

1981. *New Studies in Dada: Essays and Documents* (Driffield, England: Hutton Press).

1982. *Zurich-"Dadaco"-"Dadaglobe": The Correspondence between Richard Huelsenbeck, Tristan Tzara and Kurt Wolff (1916–1924)* (Tayport, Fife, Scotland: Hutton Press).

Siepmann, Eckhard, ed., 1977. *Montage: John Heartfield* (Berlin: Elefanten Press Galerie).

Silver, Kenneth, 1988. *Esprit du Corps: The Great War and French Art, 1914–1925* (Princeton: Princeton University Press).

Simmel, Georg, 1903. "The Metropolis and Mental Life," in Donald N. Levine, *Georg Simmel: On Individuality and Social Forms* (Chicago: University of Chicago Press, 1971), pp. 324–39. Originally published as "Die Großstadt und das Geistesleben," in *Die Großstadt: Jahrbuch der Gehe-Stiftung*, 9 (1903).

1904. "Fashion," in Donald N. Levine, *Georg Simmel: On Individuality and Social Forms* (Chicago: University of Chicago Press, 1971), pp. 294–323. Originally published as *Philosophie der Mode* (Berlin: Pan-Verlag, 1905).

1907. "Prostitution," in Donald N. Levine, *Georg Simmel: On Individuality and Social Forms* (Chicago: University of Chicago Press, 1971), pp. 121–6. Originally published in 1907 as part of *Philosophie des Geldes* (Leipzig: Duncker & Humblot, 1907), pp. 413–8.

Snitow, Ann, Christine Stansell, and Sharon Thompson, eds., 1983. *The Politics of Sexuality* (New York: Monthly Review Press).

Sobieszek, Robert, 1978. "Composite Imagery and the Origins of Photomontage," *Artforum* 17(1):58–65 (September [Part 1]); 17(2) 40–45 (October [Part 2]).

Sokel, Walter H., 1959. *The Writer in Extremis. Expressionism in Twentieth-Century German Literature* (Stanford: Stanford University Press).

Solomon R. Guggenheim Museum (New York), 1982. *Kandinsky in Munich 1896–1914* (ex. cat.).

Sontag, Susan, 1983. "Grottoes: Caves of Mystery and Magic," *House & Garden* 155:96–102, 156–8.

Spengler, Oswald, 1918–22. *Der Untergang des Abendlandes*, 2 vols. (Munich: Beck). Translated by Charles Francis Atkinson as *The Decline of the West* (New York: Knopf, 1932).

Spindler, Ernst, 1902. "Das Bismarckdenkmal für Hamburg," *Berliner Architekturwelt* 4:412–17.

Stein, Sally, 1981. "The Composite Photographic Image and the Composition of Consumer Ideology," *Art Journal* 41:39–45 (Spring).

Stokes, Charlotte, 1982. "Collage as Jokework: Freud's Theories of Wit as the Foundation for the Collages of Max Ernst," *Leonardo* 15(3):199–204.

Tafuri, Manfredo, 1976. *Architecture and Utopia* (Cambridge, Mass., Harvard University Press).

Taut, Bruno, 1919a. *Alpine Architektur* (Hagen: Folkwang).

1919b. *Die Stadtkrone* (mit Beiträgen von Paul Scheerbart, Erich Baron, Adolf Behne) (Jena: Diederichs).

1920. *Die Auflösung der Städte oder die Erde eine gute Wohnung* (Hagen: Folkwang).

1920. *Frühlicht* (Supplement to *Stadtbaukunst alter und neuer Zeit*, I, nos. 1–14. As independent publication: Magdeburg, 1921/2. 4 issues. New edition (selection) (Berlin and Frankfurt: Ullstein 1963).

1924. *Die neue Wohnung: Die Frau als Schöpferin* (Leipzig: Klinkhardt & Biermann).

Theweleit, Klaus, 1987. *Male Fantasies* (Minneapolis: University of Minnesota Press).

Tönnies, Ferdinand, 1887. *Gemeinschaft und Gesellschaft* (Leipzig: Fues).

Towers, Beeke Sell, 1990. "Utopia/Dystopia: Dadamerika and Dollarica," in *Envisioning America: Prints, Drawings, and Photographs by George Grosz and His Contemporaries, 1915–1933* (ex. cat.) (Cambridge, Mass: Busch-Reisinger Museum [Harvard University]).

Uhde, Wilhelm, 1919. "Formzertrümmerung und For-

menaufbau in der bildenden Kunst," *Das Kunst-blatt* 3(10):317–19.

Uhlman, Fred, 1960. *The Making of an Englishman* (London: Gollancz).

Ulmer, Gregroy L., 1983. "The Object of Post-Criticism," in Hal Forster, ed., *The Anti-Aesthetic* (Port Townsend, Wash.: Bay Press), pp. 83–110.

Umanski, Konstantin, 1920. *Die neue Kunst in Rußland, 1914–1919* (Munich: H. Goltz and Potsdam: Gustav Kiepenheuer).

1920. "Neue Kunstrichtungen in Rußland." Part I: "Der Tatlinismus oder die Maschinenkunst," *Der Ararat* 4:12–14; Part II: "Die neue Monumental-skulptur in Rußland," *Der Ararat* 5/6 29–33.

Verkauf, Willy, 1975. *Dada: Monograph of a Move-ment* (London: Academy Editions; New York: St. Martin's Press).

Walden, Herwarth, 1919a. *Einblick in Kunst* (Berlin: Verlag der Sturm).

1919b. *Die neue Malerei* (Berlin: Verlag der Sturm).

1918. *Expressionismus: die Kunstwende:* (Berlin: Verlag der Sturm).

Walden, Nell, and Lothar Schreyer, 1954. *Der Sturm: Ein Erinnerungsbuch an Herwarth Walden und die Künstler aus dem Sturmkreis* (Baden-Baden: Klein).

Wedderkop, Hermann von, 1921. "Dadaismus," *Der Cicerone* 13:422–30.

Weininger, Otto, 1903. *Geschlecht und Charakter* (Wien: Braumüller).

Weinstein, Joan, 1990a. *The End of Expressionism: Art and the November Revolution in Germany 1918–1919.* (Chicago: University of Chicago Press).

1990b. "The November Revolution and the Insti-tutionalization of Expressionism in Berlin," in R. Hertz and M. Klein, eds., *Twentieth Century Art Theory* (Englewood Cliffs, N.J.: Prentice Hall).

Werckmeister, O. K., 1981. *Versuche über Paul Klee* (Frankfurt: Syndikat).

1989. *The Making of Paul Klee's Career 1914–1920* (Chicago: University of Chicago Press).

Wescher, Herta, 1968. *Collage* (New York: Abrams).

Westfälisches Landesmuseum für Kunst und Kul-turgeschichte (Münster), 1980. *Reliefs* (ex. cat.).

Whyte, Iain B., 1982. *Bruno Taut and the Architecture of Activism* (Cambridge and New York: Cambridge University Press).

Willett, John, 1970. *Expressionism* (London: Weiden-feld and Nicolson).

1978. *The New Sobriety 1917–1933: Art and Politics in the Weimar Period.* (London: Thames and Hudson).

Winnicott, Donald Woods, 1971. *Playing and Reality* (London: Tavistock Publications).

Wissmann, Jürgen, 1966. "Collagen oder die Integra-tion von Realität im Kunstwerk," in W. Iser, ed., *Immanente Ästhetik; Ästhetische Reflexion; Lyrik als Paradigma der Moderne* (Munich: Wilhelm Fink), pp. 327–60.

Worringer, Wilhelm, 1908. *Abstraktion und Einfühl-ung* (Munich: Piper).

1912. *Formprobleme der Gotik* (Munich: Piper).

1953. *Abstraction and Empathy*, translated by Mi-chael Bullock (London: Routledge and Keegan Paul Ltd.); originally published as *Abstraktion und Einfühlung* (Munich: Piper, 1908).

Wright, Barbara D., 1983. "Sublime Ambition: Art, Politics and Ethical Idealism in the Cultural Jour-nals of German Expressionism," in S. E. Bronner and D. Kellner, eds., *Passion and Rebellion: The Expressionist Heritage* (Mount Holyoke: J. F. Ber-gin), pp. 82–112.

Zammito, John H., 1984. *The Great Debate: "Bolshe-vism" and the Literary Left in Germany, 1917–1930* (New York: P. Lang).

Political and Historical

Angress, Werner T., 1963. *Stillborn Revolution: The Communist Bid for Power in Germany, 1921–1923* (Princeton: Princeton University Press).

Arendt, Hannah, 1951. *The Origins of Totalitarianism* (New York: Harcourt Brace).

Berghahn, V. R., 1987. *Modern Germany: Society,* *Economy and Politics in the Twentieth Century,* 2nd ed. (Cambridge: Cambridge University Press).

Bridenthal, Renate, et al., eds., 1984. *When Biology Became Destiny: Women in Weimar and Nazi Ger-many* (New York: Monthly Review Press).

Craig, Gordon A., 1978. *Germany, 1866–1945* (Oxford: Oxford University Press).

Evans, Richard J., 1976. *The Feminist Movement in Germany, 1894–1933* (London and Beverly Hills: Sage Publications).

Herf, Jeffrey, 1984. *Reactionary Modernism: Technology, Culture, and Politics in Weimar Germany and The Third Reich* (Cambridge: Cambridge University Press).

Holborn, Hajo, 1982. *A History of Modern Germany.* 3 vols. (Princeton: Princeton University Press).

Krummacher, F. A., and Albert Wucher, eds., 1965. *Die Weimarer Republik 1918–1933: Ihre Geschichte in Texten, Bildern und Dokumenten* (Munich: Kurt Desch).

Maier, Charles S., 1975. *Recasting Bourgeois Europe: Stabilization in France, Germany, and Italy in the Decade after World War 1* (Princeton: Princeton University Press).

Mann, Thomas, 1956. *Betrachtungen eines Unpolitischen* (Frankfurt/M.: Fischer Verlag).

Mayer, Arno J., 1981. *The Persistence of the Old Regime: Europe to the Great War* (New York: Pantheon).

——— 1988. *Why Did the Heavens not Darken?* (New York: Pantheon).

Mosse, George L., 1964. *The Crisis of German Ideology: Intellectual Origins of the Third Reich.* (New York: Grosset and Dunlap).

Ritter, Gerhard A., and Susanne Miller, eds., 1975. *Die deutsche Revolution 1918–1919: Dokumente,* 2d exp. ed. (Hamburg: Hoffmann and Campe).

Ryder, A. J., 1967. *The German Revolution of 1918: A Study of German Socialism in War and Revolt* (Cambridge: Cambridge University Press).

——— 1973. *Twentieth-Century Germany: from Bismarck to Brandt* (London: Macmillan).

Scheidemann, Philipp, 1928. *Memoiren eines Sozialdemokraten,* 2 vols. (Dresden: C. Reissner).

Schmitt, Carl, 1986. *Political Romanticism* (Cambridge: MIT Press); translation of *Politische Romantik* (Munich: Duncker & Humblot, 1919).

Schorske, Carl. E., 1955. *German Social Democracy, 1905–1917: The Development of the Great Schism.* (New York: Russell & Russell).

Sontheimer, Kurt, 1962. *Antidemokratisches Denken in der Weimarer Republik: Die politischen Ideen des deutschen Nationalismus zwischen 1918 und 1933* (Munich: Nymphenburger).

Stern, Fritz, 1961. *The Politics of Cultural Despair: A Study in the Rise of the German Ideology* (New York: Anchor).

INDEX

Index